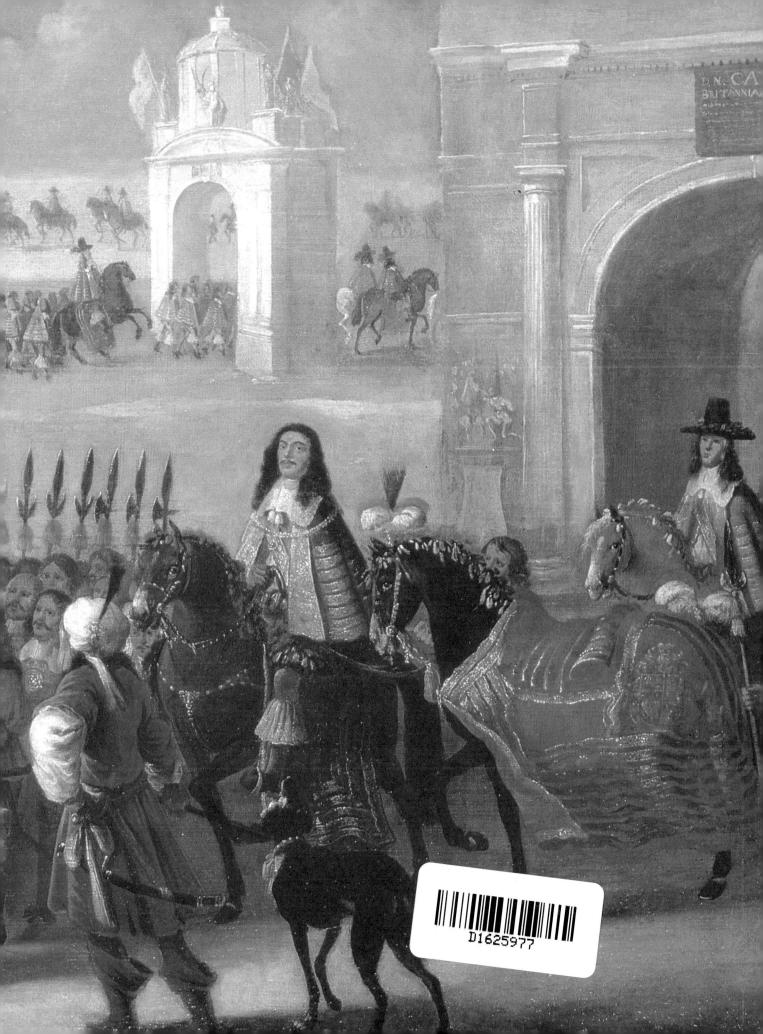

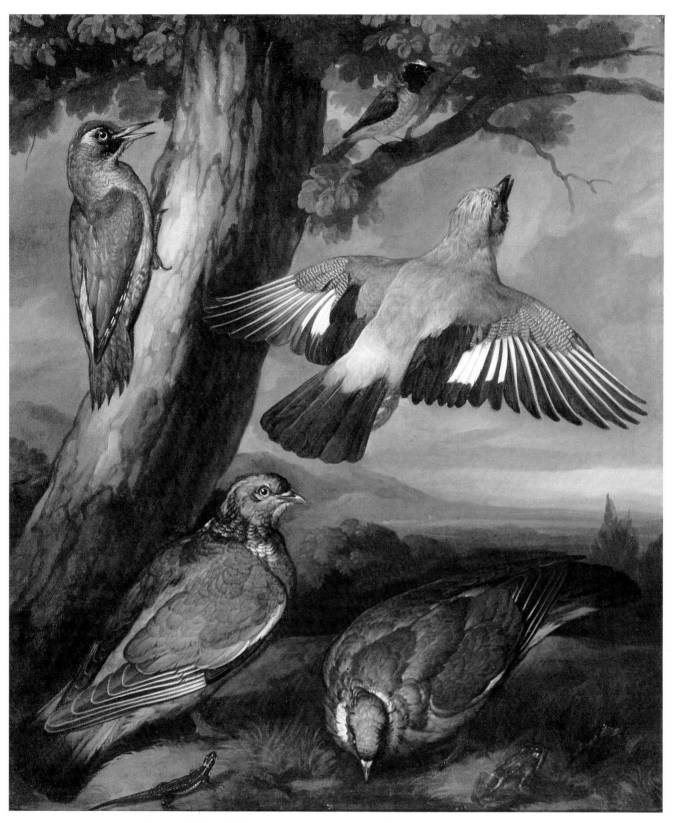

FRANCIS BARLOW, c.1628-1704. *'Landscape with a green woodpecker, a jay, two pigeons, a redstart, a lizard and two frogs'. 30ins. x 25⅛ ins. c.1650. B.A.C. Yale, Paul Mellon Collection.*

The Dictionary of
16th & 17th Century
BRITISH PAINTERS

Ellis Waterhouse

Antique Collectors' Club

British Library Cataloguing in Publication Data
Waterhouse, Ellis
The Dictionary of 16th & 17th century British painters
1. British paintings. Painters, 1500-1700. Bibliographies
759.2

Published for the Antique Collectors' Club
by the Antique Collectors' Club Ltd.

Printed in England by the Antique Collectors' Club Ltd.,
Woodbridge, Suffolk

The Antique Collectors' Club

The Antique Collectors' Club was formed in 1966 and now has a five figure membership spread throughout the world. It publishes the only independently run monthly antiques magazine *Antique Collecting* which caters for those collectors who are interested in widening their knowledge of antiques, both by greater awareness of quality and by discussion of the factors which influence the price that is likely to be asked. The Antique Collectors' Club pioneered the provision of information on prices for collectors and the magazine still leads in the provision of detailed articles on a variety of subjects.

It was in response to the enormous demand for information on "what to pay" that the price guide series was introduced in 1968 with the first edition of *The Price Guide to Antique Furniture* (completely revised, 1978), a book which broke new ground by illustrating the more common types of antique furniture, the sort that collectors could buy in shops and at auctions rather than the rare museum pieces which had previously been used (and still to a large extent are used) to make up the limited amount of illustrations in books published by commercial publishers. Many other price guides have followed, all copiously illustrated, and greatly appreciated by collectors for the valuable information they contain, quite apart from prices. The Antique Collectors' Club also publishes other books on antiques, including horology and art reference works, and a full book list is available.

Club membership, which is open to all collectors, costs £15.95 per annum. Members receive free of charge *Antique Collecting,* the Club's magazine (published every month except August), which contains well-illustrated articles dealing with the practical aspects of collecting not normally dealt with by magazines. Prices, features of value, investment potential, fakes and forgeries are all given prominence in the magazine.

Among other facilities available to members are private buying and selling facilities, the longest list of "For Sales" of any antiques magazine, an annual ceramics conference and the opportunity to meet other collectors at their local antique collectors' clubs. There are over eighty in Britain and more than a dozen overseas. Members may also buy the Club's publications at special pre-publication prices.

As its motto implies, the Club is an amateur organisation designed to help collectors get the most out of their hobby: it is informal and friendly and gives enormous enjoyment to all concerned.

For Collectors — By Collectors — About Collecting

The Antique Collectors' Club, 5 Church Street, Woodbridge, Suffolk

Abbreviations

attrib.	attributed
B.A.C. Yale	Yale Center for British Art, Yale University, New Haven, Connecticut
B.M.	British Museum
cat.	catalogue
exh.	exhibitor, exhibited, etc.
N.G.	National Gallery, London
N.M.M.	National Maritime Museum, Greenwich
N.P.G.	National Portrait Gallery, London
s. & d.	signed and dated
S.N.G.	Scottish National Gallery, Edinburgh
S.N.P.G.	Scottish National Portrait Gallery, Edinburgh
V. & A.	Victoria and Albert Museum

All pictures are in oil unless otherwise stated. Measurements are given height by width.

Contents

Abbreviations . 6
Publishers' introduction . 9
Dictionary . 11
Bibliography .306

List of colour plates

Francis Barlow:	Landscape with a green woodpecker, a jay, two pigeons, a redstart, a lizard and two frogs	frontispiece
Mary Beale:	Self-portrait	19
John Closterman:	3rd Earl of Shaftesbury with his brother	49
Samuel Cooper:	John, 1st Duke of Lauderdale	56
Michael Dahl:	Self-portrait	69
William Dobson:	Charles II as Prince of Wales	76
	Portrait of the artist with Sir Balthasar Gerbier and Sir Charles Cotterell	77
Hans Eworth:	Mary Fitzalan, Duchess of Norfolk	84
Isaac Fuller:	Charles and Colonel Carless in the royal oak	93
Orazio Gentileschi:	Allegory of Peace and Arts under the British Crown	100
Marcus Gheeraerts (ii):	The Countess of Leicester and her children	101
George Gower:	Lady Kytson	108
Nicholas Hilliard:	Alice Hilliard	125
	George Clifford, 3rd Earl of Cumberland	125
	Queen Elizabeth	125
Hans Holbein:	Christine, Duchess of Milan	127
Gerrit van Honthorst:	Charles I and Henrietta Maria as Apollo and Diana	130
Cornelius Johnson (i):	The 1st Baron Capel and his family	142
Claude de Jongh:	The Thames at Westminster Stairs	147

Godfrey Kneller:	Frances, Countess of Mar	154
Leonard Knyff:	3rd Viscount Irwin	159
Louis Laguerre:	Triumph of Diana, Goddess of the Moon	162
Peter Lely:	Diana Kirke, Countess of Oxford	174
	Sir John Cotton and his family	175
	Nymphs at a fountain	175
Alexander Marshal:	Flowers in a Delft jar	187
Daniel Mytens:	William Knollys, 1st Earl of Banbury	198
Isaac Oliver:	Portrait of a young man	207
Robert Peake (i):	Henry, Prince of Wales	210
John Riley:	Elias Ashmole	229
Peter Paul Rubens:	The Apotheosis of James I	232
	Summer	233
Thomas Sadler:	John Bunyan	236
Jan Siberechts:	Wollaton Hall and Park, Nottinghamshire	246
Dirck Stoop:	Charles II's entry into London on the day before his coronation in 1661	256
Robert Streater:	Ceiling of the Sheldonian Theatre, Oxford	267
Anthony Van Dyck:	The continence of Scipio	269
	James, 7th Earl of Derby, his lady and child	272
	Cupid and Psyche	273
Willem van de Velde (ii):	The Battle of Texel, 1673	280
Antonio Verrio:	The Heaven Room, Burghley House	288
John Michael Wright:	The Hon. John Russell	292

Publishers' preface

At the time of his death in 1985 Sir Ellis Waterhouse had completed the manuscript of this book and sorted from his extensive private collection a number of suitable photographs.

Brian Allen, the Deputy Director of the Paul Mellon Centre for Studies in British Art, London, kindly undertook the task of locating extra illustrations, checking the captions and, where practical, adding the current ownership or location of each. We believe that the result has been the provision of a substantial number of previously unpublished photographs. We are most grateful to Dr. Allen for his kindly assistance.

Thanks are also due to the staff of the Paul Mellon Centre for Studies in British Art and the Courtauld Institute of Art, London, for helping in the location of pictures. We are grateful to the large number of owners, both public and private, who have provided photographs and information. It is a tribute to the memory of Sir Ellis that nobody refused to help.

ACREMAN (ARKEMAN), Philip fl.1530/31

Probably only a decorative painter. Assisted Antony Toto (q.v.) repainting and regilding 'certain antique heads' at Hampton Court 1530; also worked at Westminster Palace.

(*E.C-M.*)

ADAME the painter See **COLONE, Adam (de)**

ADRIAEN de Colone See **VANSON, Adriaen**

AGAR, James d.1641

'Limner' or 'picturedrawer' resident in Holborn, where he was buried 9 October 1641 and a son baptised 1636.

(*Edmond, 154.*)

AGAR See also **D'AGAR**

AGAS, Samuel fl.1618 – 1668/69

Painter-Stainer living in Holborn 1618; Upper Warden of the Painter-Stainers 1653/54. Father of Robert Aggas (q.v.). He died at West Ham.

(*Edmond, 154.*)

AGGAS (AGAS, ANGUS, AUGGS, AUGUS), Robert *c.*1620 – *c.*1682

Landscape painter and also scene painter. Son of Samuel Agas (q.v.); from a family from Stoke-by-Nayland. He perhaps studied in Rome in 1651 and was made free of the Painter-Stainers' Company in 1646. He was still alive in 1682 (*Nicoll*). His one known work is an ideal landscape which he presented to the Painter-Stainers' Hall in 1679 and is now in the Court Room; it is slightly in the manner of Jan Both.

(*Buckeridge; Edmond, 154.*)

ALTHAM, Mr. fl.1660s

Perhaps, in England, an amateur painter, but a 'Monsieur Altham, Scolare di Salvator Rosa' is credited with certain landscapes in the 1788 catalogue of the Colonna Collection, Rome. He is presumably the Mr. Altham, whose portrait as a 'Hermit' by Salvator Rosa is in the Bankes Collection at Kingston Lacy (now National Trust). He may have been Leventhorpe Altham (1618-1681), a cousin of Sir John Bankes.

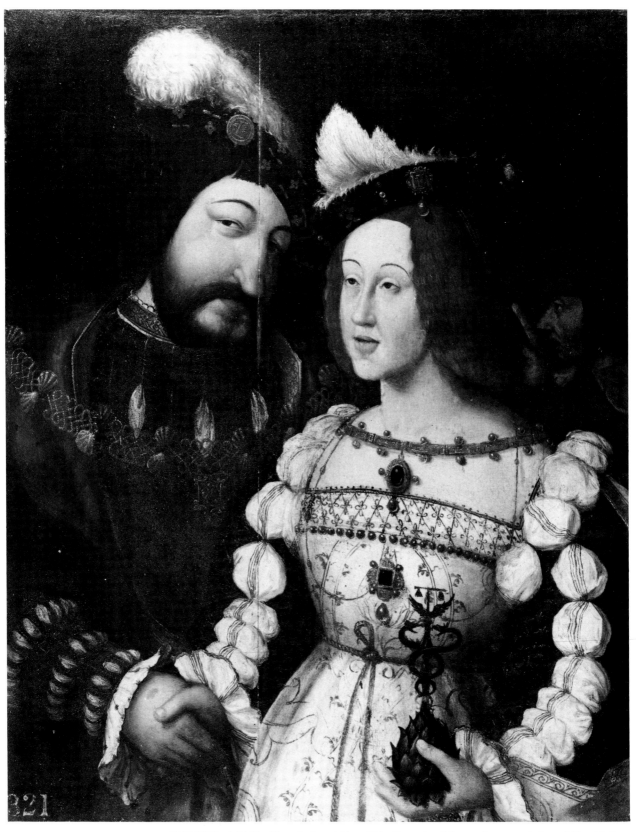

AMBROS, d.1550. 'Francis I and his wife'. Reproduced by gracious permission of Her Majesty the Queen.

12

AMBROS d.1550

'Painter to the Queen of Navarre'; briefly visited England 1532 (*Auerbach*). It seems probable this was Ambrosius Benson, portrait and religious painter of Lombard origin, Master at Bruges 1518, where he worked until his death. He is not otherwise known to have been employed by Marguerite d'Angoulême, Queen of Navarre (1492-1549).

(*Georges Marlier, A.B., 1957.*)

ANDERSON, David fl.1617 – 1624

Painter at Aberdeen. Uncle of George Jamesone (q.v.) and probably brother of John Anderson (q.v.). He is traditionally said to have done the paintings at Cullen House ('Siege of Troy', a 'Boar Hunt' and 'Planetary Deities').

(*Country Life, 23 January, 1948.*)

ANDERSON, John fl.1601 – 1649

Decorative painter at Aberdeen and Edinburgh; possibly also a portraitist. Guild burgess at Aberdeen as 'pictor' 1601; burgess at Edinburgh 1611; still alive 1649. He was probably the outstanding decorative painter in Scotland in his day, and was the master of George Jamesone (q.v.).

(*Duncan Thomson, The Life and Art of George Jamesone, 1974.*)

ANDERTON, Henry *c.*1630 – *c.*1670

Began as a pupil of Streater (q.v.) and painted landscapes and still-life, but none are known. Studied in Rome, probably in the early 1660s, and settled in London as a portrait painter, where he is said to have enjoyed court patronage *c.*1665 with the support of Frances Stuart, Duchess of Richmond. His one known signed portrait is half way between Lely and John Michael Wright (qq.v.).

(*Buckeridge, 355.*)

ANGUS See AGGAS, Robert

ANTONIO DI NUNZIATO D'ANTONIO See TOTO, Antony

ARKEMAN See ACREMAN, Philip

ARNOLD fl.1565/66

In an account book of Sir Henry Sidney for 1565/66 appears 'Arnold, for my lord's pictures £4 6s. 10d.'.

(*Hist. MSS. Commission, MSS. of Lord De L'Isle and Dudley, I (1925), 241.*)

ARNOLD, fl.1682. Still-life. s. & d. 'Arnold 1682'. 24½ins. x 28ins. Christie's sale 25.7.1952 (119).

HENRY ANDERTON, c.1630-c.1670. Portrait of a lady. 47ins. x 38ins. Signed. Private collection.

ARNOLD fl.1682

A still-life, signed on a sheet of music 'Arnold 1682', from the sale from Shardeloes, Christie's sale 25 July 1952 (119), may have been painted in England.

ARNOLD See also BRONCKHORST, Arthur

ARNOLDE fl.?1572-1598

A painter of this name is listed in F. Meres, *Palladis Tamia,* 1598. There are payments in 1572/73 to 'Arnolde the painter' for a picture of 'Andromeda' in the accounts of the Office of the Revels, which were made through John Arnolde, 'yeoman or keeper of our vestures'.

(*A. Feuillerat (ed.), Documents relating to the Office of the revels in the time of Queen Elizabeth, 1908, 175, 181.*)

ASHFIELD, Edmund fl.1669 – 1676

Portrait painter and a pioneer in England in the field of portraits in coloured chalks, which he succeeded in bringing 'to ten pounds price'. Signed and dated examples only range from 1673 to 1676 (the signature is 'E.A.' (sometimes with a ligature) followed by a smaller 'F'.). He also painted in oils and there is early evidence for two portraits, both copies, at Oxford — one of 'Duns

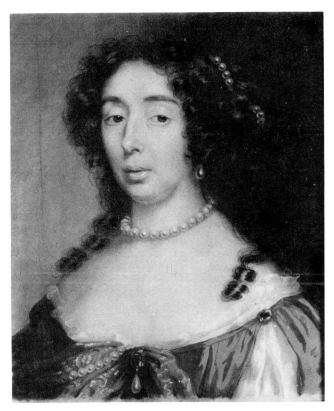 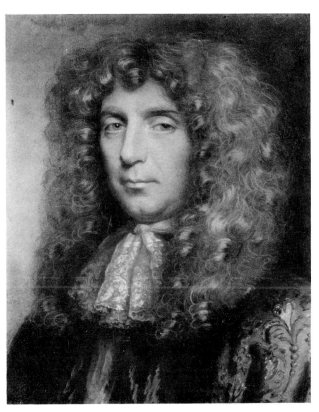

EDMUND ASHFIELD, fl.1669-1676. Portrait of a lady. s. & d.
1675. 11½ ins. x 9¾ ins. Pastel. Private collection.

EDMUND ASHFIELD, fl.1669-1676. Portrait of a man. s. & d.
1676. 11½ ins. x 9½ ins. Pastel. Private collection.

Scotus', probably of 1670, and a full-length copy of the 'Duke of Ormonde' after Lely of before 1679 (*Walpole Soc., V, 6n.*). He is said to have been a pupil of John Michael Wright (q.v.) and the teacher of Luttrell (q.v.) (*Buckeridge*). He was of good family and probably a Roman Catholic and is said to have died 'about 1700', but this may be doubted.

(*C.H. Collins Baker; Croft-Murray and Hulton, 93/94; Walpole Soc., III (1914), 83-87.*)

AUBREY, John **1626 – 1697**
The eminent antiquary; taught to paint by Jacob de Valke, and practised the arts in a desultory manner from childhood, doing several portraits from the life.

(*Aubrey's Lives, ed. A. Clark, 1898, 36, 51 n.12, 152.*)

AUGUS See AGGAS, Robert

AUSTIN, Nathaniel **fl.from 1613**
Michael Austin, an Englishman, resident in London, apprenticed his son Nathaniel on 29 April 1613 to Jan Teunissen at Amsterdam, to learn painting.

(*Oud Holland, LII (1935), 288.*)

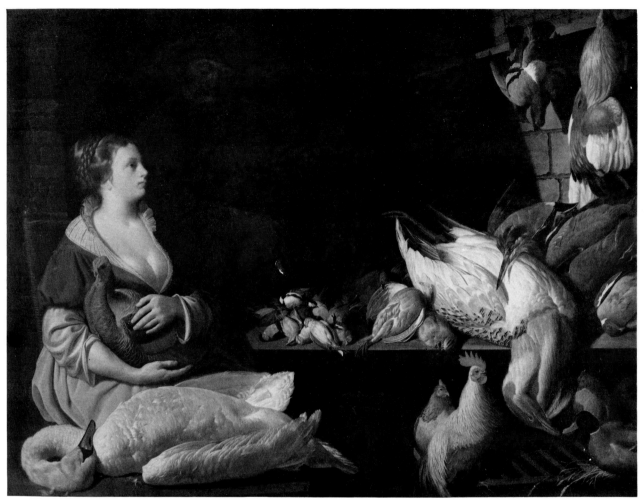

NATHANIEL BACON, 1585-1627. 'The Cookmaid'. 60ins. x 81ins. Private collection.

BACON, Sir Nathaniel **1585 – 1627**

Distinguished amateur painter of portraits and dead game. Youngest son of the premier baronet; born August 1585; K.B. 1 February 1625/26; buried Culford 1 July 1627. A minute and fantastic landscape on copper (Ashmolean Museum, Oxford) is the earliest landscape by a native British painter, but is wholly unlike his other works, which suggest study in the Low Countries, perhaps with Terbrugghen at Utrecht after 1614. His pictures were probably only painted for his own family. Some survive with his descendants at Gorhambury, but 'ten great peeces of fish and fowle &c.' have disappeared, as have paintings of classical subjects in another branch of the family. He was sufficiently proud of his professional competence for a palette and brushes to appear on his tomb.

(*Collins Baker, I, 71-73.*)

BAKER, Mrs. **fl.1677**

Received £6 15s. on 15 September 1677 for a portrait of the 2nd Duke of Newcastle (Welbeck Archives).

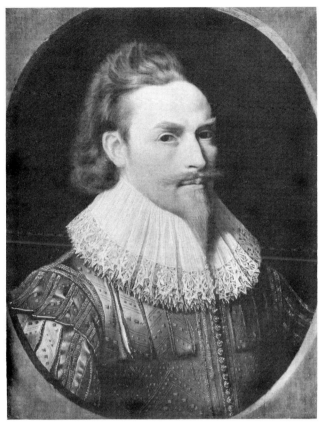 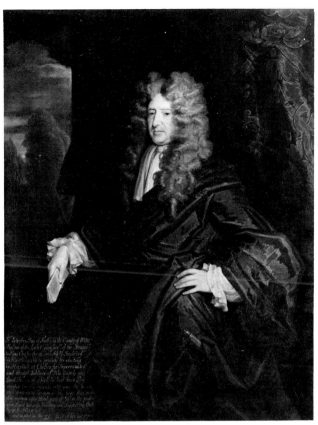

NATHANIEL BACON, 1585-1627. Self-portrait. 23ins. x 17¾ins. Painted on wood. N.P.G.

JOHN JAMES BAKKER, fl.1696-c.1712. 'Sir Stephen Fox of Farley in the County of Wilts...' (1627-1716). Private collection.

BAKKER (BACKER, BAKER, BECKER), John James **fl.1696 – c.1712**
Netherlandish sources give his name as Nicholas and say he was a native of Brabant (*Weyerman, III, 89*) who worked long in London, where he died. He was a drapery painter and copyist for Kneller (q.v.) whom he accompanied when he went to Brussels 1697, but was said to be capable of doing good portraits on his own. The only engraved one (by J. Simon) is 'Sir Stephen Fox' (private collection), 1701, as after 'J. Baker'. Two copies of Kneller portraits, of William III and Mary, formerly at Melville House and lettered as by 'J.J. Bakker' were extremely pedestrian.

(*J. Douglas Stewart, Sir Godfrey Kneller, 1983, 41n.*)

BAPTIST (i) See GASPARS, John Baptist

BAPTIST (ii) See MONNOYER, John-Baptiste

BARKER, Charles **fl.1629 – 1633**
Portraitist apparently resident at Newcastle. Payments to or concerning him appear in Lord William Howard's accounts for Naworth Castle during the years 1629 to 1633.

(*Surtees Soc., LXVIII, 1877.*)

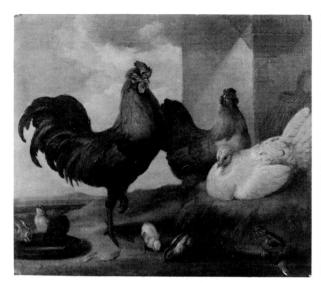
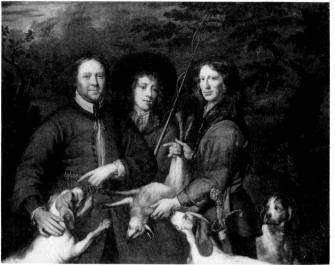
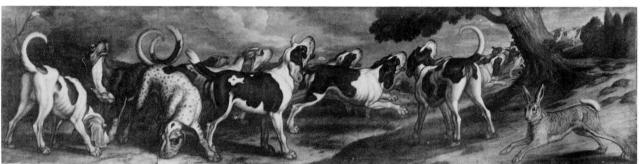

FRANCIS BARLOW, c.1628-1704. Top left: 'Poultry'. 33½ ins. x 39½ ins. s. & d. 'F. Barlow pinxit 1655'. B.A.C. Yale, Paul Mellon Collection. Top right: 'Huntsman, coachman and keeper'. Private collection. Above: 'The southern-mouthed hounds'. 2½ ft. x 15ft. Clandon Park (National Trust).

BARLOW, Francis *c.*1628 – 1704

Probably born in Lincolnshire; buried London 11 August 1704. He was the first native English book illustrator and the first professional English etcher (*Edward Hodnett, F.B., 1978*). He is said to have studied painting under William Sheppard (q.v.). His earliest dated drawing is 1648 and he became a Painter-Stainer March 1649/50. His earliest etched illustrations are for Edward Benlowes' *Theophila*, 1652, which involve a good many human figures, but by 1656 he was known as 'the famous painter of fowles, beasts and birds' which always remained his speciality, although he sometimes included the human figure. His most impressive series of bird and animal pictures is at Clandon Park (National Trust), one of which is dated 1667. His major etched work is *Aesop's Fables, 1665/66.*

(*Croft-Murray and Hulton, 96-97.*)

See colour frontispiece.

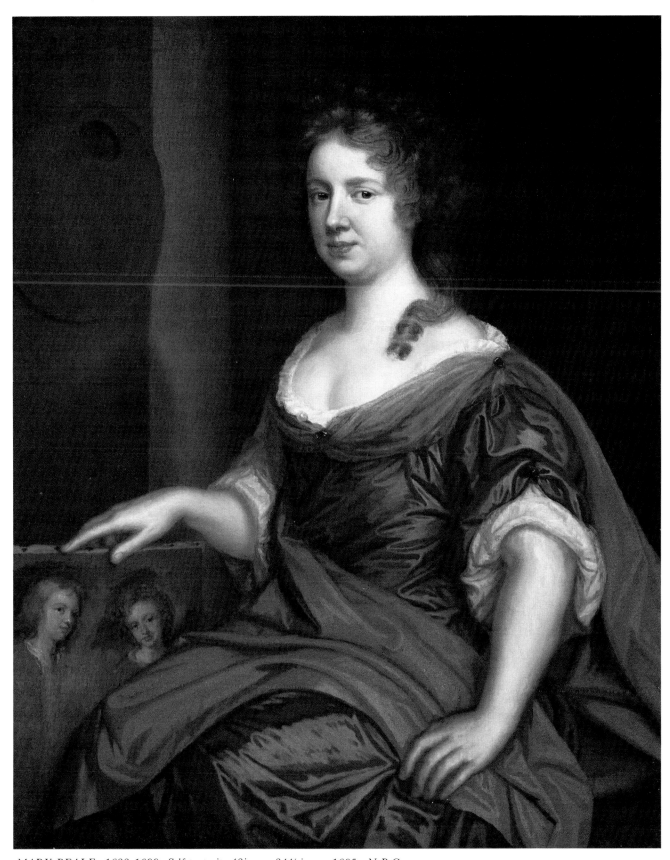

MARY BEALE, 1633-1699. Self-portrait. 43ins. x 34½ins. c.1685. N.P.G.

BARNARD, Lambert (i) fl.1514 – 1568

His son was born 1514 and he probably died January 1567/68. He was 'head of a remarkable school of early Renaissance painting' at Chichester, centered on the patronage of Robert Sherborne, Bishop of Chichester 1508-1536. His work was both religious and secular, as well as decorative, and some of it survives; he may also have been a miniaturist. His style has Flemish affinities and his Christian name suggests Liège. His son Anthony (born 1514, buried Chichester 29 December 1619) and his grandson, Lambert ii (baptised Chichester 9 September 1582; buried there 7 July 1655) carried on the family practice, but their works do not survive.

(*E.C-M.*)

BATE(S), Thomas fl.1692

He signed 'T. Bate fecit '92' on an oval portrait of '1st Lord Coningsby' reposing at full length, in Roman dress, against a view of Hampton Court, Herefordshire (Ulster Museum, Belfast). He may also have painted a distant view of Dublin in the 1690s. (An artist named Thomas Bates died in Dublin in 1677 and may be the miniaturist on glass recorded by Vertue, *i, 108*).

(*Crookshank and Knight of Glin, 1978, with colour plate.*)

BAYLIS, W. fl.1660

The signature on a portrait in an anonymous sale, Christie's, New York, 15 June 1977 (223), was read as 'W. Baylis pinxit/1660'. The picture originally came from Woollas Hall, Pershore.

BEALE, Charles (i) 1631 – 1705

Baptised Walton 9 June 1631; buried Coventry 27 November 1705. Husband of Mary Beale (q.v.). He was capable of painting and may have played a minor role in completing his wife's portraits, but no independent works are known.

BEALE, Charles (ii) 1660 – ?1714

Born London 16 June 1660; died London 1714 (or possibly 1726). Son of Charles and Mary Beale (qq.v.). He helped in his mother's studio and then studied miniature painting with Thomas Flatman (q.v.) 1676/77. His latest miniatures are dated 1688 when failing eyesight caused him to revert to the scale of life. Signed portraits are known from 1689 to 1693 and he seems still to have been painting in 1712. He sometimes signed 'C.B.' His work is more like early Richardson than Mary Beale. He was an attractive portrait draughtsman in red chalk. There are many examples in the British Museum.

(*Elizabeth Walsh and Richard Jeffree, exh. cat. 'The excellent Mrs. Mary Beale', Geffrye Museum, London and Eastbourne 1975/76.*)

BEALE, Mary 1633 – 1699

Born Mary Cradock; baptised 26 March 1633 Barrow (Suffolk), where her father was rector; married 8 March 1651/52 Charles Beale (q.v.); buried

CHARLES BEALE (ii), 1660-?1714. 'Jane Bohun'. 29¼ins. x 24ins. Charlecote Park (National Trust).

London 8 October 1699. A prolific professional portraitist of the middle classes, especially of the clergy. Possibly studied with Robert Walker (q.v.). She was already known as a painter by 1654, but she later was chiefly influenced by Lely (q v.), who was a friend and whose work she sometimes copied. Of certain works one of the earliest is the group of 'Herself, husband and elder son', *c.*1663/64 (Geffrye Museum, London), but her active practice in London only began about 1670, when her prices were £5 for a 30ins. x 25ins. and £10 for a 50ins. x 40ins. Her most active period was the 1670s and early '80s. Her husband kept very detailed notes of her studio activities and the notebooks for 1677 (Bodleian Library, Oxford) and 1681 (N.P.G.) survive, and Vertue publishes partial transcripts of others. She quite often signs and, for her bust portraits, she particularly affects a feigned stone oval surround with fruit. Neither her drawing nor her colour is comparable with that of Lely.

(*Elizabeth Walsh and Richard Jeffree, exh. cat. 'The excellent Mrs. Mary Beale', Geffrye Museum, London and Eastbourne 1975/76.*)

See colour plate p.19.

MARY BEALE, 1633-1699. 'Elizabeth Pelham'. 50ins. x 40ins. s. & d. 1683. Private collection.

MARY BEALE, 1633-1699. 'Revd. Dr. Dukefond, Rector of St. Clement Danes'. 28¼ins. x 24½ins. Signed. Sotheby's sale 6.5.1964 (117).

BECK, David ?1621 – 1656

A Dutchman, born Delft or Arnhem; died The Hague. He was pupil and assistant to Van Dyck (q.v.) in London, probably in the later 1630s. Court Painter to Queen Christina in Stockholm 1647-1651; in Rome 1653. No portraits painted in England are known for certain. A portrait of Queen Christina at Stockholm, signed and dated 1650, is a close but rather pedestrian imitation of English Van Dyck.

BECKER See BAKKER, John James

BEGA (BEGEIJN), Abraham Cornelisz 1637 – 1697

Dutch painter specialising in plants and Italianate landscapes. He ended as Court Painter at Berlin. He briefly visited England c.1673 and painted three wall panels for the Duke of Lauderdale at Ham House.

(*P. Thornton and M. Tomlin, The Furnishing and Decoration of Ham House, The Furnishing History Soc., XVI, 1980, figs. 92 and 93.*)

BELCAMP (BELCOM, BELKAMP), Jan van fl.1625 – 1651

Probably a native of the Low Countries. He was a professional copyist of portraits, especially of royal portraits, and may have created imaginary portraits of ancestors. Died December 1651 (*Walpole Soc., XLIII, xvi*). He was chiefly employed by Charles I and examples survive in the Royal Collection. There are also two variants after Holbein at Drayton.

(*Millar, 111ff.*)

ABRAHAM CORNELISZ BEGA, 1637-1697. Landscape wall panel from the Withdrawing Room at Ham House. V. & A.

BELFORD, Mark fl.1612

A limner in the service of Prince Henry, 1612.

(*Auerbach.*)

BELLIN, Edward fl.1636

A portrait of a man in a Welsh collection, in style like a provincial Cornelius Johnson, is signed 'Edw: Bellin/fecit/1636'.

(*Steegman, I, pl. 37a.*)

BELLIN, Nicholas See NICHOLAS DA MODENA

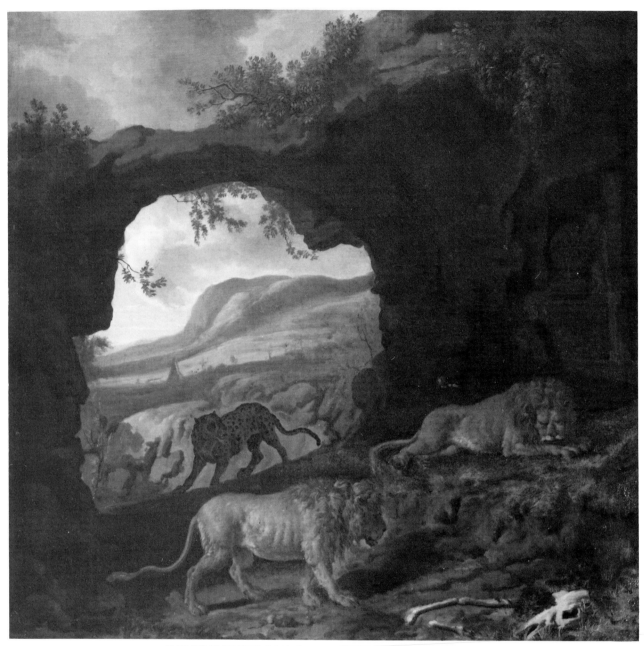

DIRCK VAN BERGEN, ?1645-c.1690. 'Pair of lions with a leopard'. V. & A. (Ham House).

DIRCK VAN BERGEN, ?1645-c.1690. Painting from the White Closet at Ham House. V. & A.

BENING (BENNINCK), Simon 1483/84 – 1561

Leading miniature painter of the Bruges-Ghent School; entered the Bruges Guild 1508; settled there 1519 and died there. He is often said to have visited London and worked for the Court, but this is not confirmed. His daughter, Levina Teerlinc (q.v.), was so employed.

(*Kren, 1983, 6ff.; Friedrich Winkler, Die Flämische Buchmalerei des xv und xvi Jahrhunderts, Leipzig, 1925, 139ff.*)

BENTHEM, Martin van fl. 1595 – 1617

Native of Emden; came to England 1595; made a denizen 1607. Painted portraits and other pictures for the Court. No work is known.

(*Auerbach; E.C-M.*)

BERCHET, Pierre 1659 – 1719/20

French history painter of considerable talent. Died in London January 1719/20, aged 61. Pupil of Lafosse. First came to England for a year 1681 as an assistant to Verrio (q.v.), but returned to France and worked at Marly. Presumably a Protestant and settled in England after the revocation of the Edict of Nantes 1685. He had considerable patronage but his only major surviving decorative work is the 'Ascension' (oil on plaster) on the ceiling of the Chapel of Trinity College, Oxford, *c.*1694. In style this is nearer to Lafosse than to Verrio.

(*Vertue, i, 87; E.C-M.*)

BERGEN, Dirck van (den) ?1645 – *c.*1690

Dutch painter of pastoral landscapes and animals. Native of Haarlem, where he was still active up to 1690. Pupil and imitator of Adriaen van de Velde. He made a brief visit to England, where he painted some overdoors and overmantels, etc., for the Duke of Lauderdale at Ham House *c.*1673.

(*E.C-M.*)

BERNART fl. 1670s

Walpole (*II, 138 n.2*) notes two portraits of 'Sir Gervase' and 'Lady Elizabeth Pierpoint' (they were probably misnamed) at The Hoo by an 'obscure painter' named Bernart. These, with two companions, were in Viscount Hampden sale 23 November 1938 (22-25) as Gascars and were by a painter very close in style to Comer (q.v.).

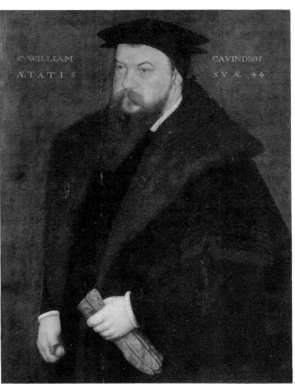

JOHN BETTES (i), fl. 1531-1570. 'A man in a black cap'. 18½ins. x 16ins. 1545. The Tate Gallery.

JOHN BETTES (i), fl. 1531-1570. 'Sir William Cavendish'. Devonshire Collection, Chatsworth. Reproduced by permission of the Chatsworth Settlement Trustees. Photograph Paul Mellon Centre.

BETTES, John (i) fl.1531-1570

Painted large-scale portraits, miniatures; a wood engraver. He died in or before 1570 and was probably the Johannes Bett buried in London 24 June 1570 (*Edmond, 67*). He was conceivably a pupil of Holbein (q.v.), and a signed portrait of 1545 is in the Tate Gallery (*Auerbach*). He was father of:

BETTES, John (ii) fl.1570 – 1616

Painted large-scale portraits and miniatures; painter-stainer. Married 1571; buried London 18 January 1615/16 (*Edmond, 97-99*). He was presumably the painter of the 1587 girl's portrait signed 'I.B.' (St. Olave's School) (*Strong, 187ff.*) He had a son, John (iii) who may have been a painter and signed 'J. Betts', 1660, a vaguely Leliesque female portrait (*The Connoisseur, July 1917, 127*). The Thomas Bettes listed as a painter in 1598 by Francis Meres seems rather to have been a cutler (*Edmond, 190 n.18*). A Dobsonish portrait of 'Sir Thomas Pope, signed 'Betts' was sold Sotheby's, 17 February 1937 (77).

BILFORD, Mr. fl.1608 – 1611

Amateur portrait painter, presumably in miniatures. Secretary to Sir Henry Wotton 1608; transferred to the service of Henry, Prince of Wales 1611, with a wager that he would do a better portrait of the Prince than Isaac Oliver.

(*L. Pearsall Smith, The Life and Letters of Sir Henry Wotton, 1907, I, 118/19n.*)

JOHN BETTES (ii), fl.1570-1616. 'Sir Thomas Pope, 3rd Earl of Downe' (1598-1667). 49ins. x 39ins. Signed 'Betts'. Sotheby's sale 17.2.1937 (77).

BIRD, Edward fl.*c.*1678 – 1693
Did religious furniture painting for Wren in various City churches, all now destroyed.

(*E.C-M.*)

BIRD, Richard fl.1678
Painted in 1678 a 'Last Judgment' on the west wall of the Beauchamp Chapel in St. Mary's, Warwick. It was largely destroyed by fire in 1694.

(*E.C-M.*)

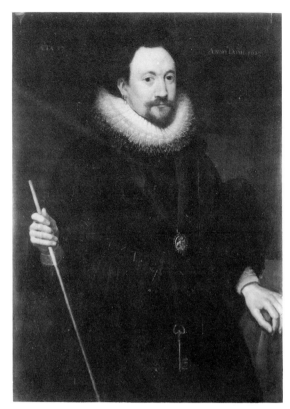

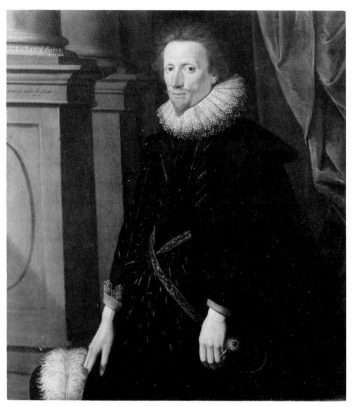

ABRAHAM VAN BLYENBERCH, fl.1617-1622. 'William Herbert, 3rd Earl of Pembroke' (1580-1630). 44ins. x 31½ins. s. & d. 1617. Powis Castle (National Trust).

ABRAHAM VAN BLYENBERCH, fl.1617-1622. 'Robert Carr of Ancram (1st Earl of Ancram)'. 40½ins. x 43½ins. s. & d. 1618. Lothian Trustees.

BLEMWELL fl.*c.*1660

Local portrait painter at Bury St. Edmunds and friend of Lely. He painted a portrait of 'John North' which was at Rougham in 1890.

(*Roger North, Lives of the Norths, 1890 ed., II, 273.*)

BLYENBERCH, Abraham van fl.1617 – 1622

Portrait and history painter. His training and style are very close to that of Mytens (q.v.), who perhaps ousted him in Court favour in London. He was in London 1617-1621, and appears in 1622 in the Guild lists at Antwerp introducing Theodor van Thulden as his pupil. A signed and dated work, the '3rd Earl of Pembroke' (Powis Castle, National Trust) of 1617, is signed 'Abraham/van Blijenb/erch fecit'. He also painted Ben Jonson and Charles I (as Prince of Wales, perhaps N.P.G. 1112). His flesh has a higher enamel than that of Mytens.

(*Millar, 83.*)

BOGDANY (BOGDANI), Jakob 1660 – 1724

Specialist painter of exotic birds. Born Eperjesen, Hungary, son of a Hungarian ambassador; died London 11 February 1724. He was in England by 1691 and was employed by William III by 1694; naturalised 1700. He claimed that he was self taught, but owed a good deal to the bird arrangements of Hondecoeter. Most of his known work in England dates from after 1700.

(*Vertue, i, 127.*)

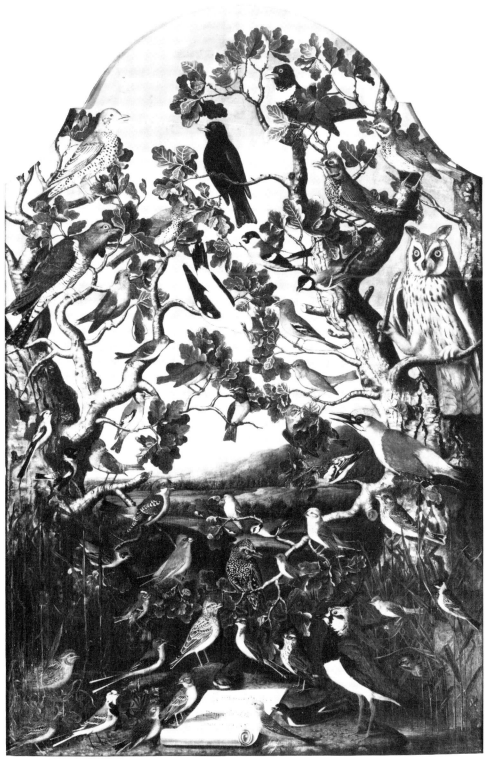

JAKOB BOGDANY, 1660-1724. 'Birds of Britain'. Anglesey Abbey (National Trust). Photograph Courtauld Institute of Art.

BOIS See **DU BOIS, Simon**

JAKOB BOGDANY, 1660-1724. 'Bird and fruit'. Anglesey Abbey (National Trust). Photograph Courtauld Institute of Art.

BOIT, Charles 1662 – 1727

The leading enamel painter of his day. Baptised Stockholm 10 August 1662; died Paris 6 February 1727. From a Huguenot family settled in Sweden, he came to England 1687 and settled in London *c.*1690, where, on the advice of Dahl (q.v.) he specialised in enamel portraits in miniature (sometimes very large) often after paintings by Kneller, Dahl, etc. Appointed Court Enamellist by William III 1696 and held the post until the death of Queen Anne (1714) when he migrated to Paris. He was away from England 1699-1703 and frequented a variety of courts, being notoriously successful with royalty.

(*Long; Nisser, 135-163, with cat.*)

BOL, Cornelis fl.1607 – ?1666

Painter of topographical landscapes. There may be confusion between several painters of the same name. I am assuming that the one who came from Antwerp (buried Haarlem 23 October 1666) was the pupil of Tobias Verhaecht at Antwerp 1607, and became a master there 1615, and was the same artist who spent some years in Paris and came to London 1635/36, where he painted three London river views formerly in the Evelyn Collection (*Vertue, iv, 53*), of one of which there is a variant signed 'C.B.' at Dulwich (*Grant, I, 9*). They initiate a tradition leading to Samuel Scott.

BOON(E), Daniel d.1692

'A Dutch droll painter, and a great admirer of ugliness and grimace, both in his small and great pictures...' (*Buckeridge*). Probably buried London 6 September 1692 (though his death is usually given as 1698). His works are in the manner of those of Egbert van Heemskerk (q.v.).

CHARLES BOIT, 1662-1727. 'Queen Anne and Prince George of Denmark'. Reproduced by gracious permission of Her Majesty the Queen.

BORCH, G. ter See TERBORCH, Gerard

BORCHT, H. van der See VANDERBORCHT, Hendrick

BORDIER, Jacques **1616 – 1684**
Enamellist miniature painter. Born Geneva; died Blois. Associate of J. Petitot (i) (q.v.) in England in the 1640s. They both left the country about 1650 and married sisters in 1651.

(*Long.*)

PIETER BORSSELAER, fl.?1644-1687. 'Lady Dugdale'. 48ins. x 38ins. 1665. Private collection.

PIETER BORSSELAER, fl.?1644-1687. 'Sir William Dugdale'. 49½ins. x 38ins. 1665. Private collection.

BORSSELAER (BUSTLER), Pieter fl.?1644 – 1687

A Dutch portrait and history painter, called Bustler (*Buckeridge*); a Roman Catholic. Possibly the man who married at Goes 1644 (*Oud Holland, 1946, 33ff.*). He was in England 1664-1679; living at The Hague in 1681 and painted chimney pieces at Middelburg 1684 and 1687. His few certain portraits, notably the antiquary 'Sir William Dugdale', 1665, and his wife (private collection), show a seriousness and concern for individual character.

(*Waterhouse,1978, 110, 344 n.32.*)

BOSSAM, John fl.1558

Hilliard writes of 'the most rare English drawer of story works in black and white, John Bossam, for one of his skill worthy to have been Serjeant Painter to any King or Emperor, whose work in that kind are comparable with whatsoever in cloth or distemper colours for white and black; who, being very poor and belike wanting to buy fair colours, wrought therefore for the most part in white and black...', but receiving no patronage he became a clergyman about the time of the accession of Queen Elizabeth.

(*Walpole Soc., I, 18.*)

BOSWELL, William fl.?1573

Recorded (1573) as having decorated an unnamed inn with antitype figures.

(*E.C-M.*)

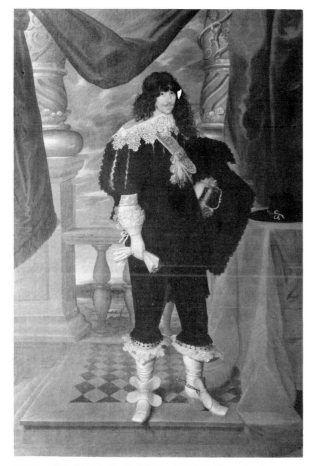
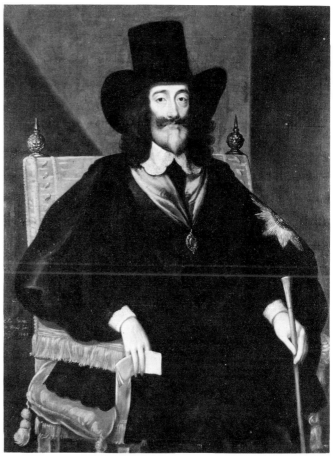

EDWARD BOWER, fl.1629-1666/67. Portrait of a man.
92ins. x 60ins. Private collection.

EDWARD BOWER, fl.1629-1666/67. 'Charles I'. 53ins. x 40ins.
s. & d. 'Edw. Bower/Att Temple barr/fecit 1648'. Private collection.

BOURGUIGNON, Pierre **1630 – 1698**

Portrait painter. Native of Namur; died London 26 March 1698, aged 68. Received into the French Academy 1671; made a denizen in London December 1681; briefly received into The Hague Academy 1687. Receipt for £24 for two 50ins. x 40ins. portraits dated 12 June 1696 (*Wemyss Castle accounts*). One of these, 'Anne, Duchess of Monmouth', survives and looks like a derivative of Mignard.

BOWER(S), Edward **fl.1629 – 1666/67**

Portrait painter. Conceivably a native of the Totnes area; died London during the fortnight preceding 9 January 1666/67. Said to have been a 'servant' to Van Dyck (q.v.). In 1629 there were complaints lodged against him by the Painter-Stainers' Company (of which he became Upper Warden 1656 and Master 1661). He had a studio 'at Temple Bar' in London by 1637, a fact he sometimes notes in his signature (Christie's sale 17 November 1967, 10). In January 1648/49 he made three variant portraits of 'King Charles I at his trial', which were much copied (*Burlington Mag., XCI (January 1949), 18ff.*). He seems to have maintained his business in London during the Commonwealth, but without being compromised. He was a somewhat pedestrian but sincere portraitist and sometimes employs Van Dyck trappings in an amateurish way.

(*York Art Gallery cat., II (1963), 6-8.*)

JOHN BRACKEN, fl.1665-1719. 'Lady Chaworth'. Sotheby's.

BOXHORN See BUCKSHORN, Joseph

BRACKEN, John fl.1665 – 1719
Portrait painter and professional portrait copyist. Native of Cumbria where he was employed by Lady Anne Clifford and did portraits of the local gentry. By at least 1707 he was settled in London, where he is last recorded as repairing the great picture for the Barber-Surgeons' Company. His Cumbrian portraits have rather a 'Commonwealth' style (represented in Abbot Hall Art Gallery, Kendal). His copies of royal portraits (some were documented at Burley-on-the-Hill) were decidedly pedestrian.

(*Mary E. Burkett, J.B., Kendal 1982.*)

BRADSHAW fl.*c.*1652
Vertue (*i, 114*) quotes a note of Richard Symonds of about 1652 that 'Peirce in Bishop gate street says Bradshaw is the only man that doth understand perspective of all the painters in London.'

WILLIAM BRASIER, fl.c.?1700. 'Trompe l'oeil'. 25ins. x 30ins. Sotheby Parke Bernet sale 29.11.1978 (5).

SARAH BROMAN, fl.1658. Portrait of a lady. 30ins. x 25ins. Signed 'Sarah Broman/pinxit-6--' (the date has been read as 1652 or 1669). Private collection.

BRASIER, William fl.*c.*?1700
An undated 'Trompe l'oeil' (Sotheby Parke Bernet sale 29 November 1978, 5) includes a letter addressed to 'Mr William Brasier Painter at London' and shows a mezzotint after a drollery in the manner of Egbert van Heemskerk (q.v.) lettered 'W. Brasier invt.'

BRAY (BRUY), Jacques de fl.1572 – 1598
Painter of French origin; listed by Francis Meres in 1598. Came to England 1572.

(*Auerbach.*)

BROMAN (BROOMAN), Mrs. Sarah fl.1658
Sanderson (*Graphice, 1658*) mentions a 'Mrs. Brooman' who painted in oil. A battered 30ins. x 25ins. of a 'Lady', suggesting a feeble imitation of a Lely (q.v.) of the later 1650s (private collection), is signed 'Sarah Broman/ pinxit -6--'. A William Broman married a Sarah Corker at St. Botolph's, 5 June 1661.

BRONCKORST (BROUNCKHORST, BRUNTKHURST), Arthur (Arnold) fl.1573 – 1583
Portrait painter of Dutch origin; associated 1573 (and later) with Cornelis Devosse (q.v.) in gold-mining in Scotland; 1580-1583 Principal Painter to the King in Scotland. He was replaced by Adriaen Vanson in Scotland in 1583 and was resident in London in that year. A portrait of '1st Lord St. John of Bletso' is signed 'A.R. (monogram) BRONCKORST FECIT 1578' (*Auerbach, Nicholas Hilliard, 1961, 266-267*). Probably by the same hand is the 'King James VI as a boy' (S.N.P.G.), but a copy of an earlier 'Lord Burghley' at Hatfield, signed 'A.B.', is hardly by the same hand, and he has been dubiously equated with

ARTHUR BRONCKORST, fl.1573-1583. 'King James VI (James I) as a boy'. S.N.P.G.

ARTHUR BRONCKORST (attrib.), fl.1573-1583. 'Lord Burghley'. Signed 'A.B.' in monogram. Courtesy the Marquis of Salisbury. Photograph Courtauld Institute of Art.

painters known as Arnold and Arnolde (qq.v.).

(*Duncan Thomson, The Life and Art of George Jamesone, 1974, 44-46.*)

BROOK(S), Joseph fl.1690 – 1725
Portrait painter and copyist at Bury St. Edmunds.

(*Collins Baker.*)

BROOKE, William d.1616
Journeyman figure painter at Exeter.

(*E.C-M.*)

BROWNE, Alexander fl.1660 – 1683
Miniaturist, writer on the arts and publisher of mezzotints (*Chaloner Smith*). He published a translation of a book on drawing, limning, etc., by O. Fialetti, 1660, and his own *Ars Pictoria*, 1669. He also taught limning to Mrs. Pepys (q.v.).

(*Long.*)

S. BROWNE, fl.1680-1691. '1st Duke and Duchess of Beaufort and their family'. 32ins. x 30ins. s. & d. 'S. Browne fecit A⁰ 1685'. Collection of the Duke of Beaufort, Badminton.

BROWNE, John fl.1502 – 1532

The first Serjeant-Painter. His will proved December 1532. It is doubtful if he was more than a herald and decorative painter. He was granted the Office of 'King's Painter' for life 20 December 1511, and the title was changed to Serjeant-Painter 12 March 1527.

(Auerbach.)

BROWNE (BROUNE), S.(?Samuel) fl.1680 – 1691

A group portrait at Badminton of the '1st Duke and Duchess of Beaufort and their family' is signed 'S. Browne fecit A° 1685', and is obviously by a painter who must have been a pupil or student of Caspar Netscher. He may well have been the Samuel Browne who, with his wife, came from The Hague to London in 1680 (*Register of Attestation, London Dutch Church, 1892, no.116*); they had a daughter baptised in 1685. In the Danish Historical Museum are portraits uncertainly called 'Prince George of Denmark' and 'Princess Anne', signed and dated 1691, but with the initial uncertain. Another family group in a private collection, similar to the Badminton one, is also dated 1691, but the initials are said to be 'C.O.'.

BUCKETT (POQUET), Rowland *c.* **1570 – 1639**

Religious and general decorative painter. His father, a German, was made a denizen 1571/72; will proved London 6 November 1639. He was twice Master of the Painter-Stainers (1626/27 and 1630/31). He was employed by the Earl of Salisbury from 1608 for various purposes and two large religious pictures, painted for the Chapel at Hatfield 1611/12, still survive (conceivably taken from foreign engravings).

(C. Kingsley Adams and E. Auerbach, Paintings and Sculpture at Hatfield House, 1971; E.C-M.)

BUCKSHORN (BOKSHOORN), Joseph **fl. 1670s**

Portrait painter and copyist. Said to have been born at The Hague, to have come to England *c.* 1670, and to have died in London aged 35 (probably before

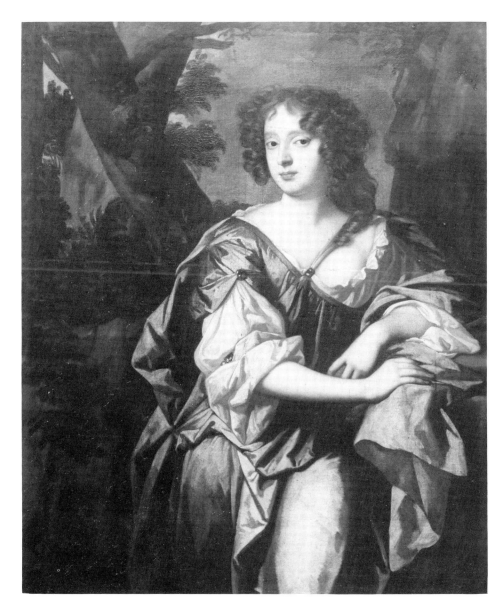

1680). He acted as a drapery painter for Lely (q.v.) and his only known portraits are Lely patterns, executed by a fairly pedestrian hand. 'Mary Isham' at Lamport Hall is documented by a letter from David Loggan to Sir Thomas Isham, dated 29 December 1675, saying that 'Mr. Boxhorn' had promised it would be done in about three weeks.

(*Buckeridge.*)

BURG See VANDERBORCHT, Hendrick

BUSTLER See BORSSELAER, Pieter

BUTLER, Samuel **1612 – 1680**
The famous writer of *Hudibras*. Aubrey, in his *Lives (1898 ed., 135)* says: 'He was thinking once to have made painting his profession... His love to and skill in painting made a great friendship between him and Mr. Samuel Cooper' (q.v.). No works are known.

ROBERT BYNG,
1666-1720. 'Two children
on a terrace'. 49ins. x 39ins.
s. & d. 'R. Byng fecit 16--'
(probably 1697). Christie's
sale 5.4.1946 (22).

BYER, Nicholas **fl. 1662 – 1681**
Portrait and history painter. Said to have been born at Trondheim, Norway;
made a denizen 2 November 1662; died Sheen 1681. He was employed by Sir
William Temple during the last years of his life, and died at his house.

(*Buckeridge.*)

BYNG, Robert **1666 – 1720**
Portrait and occasional sporting painter. Born in Wiltshire; buried Oxford 10
August 1720 (where he had lived since before 1714). On stylistic grounds he
would seem to have been a pupil of Kneller (q.v.), and his earliest dated
portraits are *c.*1697. One of his younger brothers, Edward (1675-1753), was
drapery painter to Kneller and his principal assistant until Kneller's death.

BYRNE (BURNE), H. **fl. 1678**
Miniature painter. Known only from a miniature of the '2nd Duke of
Newcastle' signed 'H.B.' and dated 1678 at Welbeck, for which (and seven

J. CARLETON,
fl. 1635-1637. 'Thomas
Danby as a child'. 28¾ ins.
x 21ins. 1635. Private
collection. Photograph
Courtauld Institute of Art.

JOAN CARLILE,
c.1606-1679. 'Sir Justinian
Isham and others stag hunting
at Petersham'. c.1650.
Lamport Hall Trust.

others) a payment to 'Mr. Byrne' is recorded.

(*R. W. Goulding, cat. of the Welbeck miniatures, Walpole Soc., IV (1916), no.174.*)

CARINGS See KEIRINCX, Alexandre

CARLETON, J. fl.1635 – 1637

Yorkshire painter of portraits and religious works. Three portraits of the Danby family, dated 1635, were formerly at Swinton Park (*John Fisher, The History and Antiquities of Masham and Mashamshire, 1885, 171*). He signed and dated 1636 an enormous 'Supper at Emmaus' after Titian, now at Temple Newsam (*Leeds Art Calendar VII, winter 1954*) and painted Old Testament figures for the chapel at Temple Newsam 1637. The Swinton portraits were like the work of a very provincial Cornelius Johnson i (q.v.) and suggest the same artist may have been painter of the full-length 'Lord Keeper Williams, Archbishop of York', signed 'J.C.' and dated 1624, in the Muniment Room at Westminster Abbey. (There were also Carletons who were Painter-Stainers in London. A George Carleton was Master 1623 and 1628 and was still alive in 1650, and an Edward was buried 13 January 1640/41.)

CARLILE, Mrs. Joan (Anne) c.1606 – 1679

Born Palmer; 1626 ('aged 20') she married Lodowick Carlile, one of the keepers of Richmond Park and a dramatist; buried Petersham 27 February 1679. (In *D.N.B.* and elsewhere wrongly called 'Anne'.) A professional portrait painter and copyist, employed by Charles I, she maintained her public reputation throughout the Commonwealth and Restoration. She perhaps modelled her style on Van Dyck (q.v.), and the one certain example of her work, a group with a dead stag, c.1650, suggests she may have had a predilection for small-scale full-length figures.

(*M. Toynbee and Gyles Isham, Burlington Mag., XCVI (September 1954), 275-277.*)

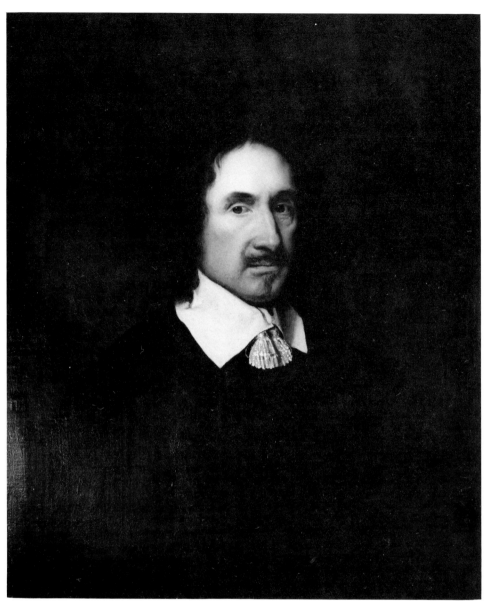

JOHN CARWARDEN, fl.1636-after 1600. 'Christopher Simpson'. Courtesy the Heather Professor of Music, Oxford. Photograph Bodleian Library, Oxford.

CARLTON, Thomas fl.1670 – 1730

One of the earliest recorded portrait painters in Dublin and member of the Council of the Guild of St. Luke there in 1670; died 1730. Known only from a dreary engraved portrait of 'John Stearne, Bishop of Clogher', which must be later than 1717.

(*Strickland.*)

CARNEY, Sir Richard fl.1652 – 1692

Irish herald painter; also documented as a 'limner'. Appointed a herald at Dublin 1652; died 1692. He was Ulster King-of-Arms and was knighted Dublin 6 April 1684.

(*Strickland.*)

LAUREYS DE CASTRO, fl.1664-1680. Mediterranean shipping scene. 31½ins. x 61ins. Signed. Christie's sale 23.6.1950 (33).

CARTER, Christopher fl.1623
Recorded in the Chamberlain's accounts for Leicester for 1623/24 for 'portratinge' the '3rd Earl of Huntingdon'. It is perhaps herald painter's work after an existing portrait.

(*Leicester Museums and Art Gallery, cat. of local portraits, 1956, no.18.*)

CARWARDEN (CAWARDEN), John fl.1636 – after 1660
Portrait painter and composer. Member of the private music of Charles I and petitioned Charles II after the Restoration for a job as a painter. Native of Herefordshire and a royalist. His one known work is the portrait of a fellow royalist musician 'Christopher Simpson' in the Examination Schools, Oxford. The spelling Cawarden is presumably a misreading of a signature on a portrait of 1658, sold 5 May 1927.

(*Grove's Dictionary of Music and Musicians.*)

CARY fl.1650s
Mentioned as a miniature painter in Sanderson's *Graphice*, 1658. His work is not known.

(*Long.*)

CASAUBON See KERSEBOOM, John

CASTRO, Laureys de fl.1664 – 1680
Specialist in scenes of Mediterranean shipping, but also painted portraits. Master in the Guild at Antwerp 1664/65; in London 1680. Half-a-dozen of his shipping scenes were in the Cartwright Collection by *c.*1686 (*Peter Murray, Dulwich Picture Gallery cat., 1980*). The City and Corporation of London

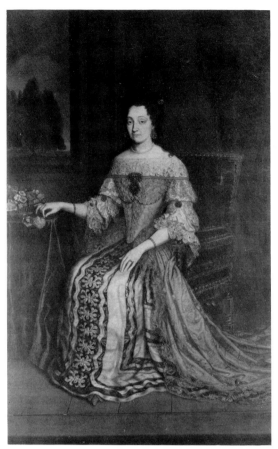

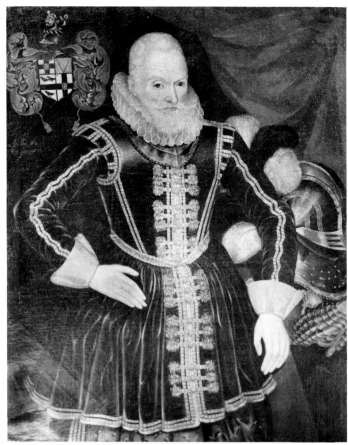

LAUREYS DE CASTRO, fl.1664-1680. 'Lady Clayton'. 93ins. x 57ins. s. & d. 1680. The City and Corporation of London.

WILLIAM CHARE, fl.1618. 'Sir Charles Brydges' (1532-1619). 46ins. x 37ins. s. & d. 'Guliells Chare 1618'. John D. Wood sale 27.5.1937 (988).

commissioned portraits of 'Sir Robert Clayton' (Lord Mayor 1679/80) and 'Lady Clayton' (signed and dated 1680) as gifts to the Lord Mayor.

(*Archibald.*)

CATINAT (CATTENAR), Giovanni Battista **fl.1691 – 1717**
Probably an Italian; ?pupil of Luca Giordano at Madrid; in England by 1700 where he assisted Verrio at Hampton Court *c.*1700 – 1704.

(*E.C-M.*)

CAWARDEN See CARWARDEN, John

CHANTERELL **fl.1626**
Evelyn says in his *Diary* (*Globe ed., 1908, 3*) under 1626: 'My picture was drawn in oil by Chanterell, no ill painter'.

CHARE, William **fl.1618**
Signed 'Guliells Chare', a portrait, dated 1618, of 'Sir Charles Brydges' is in a provincial variant of the style of Gheeraerts ii (q.v.).

CHAVES, A.R. de **fl.1688**
A portrait of 'Sir William Gage' signed 'A.R. (monogram) de Chaves fe/1688'

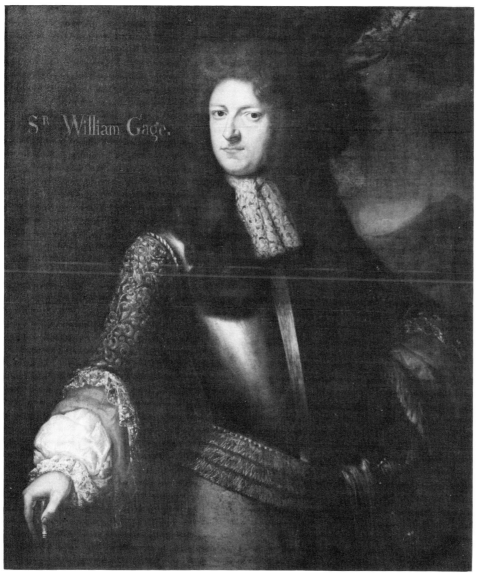

A.R. DE CHAVES, fl.1688. 'Sir William Gage'. 48ins. x 40ins. s. & d. 'A.R. (monogram) de Chaves fe/1688'. Knight Frank & Rutley sale 23.9.1952 (1762).

was in the Sir John Wood sale, at Hengrave Hall, by Knight Frank & Rutley, 23 September 1952 (1762). The signature has also been read as 'de Charos'. In style it is not unlike J. Kerseboom (q.v.)

CHERON, Louis 1660 – 1725
French history painter. Born Paris 2 September 1660; died London 26 May 1725. He won the *prix de Rome* at the French Academy in 1676 and seems to have formed his style by a study of the Raphaelesque tradition in Rome. He was invited to England by the Duke of Montagu to paint the ceilings of the state rooms at Boughton House, which were apparently ready for the entertainment of William III in 1695. These survive and are his principal surviving achievement. They are Marattesque in style and close to Giuseppe Chiari's ceiling of 1700 in the Palazzo Colonna, Rome. He remained in England and was active in teaching drawing at the London Academies.

(E.C-M.; Croft-Murray and Hulton; Waterhouse, 1981.)

WOLFGANG WILLIAM CLARET, fl.c.1665-1706. 'John, 2nd Earl of Bridgwater'. 28½ ins. x 24ins. Signed. Christie's sale 3.2.1961 (1).

WOLFGANG WILLIAM CLARET (attrib.), fl.c.1665-1706. 'George, 1st Baron Jeffreys'. N.P.G.

CLARET, Wolfgang William fl.*c.*1665 – 1706

Portrait painter, copyist and miniaturist. Had lived in London some forty years at the time of his death; will dated 17 August 1706; proved 5 September 1706 (*Burlington Mag., XXXV (1919), 87/88*). He copied portraits by Lely and Kneller (qq.v.) and the relation of his own works to Lely is like that of Mary Beale's (q.v.). His most original known works, in a full baroque style, are portraits at full length of 'William III' and 'Mary II' painted in 1690 (for £80) for the Sessions Hall, Northampton.

CLARKE, John fl.1585 – 1624

Mason and painter of London; at Oxford from 1616, where he, jointly with Thomas Knight (q.v.), painted in 1618/19 a considerable amount of decorative work (including figures), some of which survives, for the Bodleian Library, Oxford.

(*E.C.-M.*)

CLAXTON, John fl.*c.*1690

Amateur painter. He was of Shirley, Hertfordshire, and painted a portrait of his wife, Mrs. Sarah Sandys. W.H. Smyth (*Aedes Hartwellianae, 1851, 114*) says he 'very successfully copied' Kneller's (q.v.) manner. The picture was sold Sotheby's 26 April, 1938 (47).

FRANCIS CLEYN, ?1582-1657/58. Satyr and putti; detail of coving in the Green Closet at Ham House. V. & A.

CLEEF (CLEVE), Cornelis van 1520 – 1567

Flemish painter of religious and subject pictures and probably not a portraitist. Born 1520 Antwerp; died there 1567. He was the son of Joos van Cleef (fl.1511-1540/41) and was known as 'sotte Cleef' (because he went mad). After the Marian return to the Roman Catholic faith, Cornelis came to England *c.*1555, but went mad about 1556 and was returned to Antwerp in 1560. No pictures certainly done in England are known. His father, Joos van Cleef, is sometimes thought to have visited England and painted (? *c.*1536) a portrait of Henry VIII in the Royal Collection. But there is no evidence for this.

(*Ludwig Burchard, Mélanges Hulin de Loo, Bruxelles and Paris 1931, 53-65.*)

CLEYN (CLEIN), Francis (Frantz) ?1582 – 1657/58

Historical painter, designer, etcher and book illustrator. Said to have been born at Rostock in 1582; buried London 23 March 1657/58. He is also said to have spent four years in Italy before settling in Copenhagen by 1617. His chief debt is to Venetian High Renaissance painting (Tintoretto and Veronese). Court Painter to Christian IV of Denmark up to 1625 and very variously employed (*Francis Beckett, The Painter F.C. in Denmark, Copenhagen 1936*). He eventually settled in England soon after the accession of Charles I in 1625 and became principal designer to the Mortlake tapestry works. He was also much engaged in decorative painting (some survives at Ham House — *P. Thornton and M. Tomlin, F.C. at Ham House, National Trust Studies 1980, publ. 1979*) and in book illustration, but his work is always derivative rather than original (*E.C-M.; Croft-Murray and Hulton*). He is reported to have been the teacher of William Dobson (q.v.), and at least three of his children (notably Penelope) are said to have been miniaturists, but it is doubtful if miniatures signed 'P.C.' are by Penelope Cleyn, and little is known of her brothers.

(*Long.*)

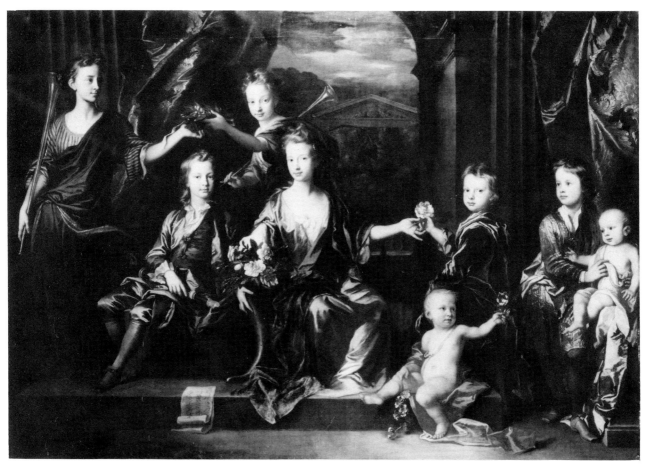

JOHN CLOSTERMAN, 1660-1711. 'The children of John Taylor of Bifrons Park'. 74½ins. x 107ins. N.P.G. (on loan to Beningbrough Hall).

CLOSTERMAN, John 1660 – 1711

Portrait painter and painter of history (but no examples are known). Said to have been born at Osnabrück, son and pupil of a painter; buried London 24 May 1711. He studied for two years in Paris with François de Troy and settled in London in 1681. He was somehow associated with John Riley (q.v.) until the latter's death in 1691, and at first painted draperies for him, but he was doing portraits on his own by the mid-1680s. He was adept at baroque poses, with rather flashily painted draperies (which contrasted with Riley's sobriety) and there is a recognisable type of 50ins. x 40ins. portrait by the Riley-Closterman firm. In the 1690s, under more distinguished patronage, he did elaborate groups of the children of the Dukes of Marlborough and Somerset, and painted his masterpiece, 'The children of John Taylor of Bifrons Park', *c.*1696 (N.P.G.). In 1698 he visited Madrid with James Stanhope and went on to Rome in 1699, where he painted Carlo Maratti, fell under the influence of the Antique, and modified his style to accord with the ideas of his new patron, the 3rd Earl of Shaftesbury (two-full length portraits of *c.*1700, one in N.P.G.). His last documented portrait is 1704 and he devoted his last years to dealing in old masters.

(Malcolm Rogers, cat. of a small J.C. exh., N.P.G., 1981; a fuller account and lists in Walpole Soc., XLIX (1983), 224ff.)

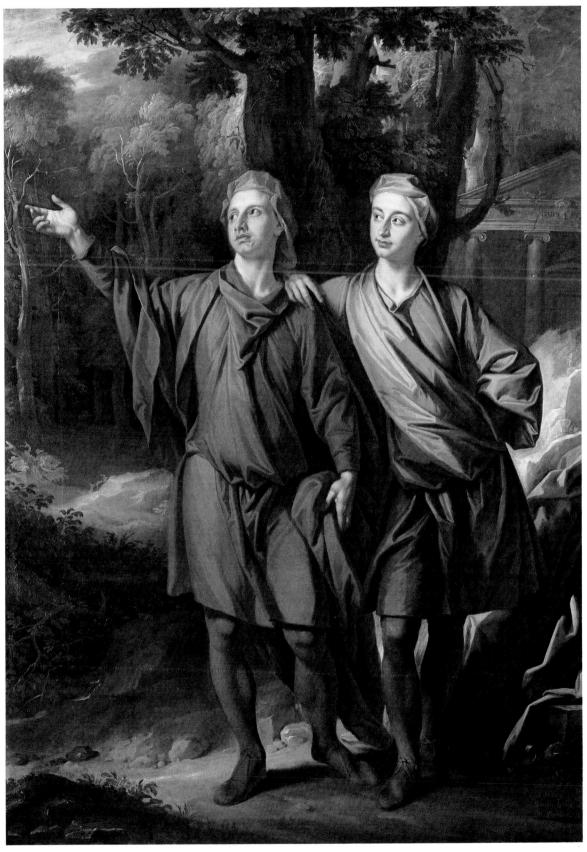

JOHN CLOSTERMAN, 1660-1711. '3rd Earl of Shaftesbury with his brother'. 95 ¾ ins. x 64 ¼ ins.
c.*1700. N.P.G. (on loan to Beningbrough Hall).*

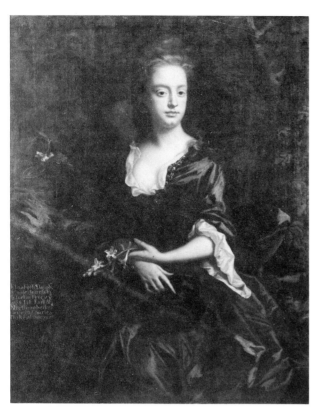

JOHN CLOSTERMAN, 1660-1711. 'Elizabeth, Duchess of Somerset'. 49ins. x 39ins. Sotheby's sale 12.10.1955 (14).

JOHN CLOSTERMAN, 1660-1711. Portrait of a man. 28½ins. x 24½ins. s. & d. on back 'J. Closterman 1682'. Christie's sale 4.12.1970 (170).

CLOSTERMAN, John Baptist fl.*c.*1690 – 1713

Portraitist; ?younger brother to John Closterman (q.v.); last recorded in London 1713. He probably assisted his brother and his own signed works show a rather broader and coarser handling than John's.

(Malcolm Rogers, Walpole Soc., XLIX (1983) 233ff.; J.D. Stewart, Burlington Mag., CVI (July 1964), 306-309.)

CLOUGH, Christopher fl.1505 – 1544

One of the very few persons in the Register of the Freemen of Leicester styled 'painter', and he may conceivably have been something more than an artisan. He was mayor of Leicester 1533/34 and 1543/44.

(Register of the Freemen of Leicester 1196-1770. ed., Henry Hartopp, Leicester 1927.)

COCKE, Edward fl.1640

Portrait painter; probably mainly copyist. In 1640 he painted various portraits of benefactors for the Ironmongers' Company.

(W. Herbert, The History of the Twelve Great Livery Companies..., 1836, ii, 603.)

COLE (COALE), Peter fl.1577 – 1608

Native of Antwerp; came to England 1577; in 1593 in prison and described as a 'picture maker'. Listed by Francis Meres 1598. Did heraldic work for the Star Chamber 1606 and 1608.

(Auerbach.)

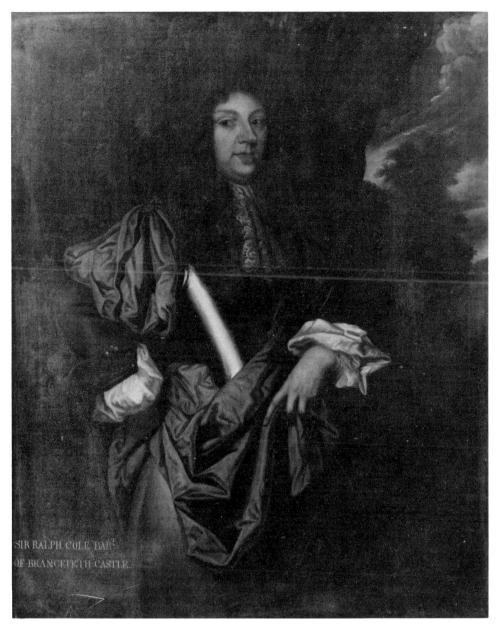

RALPH COLE, c.1642-1704. Self-portrait. 49ins. x 39ins. Christie's sale 9.7.1948 (32) as Kneller.

COLE, Sir Ralph *c.* **1642 – 1704**

Amateur painter of portraits, subject pictures and miniatures. His father, whom he succeeded as 2nd baronet (of Brancepeth) was married 'in or before 1641'. He died 9 August 1704 (*Complete Baronetage, ii, 82*). His portrait by Lely (q.v.) was engraved in mezzotint by Francis Place (q.v.), and he imitated Lely in his portrait of 'Thomas Wyndham' (at Petworth, mezzotint by R. Tompson), which resembles what is probably his self-portrait (in Wombwell sale 9 July 1948 (32) as Kneller). He also scraped a mezzotint of a portrait of 'Charles II'. Brancepeth Castle was still furnished with his own paintings in 1732 (*John Loveday, Diary of a Tour in 1732, ed. E.J.T. Loveday, Roxburghe Club, 1890, 179*). Many of these were already painted by 1677.

(*D.N.B.; Walpole Soc., X, 63/64.*)

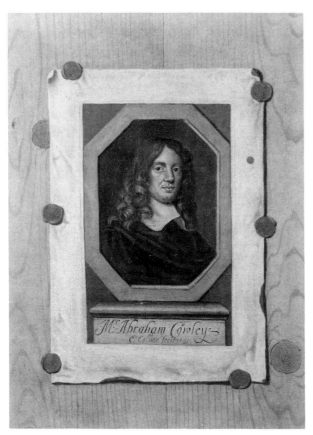

EDWARD COLLIER, fl.1673-1706. 'Mr. Abraham Cowley'. 17½ins. x 13ins. s. & d. 'E. Collier fecit 1696'. Sotheby's sale 16.11.1966 (84).

EDWARD COLLIER, fl.1673-1706. A trompe l'oeil arrangement. 29ins. x 24ins. s. & d. 'E. Collier 1698'. Sotheby's sale 21.7.1948 (112).

COLLIER, Edward fl.1673 – 1706

Dutch painter of still-lifes, vanitas pictures and *trompe l'oeil* arrangements. Entered the Guild at Leyden 1673, and was still working there in 1706 (picture sold Sotheby's 16 November, 1949, 52). He seems to have been confused with an Evert Colier, who was dead by 1702 and painted genre pictures, perhaps at Haarlem. Collier worked in London *c.*1693-1698 and, during these years, the papers in his *trompes l'oeil,* etc., are in English and one of them is normally inscribed 'Mr. E. Collier Painter at London'. His work has affinities with that of P. Roestraeten (q.v.). His latest known work, also painted in London, shows the Queen's speech for 21 December 1706 (sold Sotheby's 16 November 1983, 88).

COLONE, Adam (de) fl.1622 – 1628

Portraitist of Scottish sitters. Documented as born in Scotland, probably son of Adriaen Vanson (q.v.) and Susanna de Colone, and trained in The Netherlands (seemingly in the tradition of Miereveld). He returned about 1622 and was presumably the 'Adam Colone' paid for two portraits of James I in 1623 (possibly those now at Hatfield and Newbattle Abbey). He had settled in Scotland by 1624 and his name is plausibly linked with a group of portraits of Scottish upper class sitters, one of which, 'George, 3rd Earl of Winton and his

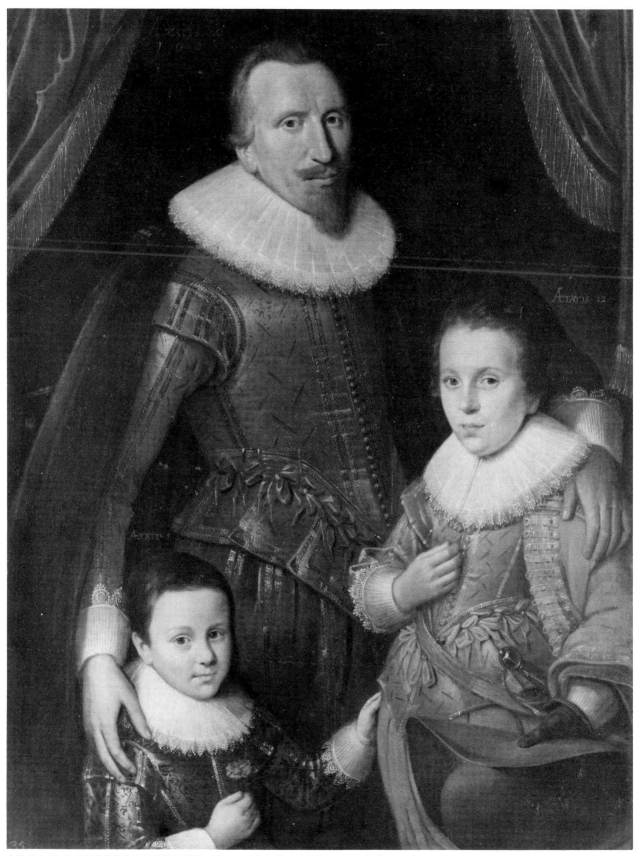

ADAM (DE) COLONE, fl.1622-1628. 'George, 3rd Earl of Winton and his two sons'.
44 ½ ins. x 33ins. Private collection.

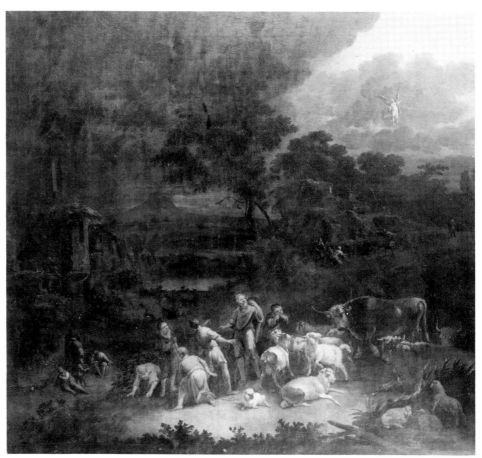

ADAM DE COLONIA, 1634-1685. Landscape with figures. 48ins. x 52ins. s. & d. Sotheby's sale 9.11.1966 (149).

two sons', is associated with a payment to 'Adame the painter'. The latest dated of these is 1628. He appears to have had a considerable influence on the portraiture of George Jamesone (q.v.)

(Duncan Thomson, The Life and Art of George Jamesone, 1974, 54-59, with list of 23 attrib. portraits 147-149.)

COLONIA, Adam de 1634 – 1685

Dutch painter of landscapes with history figures. Born Rotterdam 12 August 1634; buried London 10 September 1685. He settled in London soon after 1670. His pictures show a strong influence from Berghem and he also copied the Bassano's pictures. Signed examples of his English period are at Dulwich.

COLONIA, Hendrik Adriaen de 1668-1701

Son and pupil of the above. Died London *c.*1701 aged 33 (*Buckeridge*). He inserted figures into the landscapes of his brother-in-law Adriaen van Diest (q.v.).

COMER (of York) fl.1677 – *c.*1700

Portrait painter. Said by Vertue to have died in The Charterhouse *c.*1700. He was in London in 1677 and later lived for some years (certainly in the 1680s)

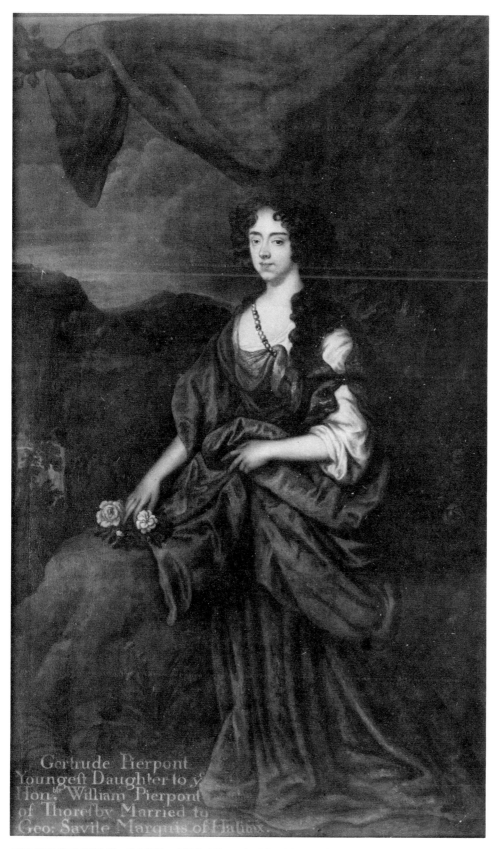

Gertrude Pierpont
Youngest Daughter to y^e
Hon^{ble} William Pierpont
of Thoresby Married to
Geo: Savile Marquis of Halifax

COMER (OF YORK), fl.1677-c.1700. 'Gertrude, Marchioness of Halifax'. 87ins. x 53ins. 1683.
Private colllection.

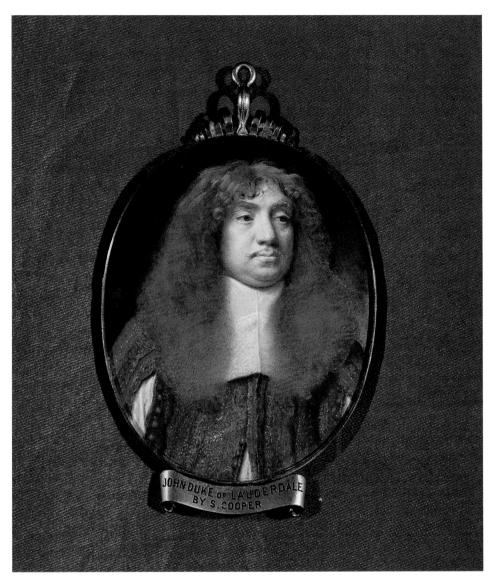

SAMUEL COOPER, ?1608-1672. 'John, 1st Duke of Lauderdale'. 3⅜ins. x 2¾ins. 1664. Miniature on vellum. N.P.G.

at York, where he was friendly with William Lodge, whose portrait he painted. He is only known for five or six life-size full-lengths of ladies at Welbeck, for which he was paid in 1683 and 1685 at the rate of £18 each (*Goulding and Adams, 434.*) In a 1699 MS. inventory of the Duke of Hamilton's pictures, a copy in crayons after Van Dyck and prospects of the cities of Zante and Athens are listed as by Cromer.

COOKE, Henry *c.*1642 – 1700

At first a portrait painter and later history painter. Died London 18 November 1700 'aged near 58' (*Buckeridge*). Studied five years with Theodore Russel (q.v.), probably in the 1660s. There is a payment of 1663 'To Mr. Cooke the picture drawer' among the accounts at Elton Hall, and a very battered portrait of 'Isaac Newton', signed and dated 1669, is at St. Catherine's College,

Cambridge. But Cooke gave up portrait painting and, after being involved in a homicide, fled the country and spent two periods, each of seven years, in Italy where he studied the old masters and became a pupil of Salvator Rosa. He does not seem to have returned to England until after the Revolution of 1688, when he was employed by William III on repairing the Raphael cartoons and, in the 1690s, had a certain vogue as a history painter. He was a learned man and of good family and his collection included many of his own copies after the old masters (notably copies of the Raphael cartoons) (*E.C-M.*). A son, Henry Cooke ii (under 21 in 1700), seems also to have been a painter and was a director of the Kneller Academy in 1711.

COOPER, Alexander 1609 – 1660

Painter of portrait miniatures of very high quality. Baptised London 11 December 1609 (*Edmond, 99*); died ?Stockholm 1660. Brother of Samuel Cooper (q.v.) and nephew of John Hoskins i (q.v.) by whom he was brought up, but he was also a pupil of Peter Oliver. He had respectable patronage in England, but was outpaced by his brother, which probably caused him to transfer his services to foreign courts. About 1631 he moved to The Netherlands where he was patronised by the family of the Elector Palatine and the House of Orange. By 1647 he was in Stockholm in the service of Queen Christina and he died in Sweden. He signs his works 'A.C.' (*Long*). His style shows affinities with the contemporary European tradition of enamel miniatures.

COOPER, Samuel ?1608 – 1672

The most distinguished portrait miniaturist of his age and, in his own lifetime, the most internationally famous English portraitist. Born London, probably late 1608 (*Edmond, 99*); died there 5 May 1672. His portrait style, which is freer and less conventional than that of earlier miniature painters, seems to have been based on the personal observation of Van Dyck's execution, but he was brought up by his uncle John Hoskins i (q.v.). He had a good education and may have travelled before settling down to a busy and successful practice in London about 1637. He was already employed by the Court of Charles I and remained in equal demand during the Commonwealth (when he produced the most distinguished and approved likeness of Cromwell) and Restoration. His likenesses, done direct from the sitter, were extremely vivid and certain unfinished heads of eminent persons (preserved in the studio as references from which repetitions were produced) are among the most splendid likenesses ever produced in England. Some of these are in the Royal Collection and were acquired by Charles II after Cooper's death. He was equally at home at Court and in the circles of the Royal Society.

(*D. Foskett, S.C., 1974, and cat. of Cooper, etc. exh., N.P.G., 1974; contemporary references are usefully collected in Long.*)

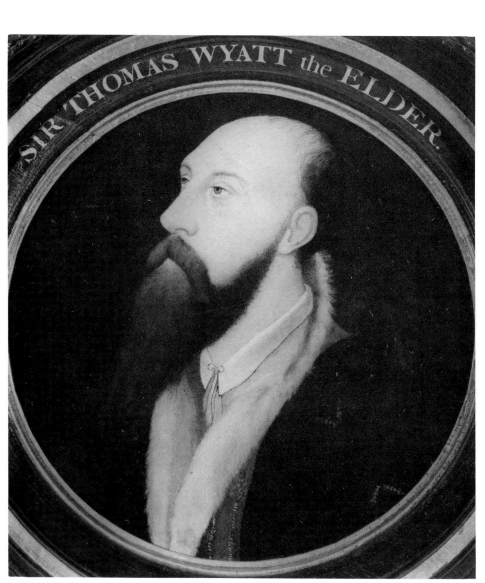

LUCAS CORNELISZ DE KOCK, 1493-1552. 'Sir Thomas Wyatt the Elder'. Private collection. Photograph Paul Mellon Centre.

CORNELISZ DE KOCK, Lucas 1493 – 1552

This more or less mythical Leyden painter is said by Carel van Mander (*ed. H. Floerke, 1908, I, 148*) to have come to England in the time of Henry VIII, and from the time of Vertue up to 1939 certain portraits once at Queensborough Castle have been associated with his name. This legend has been fully exploded (*Waterhouse, 1978, 339 n.20*).

CORNELIUS See KETEL, Cornelis, and ZEEU, Cornelius de

CORTE, Cesare da 1550 – soon after 1613

A Genoese painter who is said by R. Soprani (*Le Vite de' Pittori &c, Genovesi, Genoa 1674, 67*) to have come to England where he had a great success and painted a portrait of 'Queen Elizabeth'. This visit is not otherwise recorded. He came to a sticky end at the hands of the Inquisition.

CORVUS, Joannes fl.1512 – 1544

The name is a Latinised form of Jan Rav, Raff, Rauff or Raven. A native of

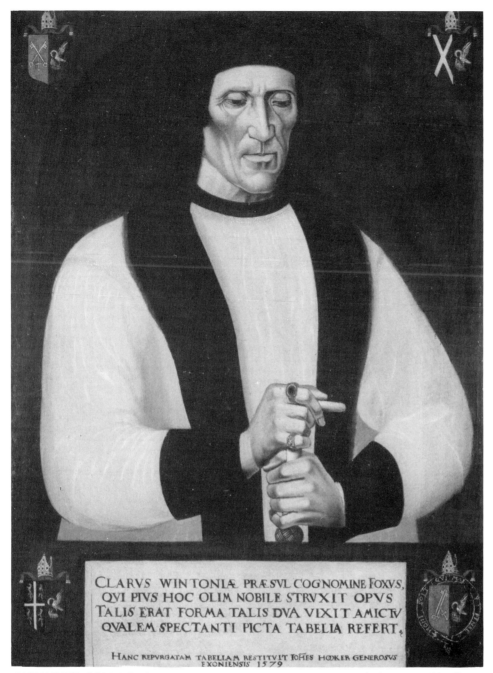

JOHANNES CORVUS, fl.1512-1544. 'Richard Foxe, Bishop of Winchester'. 1522. Corpus Christi College, Oxford. Photograph Paul Mellon Centre.

Flanders, he was said to have been a member of the Painters' Guild in Bruges 1512; came to England possibly *c.*1518, and painted a portrait of 'Bishop Foxe' which bears the date 1522. Did decorative painting for the Crown (as Raff) 1527-1531; did maps of England and London for François I 1532 and 1534; living in London 1540 and made a denizen 13 May 1544. He is known only from portraits of 'Bishop Foxe' (Corpus Christi College, Oxford) and 'Mary Tudor' (Sudeley Castle), which were once signed on the frames (both now lost) 'Joannes Corvus Flandrus'. Both portraits look as if they might be posthumous.

(*Auerbach.*)

COTTON

'The muniments of the city of Dublin record the admission to the franchise in 1650 of "Thomas Cotton, limner, son of Ralph Cotton, picture-maker".'

(*Strickland.*)

COVELL fl.1646

A portrait painter active in Bristol in 1646, when he painted 'Sir Thomas Fairfax' without sittings.

(*C.R. Markham, A Life of the Great Lord Fairfax, 1870, 429.*)

CRADOCK, John *c.*1595 – 1652

Amateur painter. Born Newark-on-Trent; died Barrow, Suffolk, where he was Rector, March 1651/52. He was the father of Mary Beale (q.v.). In 1648 he was made free of the Painter-Stainers' Company, to which he presented a 'Still-life of fruit' which survived until 1940.

(*Elizabeth Walsh and Richard Jeffree, exh. cat. The excellent Mrs. Mary Beale, Geffrye Museum, London and Eastbourne 1975/76.*)

CRADOCK, Marmaduke (*not* Luke) *c.*1660 – 1716/17

Painter of birds and animals in the manner of Casteels. Born in Somerset; buried London 24 March 1716/17.

(*Croft-Murray and Hulton; Waterhouse, 1981.*)

CRADOCK, Mary See BEALE, Mary

CRAKE, Francis fl.1685

Provincial portrait painter of no particular style. A head of a man of 80, signed 'Fra. Crake fecit 1685' formerly belonged to Lord Zouche.

CRITZ, Emanuel de 1608 – 1665

Portrait painter; son of John de Critz i (q.v.); baptised London 25 September 1608 (*Edmond*); buried there 2 November 1665. Presumably trained by his father; he has, probably incorrectly, been credited with the group of Tradescant portraits at Oxford (see Thomas de Critz). He bought pictures and sculpture at the Commonwealth sale and tried unsuccessfully in 1660 to be made Serjeant-Painter, some of the functions of which office he may have fulfilled during the Commonwealth. The only certain clue to his style is a life-size full-length of 'Sir John Maynard' which seems to be signed and dated 1657 and is in the Commonwealth style of Robert Walker.

(*Mrs. R.L. Poole, Walpole Soc., II, 54ff., corrected by Mary Edmond, Walpole Soc., XLVII.*)

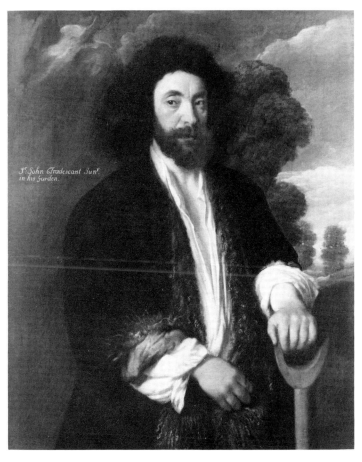

EMANUEL DE CRITZ, 1608-1665. 'Sir John Maynard' (1602-1690). 80ins. x 48ins. Private collection. Photograph Courtauld Institute of Art.

THOMAS DE CRITZ, 1607-1653. 'John Tradescant Junr. in his garden'. 42ins. x 39ins. Ashmolean Museum, Oxford.

CRITZ, John de (i) c.1552/53 – 1642

Portrait painter and Serjeant-Painter. Born at Antwerp c.1552/53; buried London 14 March 1642. Brought to England 1568 and apprenticed to Lucas de Heere (q.v.). From 1582 to 1588 he was much employed by Sir Francis Walsingham and sent abroad as a courier, especially to Paris. By 1598 he was one of the leading portrait painters in London. He had a grant of the reversion of the office of Serjeant-Painter in June 1603 and held that office jointly with Leonard Fryer from 1605, and with Robert Peake from 1607 to 1619. He was painting royal portraits from 1606, but seems later to have abandoned this role in favour of Van Somer (q.v.) and Mytens (q.v.). Bought the reversion of the office of Serjeant-Painter for his eldest son in 1610. He presumably created the standard type of portrait of 'Sir Francis Walsingham' (e.g. N.P.G.) and a standard type of '1st Earl of Salisbury' is documented; the many repetitions of the earlier type portraits of 'James I' must also have come from his studio, and a number of possible attributions are reproduced in *Strong, 260-267*. Latterly he seems to have done mostly heraldic and decorative painting.

(Auerbach, 148; Edmond; Mrs. R.L. Poole, Walpole Soc., II.)

61

CRITZ, John de (ii) early 1590s – *c*.1642

Son of John de Critz i (q.v.). Sworn in as Serjeant-Painter 18 March 1641/42;
died at Oxford soon afterwards. He was probably only a decorative painter.

(*Edmond.*)

CRITZ, Thomas de 1607 – 1653

Portrait painter; a younger son of John de Critz i (q.v.). Baptised London
1 July 1607; buried London 22 October 1653. He did decorative and restoring
work for the Crown 1629-1637 and there is evidence that he painted portraits.
A good case has been made that he was the member of the de Critz family who
painted, in the 1640s, the group of Tradescant family portraits in the
Ashmolean Museum, Oxford, which are among the most distinguished and
original portraits of the time and have previously been attributed to Emanuel
de Critz.

(*Edmond, 156ff.*)

CROKER (CROCKER), Joachim d.1699/1700

Portrait painter, possibly of German origin. Died Dublin January 1699/1700.
He is known only for having painted a portrait of 'Joseph Toplis' which was
hung in the Hall of the Guild of St. Luke in Dublin in 1699.

(*Strickland.*)

CROSS(E), Peter *c*.1645 – 1724

Miniaturist. Born London; buried there 3 December 1724. In the earlier
literature his Christian name is given wrongly as Lawrence or Lewis (*J.
Murdoch, Burlington Mag., CXX (May 1978), 288-290*). He was probably a pupil
of Samuel Cooper (q.v.) and he latterly developed an odd stippling technique.
He gave up painting because of ill health *c*.1721.

(*Mary Edmond, Burlington Mag., CXXI (September 1979), 585/86*).

CUNNEY fl.1658

Portraitist working at Manchester 1658. In *Autobiography of* (Rev.) *Henry
Newcome* under 15 September 1658 is written: 'My picture was brought home
by Mr. Cunney this day... Mr. Cunney offered to do it for half the price!'

(*Chetham Soc., XXVI, 1852.*)

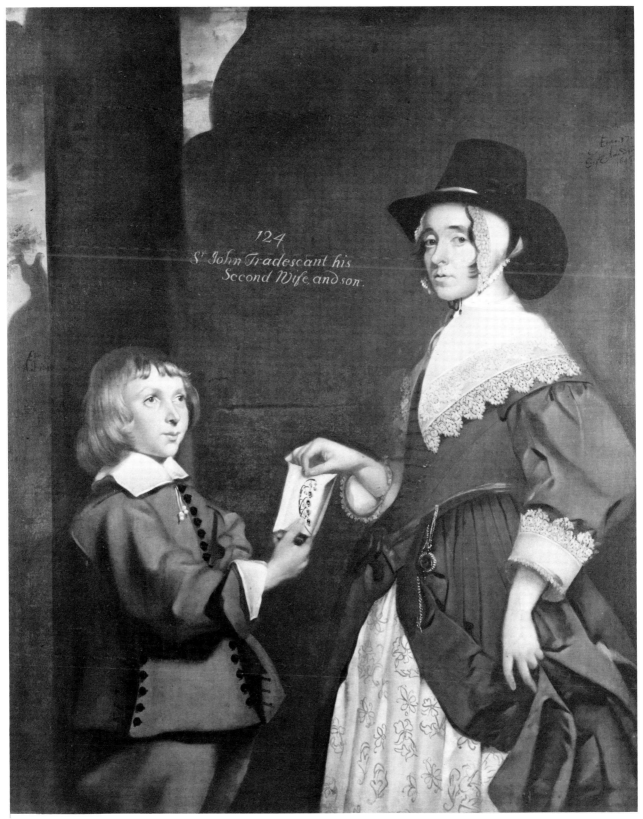

THOMAS DE CRITZ, 1607-1653. 'Hester Tradescant and her stepson John Tradescant
iii'. Ashmolean Museum, Oxford.

The group of Tradescant portraits at the Ashmolean Museum, Oxford, has probably incorrectly been
ascribed to Emanuel de Critz, younger brother of Thomas.

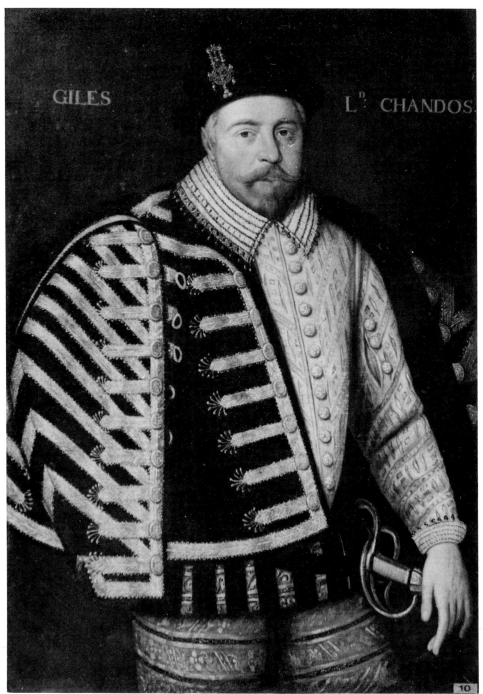

HIERONIMO CUSTODIS, fl.1589-1592. 'Giles, (3rd) Lord Chandos' (1528-1593). 40ins. x 28ins. Christie's sale 11.6.48 (101).

CUSTODIS, Hieronimo fl.1589 – 1592

Portrait painter from Antwerp. His name may be a Latinisation of Jerome de Coster(e). He was a member of the Dutch Reformed Church in London in 1592, where his widow remarried in 1593. He signed and dated three portraits in 1589, of which that of 'Elizabeth Brydges' (Woburn) is of considerable charm and curiously English. The lettering on the signed portraits is rather distinctive and has led to a number of possible attributions.

(Strong, 195-205.)

CHARLES D'AGAR, 1669-1723. 'The honble. Frances, Lady Worsley'. V. & A. (Ham House).

CHARLES D'AGAR, 1669-1723. 'Lord George Douglas'. Collection of the Duke of Buccleuch, K.T., Drumlanrig Castle.

D'AGAR (DE GARR), Charles 1669 – 1723

Portrait painter. Born Paris 1669; died London 1723. Son of Jacob D'Agar (q.v.). The whole family emigrated to London 1681. After six years with his father in Copenhagen, Charles returned to London in 1691 where he had a good portrait practice, mainly after 1700.

(*Waterhouse, 1981.*)

D'AGAR, Jacob 1642 – 1715

Mainly a portrait painter. Born Paris February 1642; died Copenhagen 15 November 1715. Said to have been a pupil of F. Voet at Paris; *agréé* at the Académie 1675, but expelled for being a Protestant 1682. Moved to London with a wife and four children (and five kinsmen) all of whom became denizens 14 October 1681. He may have painted a few portraits in London but moved *c*.1684 to Copenhagen, where he was Court Painter to Christian V and Frederick IV until his death. His self-portrait is in the Uffizi. His work has been confused with that of his son Charles (q.v.)

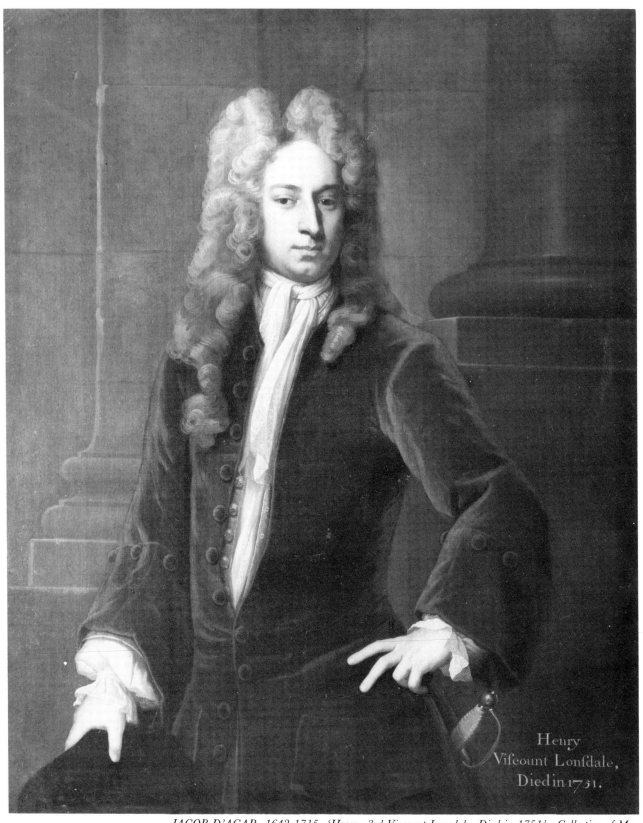

Henry
Viscount Lonsdale,
Died in 1751.

JACOB D'AGAR, 1642-1715. 'Henry, 3rd Viscount Lonsdale, Died in 1751'. Collection of Mrs.
P. Gordon-Duff-Pennington, Muncaster Castle. Photograph Courtauld Institute of Art.

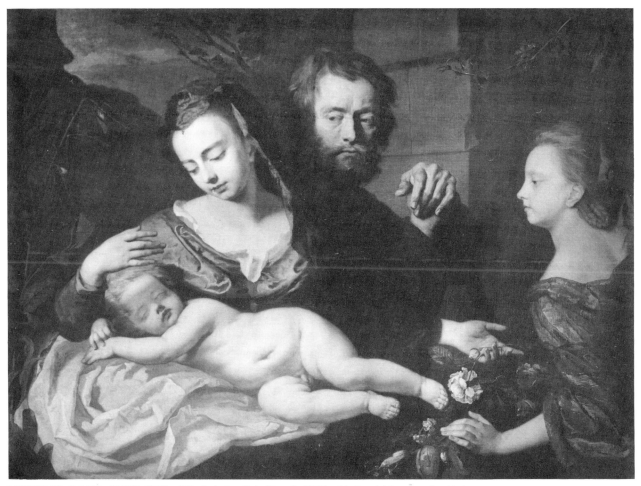

MICHAEL DAHL, ?1659-1743. 'The holy family'. Signed. 1691. National Museum, Stockholm.

D'AGAR, Peter fl.1671 – after 1681

In the Calendar of Treasury Books under 7 June 1681 Peter D'Agar 'painter' petitioned that he had lived in London for ten years being a Protestant, and 'now keeping the Royal Academy for Painting, designing, mathematics &c. in the Savoy' had a design to reside in London.

DAHL, Michael ?1659 – 1743

Portrait painter and occasional painter of histories. Born Stockholm 29 September, probably 1659, died London 20 October 1743. He studied in Stockholm under Ehrenstrahl (q.v.), and seems to have had a good education. He started his travels in 1682, coming first to London, where he was in contact with Kneller. From 1684 to 1689 he travelled with Henry Tilson (q.v.), mainly to Paris, Venice and Rome (where they stayed a year). He settled for good in London in 1689, and his 1691 self-portrait (N.P.G.) shows him as quite a smart young man. By 1700 he was the best patronised portrait painter in London after Kneller, whom he took to some extent as his model, but he has none of Kneller's brashness and his women's portraits show greater modesty and refinement. His heyday was during the reign of Queen Anne, but he painted much for the 'proud' Duke of Somerset in the 1690s, notably, about 1696, the 'Petworth Beauties' in rivalry with Kneller. His *oeuvre* is extremely extensive and the beginning of a catalogue has been made in *Nisser*.

MICHAEL DAHL, ?1659-1743. 'Lord Charles and Francis Seymour'. Collection of Lord Egremont, Petworth House. Photograph Courtauld Institute of Art.

MICHAEL DAHL, ?1659-1743. 'Countess of Suffolk'. (This picture has recently been attributed to Thomas Gibson.) Blickling Hall (National Trust).

DAKERS d.1669

In 'The Obituary of Richard Smyth' (for 1627-1674, mainly City of London persons, *Camden Soc., 1849, 80*) under 26 March 1669: 'Capt. Dakers, in Finsbury LordSP. the City painter, died this morning'.

DANCKERTS (DANKERS) Hendrik *c.*1625 – *c.*1680

Engraver and specialist in topographical landscapes. Native of The Hague; died in Amsterdam *c.*1680. He began as an engraver of British royal portraits at The Hague 1645/47 (engravings in *Hollstein, V, 133ff.*). In Italy, mainly Rome, 1653-1658; came to England 1658, where he specialised in topographical landscapes to fit into the wainscotting, and ran almost a small factory for stock designs (four for Pepys 1669). He was much employed by Charles II and married in the Catholic Chapel Royal October 1664. He painted for the King 'all the seaports in England and Wales; as also the royal palaces' (*Buckeridge*). He was the leading painter of topographical views in England until he retired to Amsterdam at the time of the Popish Plot (1679), and is said to have died soon afterwards. His known commissions are listed in the *Ogdens, 153/54.*

MICHAEL DAHL, ?1659-1743. Self-portrait. 49ins. x 39ins. s. & d. 1691. N.P.G.

DANCKERTS (DANKERS), Johan **1613 – *c.*1686**

Engraver and history painter. Born at The Hague 1613; died at Haarlem
*c.*1686. Elder brother of Hendrik (q.v.) with whom he travelled in Italy
1653-1658. He came to England in 1658 but it is not clear if he remained there.
A landscape by him in the Royal Collection is said to be signed 'May Day
1667'.

(*Hollstein, V, 136.*)

DANIELL, Roger **d.1667**

In 'The Obituary of Richard Smyth' (for 1627-1674, mainly City of London
persons, *Camden Soc., 1849, 77*) under 5 October 1667: 'Roger Daniell,
paynter in London, and sometime heretofore in Cambridge, died in London;
buried from his son-in-law Redman's house in St. Gregries'. (He need not
have been a painter of pictures.)

DAUDET (DOWDETT), Samuel **fl.1694 – 1727**

Portrait painter of rather nondescript character by whom works are
documented for 1694 and 1727.

(*Collins Baker, II, 69/70.*)

DAVENPORT, Mr. ***c.*1642 – 1692**

Portrait painter. Died June 1692 (*Talley, 1981, 312*) when 'about the age of
fifty'. He was a pupil and very competent copyist of Lely and was at one time
associated with Greenhill.

(*Vertue, iv, 27.*)

DAYLEY, John **fl.1686**

Limner; of the City of Lichfield. Married Dorothy George of Houghton Parva,
Northamptonshire, January 1685/86.

(*Peterborough Marriage Licences.*)

DE BRAY See BRAY, Jacques de

DE COLONIA See COLONIA, Adam de

DE CRITZ See CRITZ, Emanuel, John and Thomas de

DE HEERE See HEERE, Lucas de

DE JONGH See JONGH, Claude de

DELAFOSSE See LAFOSSE, Charles de

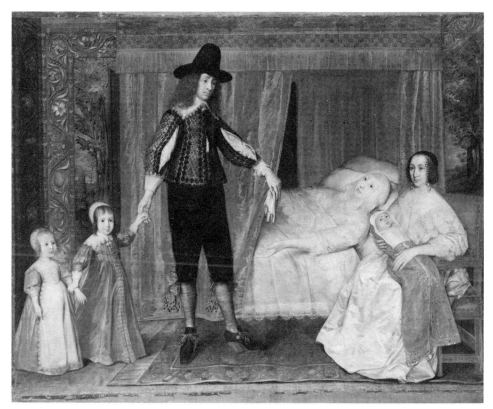

DAVID DES GRANGES, 1611-c.1671/72. 'The Saltonstall family'. (The attribution of this work to Des Granges is no more than traditional.) The Tate Gallery.

DE MELE (MELLE) See also MELE, Matthäus de
There is confusion over painters of this name.
(i) Two vaguely Knellerish portraits of English sitters, which seemed to be signed and dated 'A De Mele 1689', were sold Christie's 7 March 1952 as 'A. de Mele' and 'A. de Wiele'.
(ii) *Th.-B.* and *Wurzbach* list a Matthäus de Mele (Meele) born at The Hague 1664; died there ?1714, 1724 or 1734, who was a drapery painter for Lely and returned to The Hague after 1680.
(iii) *Strickland* lists a Paul de Melle who was a portrait painter at Dublin 1670 to 1680 and was warden of the Guild of St. Luke in 1675.

DE NEVE See NEVE, Cornelius de

DEREYNE See REYN, Jean de

DERYKE See RYCK, Willem de

DES GRANGES, David 1611 – *c.*1671/72
Miniaturist and perhaps also portraitist on the scale of life. Baptised London 24 March 1611; probably died there 1671/72 (*Edmond*). He married a member of the Hoskins clan (q.v.) and his miniatures, frequently signed 'D.D.G.' are often quite accomplished. He was employed by both Charles I and Charles II, and may have followed Charles II to The Hague. In 1658 he was also described

DAVID DES GRANGES, 1611-c.1671/72. 'Sir Robert Chester, Kt.'. 29ins. x 24½ins. s. & d. 'David des/Granges 1632'. With Lane Fine Arts 1983.

as a portraitist on the scale of life (*Sanderson, Graphice, 1658*), but the attribution to him of 'The Saltonstall family' (Tate Gallery) is no more than traditional (*Long; Murdoch &c.*). Signed and dated portraits of 1632 and 1661 are recorded.

DEVOSSE (DE VOS), Cornelis **fl.1558 – 1577**
Limner. Married London 1558; probably travelled abroad 1567-1575. His work is not known (*Auerbach*). In 1580 he had business connections with Hilliard.

DE WITTE See WET, Jacob de

ADRIAEN VAN DIEST, 1655-1704. 'Bulldog in Dunham Park'. Dunham Massey (National Trust). Photograph Courtauld Institute of Art.

DICKSON, A. fl.1690s

His name is given as the painter of a portrait of 'Lady (Grace) Gethin' (d. 1697) engraved by W. Faithorne 1699 as the frontispiece to *Reliquiae Gethinianae*. It may well have been painted in Ireland, by the 'Mr. Dixon' whose portrait of 'John Kade' was hung in the Guild of St. Luke's Hall, Dublin, 1760.

(*Strickland.*)

DIEPENBEECK, Abraham van 1596 – 1675

Flemish designer of stained glass and all purpose painter. Baptised Herzogenbosch 9 May 1596; buried Antwerp 31 December 1675. He came to Antwerp as a stained glass Master 1623, but was not admitted Master as a painter until 1638/39. Most of his pictures are much influenced by the work of Rubens. He visited England about 1629 and painted a dozen life-size pictures of the Earl of Newcastle's managed horses, which were later engraved, as well as views of his principal seats and portraits. A number of these survive at Welbeck.

DIEST, Adriaen van 1655 – 1704

Painter of topographical and ideal landscapes. Born The Hague 1655; died London 1704. Son and pupil of Willem van Diest, a marine painter, who

ADRIAEN VAN DIEST, 1655-1704. 'Dunham'. Dunham Massey (National Trust). Photograph Courtauld Institute of Art.

brought him to England 1672. His commissioned pictures, many of them of West Country castles and harbours, have some merit. But, in his later years he produced endless ideal landscapes as overdoors, overmantels, etc.

(*Buckeridge; Ogdens.*)

DIGBY, Kenelm **1625 – 1648**
A picture of 'St. Francis' signed 'Kenelmus Digbaeus pinxit, 1643' is noted at Mount St. Bernard Monastery, Charnwood Forest (*Notes & Queries, Series I, VI (1852), 174*). It is suggested in *D.N.B.* that this was by the eldest son of Sir Kenelm Digby (1603-1665).

DIGBY, Simon (Bishop) **fl.1668 – 1720**
Amateur miniaturist of considerable gifts. Son of an Irish bishop; received his first church preferment 1668; died at Lacken, county Roscommon, 7 April

1720. He 'was a great master of painting in little water colours, and by that quality recommended himself to men in power and ladies, and so was early made a Bishop' (of Limerick 1678; Elphin 1691).

(*Buckeridge; Strickland.*)

DIXON, Matthew fl.1671 – 1710
Portrait painter in oils and crayons. Buried at Thwaite, Suffolk, 2 November 1710. Pupil of Lely and confused by Vertue and Walpole with his son, John Gostling Dixon (d. 1720/21) who was probably not a painter (*M. Edmond, Burlington Mag., CXXV (October 1983), 612*). One of the portraits at Ecton was dated 1671, and a portrait at Arbury is signed with the name 'Matthew'. There were payments at Ecton in 1679 and 1680 at the rate of £8 50s. for a 50ins. x 40ins. portrait (sale cat. Sotheby's 12 October 1955, 74-78). Lely had a servant named Dixon and either he or Matthew was an occasional buyer at the sale of Lely's pigments and fabrics (*Talley, 361ff.*). He retired from his profession early (before 1691) to Suffolk.

(*Vertue, ii, 59.*)

DIXON, Nicholas *c.*1645 – *c.*1708
Painter of portrait miniatures and later specialised in watercolour copies on vellum after old masters. Possibly pupil of Samuel Cooper (q.v.) whom he succeeded as Royal Limner in 1673. His earlier miniatures are of good quality (*Murdoch &c.*). He was still alive in 1708 when the Duke of Newcastle bought his collection of miniature copies.

(*M. Edmond, Burlington, Mag., CXXV (October 1983), 611.*)

DOBSON, William 1611 – 1646
Portrait painter (but occasionally strayed into subject pieces). Baptised London 4 March 1610/11; buried there 28 October 1646. He came from a gentle family from St. Albans, and had a good, probably classical, education (which he likes to display in the statues and reliefs which adorn the backgrounds of many portraits). He is the heroic portraitist of the Royalist cause during the Civil War, as displayed by the Court of Charles I at Oxford 1642-1646. No certain work from before 1642 is known, though he is recorded as having been apprenticed to William Peake (q.v.), probably *c.*1626-1632, and to have learned his art from Francis Cleyn (q.v.). He was always conscious of Van Dyck's role as the recorder of the royal image and that of the Court, and his own deliberate clumsinesses exploit the trappings of Van Dyck's baroque to provide a contrasting image of the Caroline Court under Civil War conditions. The patterns and colour of Titian and Tintoretto, whose work he may have

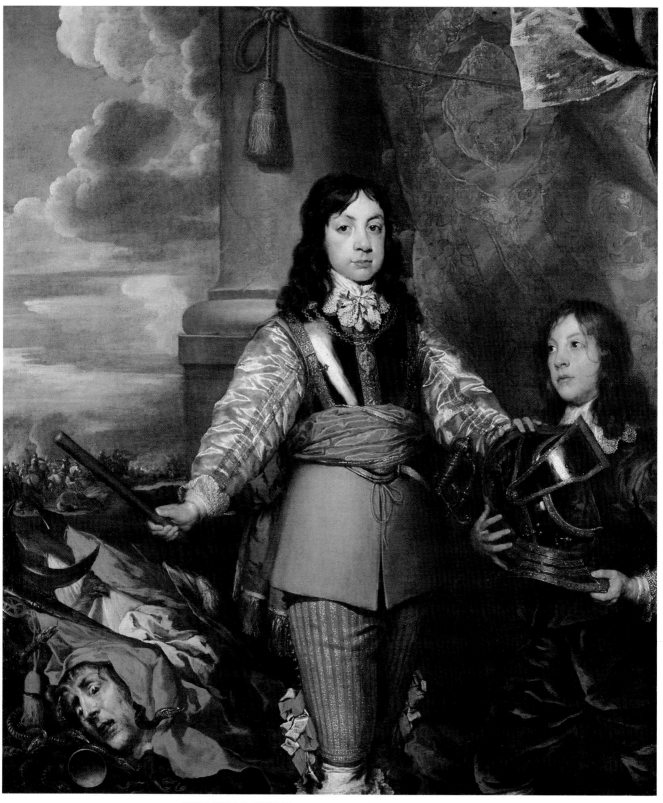

WILLIAM DOBSON, 1611-1646. 'Charles II as Prince of Wales'. S.N.P.G.

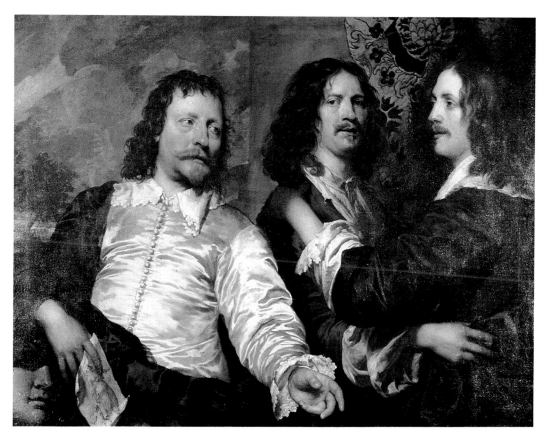

WILLIAM DOBSON, 1611-1646. 'Portrait of the artist with Sir Balthasar Gerbier and Sir Charles Cotterell'. 38 ½ ins. x 49 ½ ins. Collection of the Duke of Northumberland (Alnwick).

studied in the Royal Collection, are the basis of his highly personal and distinguished style, which justifies the view of him as 'the most excellent painter that England hath yet bred' (*Aubrey's Lives*). He is the great master of the long three-quarter length and is not perfectly happy with whole lengths. After Van Dyck's death (1641) he filled the role of Principal Painter, but there is no documentary evidence that he was so appointed.

(*Malcolm Rogers, cat. W. D. exh., N.P.G., 1983/84.*)

DOWDETT See DAUDET, Samuel

DU BOIS, Edward 1619 – 1696

Landscape painter. Baptised Antwerp 9 December 1619; buried London 6 September 1696. Was in Italy 1653-1661, much of the time allegedly in Savoy. Said to have come to England *c.*1662, where he remained till his death, but gave up painting about 1694. He was elder brother to Simon du Bois (q.v.), whose work Vertue considered much superior to his. His landscapes were 'after the Italian gusto'.

(*Croft-Murray and Hulton; Ogdens, 116.*)

WILLIAM DOBSON, 1611-1646. 'Allegory of the Civil Wars in France'. 49ins. x 57½ins.
Collection of C. Cottrell-Dormer, Rousham.

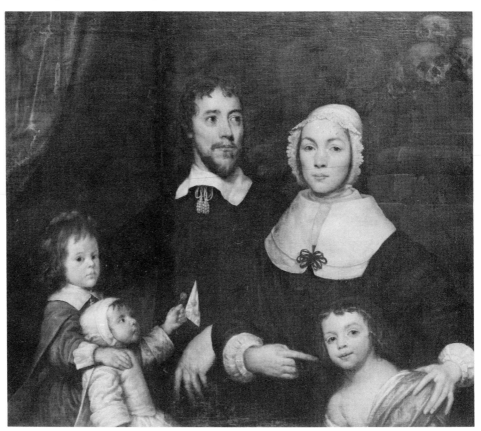

SIMON DU BOIS, 1632-1708. 'Countess of Clare'. 29ins. x 24½ ins. s. & d. 1684. Sotheby's sale 27.5.1964 (14).

SIMON DU BOIS, 1632-1708. Portrait of a man. 29ins. x 24½ ins. s. & d. 1683. Christie's sale 20.11.1964 (26).

DU BOIS, Simon **1632 – 1708**

Best known for portraits and portrait miniatures, but also painted battle scenes, pictures with horses, cattle, etc., and did a good many fakes of old masters. Baptised Antwerp 26 July 1632; buried London 26 May 1708. Younger brother of Edward Du Bois (q.v.), they seem to have shared an establishment in London. He was a pupil of Wouverman 1652/53 and later in Italy, where he is recorded at Venice 1657 and was paid in Rome in 1667 for a portrait of Alexander VII (*Archivio Chigi*). His earliest known English portrait is signed 'S. du Bois fecit London 1681'. A pair of 1682 portraits at Dulwich are in a style between Mary Beale and Riley (*Croft-Murray and Hulton; Vertue*). He may be the Simon Dubois who became a denizen 8 May 1697.

DUGY, J. **fl.1629**

A female portrait signed 'J. Dugy pinxt. 1629' is in N.P.G. Reference Coll.

(*Burlington Mag., XXIX (December 1916), 374.*)

Opposite:
WILLIAM DOBSON, 1611-1646. A family group, possibly of the Streatfield family. 42ins. x 49½ ins. B.A.C. Yale, Paul Mellon Collection.

GODDARD DUNNING 1614-after 1687. 'Self-portrait with still-life'. Blickling Hall (National Trust).

DUNNING, Goddard **1614 – after 1678**
?Amateur painter of very little competence. He signs on the backs of two pictures dated 1677 (a copy after Bower's 'Charles I at his trial') and 1678 ('Self-portrait with still life' at Blickling) that they were painted in 'the 63rd and 64th yeare of his age'. There is also a doubtfully identified portrait in the Bodleian

(Norwich Castle Museum, cat. of Still-life exh., 1955, 13.)

DUVAL, Philippe **fl.1672 – *c*.1709**
French painter of historical subjects. Died London *c*.1709. Said to have been a pupil of Le Brun and to have studied Venetian painting at Venice and Verona. He settled in England by 1672. His work is not known.

(Vertue, i, 126.)

DYCK See VAN DYCK, Sir Anthony

EDEMA, Gerard ***c*.1652 – *c*.1700**
Painter of wild landscapes, often with waterfalls. Probably a native of Friesland; said to have died at Richmond, Surrey, aged 48. Pupil at

Amsterdam of Allard von Everdingen, whose Scandinavian type landscapes he imitated. He came to England c.1670 (*Buckeridge*), and also visited Norway and Newfoundland which provided the scenery for his 'views of a broken world', but he may have done them out of his head. They are of all sizes and very dashingly executed. His signature is not easy to read.

EHRENSTRAHL, David Klöcker **1626 – 1698**
Portrait and history painter. Born Hamburg 23 September 1629; died Stockholm 23 October 1698. He was Court Painter at Stockholm from 1661, the dominant figure in Swedish painting, and the teacher of Michael Dahl (q.v.). He is reported by Vertue (*iii, 28*) to have visited England November 1660. There is a portrait of 'General Massey' ascribed to him.

(*Th.-B., s.v. Klöcker.*)

ELLIOTT, Francis *c.*1667 – after 1692
All purpose painter (portrait, landscape, copying). Employed by the 2nd Duke of Newcastle 1690/91.

(*Goulding and Adams, 442/43.*)

ENGLISH, Josias fl.1654 – *c.*1718
Amateur painter and etcher. Died at Mortlake *c.*1718.

(*Redgrave; Vertue, i, 59.*)

ESSELENS, Jan **1626 – 1687**
Dutch landscape painter, draughtsman and engraver. Born and died in Amsterdam. He is believed to have visited England and Scotland in his capacity as a silk and velvet merchant. Two drawings of London are at Copenhagen (*Burlington Mag., LXVIII (June 1936), 394.*)

ETTY, John fl.1697
Limner; admitted as freeman of the City of York 1697.

(*Surtees Soc., CII (1899), 179.*)

EVELYN, Mrs. John *c.*1635 – 1709
Amateur painter. Born Mary Browne; died London 9 February 1708/9 aged 74. Two pictures of flowers are known and she copied a miniature which she presented to the King in 1661 (*Helen Evelyn, The History of the Evelyn Family, 1915, 93/94*). Her husband, the diarist John Evelyn (1620-1705/6), practised many of the arts, but perhaps not painting, except in miniature.

(*Long.*)

HANS EWORTH, fl.1540-c.1573. 'Henry VIII and family'. Dent-Brocklehurst Collection, Sudeley Castle.

EVOMS, John fl.1625

Presumably a miswriting for Evans. He became an apprentice to Cornelis Johnson i (q.v.) in January 1625.

(M. Whinney and O. Millar, English Art 1625-1714, 1957, 67.)

EWORTH, Hans fl.1540 – *c.*1573

Portrait and history painter. Received as Master in the Antwerp Guild 1540 (as 'Jan Eeuwowts'); last recorded (as 'Haunce Eottes') making patterns for the Revels Candlemas 1573/74. (The spelling of his name varies from Haward to Suett!) He seems to have been trained at Antwerp (where others of the family were painters) in the tradition of Frans Floris, both for portrait and allegory. He came to England perhaps by 1545 and was made a denizen (as 'John Euwouts') October 1550. Dated pictures range from 1549 to 1570 and it is generally accepted (on evidence which is less than probative) that he is the painter who signs 'H.E.' and who was once supposed to be Lucas de Heere (q.v.). His first portraits (1550) are in a robust Floris style, but, as he became involved in Court patronage, the influence of Holbein's example and of Mor's (q.v.) reticent Hapsburg style influenced him; his last works anticipate the Elizabethan 'costume piece'. His work has a high enamel and he has a strong sense of character. It is likely (but not documented) that he was Official Painter to Queen Mary I, and he was only beginning to ingratiate himself with Queen Elizabeth ('Queen Elizabeth and the Three Goddesses', 1569, Royal Collection) shortly before he died. He was perhaps the most distinguished portrait painter in the troubled period between the death of Holbein and the emergence of Hilliard.

(Documents in Auerbach; illustrations in Strong, cat. Hans Eworth exh., Leicester and N.P.G., 1965 and 1966.) See colour plate p.84.

EYCKE, John fl.1624 – after 1640

Portrait painter in a tradition akin to Mytens (q.v.). He was made a freeman

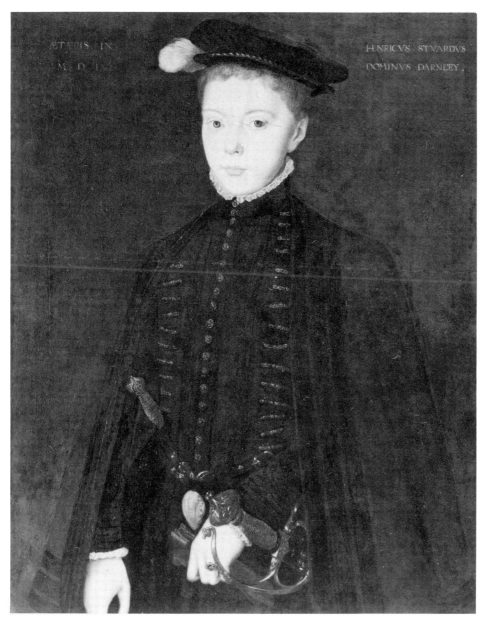

HANS EWORTH, fl.1540-c.1573. 'Lord Darnley'. 28ins. x 21ins. s. & d. 1555. Private collection.

of the Painter Stainers in 1640. His signed full-length of '1st Lord Fitzwilliam', 1630, and companion are published in *J. W. Goodison, Burlington Mag., LXXIII (September 1938), 125*). His name is perhaps also spelled 'Yeekes'.

EYDEN, Jeremias van der fl.1658 – 1695

Journeyman portrait painter. Native of Brussels; pupil of Hanneman (q.v.) at The Hague 1658. Buried Stapleford, Leicestershire, 17 September 1695 (*Rev. I. Eller, History of Belvoir Castle, 1841, 288*). He was at one time assistant and drapery painter for Lely and sometimes appears as 'Vanroyden'. He appears in the 1675 and 1676 accounts of the Duke of Rutland and is responsible for the made-up portraits of the first eight Earls of Rutland at Belvoir Castle.

(*Buckeridge, s.v. Van der Heyden.*)

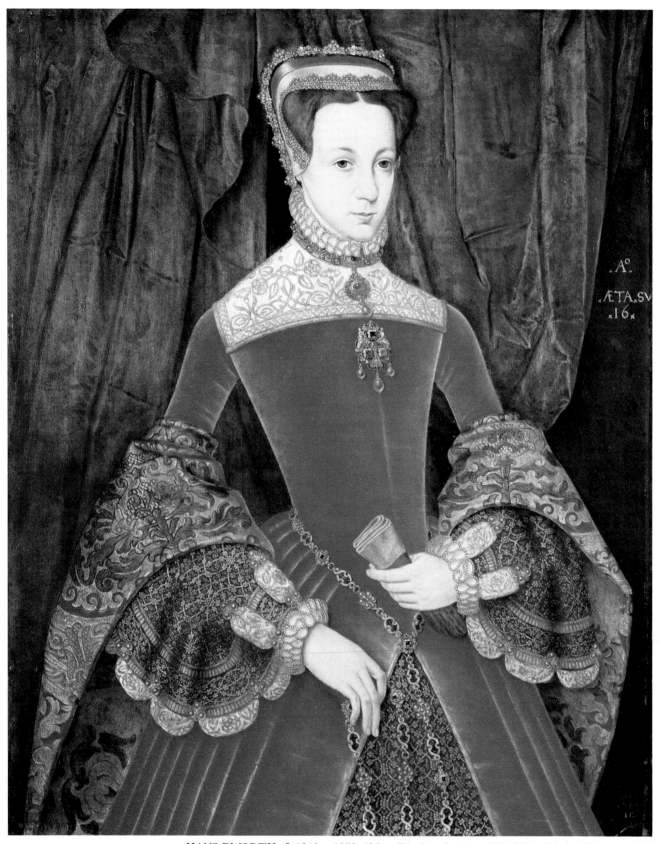

HANS EWORTH, fl.1540-c.1573. 'Mary Fitzalan, Duchess of Norfolk'. 35ins. x 28ins. c.1555. B.A.C. Yale, Paul Mellon Fund.

FAES, van der See LELY, Sir Peter

FAITHORNE, William *c.*1616 – 1691
Mainly engraver and etcher, but *c.*1680 he took to doing portraits in crayons
and plumbago; buried London 13 May 1691 'being near 75 years of age'
(*Buckeridge*). Apprenticed to William Peake (d.1639) for ten years and passed
on to his son, Sir Robert Peake (q.v.). Briefly in the Royalist army as 'painter
to Prince Rupert', but captured 1645 and exiled to France, where he is said
to have studied with Nanteuil and Philippe de Champagne. Returned to
England *c.*1650 and was free of the Goldsmiths' Company 1652. He became
a leading printseller and turned to making portraits in crayons *c.*1680,
inventing a way of doing them on copper.

(*Croft-Murray and Hulton.*)

FENNER, Mr. fl.1616
A full-length of 'James I' was put up in Bury St. Edmunds Guildhall 'by the
Trustees of the Guildhall Feoffment, who paid £40 to Mr. Fenner, the painter,
for it'.

(*Rev. Edmund Farrer, Portraits in Suffolk Houses (West), 1908, 59.*)

FERGUSON, William Gouw 1632/33 – after 1695
Painter of arrangements of dead game and overdoors or overmantels, often
with bas-reliefs and a slightly eerie air. Born in Scotland; married, aged 48,
Amsterdam 1681; his latest dated picture 1695. He seems to have been trained
in Holland, but travelled in France and Italy and was settled at The Hague
by 1660. He painted two pictures for the Duchess of Lauderdale's Private
Closet at Ham House in the 1670s. Vertue says he died in England (*E. C-M.*).
Three signed still-lifes are in the Edinburgh Gallery.

FERRERS, Benjamin fl.*c.*1695 – 1732
Mainly a deaf and dumb portraitist. His known rather dull portraits are all
after 1700, but his earliest dated work, of ?1695, is of better quality and shows
a plant in a very fancy oriental pot (Newbattle Abbey).

(*Waterhouse, 1981.*)

FISHER, John fl.*c.*1677
Amateur history painter, resident in Hereford. Known only from a destroyed
ceiling painting of 'Ganymede' painted for a Hereford attorney (*E. C-M.*
quoting Camden Soc., 1867, pl. CCXIV).

BENJAMIN FERRERS,
fl.c.1695-1732. 'Plant in
a china pot', 41ins. x
23½ins. s. & d. Newbattle
Abbey (Lothian Trustees).

ROBERT FISHER, fl.1655. 'John Wilson'. s. & d. 1655. Heather Professor of Music, Oxford. Photograph Bodleian Library.

FISHER, Robert fl.1655

Probably an Oxford portrait painter, possibly an amateur. He is known only from his portrait of 'John Wilson', Professor of Music at Oxford, s. & d. 1655 (Examination Schools, Oxford). It suggests a knowledge of Isaac Fuller (q.v.).

(Oxford Historical Portraits exh., 1905, pl. XI.)

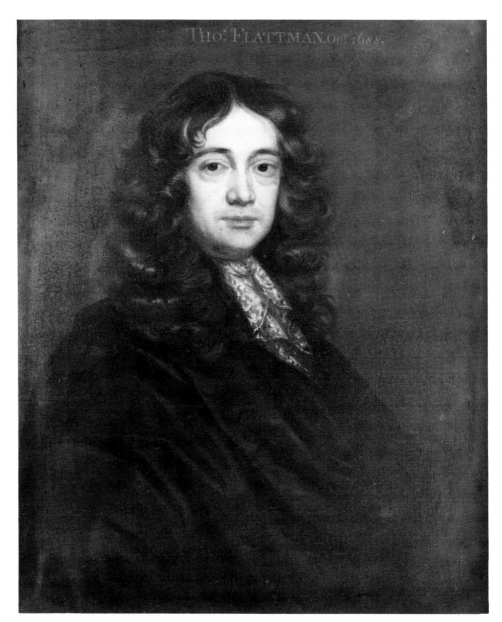

THOMAS FLATMAN, 1635-1688. Self-portrait. Collection of Lord Sackville, Knole. Photograph Courtauld Institute of Art.

FLATMAN, Thomas **1635 – 1688**

Poet and gentleman (but hardly 'amateur') painter of portrait miniatures. Born London 1635; died there 8 December 1688. His miniature style derives from that of Samuel Cooper (q.v.) and he was the most distinguished miniaturist of his generation. He became an F.R.S. in 1668 and frequented for preference an Anglican and aesthetic circle which included the Beales (q.v.). His self-portraits (*Graham Reynolds, Burlington Mag., LXXXIX (March 1947), 63ff.*) and his poetry reveal a mildly neurotic and highly educated (he was an M.A. and called to the bar) individual. There are probable self-portraits on the scale of life in N.P.G. and at Knole.

(*Long.*)

FLESSHIER, Bartholomew fl.1602 – 1618

?Limner. In a list of aliens in England in 1618 (*Camden Soc., LXXXII (1862), 84*) is Bartholomew Flusheir 'a limber' (*sic*) born at The Hague and in England for 16 years.

FLESSIER (FLESSHIERS), Balthasar fl.1575 – after 1619

Portrait painter of ?Flemish origin. Probably in the Ghent Guild 1575; at Middelburg 1579-1585; at The Hague 1587-1619; died by 1626. One of his daughters married the sea painter Jan Porcellis, and he had at least four sons who were painters. It is usually supposed that it was Balthasar who came to England, but this is very doubtful.

(*Th.-B.*)

FLESSIER (FLESSHIERS), Tobias fl.1652 – 1663

Painter of sea pieces and still-life; a son of Balthasar Flessier (q.v.). He was in trouble with the Painter-Stainers 1652 and is listed as famous for sea pieces in 1658 in Sanderson's *Graphice*. Two such were in the Royal Collection. Walpole notes sea pieces at Ham House, but these would have been from the 1670s.

FLESSIER (FLESSHIERS), Willem fl.1627 – ?1666

Portrait painter. Son of Balthasar Flessier (q.v.) (*Th.-B.*). A rather feeble full-length of 1642, with an inscription in French and signed 'W. Flesshiers, Bristol', is in the Bristol Art Gallery.

FLICKE, Gerlach fl.1545 – 1557/58

Portrait painter, also known in England as 'Garlick'. Of German nationality and owned property at Osnabrück; came to England *c.*1545; died London 1558. He is known only from three signed works of considerable distinction (*Strong, 78ff.*), one of which is a miniature diptych including a self-portrait (Sotheby's sale, 9 July 1975, 16) painted in prison, apparently under sentence of death. He seems to have been trained in the Westphalian tradition of portraiture and probably came to England soon after Holbein's death. He might have been a serious candidate for Court employment if he had not become involved in religious politics. His will was proved in London by his wife 11 February 1557/58.

(*Auerbach.*)

GERLACH FLICKE, fl.1545-1558. 'Thomas Cranmer'. 1546. N.P.G.

FORSTER, Thomas *c.* 1677 – after 1713

Miniaturist notable for his likenesses in plumbago on vellum. Aged 31 in 1708; his latest known dated works 1713. His work is of great elegance and minuteness. Examples in painting are not known.

(*Long; Walpole Soc., XIV (1926), 73ff.*)

FOSSE, Charles de la See LAFOSSE, Charles de

FOUR, René du fl. 1678

Recorded as apprentice to Verrio and working at Windsor in 1678.

FOX, Vincent See VOLPE, Vincenzo

FRANCIS, Thomas fl. 1672 – 1678

Herald painter in the Montgomery district documented in the Chirk Castle accounts from 1672 to 1678. He was also paid in 1672 for making three landscapes for chimney pieces and for painting the sign for The Bull Inn at Denbigh.

(*Chirk Castle Accounts (cont.), 1666-1673, Manchester, 1931, 97.*)

FREEMAN, John fl.*c.* 1660 – 1686

History and scene painter. Said to have been a serious rival to Fuller (q.v.). He painted a staircase at Belvoir Castle 1686, since destroyed (*Buckeridge; E.C-M.*). He was teaching painting in 1663.

(*Collins Baker, II, 132.*)

FRERES, Dirk (Teodoro) 1643 – 1693

Dutch history painter. Born Enkhuyzen 1643; died on boat going home 1693. He was in Rome 1666; came to England 1678/79 (*Vertue, i, 71*) at Lely's suggestion, in hope of getting the work at Windsor which went to Verrio. He painted a small room at Burghley House (*E.C-M.*) and is said to have been the teacher of Thomas Hill (q.v.). He was employed by the House of Orange in Holland.

FRYER, Leonard fl. 1597 – 1605

Serjeant-Painter from 1598 to 1605 (from May 1605 jointly with John de Critz i (q.v.). Will proved 18 December 1605. As Serjeant-Painter he seems only to have fulfilled the decorative aspects of the task, although Vertue says he saw a picture by him in the Painters' Hall.

(*Auerbach; Edmond, 184-186.*)

ISAAC FULLER,
fl.1644-1672. Top left:
Detail of self-portrait.
Bodleian Library, Oxford.
Top right: 'Matthew Lock'.
Examination Schools, Oxford.
Right: Portrait of a child.
16ins. x 14 ¼ ins. By
permission of the Governors of
Dulwich Picture Gallery.

ISAAC FULLER, fl.1644-1672. 'Charles and Colonel Careless in the royal oak'. 84ins. x 124ins. c.1660-1670. N.P.G.

FULLER, Isaac fl.1644 – 1672

Portrait and history painter. An alleged date of birth (1606) is unsupported and the first mention of him is at Oxford in 1644; died London 17 July 1672. He was on the Royalist side in the Civil War and has affinities with Dobson (q.v.) though his style of execution is more impetuous and clumsier. He seems to have retired to Paris where he studied under François Perrier, probably 1645-1650, where he learned engraving and developed a tendency to rather Michelangelesque musculature. He was back in England by 1650, published a Drawing Book, with etched plates, 1654, and had a good reputation as a history painter by 1658 (*Sanderson, Graphice*). His principal surviving history

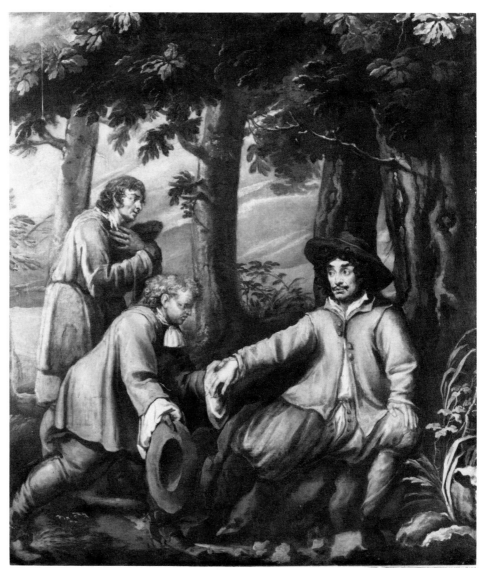

ISAAC FULLER, fl.1644-1672. 'Col. Careless and Richard Penderel in Boscobel wood'. N.P.G.

works are five large pictures of the 'Escape of Charles II after the Battle of Worcester' (*E. Croft-Murray, Archeologia, CIII (1971), 99ff.*), bought by the N.P.G. (Christie's sale 23 March 1973, 156) and on display in the Banqueting House. After the Restoration he went to Oxford, where he painted 'The Last Judgment' at Magdalen (destroyed) and the 'Resurrection' at All Souls (some fragments in the Ante-Chapel: *Burlington Mag., CII (October 1960), 450ff.*). He later specialised in rather Bacchic scenes for London taverns. Few absolutely certain portraits survive, but his self-portraits (N.P.G. and Bodleian Library) are remarkable and powerful and he has a rather recognisable type of hand, perhaps of Venetian origin. He influenced Lely's Commonwealth style. A son, Isaac Fuller ii (fl.1678-1709) followed in his footsteps but was feebler.

(*E. C-M.*)

JAMES GANDY, 1619-1689. 'William Jane'. Photograph Bodleian Library, Oxford.

GANDY, James **1619 – 1689**

Portrait painter. Said to have been a native of Exeter and by M. Pilkington (*The Gentleman's and Connoisseur's Dictionary of Painters...1250-1767, 1770*) to have died in 1689 aged 70. He is said to have been a pupil of Van Dyck (q.v.) and was certainly familiar with his technical practice and he is reputed to have copied Van Dyck very cleverly, but no recognised works support this. He was taken to Ireland in the service of the Viceroy, the 1st Duke of Ormonde, in 1661, and is said to have died there 1689. A portrait at Kingston Lacy of 'Ormonde' is curiously pedestrian and does not suggest a knowledge of Van Dyck. Two Irish portraits of the 1680s sold 16 June 1961 are possible attributions. He was the father of William Gandy (q.v.) and perhaps also of a Thomas Gandy who was Upper Warden of the Painter-Stainers' Company 1699, and its Master 1704.

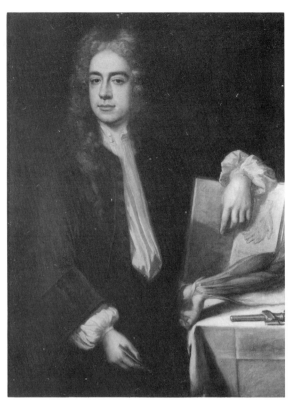

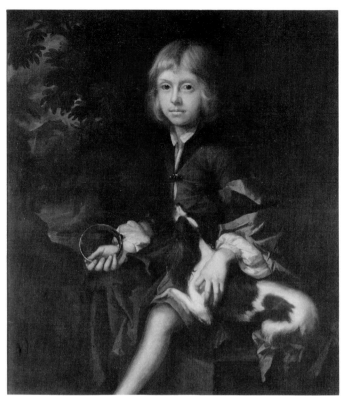

WILLIAM GANDY, c.1655-1729. 'John Patch'. 48ins. x 33ins. Royal Devon and Exeter Hospitals.

WILLIAM GANDY, c.1655-1729. 'Master Willcock, son of Thomas Willcock, Sheriff of Exeter'. 37ins. x 32½ins. Signed 'W. Gandy fe.'. Present whereabouts unknown.

GANDY, William *c.*1655 – 1729

Itinerant portrait painter in Devonshire; died Exeter 1729 (*Waterhouse, 1981*). Son of James Gandy (q.v.), he probably practised in Ireland (where he is said to have studied under Gaspard Smitz) before settling in England before 1700. He was apprenticed to his ?brother Thomas, a painter-stainer. He is a plausible candidate for the authorship of *Notes on Painting*, 1673-1699 (*Talley, 306ff.*). His known work is all after 1700, with the possible exception of a signed 'Master Willcock' of *c.*1700.

GARDINER, Christopher fl.1672 – 1683

Portrait painter, or perhaps rather copyist and herald painter. Native of Bristol; freeman of Salisbury 1672 where he was still living 1683. His portrait of 'Sir Robert Hyde' (Salisbury Corporation) is a pedestrian copy.

(*C. Haskins, The Salisbury Corporation Pictures and Plate, 1910, 15, 153.*)

GARLICK See FLICKE, Gerlach

GARRARD See GHEERAERTS, Marcus

HENRI GASCARS, c.1635-1701. Portrait of two ladies (by or after Gascars). 43ins. x 68ins. Christie's sale 20.6.1947 (73) as Mignard.

GASCARS, Henri *c.*1635 – 1701

Very French portrait painter; in Rome he also painted an altarpiece. Born Paris *c.*1635; died Rome 18 January 1701. He was studying in Rome 1659, and may have studied under Mignard (of whose style his work is a parody) in Paris. *Agréé* at the Paris Academy 1671; left Paris for England after 6 March 1672 and was much patronised by the Duchess of Portsmouth (large portraits at Goodwood). He did good business at the English Court and a number of very early mezzotints were scraped after portraits by him. The most laughable of his English portraits is the 'James, Duke of York, as Lord High Admiral' (Greenwich). He left England soon after Louis XIV ceased to pay a subsidy (1677) to Charles II and went to paint the signing of the peace treaty at Nijmegen (1678). He was received into the French Académie in 1680 and then set out on his travels: Modena 1681, Venice 1686 (where he made many copies after Tintoretto), Poland 1691 and eventually Rome, where he died.

(*Waterhouse, 1978, 105.*)

GASPARS, John Baptist fl.1641 – 1692

Portraitist and all-purpose painter; chiefly known as having painted 'postures' for Lely (from *c.*1660), Riley and Kneller. Generally known as 'Lely's Baptist'

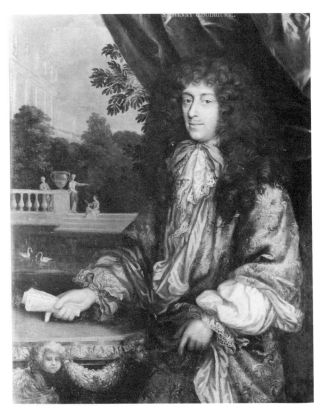

HENRI GASCARS, c.1635-1701. 'Sir Henry Goodricke'. 48½ins. x 38½ins. Signed. Christie's sale 3.5.1940 (5).

JOHN BAPTIST GASPARS, fl.1641-1692. 'Sir Justinian Isham'. 1676. Lamport Hall Trust.

(*Buckeridge*). Native of Antwerp and son of a painter; Master at Antwerp 1641/42 (as 'Jan Baptist Jaspers'). Said to have been a pupil of Willeboerts. In England by 1650, when he was a buyer at the Commonwealth sale; entered the service of General Lambert whom he taught to paint; from *c.*1660 he was a leading executant in Lely's studio, but was also allowed to do work on his own. A posthumous portrait of 'Sir Justinian Isham', 1676 (Lamport Hall) is documented by a letter from David Loggan, and, though based on Lely, does not seem to be a copy. He was also a picture restorer. He is said to have died in 1692.

GAWDY, Sir John, Bart. 1639 – 1708/9

Amateur portrait painter; deaf-mute. Born 25 September 1639; succeeded to baronetcy 1669; died January 1708/9. Studied with Lely when young and became quite a competent artist (*Vertue, v, 45*). For an alleged self-portrait see *Duleep-Singh, I, 160*. The dumb painter may have been his younger brother, Framlingham, who studied painting under John Freeman (q.v.), with help from Lely, 1663-1667.

(*Hist. MSS. Commission, 1885, 198ff.*)

GEEST, Julius de fl.1656 – 1699

Flemish portrait painter. Pupil of Erasmus Quellinus; Master at Antwerp 1656/57. He is known only from a portrait group of the 'Family of the 5th Lord

GEORGE GELDORP, c.1595-1665. 'Sir Arthur Ingram' (c.1570-1642). 84ins. x 57½ins. Leeds City Art Galleries (Temple Newsam House).

GEORGE GELDORP, c.1595-1665. 'Thomas, Lord Bruce of Kinloss, 1st Earl of Elgin'. Hardwick Hall (National Trust). Photograph Courtauld Institute of Art.

Blantyre' (Duke of Hamilton, Lennoxlove) signed 'J. de Geest/1698' which looks as if it was painted in Scotland (eight figures, an early conversation piece). He worked mainly at Leeuwarden; died 25 May 1699.

(*Th.-B.*)

GELDORP, George *c.*1595 – 1665

Portrait painter, copyist, dealer, restorer, agent, pimp and general art-busybody. Son of a painter resident at Cologne; Master at Antwerp 1610 where he remained until 1623 when he came to England. Died London 14 November 1665. His documented works are full-lengths at Hatfield of 1626 of '2nd Earl of Salisbury and wife' (*Collins Baker, I, 66-70*) which are close in style to contemporary works by Mytens and Cornelius Johnson i (qq.v.). He was involved in Van Dyck's coming to England, and later specialised in copies of Van Dyck; *c.*1638-1640 he was associated with Van Dyck in picture dealing (*Burlington Mag., August 1955, 255*) and was later associated with Gerbier (q.v.) and Lely under the Commonwealth. After the Restoration he became Keeper of the King's Pictures. He was probably often employed on political negotiations under artistic cover.

ORAZIO GENTILESCHI, 1563-1639. 'Allegory of Peace and the Arts under the British Crown'. c.1636-1638. Originally in the Queen's House, Greenwich; now at Marlborough House, London. Crown copyright: Reproduced with the permission of the Controller of Her Majesty's Stationery Office.

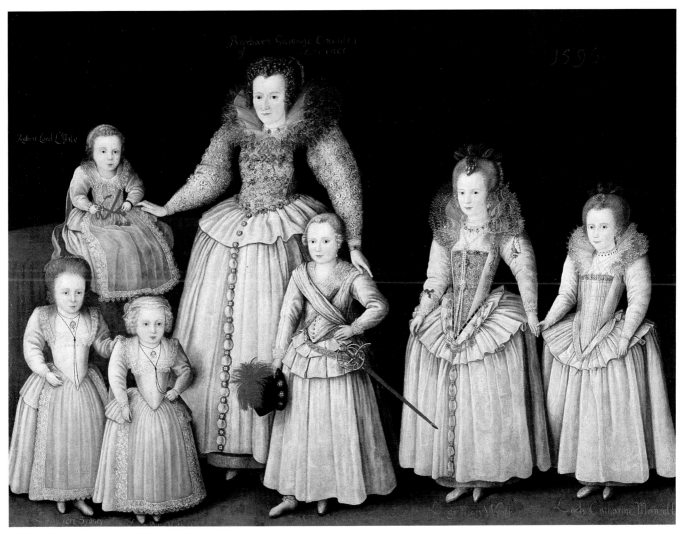

MARCUS GHEERAERTS (ii), 1561/62-1635/36. 'The Countess of Leicester and her children'.
1596. By permission of Viscount de L'Isle, V.C., K.G., from his collection at Penshurst Place.

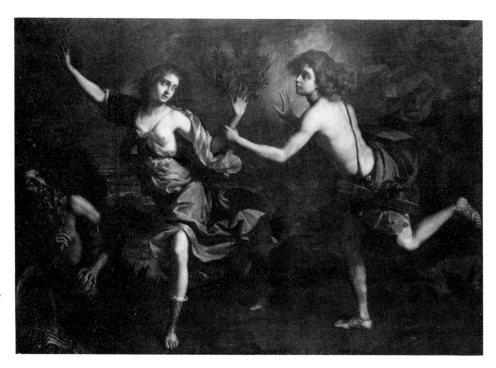

*BENEDETTO GENNARI,
1633-1715. 'Apollo and
Daphne'. 78ins. x 107ins.
Christie's sale 23.2.1962
(63).*

GENNARI, Benedetto 1633 – 1715

Bolognese painter of history and portrait. Born Cento 19 October 1633; died
Bologna 9 December 1715. Nephew, pupil and imitator of Guercino. After
some work in Emilia, he came, via Paris (1672) to London, where he arrived
24 September 1674, and was at once employed by Charles II, for whom he
painted rather distasteful erotic mythologies for the dining room at Windsor
and elsewhere (of which six survive in the storerooms of Hampton Court), and
altarpieces for the Queen's Roman Catholic chapels (of which the
'Annunciation', 1686, for the Chapel at Whitehall is at Sarasota, and the
'Holy Family', 1682, for St. James's Palace is at Birmingham). He also did
portraits ('Queen Catherine of Braganza', Goodwood) and painted
mythologies for various courtiers. He kept a record (unpublished) of his
commissions (Bologna, *Archiginnasio MS. B344*) which covers his whole English
period up to 1688 when he followed James II to St. Germain, where he
continued in royal service up to April 1692 when he returned to Bologna. His
figure style is easily recognisable, but his portraits show some variety, but are
usually decidedly unEnglish.

(*M. Levey, Later Italian Pictures in the Collection of Her Majesty the Queen, 1964,
21-23, 81; Dwight Miller, Apollo, CXVII (January 1983), 24-29.*)

GENT, ?P. fl.*c.*1670

A portrait of 'Herbert Croft', Bishop of Hereford, at Croft Castle, seems to
be signed 'P. Gent' or 'P.E. Gent' and is of considerable distinction.

(*Ingamells, 166/67.*)

GENTILESCHI, Orazio 1563 – 1639

Italian historical and religious painter. Born Pisa 9 July 1563; died London
7 February 1639. He arrived in Rome 1576 or 1578, but it was only after 1600
that his art shows a profound influence from Caravaggio. Up to 1620 he

worked mainly for the Roman area and the Marche. His travels begin 1621: Genoa, Turin and Paris, until he arrived in London in the autumn of 1626, probably on the invitation of the Duke of Buckingham. He was employed as an official Court Painter by Charles I until his death, but not much work of his London period survives, although, apart from Van Dyck, Gentileschi was Charles I's only capture of an artist with a major European reputation. His major surviving work is the very battered ceiling, 'Allegory of Peace and the Arts under the British Crown', *c.*1636-1638, for the Queen's House, Greenwich, which is now incorrectly installed at Marlborough House. In this he may have had some slight help from his daughter, Artemisia Gentileschi (born Rome 8 July 1593; died Naples 1652/53), a doughty pioneer of women painters, who briefly visited London 1638/40, and had some success, though none of her English work is known. Gentileschi's work was entirely without influence in England.

(*R. Ward Bissell, Orazio Gentileschi, Pennsylvania State University Press 1981; for Artemisia see do., Art Bulletin, L (June 1968), 153-167.*)

See colour plate p.100.

GERBIER, Sir Balthasar 1591/92 – 1663

Painter, art-busybody, architect, diplomatic agent and pamphleteer. Born Middleburg 23 February 1591/92; died Hamstead Marshall, Berkshire, probably 1663. He acquired some artistic training in Germany and was brought to England with the Dutch Ambassador in 1616, becoming almost at once art adviser and general factotum to the Duke of Buckingham, for whom he acted as architect, decorator and miniaturist. His few miniatures are very competent (list in *Long*) and portraits on the scale of life have been ascribed to him. After Buckingham's murder (1628), he was naturalised in 1629 and entered the service of Charles I, being employed on diplomatic missions, under cover of artistic activity, at Brussels 1631-1640, where he betrayed the confidence of the King to the Regent of The Netherlands. He was knighted 2 October 1638 at Hampton Court. In Paris 1643-1649, where he began his career as a pamphleteer. In 1649 he started an Academy in London for teaching almost everything, which soon collapsed. He returned from Holland to London in 1661 and made extravagant claims which were not admitted. He then took to architecture, at which he had some skill, and seems to have died at Hamstead Marshall, where he was building a house for Lord Craven, about 1663 (although a long posthumous notice in the church says he died 1667). Although he was in touch with Rubens, Van Dyck, Lely, etc., he was a person of no artistic importance.

(*Colvin, 1978, 335-337; Hugh Ross Williamson, Four Stuart Portraits, 1949, 26-60.*)

GHEERAERTS, Marcus (i) *c.*1520 – *c.*1590

Flemish painter and etcher (the name is also spelled 'Garrard', 'Garret' and in every possible way). Born Bruges *c.*1520; died before August 1591. He was trained in a style close to that of Frans Floris and entered the Bruges Guild 1558, already a professional etcher and painter. In March 1568 he fled with his son, Marcus Gheeraerts ii (q.v.) to London where he was active in designing illustrations for books (*Edward Hodnett, M.G. the Elder, Utrecht 1971*). He remained in London until 1677, when his name appears in the Antwerp Guild, and he remained at Antwerp until at least 1586. It is not certain whether he then returned to London. He started as a religious painter, but no documented works are known; he is also known to have painted at least one portrait but it is doubtful if he did so in England. He is the first etcher known to have practised in England. His most memorable achievement is the illustrated *Aesop*, published in Bruges 1567.

(*A. Schoteet, M.G., Bruges 1941.*)

GHEERAERTS, Marcus (ii) 1561/62 – 1635/36

One of the leading fashionable portrait painters of his age. Born Bruges 1561/62; died London 19 January 1635/36. Son (and perhaps pupil) of Marcus Gheeraerts i (q.v.), with whom he came to England in 1568, where he

MARCUS GHEERAERTS (ii), 1561/62-1635/36 'Barbara Gamage (Countess of Leicester) and her eldest daughter Lady Mary Wroth'. 45ins. x 32ins. s. & d. 'Mark Garrard 1612'. By permission of Viscount de L'Isle, V.C., K.G., from his collection at Penshurst Place.

remained all his life. His great patron seems to have been Sir Henry Lee of Ditchley (who was a witness at the baptism of one of his children), for whom he presumably painted in 1592 the great Ditchley 'Queen Elizabeth' (N.P.G.), which perhaps made his name, and he was taken over as Court Painter by James I and Anne of Denmark. His fashionable vogue perhaps lapsed with the arrival of Mytens and Van Somer (qq.v.), etc., after which country gentry and university colleges became his best patrons. His son, Marcus Gheeraerts iii

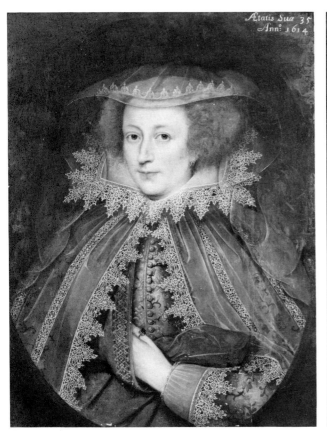

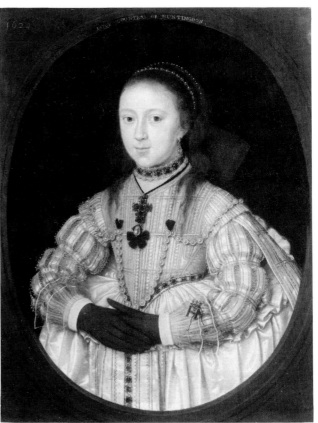

MARCUS GHEERAERTS (ii), 1561/62-1635/36. Portrait of a lady. 29ins. x 22½ins. 1614. B.A.C. Yale, Paul Mellon Collection.

MARCUS GHEERAERTS (ii), 1561/62-1635/36. 'Lucy, Countess of Huntingdon' (d.1679). 30½ins. x 24½ins. s. & d. 'Marcus Gheeraedts fecit 1623'. Private collection.

(baptised 22 August 1602; probably died *c*.1654) became a freeman of the Painter-Stainers 1628, but is not known as a painter (*Edmond*). His wife was a de Critz, a half-sister married Isaac Oliver and there probably was close liaison between the studios of all these portrait painters (*Strong, 269ff.*) but the attributions are often speculative (*Auerbach*). His studio no doubt produced a great many of the 'Jacobethan' full-lengths, but there are no tricks of handling which enable them to be identified.

See colour plate p.101.

GIBSON, Edward 1668 – 1701

Portrait draughtsman. Buried at Richmond, Surrey, aged 33. Perhaps son of Richard Gibson (q.v.) He is only known from his self-portrait of 1690 in chalks (N.P.G.) which is clearly the work of a professional (*David Piper, 17th century cat., N.P.G., 1963*). Buckeridge says he also painted in oils.

GIBSON, Richard 1615 – 1690

Miniature painter. Possibly born in Cumberland; buried London 23 July 1690 aged 75. He was a dwarf and at first in the service of 4th Earl of Pembroke. He learned drawing from Francis Cleyn (q.v.) and learned much from Lely. He was at one time Page of the Backstairs to Charles I (*Buckeridge*) and made miniature copies of pictures in the Royal Collection. Before 1669 he signed

'D.G.' ('Dick' or 'Dwarf' Gibson), but later 'R.G.' or 'R. Gibson' (*J. Murdoch and J.V. Merrill, Burlington Mag., CXXIII (May 1981), 282-289*, where the technical peculiarities of his work are analysed). He married, 1640/41, another dwarf, but their numerous children were of normal size; one was Susan Penelope Rosse (q.v.), also a miniaturist, and others may have helped him in later life in the production of workshop replicas. He taught painting to the daughters of the Duke of York and accompanied Princess Mary to The Hague when she married the Prince of Orange. He perhaps remained at The Hague until 1688.

(*Long.*)

GIBSON, William *c.*1645 – 1703

Miniaturist. Buried at Richmond, Surrey, 11 December 1703. A pupil of his uncle, Richard Gibson (q.v.) and of Lely, whose works he excelled in copying in miniature. He was 58 when he died.

(*Buckeridge; Goulding, Walpole Soc., IV, 29.*)

GIROLAMO DI TOMMASO DA TREVISO fl.1523 – 1544

Recognised painter at Bologna in a post-Raphaelesque style; he entered the service of Henry VIII *c.*1538 as a military architect and engineeer, and was killed at the siege of Boulogne 10 September 1544. For a possible attribution of a picture by him at Hampton Court, and painted in England, see *Pouncey, Burlington Mag., XCV (June 1953), 208.*

(*J. Shearman, The Early Italian Pictures in the Collection of Her Majesty the Queen, 1983, cat. no. 115.*)

GLOVER, Moses fl.1640

Called 'the painter' and paid for work at Syon House in 1640.

(*Burlington Mag., XCVII (August 1955), 255.*)

GOLCHIS, Peter fl.1598

Listed as a painter in F. Meres' *Palladis Tamia*, 1598, but not otherwise known. The name could be a corruption of Goltzius.

GOMERSALL, Thomas fl.1670 – 1683

Limner and perhaps portraitist in the North West. Said to be from Chester; married at Wrexham 1670, later moved to Shrewsbury. Painted a portrait at Chirk 1683.

(*Chirk Castle Accounts, 1666-1753, ed. W.M. Myddelton, 1931, 158 n.*)

GOODERICK (GOODRICH), Matthew fl.1617 – 1654

Mainly a decorative painter and employed in the service of the Crown.

(*E.C-M., 202ff.*)

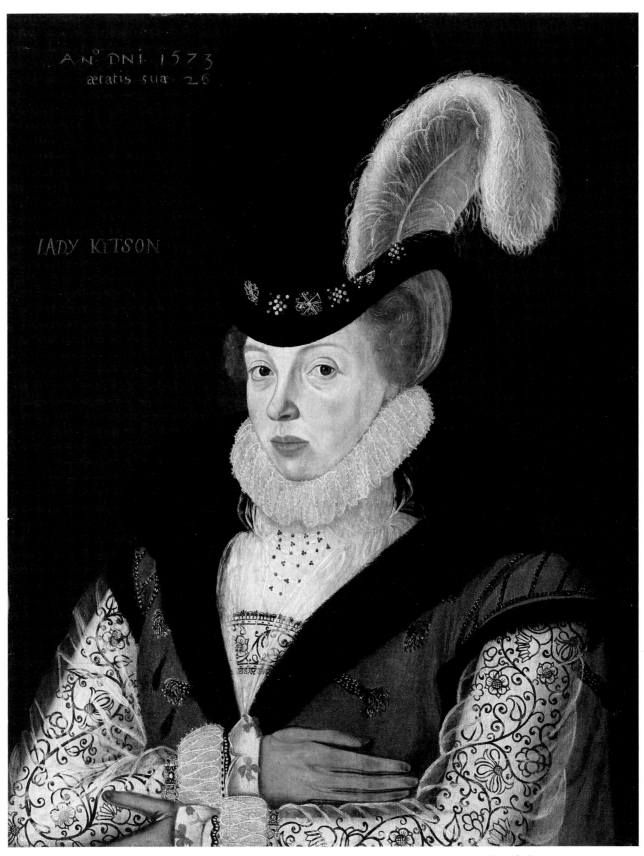

GEORGE GOWER, c.1540-1596. 'Lady Kytson'. 1573. The Tate Gallery.

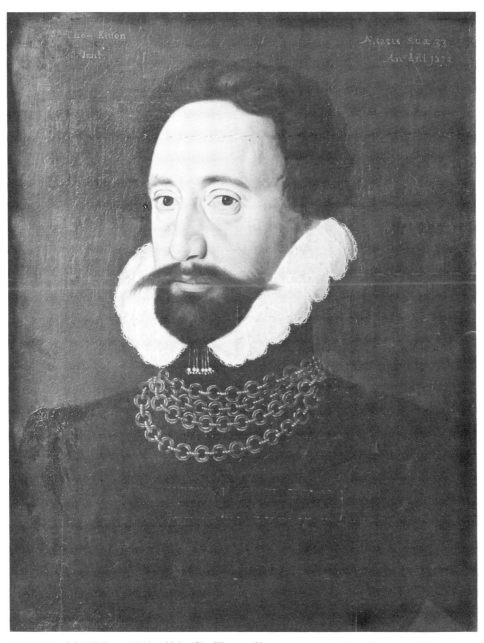

GEORGE GOWER, c.1540-1596. 'Sir Thomas Kytson Junr.'. 1573. The Tate Gallery.

GOWER, George *c.* **1540 – 1596**

Portraitist and Serjeant-Painter. Of the family of Gower of Stettenham, Yorkshire. Established as a portraitist in London by 1573; Serjeant-Painter 1581-1596; buried London 30 August 1596. Two documented portraits, of 'Sir Thomas' and 'Lady Kytson', 1573, are in the Tate Gallery (*J.W. Goodison, Burlington Mag., XC (September 1948), 261ff.*). Many speculative attributions in *Strong, 167ff.*

(*Auerbach; Edmond.*)

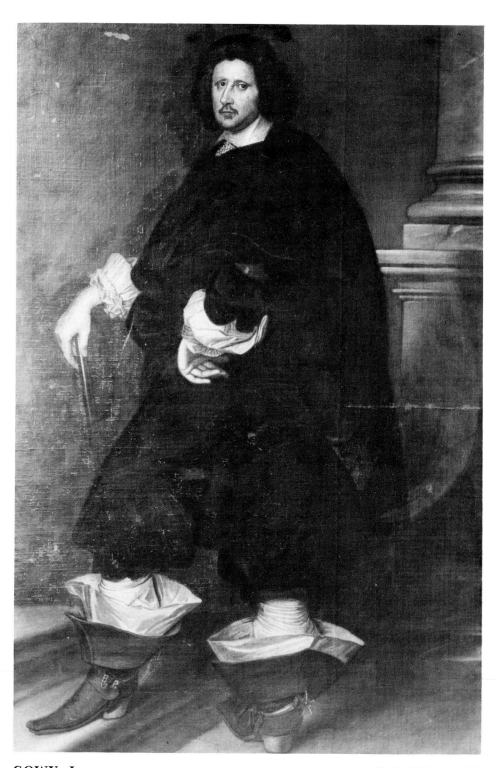

J. GOWY, fl.?1632-?1661. Portrait of a man. 80ins. x 49ins. Signed. Christie's sale 22.6.1951 (31).

GOWY, J. fl.?1632 – ?1661

His signature appears on a portrait formerly at Wilton (Christie's sale 22 June 1951 (31) of *c.*1645/50) and on a portrait of 'Thomas Wood' (with a date ?1661) at Christ Church, Oxford (*Collins Baker, II, 5-8,* with confusions). Hollar etched two portraits after 'Gowy' done in England 1644. He was probably the 'Jacomo Pedro Gouwi' (i.e. of ?Spanish extraction) who was a pupil at Antwerp 1632/33 and became a Master there 1636/37 (as 'Jacques Peeter Gouwi').

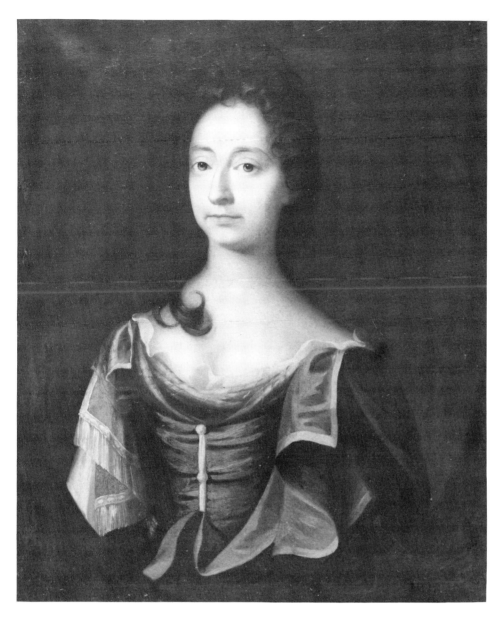

MR. GRAVES,
*fl.1689-1692. 'Mary
Arthington, Mrs. Thomas
Worsley'. 30ins. x 25ins.
Private collection. Photograph
Courtauld Institute of Art.*

GRAVES, Mr. fl.1689 – 1692

Portrait painter. Recorded as coming from London to East Claydon 30 April 1689 (*Verney MSS.*), and as painting four portraits of Mrs. Thomas Worsley and three children in 1692 (still at Hovingham) in a provincial style nearer to Dahl than Kneller.

(*Diary of Thomas Worsley.*)

GREENBURY, Richard before ?1600 – after 1651

Portraitist and all-purpose painter and copyist, and a Roman Catholic. Already employed by the Crown 1623 and called 'Painter to the Queen' 1631; was employed at Oxford (New College and Magdalen) 1626-1638 and invented a technique for painted cloths. He is last documented as painting a lecture on anatomy for the Barber-Surgeons. A copy after Durer's portrait of his father survives at Syon House.

(*Poole, II, xv-xxii.*)

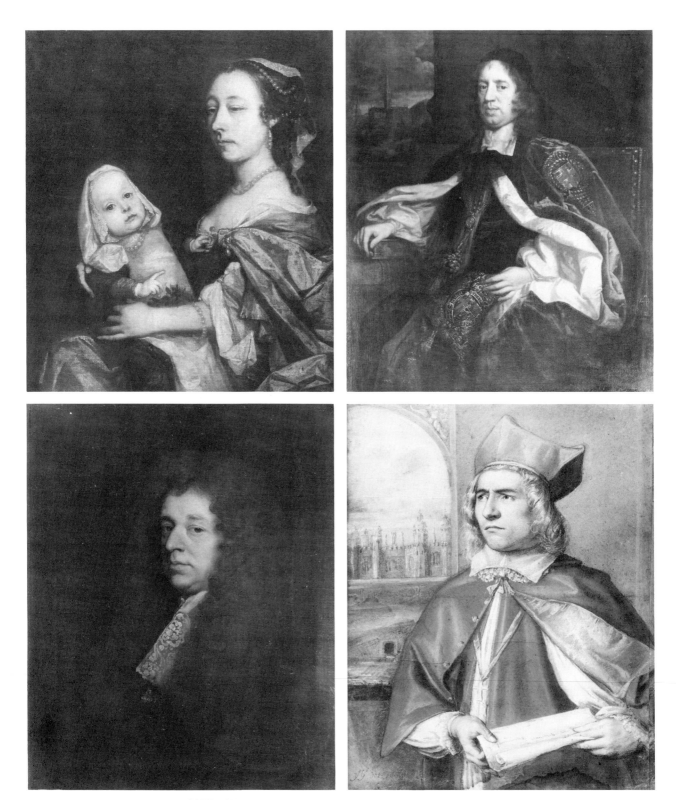

JOHN GREENHILL, c.1644/45-1676. Top left: Portrait of a lady with a child. 27½ ins. x 23ins. s. & d. 'John Green^{hill} fecit 1665'. B.F.A.C. 1938 (12). Top right: 'Seth Ward, Bishop of Salisbury'. 50ins. x 40ins. Salisbury Guildhall. Above left: 'Thomas Weedon Esq.'. 29ins. x 24½ins. Signed 'J.G.' in monogram. Christie's sale 18.10.1946 (93). Above right: 'Joseph Harris as Wolsey'. Chalk. Magdalen College, Oxford.

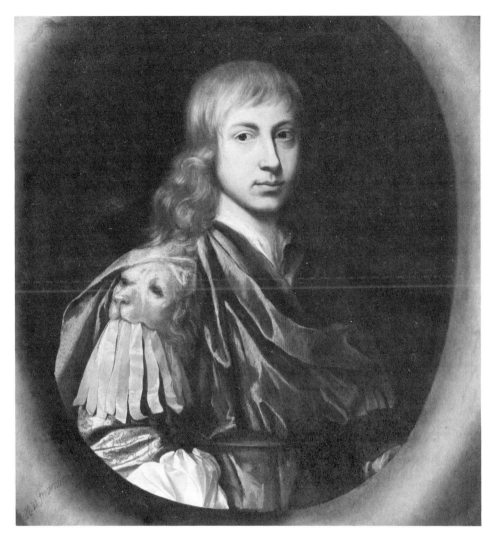

GREENHILL, John *c.*1644/45 – 1676

Portraitist in oils and crayons; etcher. Born Salisbury *c.*1644/45; buried London 19 May 1676. He was of good family and had some rudimentary local training before going to London. In London by October 1662; his self-portrait, aged 20 or less (Dulwich), shows no experience of Lely (the other documented Dulwich portraits are baffling). In 1663-1664 he was doing crayon drawings of actors in character parts. Later he 'became a disciple of Sir Peter Lely, whose manner in a short time he successfully imitated' (*Buckeridge*). He was closest to Lely about 1673 (his 'Seth Ward' (Salisbury Guildhall) of 1673 could be a copy of a Lely). At the end of his life he was getting closer to what was to be the style of Riley (q.v.). He sometimes signs 'J.G.' in monogram, notably on portrait drawings (*J. Woodward, Tudor and Stuart Drawings, 1951*). He fell into bad theatrical company at the end of his life (Mrs. Aphra Behn was infatuated with him) and died of an accident occasioned by riotous living.

(*Croft-Murray and Hulton, 338ff.; S. Whittingham, 'John Greenhill 1642-1676: Sir Peter Lely's most excellent disciple', The Hatcher Review, II, Autumn 1980.*)

GREVENBROEK, Martinus van 1646 – after 1670

Portrait painter and copyist; recorded at The Hague 1670 'aged 24'. He is presumably the 'Mr. Grevenbrook the Dutch painter' who painted copies for

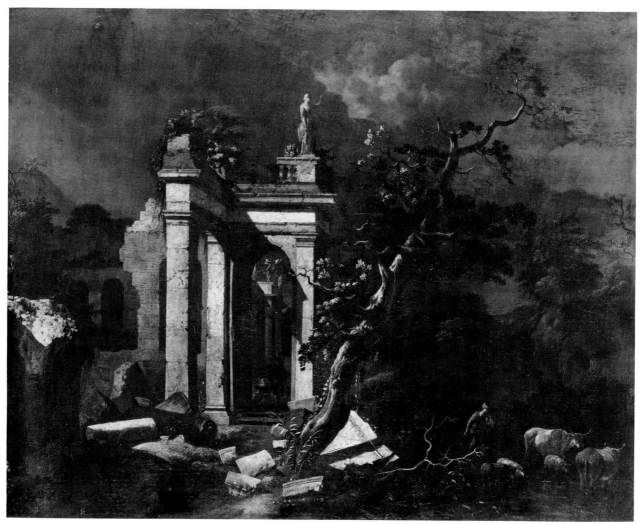

JAN GRIFFIER (senior), c.1645/?1652-1718. 'Classical landscape with cattle'. 15½ins. x 19ins.
s. & d. 1679. Christie's sale 16.7.1954 (123).

the Earl of Northampton 1665 and 1666 (*Castle Ashby MSS.*). A signed portrait of a boy (Christie's sale 28 July 1937, 97a) is possibly of a British sitter.

GRIFFIER, Jan (senior) *c.*1645/?1652 – 1718
Painter of landscapes and topographical views; he also did etchings (after Barlow) and some mezzotints signed 'I.G.f.'. Born Amsterdam; died London. Pupil of Roghman in Rotterdam and, after coming to London in the 1660s, of Jan Looten. Bcame a Painter-Stainer 1677; returned to Holland *c.*1695-*c.*1705. Two of his descendants were also painters in England.

(*Croft-Murray and Hulton.*)

GROSSING fl.1679
In the Earl of Bedford's accounts for 1679 is a payment to Grossing for a miniature of the Earl.

(*G. Scott Thomson, Life in a noble household, 1937, 297.*)

H.J. (monogram) fl. 1647 – 1662

Portraitist who signs with a monogram which appears to read as 'J.H.'. Signed and dated works range from 1647 to 1662, and there is some reason to think he was mainly active in Royalist circles in the North West. He cannot be Hayls, but it is possible he may be Hesketh or Hodges (qq.v.) (*M.R. Toynbee, Country Life, 15 September 1950, 840-842 and 13 May 1954, 1503*). It has been suggested he may be the 'I. Haskins' (q.v.) who signed a portrait of 1645 engraved by Hollar (*Country Life, 17 June 1954, 2011*.)

HALES See HAYLS, John

HANNEMAN, Adriaen ?1604 – 1671

Portrait painter. Born, probably in 1604, at The Hague, where he was buried 11 July 1671. Pupil at The Hague of Anthonie van Ravestyn 1619; came to London 1626 where he married and remained until about 1638 when he returned to The Hague. He was a prominent member of the Painters' Guild at The Hague from 1640, and during the Commonwealth painted many members of the English Court in exile there (*M.R. Toynbee, Burlington Mag., XCII (March 1950), 73-80*). He may have been an assistant to Van Dyck in London from 1632; his later portrait style is certainly modelled on Van Dyck. The most important of the few portraits known to have been painted in England, 'Cornelius Johnson, his wife and son', *c.*1630/32, is in the Rijksmuseum, Enschede.

(*O. ter Kuile, A.H., Alphen aan den Rijn, 1976.*)

HANWELL fl. 1676

A payment of 1676 in the Joyners' Company records of 30s. for a panel representing a sitting of the Court is quoted in *Notes & Queries (XI Series, XII, 1915, 102)*.

HARRISON, Augustine fl. 1611

In the Earl of Cumberland's accounts (*Chatsworth, Bolton Abbey MSS., 94, f.182*) is a payment of £6 on 13 October 1611 to 'Augustine Harrison a Picture drawer in London, for three weeks work done at Landsbrough, himself, and two men, and it was in full payment for the drawing up and finishing two pictures for my Lady Margarett and my Lady Frances'.

(*Information from Lawrence Stone.*)

HARTOVER, Peter fl. *c.* 1674

Provincial follower of Siberechts as county house painter.

(*Harris, 78/79.*)

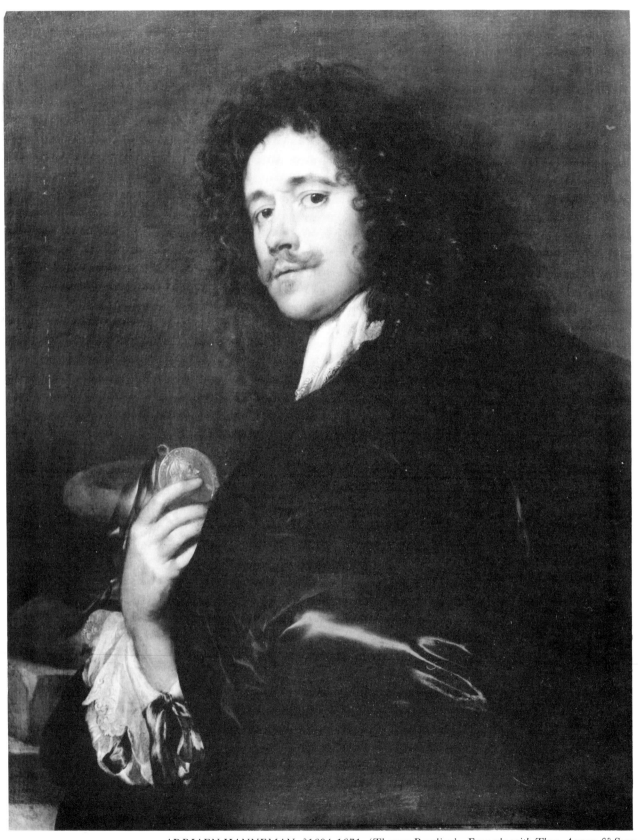

ADRIAEN HANNEMAN, ?1604-1671. 'Thomas Rawlins'. Formerly with Thos. Agnew & Sons Ltd., London.

116

THOMAS HAWKER, fl. 1680-1700. 'Charles, Lord Willmott'. 29½ins. x 25ins. Victor Montagu, Mapperton.

HASKINS, I. fl.1645

Perhaps an error for J. Hoskins' female portrait engraved by Hollar (*J.L. Nevinson, Country Life, 17 June 1954, 2011*). See also under H.J. above.

HAWKER, Thomas fl.1680 – 1700

Portrait painter; pretty certainly the same as the painter called by Walpole (after Vertue) 'Edward' Hawker, whose dates are *c.*1641 to *c.* 1721. He may have been the chief assistant to Lely at the time of Lely's death (1680) and took the lease of Lely's house for some years in the 1680s, but defaulted, and was in Covent Garden in 1700. He was a close but pedestrian follower of Lely and charged £15 for a 50ins. x 40ins. in 1683 (*Diaries of Sir Edward Dering, 1976, 5*).

(*Collins Baker, I, 179-181.*)

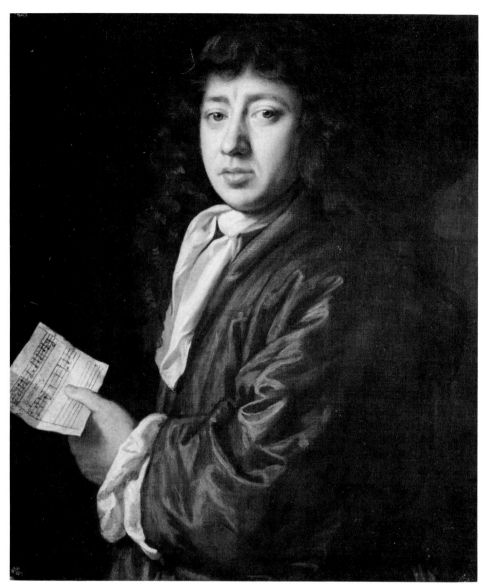

JOHN HAYLS, fl.1651-1679. 'Samuel Pepys'. 1666. N.P.G.

HAYLS (HALES), John fl.1651 – 1679

Portrait painter. Buried London 27 November 1679. A kinsman (?by marriage) of Samuel Cooper (q.v.) and said also to have tried miniature painting; he was a lesser competitor of Lely and perhaps his contemporary, and is said by Buckeridge to have been an excellent copyist of Van Dyck portraits. His name is given, without real evidence, to various portraits in a style between Dobson and early Lely, but his one documented portrait, the 'Samuel Pepys' of 1666 (N.P.G.), is unlike these (or anything else).

(Croft-Murray and Hulton, 343/44.)

HEEMSKERK, Egbert van 1645 – ?1704

Painter of boors and drolleries. There were two, father and son (conceivably even three), whose works are indistinguishable; both said to have been born in Haarlem and died in London. A painter of this name is documented in

EGBERT VAN HEEMSKERK, 1645-?1704. 'An election in Oxford Guildhall'. 25ins. x 30½ins. 1687/88. Oxford Town Hall.

Amsterdam in 1666, aged 31, but need not have come to England. The main source is Buckeridge (writing *c.*1706), who says 'he died in London about two years ago'. He introduced drolleries in the manner of Brouwer, specialising in 'drunken drolls, wakes, quaker meetings and some lewd pieces' which 'have been in vogue among the waggish collectors, and the lower rank of virtuosi'. They are often signed 'H.K.' (in monogram) or 'E.H.Kerk'. There is a mezzotint after a self-portrait by John Oliver, and a list of engravings after pictures done in England is in Hollstein (*VIII, 227*). He perhaps came to England in the 1670s and lived for some time at Oxford where he painted 'An election in Oxford Guildhall', 1687/88 (Oxford Town Hall, *see Oxoniensia, VIII/IX (1943-44), 154ff.*), and painted some works for the Earl of Rochester (d.1680) (work in hand by Robert Raines). The son is supposed to have died 1744.

(*For pictures of Quaker meetings, see F. Saxl, Journal of Courtauld and Warburg Institutes, VI (1943), 214-216.*)

EGBERT VAN HEEMSKERK, 1645-?1704. 'A Court of Justice'. s. & d. 1671. Christie's sale 18.11.1938 (54).

HEERE, Lucas de 1534 – 1584

Flemish painter, sculptor, poet and humanist. Born Ghent 1534; died Ghent (or possibly Paris) 29 August 1584. He was a portrait and history painter and designer of tapestries and decorations, with a special penchant for costumes. He was a pupil of Frans Floris and there is a biography of him by his own pupil, Carel van Mander. He came to London for religious reasons *c.*1567 and returned to Ghent after the 'Pacification of Ghent' November 1576. He was an important member of the Anglo-Netherlandish refugee world in London and was for a time supposed to be the painter of the portraits signed 'H.E.', now given to Eworth (q.v.). He may have been the teacher of some portraitists working in England. His only certain oil painting is a 'Solomon and the Queen of Sheba', s. & d. 1559 (St. Bavo, Ghent), but when in England he produced a *Beschrijving der Britsche Eilanden* (MS. B.M., published 1937) amply illustrated in watercolours.

(Best account, with bibliography, Frances A. Yates, The Valois Tapestries, 1959, 17ff.)

HEES, F. van fl.1655 – 1656

A pair of portraits of 'John Millington' (of Wandsworth) and his wife (Penrice
Castle) are clearly signed 'F.v. hees F/A° 1655' (*Steegman, II, figs. 24a and b*).
They may have been painted in England. Two of 1656 were in the Earl Howe
sale 7 December 1933 (21).

HELLIAR, John fl.1696 – 1734

In 1696/97 the Corporation of Plymouth paid £14 to John Helliar 'the lymner'
for painting a portrait of William III 'at large', its gilt frame and for repairing
other pictures. Helliar was Mayor of Plymouth 1733/34.

(*Transactions of Devonshire Association, 1879, 135.*)

HENNIN (HENNY), Adriaen fl.1665 – 1710

Landscape painter and occasional portraitist. In The Hague Guild 1665; said
(*Walpole*) to have died in England 1710. Also said to have been a pupil of
Berghem, but he spent two years in Paris and adopted a Gaspardesque
manner. He probably settled in England *c.*1676, when he was in touch with
the Beales (q.v.). A female portrait at Callaly Castle, signed
'ADHennin/1677', is close to Mary Beale in style, but his main work was in
landscape, sometimes with classical figures.

(*Ogdens.*)

HERNE, William fl.1552 – 1580

Serjeant-Painter. Born Darton, Yorkshire; buried Shoreditch 25 April 1580.
First mentioned in a minor role 1552; he was appointed Serjeant-Painter for
life in 1572, but only decorative works are recorded (*Auerbach, 146/47*). A son,
George Herne, was warden of the Painter-Stainers' Company 1605.

(*Edmond, 179/80.*)

HESKETH, ?Jerome fl.1643

Mentioned by Aubrey (*Brief Lives, 1898 ed., 38, 51*) as a priest and assistant
to Dobson (q.v.) at Oxford in 1643. He made topographical drawings for
Aubrey. A Jerome Hesketh was professed a priest at Douai in 1643 and later
sent to Lancashire. He is a possible candidate for the portraitist who signs
'J.H.' (q.v.) (*M.R. Toynbee, Country Life, 13 May 1954, 1503.*)

HESKET, Henry fl. mid-17th century

In a list of pictures to be preserved as heirlooms at Wentworth Woodhouse
under the will of William, 2nd Earl of Strafford (proved York, 7 November
1695), are eight pictures 'copied by Henry Hesket' after various painters.

(*Information from Geoffrey Beard.*)

HESKETT fl.1621

In Lord William Howard's accounts for Naworth Castle, under 10 June 1621,
is a payment of £10 to Mr. Heskett 'for mending my Lord's closet, gilding a
bedstead, drawing Mrs. Elizabeth and Mrs. Marye's pictures, and Mr.
Thomas'.

(Surtees Soc., 68 (1877), 182.)

HEUDE, Nicolas fl.1672 – 1703

Decorative history painter of French training; native of Le Mans; said to have
died Edinburgh 1703. First *agréé* at French Academy 1673, but finally left
France for London, at first as an assistant to Verrio, in 1683, since he was a
Protestant. He settled in Scotland *c.*1695.

(E.C-M., 248.)

HIGHMORE, Thomas 1660 – 1720

Presumably a decorative painter. Born London 22 June 1660; died there 8
March 1720. He was apprenticed to Leonard Cotes for seven years in 1674,
and was appointed Serjeant-Painter in April 1703, being eventually succeeded
in that office by his pupil Sir James Thornhill. His work is not known.

THOMAS HILL, 1661-1734. 'Sir Henry Goodricke' (1642-1704/5). c.1695. With Pawsey &
Payne, London, in 1980.

HILL, Thomas 1661 – 1734

Portraitist of considerable distinction; most of his known work dates from after
1700. Said to have been born 1661 and to have died at Mitcham 1734. Pupil
of Faithorne for drawing and of Dirk Freres for painting *c.*1678/79. His early
style has some affinity with that of Dahl and his most important work, a huge
family group at Melbury of *c.*1698, is reproduced in *Historical Monuments
Commission: West Dorset, 1952, 146.* A dozen or so of his portraits were
engraved, the only one of before 1700 being the 'Sir Henry Goodricke' of
*c.*1695.

(Goulding and Adams, 449/50.)

HILLIARD, Laurence **1581/82 – 1647/48**

Miniature painter, son of Nicholas Hilliard (q.v.). Baptised London 5 March 1581/82; buried there 23 February 1647/48. He was a pupil of his father and was made free of the Goldsmiths' Company 7 June 1605; given the reversion of his father's post as 'His Majesty's limner' 13 October 1608. A number of signed miniatures are known, but they do not compare favourably with his father's work.

(Erna Auerbach, Nicholas Hilliard, 1961, 224-232; Edmond, 68ff.)

HILLIARD, Nicholas **1547 – 1618/19**

Painter of portrait miniatures and goldsmith; perhaps also painter of portraits on the scale of life. Born at Exeter, son of a prosperous goldsmith, pretty certainly in 1547; buried London 7 January 1618/19. He became a Freeman of the Goldsmiths' Company 29 July 1569 and seems to have become the Queen's Limner almost at once, a position he continued to hold under James I. Apart from two years in Paris, 1576-1578, he worked continuously in London. He is the greatest master of the portrait miniature, and there is fairly good evidence that he may have occasionally painted portraits (e.g. of Queen Elizabeth) on the scale of life, but no such portraits are known which approach the extraordinary elegance and refinement of his miniatures. He wrote a *Treatise on the art of limnings* at some date between 1597 and 1603 (*Walpole Soc., I, 1911/12*).

(Erna Auerbach, N.H., 1961; Mary Edmond, Hilliard and Oliver, 1983.)

HODGES, ?T. **fl.1666 – 1688**

Portraitist. A rather nonedescript portrait of 'Sir Edward Stanley, 3rd Bart. of Bickerstaff' at Knowsley (facsimile of signature in 1875 cat., 96) is signed 'T. (?J.) hodges Fecit/A°.1666'. A Hodges (and also a Hodgskis) is listed as a 'good painter by the life' by Randle Holme (*Academy of Armory, Chester 1688*). He was no doubt active in the North West.

HOFNAGEL (HOEFNAGHEL), Joris (George) **1544 – 1600**

Poet, miniaturist and all purpose-painter. Born Antwerp 1545; died, probably at Vienna, 1600. He started life as a merchant, but had probably been trained as a draughtsman. In a much travelled career, he was in England in 1568/69 (*J.A. van Dorsten, The Radical Arts, 1970*, which has some wild attributions). His only certain work, done in England, is a signed 'Wedding at Horsleydown in Bermondsey', in which a recognisably English scene is shown in a purely Flemish landscape tradition.

(Burlington Mag., CXXVI (July 1984), 411ff.)

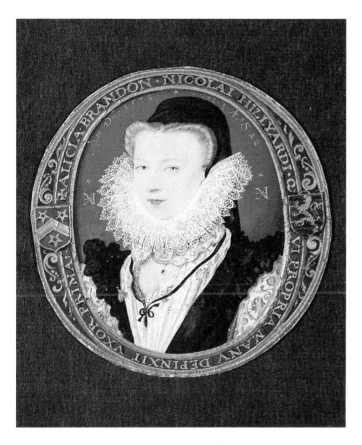

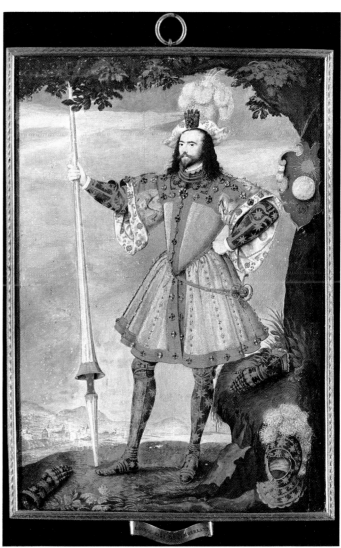

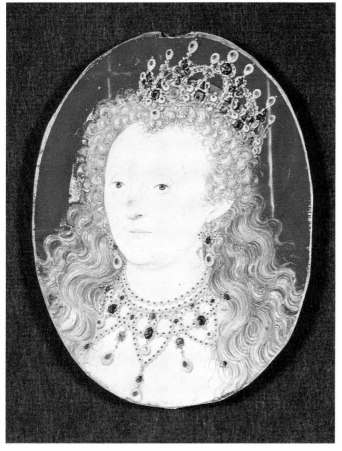

NICHOLAS HILLIARD, 1547-1618/19. Top left: 'Alice Hilliard'. 1578. V. & A. Above: 'George Clifford, 3rd Earl of Cumberland'. 11ins. x 8ins. N.M.M. Left: 'Queen Elizabeth'. 2½ins. x 1¾ins. V. & A.

HANS HOLBEIN, 1497/98-1543. 'The Merchant Georg Gisze'. Gemäldegalerie, Staatliche Museen, Preussischer Kulturbesitz, Berlin (West). Photograph Jörg P. Anders.

HOLBEIN, Hans 1497/98 – 1543

One of the great masters of the Northern Renaissance and influential in every branch of the graphic arts. Born Augsburg 1497/98; son of the distinguished painter Hans Holbein the Elder; will proved London 29 November 1543. He began as a German Late Gothic religious painter, but refined his style at Basel under the influence of Erasmus and Froben after 1515. By 1520 he had experienced (probably at the French Court) the implications of Italian High Renaissance style. Religious troubles at Basel led to his first visit to England, via Antwerp, 1526-1528, when he painted a handful of portraits for Sir Thomas More and his humanist friends. He was back in Basel in 1528 but finally settled in London in 1532 and is first recorded, 1536, in the service of Henry VIII who seems only to have valued him as a superlative portrait painter, and the group of portrait drawings now at Windsor (*K.T. Parker, The drawings of H.H. ... at Windsor Castle, 1945*) is an astonishing record of the personalities of his Court. Holbein also worked as a book illustrator and made designs for jewellery, pageants and wall decoration. His occasional miniatures are also of the highest quality. He relies for his effects on line, but his later English Court portraits, perhaps owing to the limited access granted him by his sitters, have an odd two-dimensional quality, though his power of creating a convincing likeness has never been surpassed.

(*A.B Chamberlain, H.H. the younger, 1913; John Rowlands, Holbein, 1985.*)

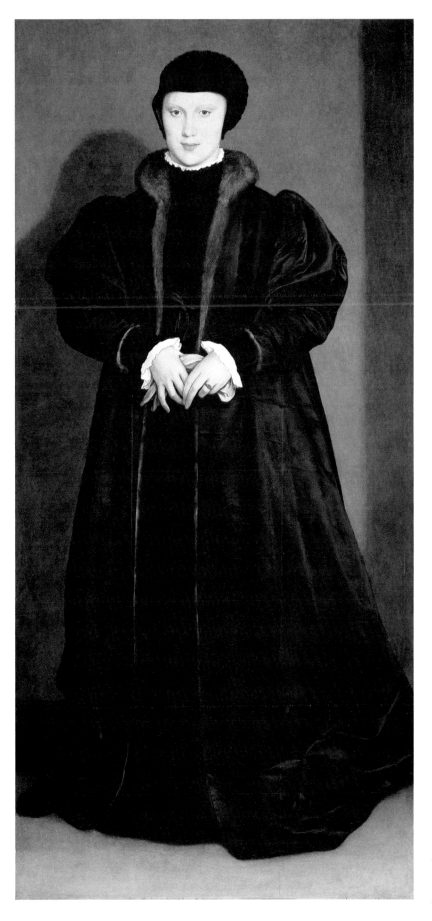

HANS HOLBEIN,
1497/98-1543.
'Christine, Duchess
of Milan'. N.G.

127

HANS HOLBEIN, 1497/98-1543. Top left: 'Sir Thomas More'. Copyright The Frick Collection, New York. Top right: 'Erasmus of Rotterdam'. Private collection. Photograph Courtauld Institute of Art. Left: 'Sir Henry Guildford'. Reproduced by Gracious Permission of Her Majesty the Queen.

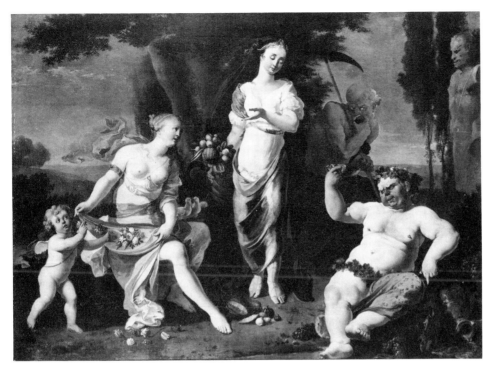

*ABRAHAM HONDIUS,
c.1625/30-1691. Greek
mythological figures.
42ins. x 56ins. s. & d.
1676. Christie's sale
9.12.1955 (261).*

HOLDERNESSE ?fl.16th century

A picture of 'an old woman with a death's head' is ascribed to Holdernesse
(whom *Vertue, iv, 69,* calls 'an English artist, I believe') in a list of the Duke
of Buckingham's pictures *c.*1648. It is probably a misunderstanding.

HOLME, Randle fl.17th century

Four generations of Randle Holmes were herald painters at Chester and
Deputies of the College of Arms. One of them had John Souch (q.v.) as his
apprentice 1616/17. The four generations are: (1) died January 1654/55, aged
84; (2) 1601-1659; (3) 1627-1699/1700; (4) 1659-1707.

*(D.N.B.; Journal of Chester and North Wales Arch. and Hist. Soc., IV (1892),
113-170: XVI (1909), 26-35: XX (1914), 153-191: XXII (1918), 5-11.)*

HONDIUS (DE HONDT), Abraham *c.*1625/30 – 1691

Dutch painter of every sort of subject; also etcher. Born Rotterdam, probably
between 1625 and 1630 (1638/39 is less likely); buried London 17 September
1691 His earliest signed and dated picture is 1651 and he worked at
Rotterdam and Amsterdam before settling in England (at least by 1674).
Buckeridge rightly notes that he specialised in 'beasts and hunting pieces'.

(Croft-Murray and Hulton.)

HONTHORST, Gerrit van 1590 – 1656

Dutch painter of history, genre and portraits. Born Utrecht 14 November
1590; died there 27 April 1656; pupil of Abraham Bloemaert at Utrecht 1620.
He was a good deal employed in Italy (where he was known as 'Gherardo delle
Notti') and painted altarpieces and history pictures in a Caravaggesque style.
Back in Holland he quickly became famous and was one of the chief painters
of the Utrecht Caravaggesque school, specialising in Arcadian themes and
genre figures. He was in England only from April to December 1628, coming

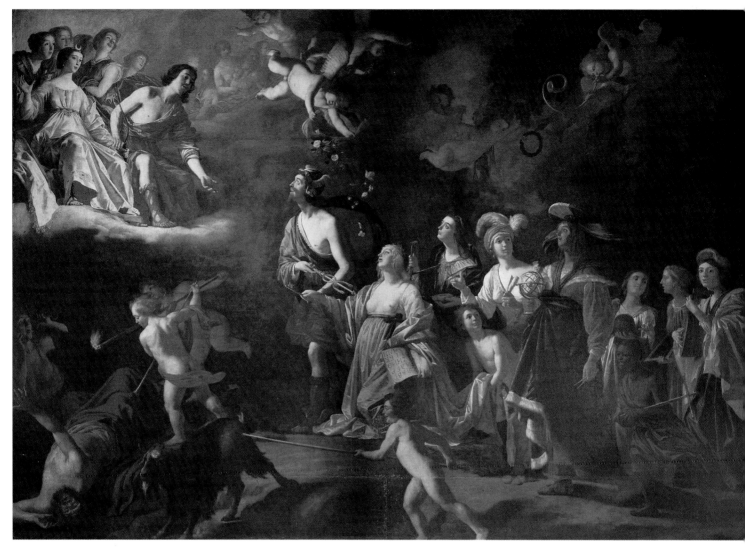

GERRIT VAN HONTHORST, 1590-1656. 'Charles I and Henrietta Maria as Apollo and Diana receiving the Liberal Arts who are introduced by Buckingham'. Reproduced by Gracious Permission of Her Majesty the Queen.

at the instigation of the Duke of Buckingham (who was murdered in August that year) and was chiefly employed on an enormous (and rather absurd) picture of 'Charles I and Henrietta Maria as Apollo and Diana receiving the Liberal Arts who are introduced by Buckingham' (Hampton Court). He returned to Holland with introductions from Charles I to his sister, the Queen of Bohemia, at The Hague, for whom he painted a great many portraits. From 1637 to 1652 he was largely at The Hague and Official Painter to Frederick Henry, Prince of Orange (d.1647). He returned for good to Utrecht in 1652. In his later years he was internationally famous as a portrait painter in a courtly tradition.

(J. Richard Judson, G. v.H., The Hague 1959; for Honthorst's activity in London see Christopher White, The Dutch Pictures in the Collection of H.M. the Queen, 1982, xxiii-xxix, 55ff.)

SAMUEL VAN HOOGSTRAETEN, 1627-1678. 'Thomas Godfrey'. 41ins. x 30½ins. s. & d. 1663. Private collection.

SAMUEL VAN HOOGSTRAETEN, 1627-1678. 'Perspective'. 104ins. x 53¾ins. s. & d. 1662. Dyrham Park (National Trust).

HOOGSTRAETEN, Samuel van 1627 – 1678

Dutch painter of portrait, genre and architectural and *trompe l'oeil* arrangements. Born Dordrecht 2 August 1627; died there 19 October 1678. He worked in England 1662-1667, mainly on portraits and perspective arrangements. At some time in the 1640s he was a pupil of Rembrandt at Amsterdam, but was back at Dordrecht by 1648. In the early 1650s he was at Vienna and Rome; in 1656 he married at Dordrecht. The 'Perspective' at Dyrham Park (National Trust), which is probably that seen by Pepys 'in Mr. Povy's closet' 19 January 1663, is signed and dated 1662, and the full-length of 'Sir Norton Knatchbull' (Lord Brabourne) 1667. In 1668 he was in the Guild at The Hague, where he painted genre scenes in the manner of Pieter de Hooch, but by 1673 he was back at Dordrecht, where he published a book on painting in 1678. He also scraped a few etchings. His signature is 'S.vH.' in monogram. The portraits he painted in England are naturalistic and rather uncourtly.

(Neil Maclaren, The Dutch School, N.G. cat., 1960, 191/92.)

HORNEBOLTE (HORENBOUT), Gerard fl.1487 – c.?1531

Flemish painter and miniaturist; Master at Ghent 1487, where he was head of a flourishing atelier. Court Painter to Margaret of Austria 1515, for whom he completed the Sforza Hours (B.M.) 1519/20. In the mid-1520s came with his family to England and appears on the royal payroll 1528-1531. His wife died in London 1529, and a daughter, Susanna (c.1503-?1545), also an admired miniaturist, is said to have died at Worcester 1545 (D.N.B.). No work in England by either is known. He is said to have died at Ghent in 1540 (D.N.B.). He may have been the father of Lucas Hornebolte (q.v.)

(*Auerbach; Kren, 118ff.*)

HORNEBOLTE (HORENBOUT), Lucas fl.1512 – 1544

Painter and miniaturist from Ghent. Certainly kinsman and probably son of Gerard Hornebolte (q.v.). Master in Ghent Guild 1512; died London April/May 1544; settled in London probably c.1525/26; in Henry VIII's service from 1528 with a higher salary than Holbein. He is credited (*van Mander*) with having taught Holbein (q.v.) the art of painting portrait miniatures. Made a denizen and appointed 'King's Painter' 1534. Several miniatures of the Royal Family have been plausibly ascribed to him (*Murdoch &c., 29ff.*), but no portrait on the scale of life has so far been identified (*Burlington Mag., CXXIII (November 1981), 304*). He was no more than a respectable miniaturist.

HOSKINS, John (i) c.?1595 – 1664/65

Miniaturist. Possibly a native of Wells; born 1590s; buried London 22 February 1664/65. His portrait miniatures begin in the early 1620s in a tradition deriving from Hilliard and are signed 'H.', though he is said to have been trained as a portraitist on the scale of life. He was much employed by Charles I, who appointed him 'limner to the King' in 1640 (but hardly employed him afterwards). In the 1630s he was especially occupied in making miniature versions or variations on Van Dycks. He was uncle and guardian to Samuel Cooper (q.v.), whom he probably taught and who may have helped in his studio. It seems probable that he did little after the Civil War and he died in indigence. He was father of John Hoskins ii (q.v.) and for the confusion and controversy about whether there were one or two John Hoskins see *J. Murdoch, Burlington Mag., CXX (May 1978), 284ff.*

(*Edmond.*)

HOSKINS, John (ii) c.?1630 – after 1693

Miniaturist and son of John Hoskins i (q.v.) His age is deduced from a self-portrait of 1656; married 1669/70; last recorded as alive in Mrs. Cooper's will of 1693. He was presumably trained by and an assistant to his father and seems to have had fair business during the Commonwealth, but he may have given

JOHN HOSKINS (i), c.?1595-1664/65. 'Alice Stubbs, Lady l'Estrange'. Private collection. Photograph Paul Mellon Centre

up practice soon after the Restoration. He signs 'I.H.' in a variety of forms. (*Mary Edmond, Burlington Mag., CXXVII (February 1985), 84; Murdoch &c.*)

HOUSMAN See HUYSMANS, Jacob

HOW, F. fl.?1650s

A portrait, probably from the 1650s (Holkham) of an old gentleman holding a paper on which is what may be a signature 'F. How', has led Collins Baker (*102ff.*) to invent a painter of this name, who is quite probably mythical.

HUGH HOWARD, 1675/76-1737/38. 'Anne, eldest daughter of James and Anne Sotheby'.
29¼ ins. x 24¼ ins. 1697. Sotheby's sale 12.10.1955 (88).

HOWARD, Hugh 1675/76 – 1737/38

Portrait painter and, later, 'art expert'. Born Dublin 7 February 1675/76, the younger son of a good family; died London 17 March 1737/38. He may have studied under Dahl before setting out for Rome in 1697, where he was a favourite pupil of Carlo Maratta until 1700. Most of his surviving portraits were painted in London up to 1714, when he married money and became a bureaucrat.

(M. Wynne, Apollo, XC (October 1969), 314-317.)

OTTO HOYNCK, c.1636-c.1686. One of the artist's animal portraits. 44ins. x 56ins. s. & d. 'Otto Hoynck fecit 1675/76'. Christie's sale 16.3.1956 (121).

HOYNCK, Otto *c.*1636 – *c.*1686

Dutch painter of men and animals. Born at The Hague, where he was in the Guild 1661; last documented 1686 (*Oud Holland, L (1933), 179*). He was in England in 1676. His portraits are very pedestrian.

HUBBARD (HUBBERT) fl.1583 – 1586

Painter of portrait and genre. A picture of 'A butcher and a maid buying meat' is recorded 1583; painted a portrait for the Earl of Northumberland in 1586 for £12. Portraits by him are recorded in the Lumley Inventory 1590.

(*Strong, 185.*)

HUNSTON, Brian fl.1605

A painter of this name was involved in the Gunpowder Plot (*Calendar of State Papers, 18 November 1605*).

JACOB HUYSMANS, c.1633-c.1696. *Unnamed family group. 52½ ins. x 67ins. Sotheby's sale 7.7.1982 (26).*

HUNT, Richard fl.1642

A portrait of a man, dated 1642 and in the manner of Cornelius Johnson i (q.v.), and said to be signed 'R.d Hunt fecit', was formerly in the possession of Arthur Kay.

HUYSMANS, Jacob *c.*1633 – *c.*1696

Flemish painter of portraits and religious and secular histories. Born Antwerp, where he was a pupil of Frans Wouters 1649/50; died London, reputedly 1696. He came to England soon after the Restoration and was settled in London by 1662. He was presumably a Roman Catholic and, according to Pepys, by August 1664 he was considered by Court circles around Queen Catherine of Braganza as the chief rival to Lely (q.v.). He seems to have considered himself 'the Queen's painter' and his best portraits of her show an understanding of her refined and modest character which is not shown in Lely's more

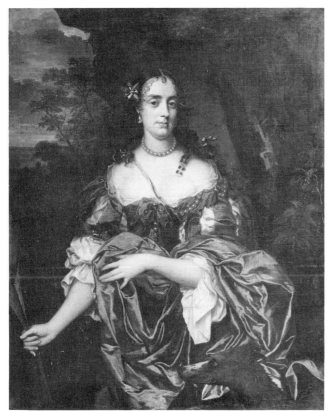

JACOB HUYSMANS, c.1633-c.1696. Portrait of a lady, ?Catherine of Braganza. 48½ins. x 39½ins. Sotheby's sale 24.5.1933 (70) as Lely.

JACOB HUYSMANS, c.1633-c.1696. 'Bathsheba'. 40½ins. x 32ins. s. & d. 1696. Private collection. Photograph Courtauld Institute of Art.

voluptuous inventions. Huysmans employs continental baroque conventions (a lamb, cupids, etc.) and examples of his more elaborate portraits of the Queen (as St. Catherine and as a shepherdess) are in the Royal Collection. She and her ladies in waiting were his best patrons but Huysmans never gave them the glamour and sex appeal with which Lely endowed the other ladies of the Court. His colour, often with shot tones, is much less sonorous than Lely's, but he seems to have more women than men sitters. Latterly he perhaps specialised in children, but a few portraits of elderly men (e.g. 'Izaak Walton' and 'Father Hudleston', 1685) show unexpected powers. He painted the altarpiece (now lost) for the Queen's Chapel, and mythological pictures, which he is known to have painted, have not yet been identified. He occasionally signs 'I.Hs.'.

(*D.N.B.*)

I.W. See W.I.

ISAACSON **fl.mid-17th century**

A family of painter-stainers, one of whom (Richard) was Sherif of London. They were active in the first half of the seventeenth century, but it is doubtful if they did more than decorative work.

(*E.C-M., 204/5.*)

JACOB HUYSMANS, c.1633-c.1696. 'Izaak Walton' (1593-1683). Signed 'I. H'. c.1663. N.P.G.

J. C. **fl.1680s**

A portrait of 'Sir Richard Shirley, Bart.' (*c.* 1655-1692), clearly signed 'C.J.' and unrelated to either Cornelius Johnson, but of marked individuality, is in a private collection.

 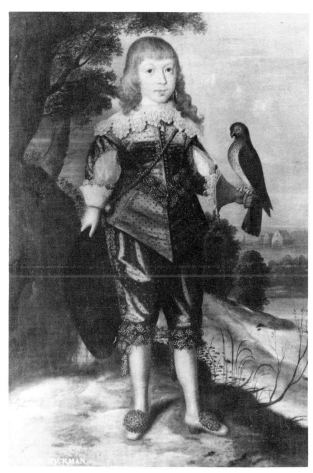

GILBERT JACKSON, fl.1622-1640. 'Bishop Williams'. s. & d. 1625. The Master and Fellows of St. John's College, Cambridge.

GILBERT JACKSON, fl.1622-1640. 'Master William Hickman'. 49ins. x 33½ins. s. & d. 1634. Private collection.

J.H. See H.J.

JACKSON, Gilbert fl.1622 – 1640
Portrait painter (probably itinerant). Signed and dated works range from 1622 to 1640. His style has affinities with (but is inferior to) that of Cornelius Johnson i (q.v.), but he has a liking for acid green and vermilion bows, and his lace collars look as if they had been soaked in water. He seems to have visited North Wales in the 1630s and had an academic clientele at Oxford and Cambridge. Bishop (later Archbishop) Williams was his most distinguished sitter and reinforces a connection with Wales. He often signs: 'Gil. Jack' and it may be that his 'G.J.' and the 'C.J.' of Cornelius Johnson have been confused. The fullest list of his known portraits (though swollen with unacceptable attributions and inaccurate statements about pictures discovered by *A.J. Finberg, Walpole Soc., X*) is in *Poole, II, xxv/xxvi.*

JACOBSON, J. fl.1659—1699
Portrait painter. A portrait of 1659 is recorded in a sale 7 June 1918 (35) and there is at Trinity House, Hull, a modern copy said to derive from a lost portrait of 'Thomas Ferris' of 1699.

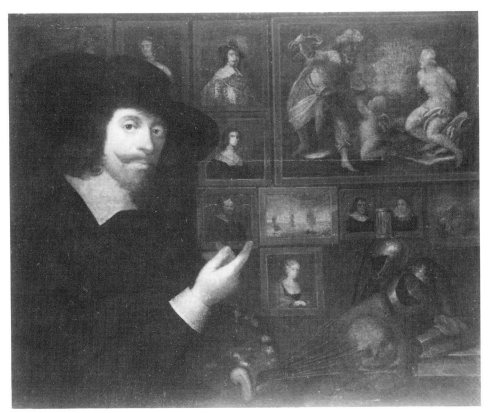

GEORGE JAMESONE, c.1589/90-1644. Self-portrait. 27ins. x 33ins. Private collection.

JAMESONE, George *c.* **1589/90 – 1644**

Scottish portrait painter. Born Aberdeen 1589 or 1590; died there late 1644. Son of a prosperous mason, he was the founder of the native Scottish school of portraiture, and he perhaps also painted histories (but none are known). Apprenticed to John Anderson (q.v.) at Edinburgh 27 May 1612, he was back in Aberdeen in 1620, the date of his earliest known portrait, 'Sir Paul Menzies' (Mariscal College, Aberdeen). He had a considerable clientele among the Scottish nobility, and he took up residence (at least during the summer months) at Edinburgh from 1633 onwards, but never gave up his Aberdeen base. His portrait style is often a rather less competent equivalent to that of Cornelius Johnson i (q.v.), but he seems to have employed less satisfactory pigments and few of his pictures are now in anything like pristine condition. In 1636 he took John Michael Wright (q.v.) as a pupil at Edinburgh. For long all Scots portraits of the first half of the seventeenth century were ascribed to him, but enough signed and dated examples survive to establish his style.

(*Duncan Thomson, The Life and Art of G.J., 1974.*)

JANSSEN(S) See JOHNSON, Cornelius

JOHNS See JOHNSON, William

JOHNSON, Adrian **fl.1550**

'Adrian Johnson, picture maker, Dutchman, dwelling in Aldgate Ward, London' was made a denizen 29 October 1550. No works by him are known.

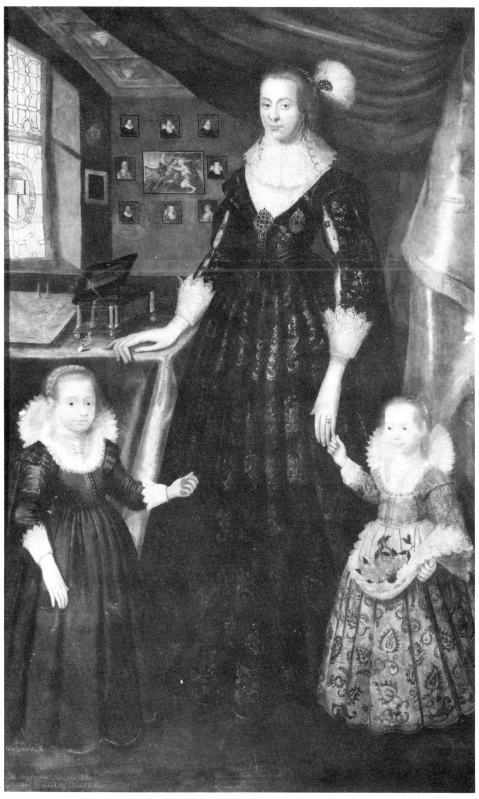

GEORGE JAMESONE, c.1589/90-1644. 'Lady Anne Erskine, wife of 6th Earl of Rothes with her two children'. 85ins. x 51ins. s. & d. 1626. S.N.P.G.

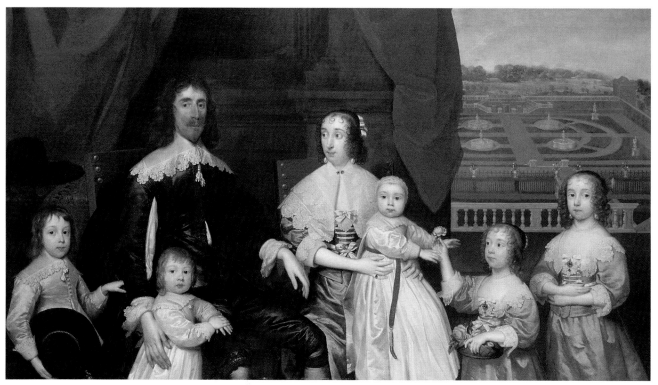

CORNELIUS JOHNSON (i), 1593-1661. 'The 1st Baron Capel and his family'. 63ins. x 102ins. c.1640. N.P.G.

JOHNSON (JONSON), Cornelius (i) 1593 – 1661

Portrait painter and miniaturist. Baptised London (at the Dutch Church) 14 October 1593; died Utrecht 5 August 1661. His parents had been refugees from Antwerp, but the family hailed from Cologne (and, after retiring to Holland in 1643, he signs his name as 'Jonson van Ceulen'). It is probable he was trained in Holland and that he returned to London, a fully formed painter, about 1618. The earliest (apparently) signed portrait by him is 1617, but there is a long series of signed and dated portraits (usually in the form 'C.J.') from 1618 until 1643. At first he favoured panel, but later canvas, and he always preferred the feigned oval (suggestive of miniatures, of which his own begin in 1625), and his earlier works have a high and glossy enamel. His portraits are very sensitive to character and are beautifully drawn and meticulously painted. After Van Dyck's arrival, he 'smartened' his style and even painted some full-lengths. He was sworn as 'King's Painter' in 1632. His wife's fears of the Civil War caused him to retire to Holland in October 1643 and he was at Middelburg 1644, Amsterdam 1646 and Utrecht 1652.

(*Preliminary list of works in A.J. Finberg, Walpole Soc., X (1922), but twice as many are now known.*)

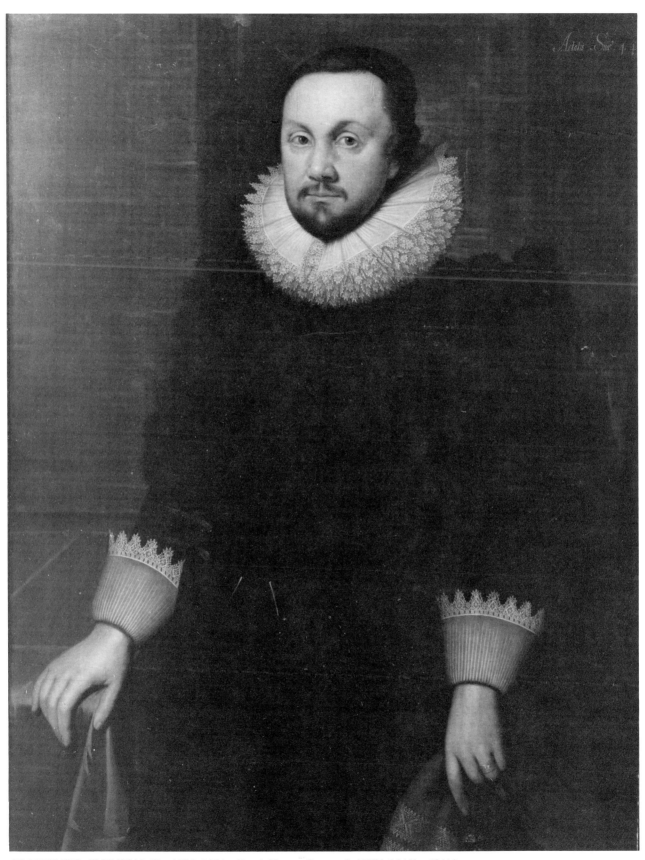

CORNELIUS JOHNSON (i), 1593-1661. 'Lord Keeper Coventry' (1578-1640). 43½ins. x 32½ins. s. & d. 'C.J. f/1623'. With Leggatt Bros., London, in 1946.

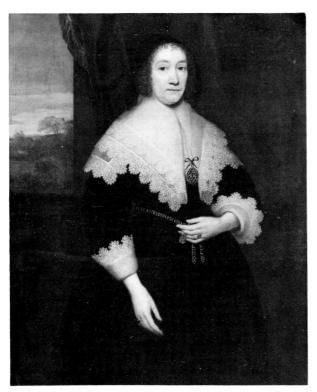

CORNELIUS JOHNSON (i), 1593-1661. 'Lady Coventry'. 49ins. x 39ins. s. & d. 1639. Christie's sale 13.3.1970 (100/1).

CORNELIUS JOHNSON (i), 1593-1661. 'Lord Coventry'. 49ins. x 39ins. s. & d. 1639. Christie's sale 13.3.1970 (100/2).

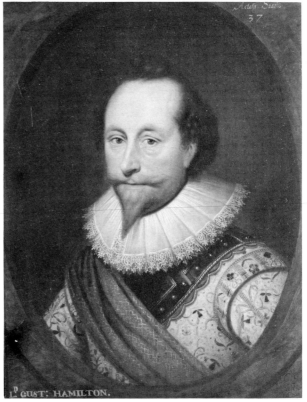

CORNELIUS JOHNSON (i), 1593-1661. 'Countess of Arundel'. 26ins. x 19ins. s. & d. 'Cornelius Johnson/fecit 1619'. B.A.C. Yale, Paul Mellon Collection.

CORNELIUS JOHNSON (i), 1593-1661. 'Lord Gustavus Hamilton'. 26ins. x 20ins. s. & d. 'C.J./fecit/1620'. B.A.C. Yale, Paul Mellon Collection.

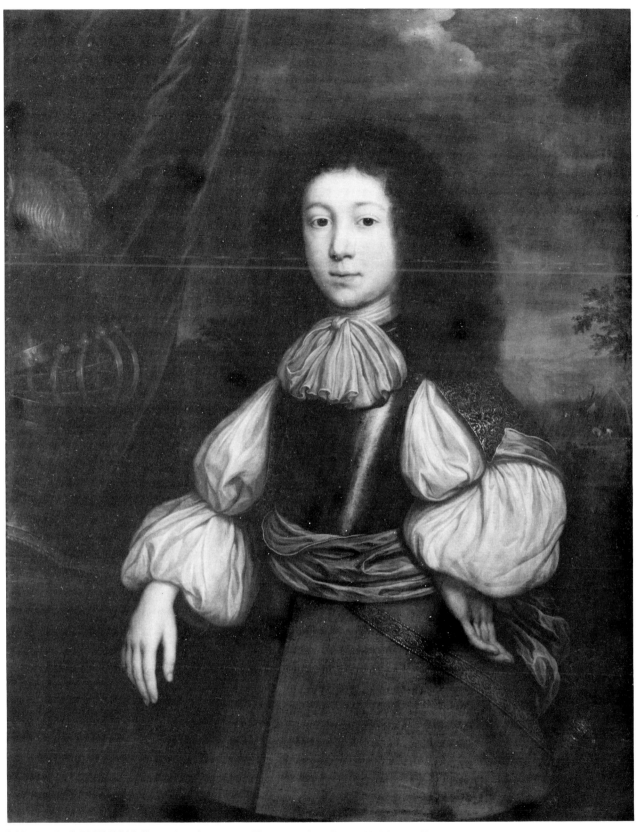

CORNELIUS JOHNSON (ii), 1634-after 1700. 'Henry Paget'. 35ins. x 27½ins. s. & d. 1672.
Sotheby's sale 25.4.1945 (133).

THOMAS JOHNSON, fl.1634-1685. 'Courtyard of the Royal Exchange'. 43½ins. x 78ins. s. & d. 1671. With Leger Galleries, London, 1970.

JOHNSON (JONSON), Cornelius (ii) 1634 – after 1700

Portraitist; son of Cornelius Johnson i (q.v.); baptised London 15 August 1634; still alive (at Utrecht) 1700 (*Long; 223*). Presumably pupil and certainly a much feebler imitator of his father. He may also have painted miniatures. It is unlikely that he ever painted in England, since he accompanied his parents to Holland in 1643.

JOHNSON, Thomas fl.1634 – 1685

Architectural painter and draughtsman. He is presumably the man recorded as a painter-stainer in 1651, and is chiefly notable for having signed and dated a painting (1657) of 'Canterbury Cathedral with Puritan despoilers', which he showed to the Royal Society in 1685. He may be the 'Thomas Johnson, paynter' admitted a Freeman at York in 1669.

(*Croft-Murray and Hulton; Waterhouse, 1978, 342 n.33.*)

JOHNSON (JOHNS), William fl.1523 – 1552

Artist who did some painting in Bletchingly church in 1552.

(*E.C-M., 181*)

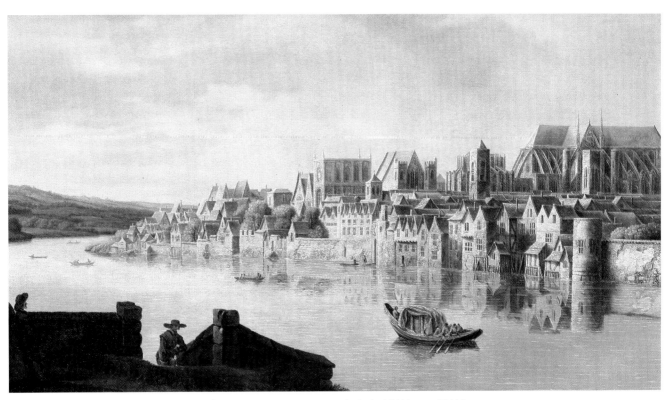

CLAUDE DE JONGH, fl.1615-1663. 'The Thames at Westminster Stairs'. 18¼ins. x 31½ins. 1637. B.A.C. Yale, Paul Mellon Collection.

JONES, Inigo 1573 – 1652

The great architect and the most powerful influence on the arts in the reign of Charles I. Born London 1573; died there 26 June 1652. He is described as a 'picture-maker' in 1603 and his drawings for masques suggest that he may have been trained as a painter but no oil painting is known. A landscape at Chatsworth long ascribed to him is probably by F. Wouters.

JONES, T. fl.1628

A portrait of a young lady dated 1628, in the possession of Mrs. Vaughan Morgan (1938), is signed '?T. Jones/fecit'. What appears to be the companion, of her husband, is dated 1620. Their style is not unlike that of Gilbert Jackson (q.v.).

JONGH, Claude de fl.1615 – 1663

Dutch landscape painter and draughtsman. Earliest dated drawing 1615; Master in Utrecht Guild by 1627; buried Utrecht 16 March 1663. Although based on Utrecht, his landscape paintings are in the 'Haarlem' tradition of Esaias van de Velde and the young Van Goyen. He paid periodic (?and brief) visits to England 1615, 1625, 1627 and 1628. His most important picture of an English subject is 'Old London Bridge, 1630' (Kenwood House).

(John Hayes, Burlington Mag., XCVIII (January 1956), 5-11.)

JONSON, Cornelius See JOHNSON Cornelius

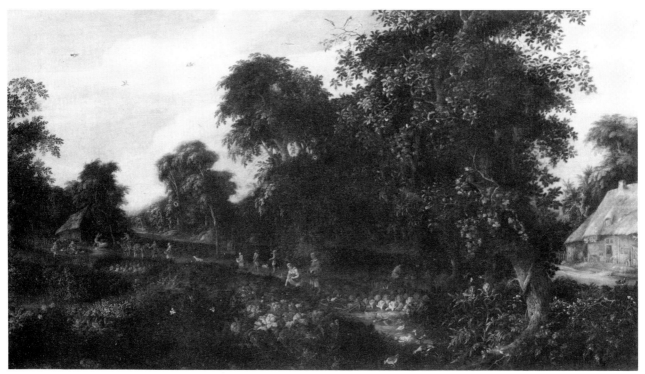

ALEXANDRE KEIRINCX, 1600-1652. 'Cabbage picking'. 26ins. x 45ins. s. & d. 1621. Sotheby's sale 10.6.1961 (161).

KEIRINCX (CARINGS), Alexandre 1600 – 1652

Flemish painter of topographical views and wooded landscapes. Native of Antwerp, where he was a Master 1618/19; died Amsterdam 1652 (where he had settled in 1650, after previous visits). He visited England in 1625 and 1639-1641 and seems to have painted some royal castles in Scotland for Charles I.

(*Bautier &c.*)

KERSEBOOM (CASAUBON), Frederick 1632 – 1693

Portrait and history painter. Born Solingen, Rhineland, 1632; buried (St. Paul's, Covent Garden as 'Frederick Casaubon') 30 March 1693. He is said to have studied under Le Brun in Paris and then spent fourteen years in Rome (two of them under Poussin). He came to England, probably in the early 1680s and attempted history painting with little success (for a mezzotint by B. Lens after his very Poussinesque 'Aeneas receiving arms from Venus' see *Colloque Poussin, 1960, I, fig. 251*). What may well be his masterpiece (though only signed 'Kersseboom ft.' with no initial) is 'John Langham, aged 12, 1683, playing his viola da gamba' (*Country Life, 19 February 1970, 436*). His 'Theophilus Leigh' at Stoneleigh (which has an unsigned companion) is signed 'F. Kerseboom 1688' (*Collins Baker, II, 48*). He was the uncle of John Kerseboom (q.v.)

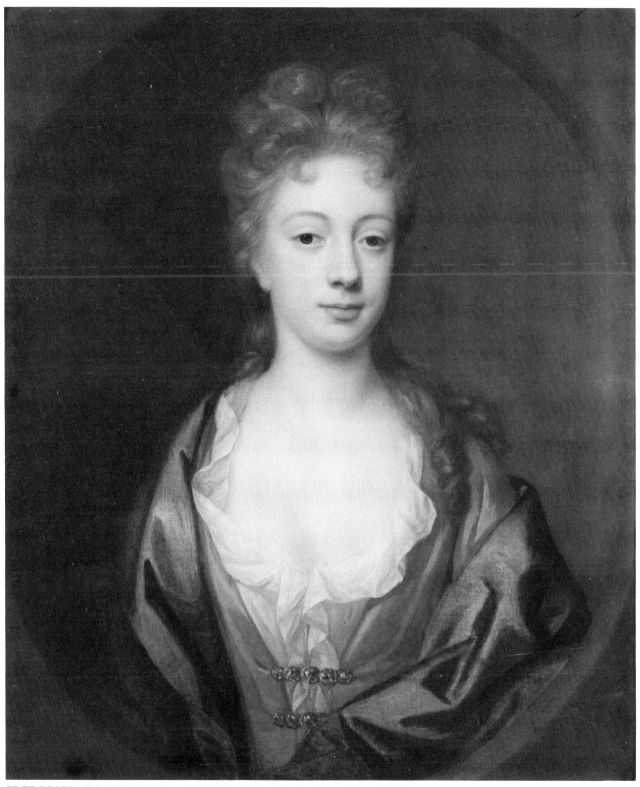

FREDERICK KERSEBOOM, 1632-1693. 'Miss Bate' (later Mrs. Fielding). 30ins. x
25ins. Private collection. Photograph Paul Mellon Centre.

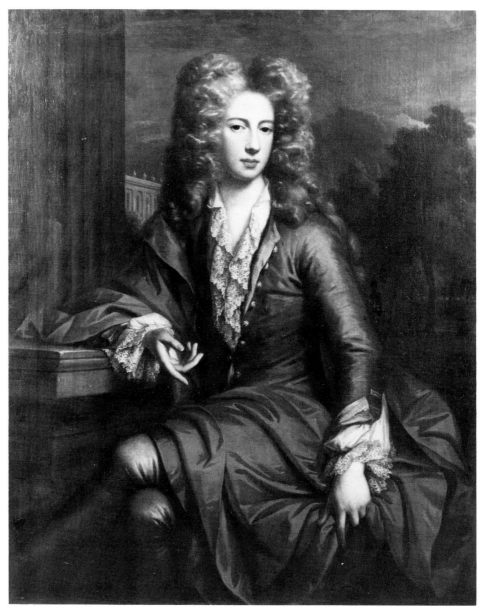

JOHN KERSEBOOM, fl.1680s-1708. 'Richard Gomethan'. Christie's sale 29.1.1982 (91).

KERSEBOOM, John (Johann) fl.1680s – 1708

Portrait painter. Nephew of Frederick Kerseboom (q.v.) whom he probably accompanied to England in the 1680s. Buried London 26 October 1708. He probably had a larger portrait clientele than his uncle and contemporary mezzotints of some eight portraits are known, the best thing being 'Hon. Robert Boyle' of *c.* 1689 (Royal Society). His patterns derive from Lely and Kneller, but his heads have recognisable individuality. He charged £16 10s. for a 50ins. x 40ins. with frame in 1694.

KETEL, Cornelis 1548 – 1616

Dutch painter of portraits and allegorical histories. Born Gouda 15 March 1548; buried Amsterdam 8 August 1616. He worked briefly at Fontainebleau

*CORNELIS KETEL, 1548-1616. 'William Gresham of Titsey'. 40½ ins. x 30½ ins. s. & d.
'CK. F. (in monogram) 1579'. Private collection.*

and Paris in the middle 1560s and was in England 1573-1581, where he was patronised by Sir Christopher Hatton and is said to have painted a portrait of Queen Elizabeth. Three or four portraits signed 'C.K.' from these years are known (*Strong, 151-157*) in a normal Netherlandish style, which he continued for a time after returning to Amsterdam. In later life, according to Carel van Mander, he painted many mannerist allegories (which have disappeared) and experimented with painting with his hands and feet (*W. Stechow, Album Amicorum J.G. van Gelder, The Hague 1973, 310/11*). His most important English work is the now ruined 'Martin Frobisher', 1577, in the Bodleian Library, Oxford.

(*Auerbach.*)

ANNE KILLIGREW, 1660-1685. Self-portrait. By permission of the Trustees of the will of the 8th Earl of Berkeley. Photograph Courtauld Institute of Art.

D. KING, fl.1680. 'John Lavie, a French Protestant'. 27ins. x 24ins. s. & d. 1680. Christie's sale 25.7.1958 (129).

KICKEES, Edward fl.*c.*1660 – 1687

Probably a painter of Dutch origin who worked in the Canongate, Edinburgh, in the 1680s and had moved to England by 1687.

(*Archives of London Dutch Church, Register of attestations, &c., 1892, 133, no. 1918; cf. also 75, no.1054.*)

KILLIGREW, Anne 1660-1685

Gentlewoman amateur painter of portrait and history; also a poet. Born London 1660; died there 16 June 1685. Her father was chaplain to the Duke of York (later James II) and she became maid of honour to his second Duchess. Her self-portrait, in the manner of Kneller, is engraved in mezzotint by I. Beckett; this, a portrait of James II (1685) and a history piece are illustrated in *Burlington Mag., XXVIII (December, 1915), 112ff.* Dryden wrote an ode in her memory.

(*D.N.B.*)

KING, D. fl.1680

A portrait of 'John Lavie, a French Protestant', signed and dated 1680, and in the manner of Riley (q.v.), was sold at Christie's 25 July 1958, 129.

KING, Daniel *c.*1620 – *c.*1664

Only certainly known as a topographical graphic artist and etcher, but he also wrote *Secrets in the Noble Art of Miniature or Limning, c.*1653/57 (MS. in B.M.).

SAMUEL KING, fl.1690s. 'Children of Theophilus Leigh'. 44ins. x 71ins. s. & d. 'Sam:King/Pinxit July y 10'th/1695'. By kind permission of Stoneleigh Abbey Preservation Trust Limited.*

A native of Cheshire, where he was apprenticed for ten years in 1630 to one of the Randle Holmes (q.v.). He was settled in London and publishing at least by 1656 and is said to have died there *c.*1664.

(*D.N.B.; Talley, 207ff.*)

KING, Samuel fl.1690s
Provincial portrait painter working in the Midlands between 1693 and 1695 in a style derived from Kneller. For a number of works formerly at Bessels Leigh see Collins Baker (*II, 201ff.*). His picture at Stoneleigh of the 'Children of Theophilus Leigh' is signed 'Sam: King/Pinxit July y*c* 10'th/1695'.

KIRK (KYRKE), Samuel fl.1594 1655
All-purpose painter, based on Lichfield. Dates recorded are 1594, 1632 and 1655. At Stoneleigh a full-length of 'Sir Christopher Hoddeson' is inscribed '1594 Sam Kyrke' (a three-quarter length posthumous variant, signed '1632 Sam:Kyrk/Lichfield fecit', was sold Christie's 2 November 1984, 58), and two woodcuts by Vaughan after Sam Kirk, 16--, are reported in the Lichfield Museum, with views of Lichfield Cathedral. At Staunton Harold Church, Leicestershire, is a painted ceiling with clouds, a dog's head and the sacred monogram signed 'Samuell Kyrk pinxit 1655' and 'Zachary Kyrk'.

(*E.C-M., 222.*)

KLÖCKER See EHRENSTRAHL, David

FRANCES, COUNTESS of MAR,
2nd Wife of JOHN 6th EARL, and
Dr of 1st DUKE of KINGSTON.
Died 1762.

By SIR GODFREY KNELLER.

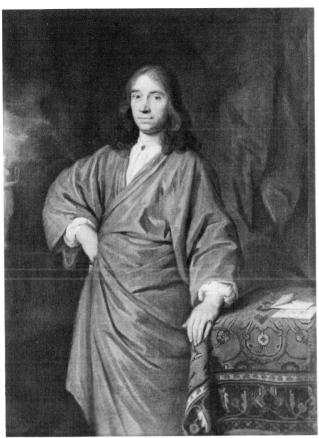

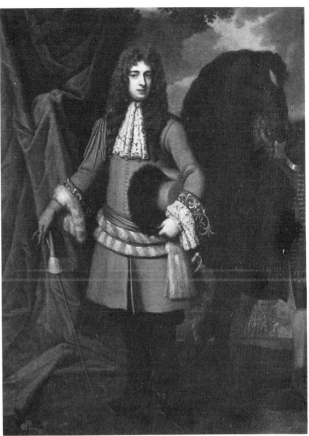

GODFREY KNELLER, 1646-1723. 'John Banckes'. 54ins. x
40ins. s. & d. 'Godefrid Kneller Aº 1676 F.'. Private collection.

GODFREY KNELLER, 1646-1723. 'Captain Thomas Lucy'
(1642-1684). s. & d. 1680. Charlecote Park (National Trust).
Photograph Courtauld Institute of Art.

KNELLER, Sir Godfrey 1646 – 1723

The most prolific and distinguished painter of baroque portraits in England,
and an occasional religious history painter. Born Lubeck, probably 8 August
1646 (1649 is also a possibility); died London 26 October 1723. He had some
training with Bol and Rembrandt in the early 1660s, and his first dated portrait
is 1666. He spent 1672 to 1675 in Italy (Rome and Venice) and came to
London in 1676. By 1679 he had painted the King and he remained the most
famous and successful portrait painter in England until his death. In 1688 he
was appointed Principal Painter to the King (jointly with Riley (q.v.), who
died 1691), a post he retained until his death, being made a knight in 1692 and
a baronet in 1715. His reputation and his vanity were both prodigious, and
he maintained a busy studio, latterly presided over by Edward Byng
(*Waterhouse 1981*), which turned out a very great number of repetitions, often

Opposite:
GODFREY KNELLER, 1646-1723. 'Frances, Countess of Mar'. S.N.P.G.

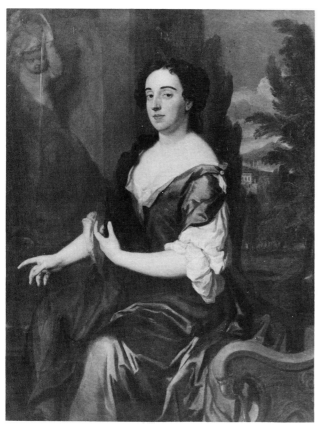

GODFREY KNELLER, 1646-1723. Portrait of a lady. s. & d.
'G. Kneller fec./1684'. Sotheby's sale 18.5.1966 (118).

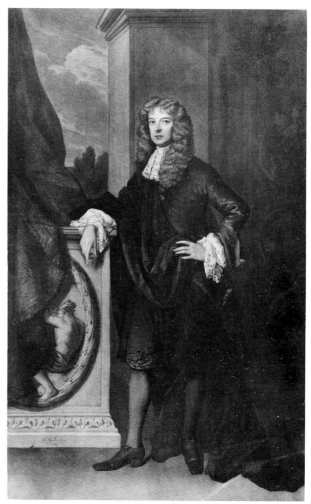

GODFREY KNELLER, 1646-1723. 'Hon. Hugh Hare'
(1668-1707). 94ins. x 60ins. s. & d. 'G. Kneller fecit/Aº.
1685'. Private collection.

of undistinguished quality, of his commissioned portraits. Kneller visited
Versailles 1684/85 to paint Louis XIV for Charles II, and Brussels 1697 to
paint the Elector of Bavaria for William III, and both visits had some impact
on his style. At his best, and with an intelligent sitter, he could be a portraitist
of great distinction, but he justifiably despised many of his sitters and could
often be perfunctory. He created a new format — the Kit-cat, 36ins. x 28 ins.,
which showed one hand — for his portraits of the members of the Kit-cat Club
(the leaders of the Whig establishment) which now belong to the N.P.G. (many
of them on view at Beningbrough). The style had a profound influence on
British eighteenth century portraiture. As a portraitist Kneller dominated his
age, but much of his best work was done before 1700; many of his unfinished
works were completed by Edward Byng or others. He was the first governor
of the first 'Academy' in London, from 1711 until he was succeeded by
Thornhill in 1718. When he took the trouble he was capable of great virtuosity
of execution.

(J. Douglas Stewart, Sir G.K. and the English Baroque portrait, Oxford 1983, and cat.
Kneller exh., N.P.G. 1971.)

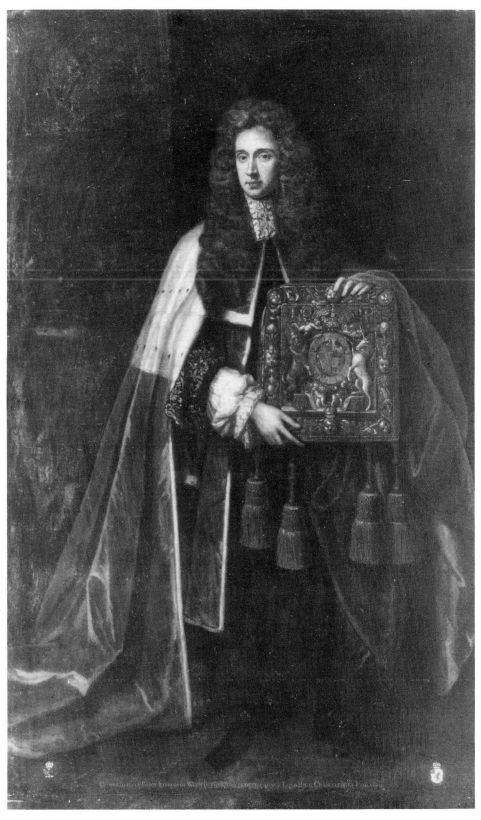

GODFREY KNELLER, 1646-1723. 'George Jeffreys, Baron of Wemm in the County of Salop and Lord High Chancellor of England'. 90ins. x 56ins. s. & d. 1687. Sotheby's sale 16.7.1952.

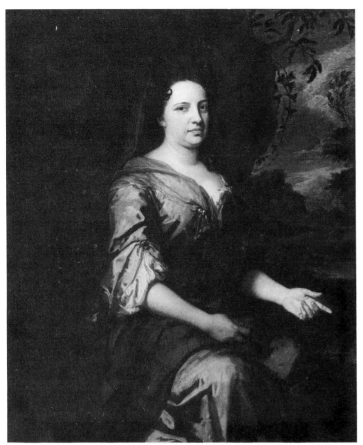

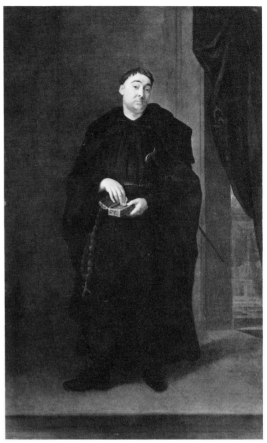

GODFREY KNELLER, 1646-1723. 'Mrs. Dunch'. 50ins. x 40ins. s. & d. 'G. Kneller fecit/1689'. From the collection at Parham Park.

GODFREY KNELLER, 1646-1723. 'Anthony Leigh, Comedian to His Majesty' (as the Spanish Friar — Dryden). 91 ¼ ins. x 56ins. s. & d. 1689. N.P.G.

KNELLER, John (John Zachary) 1642 – 1702

Portrait painter; elder brother of Sir Godfrey Kneller (q.v.). Born Lubeck 15 December 1642; buried London 31 August 1702. He accompanied his brother to Italy in 1672 and to England in 1676 and made copies of his brother's portraits in miniature. He is also said to have gone in for still-life and watercolour painting.

(*Buckeridge.*)

KNIGHT, Thomas fl.1618 – 1652

He painted a good deal of decorative work (including figures) jointly with John Clarke (q.v.) in the Bodleian Library, Oxford, 1618/19. He is presumably the same Thomas Knight who was active in the Painter-Stainers' Company from 1629 to 1652, and was Master in 1641 and 1648.

(*E.C-M.*)

KNYFF, Jacob 1640 – 1681

Topographical landscape painter. Baptised Haarlem 1 January 1640; died London 1681. Elder brother of Leonard Knyff (q.v.) He visited Paris before coming to England and there are at Berkeley Castle views of Fountainebleau, and Paris, 1673, and also of the Durdans, signed and dated 1673, which was presumably the year he came to England.

LEONARD KNYFF, 1650-1722. '3rd Viscount Irwin'. Leeds Art Galleries, Temple Newsam House.

KNYFF, Leonard (Leendert) 1650 – 1722

Painter of bird's-eye views of estates and of animal pictures in the manner of Barlow (q.v.) Born Haarlem 10 August 1650; younger brother of Jacob Knyff (q.v.); died London 1722. He was a prolific landscape painter (*Ogdens*) but most of his documented paintings are after 1700 (*Waterhouse, 1981*). Made a denizen 1694. For two views of Hampton Court, Herefordshire, of 1699 (B.A.C. Yale), see *Country Houses in Great Britain, exh. cat., B.A.C. Yale, 1979.* He was also a picture dealer and auctioneer.

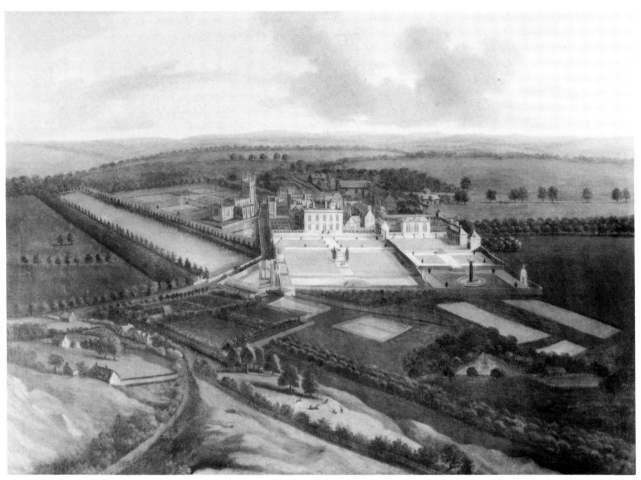

LEONARD KNYFF, 1650-1722. 'Staunton Harold'. Collection of the Rt. Hon. the Earl Ferrers.
Photograph Paul Mellon Centre.

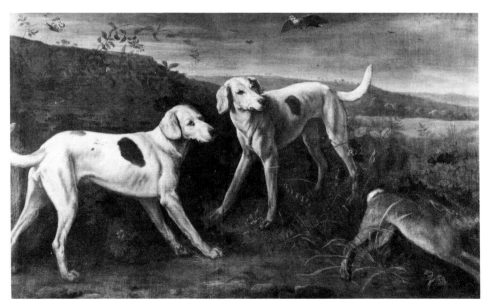

LEONARD KNYFF, 1650-1722. 'Hounds with a hare'. From the Halifax Collection. Photograph
Courtauld Institute of Art.

160

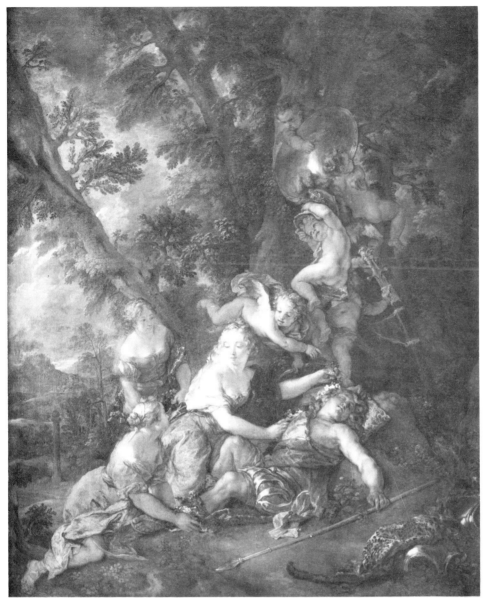

CHARLES DE LAFOSSE, 1636-1716. 'Venus discovering Mars asleep'. Basildon Park (National Trust).

LACY, Rowland
A picture of 'Cleopatra' by Roland Lacy in Vertue's catalogue of the Duke of Buckingham's Collection, is probably a misprint for Rowland Lockey (q.v.).

LAFOSSE, Charles de 1636 – 1716
The leading French painter of baroque histories in the generation after Le Brun. Born Paris 1636; died there 13 December 1716. Pupil of Le Brun; in Rome 1658-1660 and then three years in Venice. He made two visits to London, 1689 and 1690-1692, to paint most of the walls and ceilings of Montagu House (destroyed). Returning to Paris he became *Peintre du roi,* 1696, and Director and later Rector and Chancellor of the Academy (*E.C-M.*). Two pictures from Boughton, which could be examples of Lafosse painted in England, are at Basildon Park (National Trust).

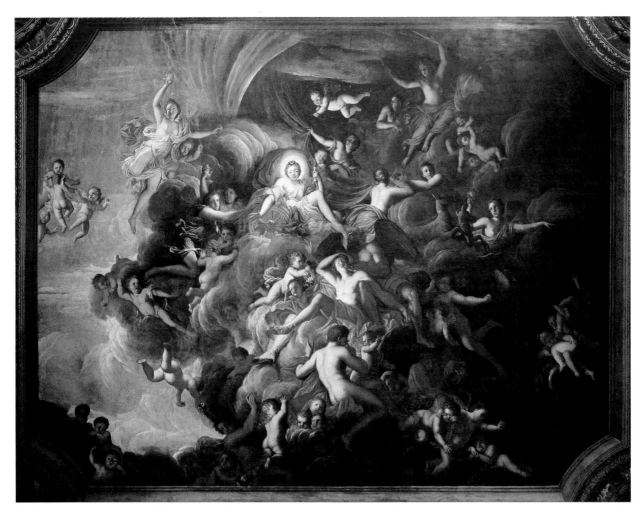

LOUIS LAGUERRE, 1663-1721. 'Triumph of Diana, Goddess of the Moon'. Ceiling of State Bedroom, Chatsworth. Devonshire Collection, Chatsworth. Reproduced by permission of the Chatsworth Settlement Trustees.

LAGUERRE, Louis **1663 – 1721**

A very accomplished painter of historical scenes on walls and ceilings, but occasionally painted easel pictures and portraits. Born Versailles 1663; died London 20 April 1721. He was Jesuit-trained and a pupil of Charles Le Brun at the French Academy. Came to England *c.*1684 as an assistant to Verrio (q.v.), but was already working on his own in 1687. His chief surviving works from before 1700 are at Sudbury Hall, *c.*1691; Chatsworth, 1689/1694; and Burghley, 1698. For his activity after 1700 see *Waterhouse, 1981*. He was the natural successor to Verrio's vogue as a baroque history painter, but was partly eclipsed, after 1700, by Thornhill.

(*E.C-M.*)

LAMBERT, John *c.***1640 – 1701/2**

Amateur portrait painter. Born Yorkshire *c.*1640; died there 14 March 1701/2. He was son of the famous Parliamentary general, John Lambert, and was described by Thoresby (*Diary, 1830 ed., I., 131n.*) as a 'great scholar and virtuoso and most exact limner'. He signed a few family portraits 'I.L.' (e.g. 'John Lister', 1696, formerly at Gisburne), which are vaguely in the manner

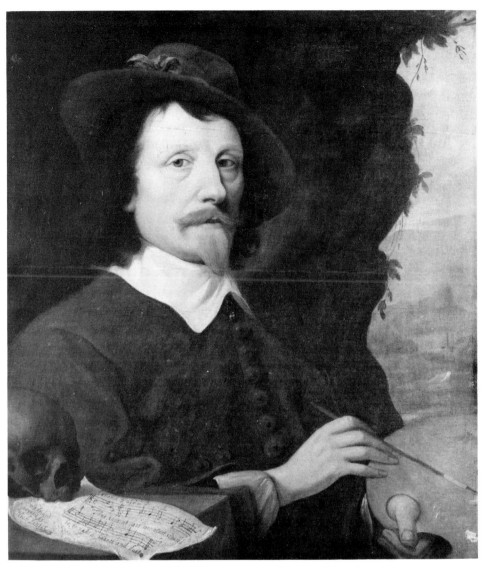

NICHOLAS LANIER, 1588-1665/66. Self-portrait. 26ins. x 23ins. Signed 'Made and/paynted by/Nick:Lanier'. Faculty of Music, Oxford.

of Riley (q.v.). He was in close touch with the York group of artists (Lodge, Place (qq.v.), Gyles, etc.,), see *Walpole Soc., X, 64/65*. The statement that his father (*Walpole, II, 71*) painted flowers is due to a confusion over two floral wreaths at Penshurst, which are actually signed 'M.L.' (i.e. Martin Lambert, a French painter).

LANIER(E), Nicholas 1588 – 1665/66

Musician (singer and composer) and amateur painter. Baptised London 10 September 1588; died there February 1665/66. He came from a family of musicians and was made Keeper of the King's Music in 1625 and sent to Italy to collect pictures for Charles I. He was reinstated at the Restoration. His one known painting is a self-portrait, of rather feeble quality, presented to the Music School, Oxford.

(*Poole, I, 154.*)

PROSPER HENRICUS
LANKRINK,
c.1628-1692. Landscape.
28½ins. x 58½ins.
Christie's sale 1.2.1946 (98)

GERARD LANSCROON,
c.1655-1737. Portrait of a
child. 50ins. x 40ins.
s. & d. 'G. Lanscroon
f./1690'. Sotheby's sale
12.5.1954 (83).

NICOLAS DE LARGILLIERRE, 1656-1746. Still-life. 9ins. x 12¾ins. s. & d. 'N. De Largillierre 1677'. Formerly in the collection of Fritz Lugt.

LANKRINK (LANCKRINK), Prosper Henricus *c.*1628 – 1692

Landscape and history painter; probably also a picture dealer. Of German origin; born about 1628 and brought up at Antwerp; buried London 11 July 1692. He settled in London before 1673 and was largely active in painting backgrounds and accessories for Lely. His landscapes were famous and in the manner of Salvator Rosa and Titian. His posthumous sale catalogue (11 January 1693) is published in *Burlington Mag., LXXXVI (February, 1945), 29-35.)*

(Buckeridge.)

LANSCROON, Gerard *c.*1655 – 1737

History painter and occasional portraitist. Son of a sculptor from Malines with whom he came to England 1677; assistant to Verrio 1678 but working on his own from 1690; buried London 26 August 1737. There is some ceiling painting by him at Melbury from the 1690s; his occasional portraits suggest some Italian influence.

(E.C-M.)

LARGILLIERRE, Nicolas de 1656 – 1746

One of the two leading portrait painters of the French court and society of his age; also occasional religious painter. Baptised Paris 10 October 1656; died there 20 March 1746. Trained in Antwerp as a still-life painter and Master there 1673/74. In England 1675-1679, where he painted a few still-lifes and was assistant to Verrio (q.v.) 1679. He was also friendly with Lely and decided to become a portrait painter on returning to Paris. He also painted a portrait of J. Siberechts (q.v.), Nottingham. Except for a brief visit to London in 1686

WILLIAM LARKIN, fl. ?early 1580s-1619. 'Lady Dorothy Cary'. 81ins. x 48ins. The Suffolk Collection, Rangers House, Blackheath (English Heritage).

WILLIAM LARKIN, fl. ?early 1580s-1619. 'Richard Sackville, 3rd Earl of Dorset'. 81¼ins. x 48ins. 1613. The Suffolk Collection, Rangers House, Blackheath (English Heritage).

to paint James II and his Queen, his successful career was wholly in Paris, where he was *agréé* at the Academy in 1683.

(*Myra Nan Rosenfeld et. al., cat. Largillierre exh. 1981, Montreal Museum of Fine Arts, 1983.*)

LARKIN, William fl. ?early 1580s – 1619

Portrait painter; probably native of London; died there 1619; will proved 14 May. He had a distinguished clientele and there are two heads on copper at Charlecote of 'Lord Herbert of Cherbury' and 'Sir Thomas Lucy' (*Burlington Mag., CXVIII (February 1976), 80-83; Edmond.*) The suggested extension of his work in Strong (*313ff.*) seems largely misconceived.

LASORE See LIZARD, Nicholas

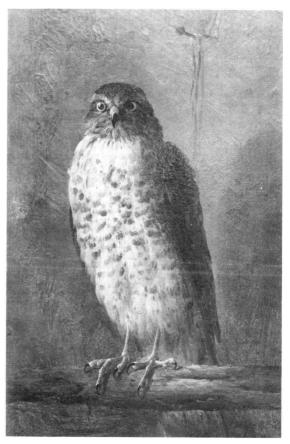

MARCELLUS LAURON, c.1648/49-1701/2. 'Charles II'. Christ's Hospital, Horsham. Photograph Paul Mellon Centre.

MARCELLUS LAURON, c.1648/49-1701/2. 'A kestrel'. 13¼ins. x 8¼ins. Private collection. Photograph Paul Mellon Centre.

LAURON (LAROON), Marcellus *c.*1648/49 – 1701/2

Portraitist, professional copyist, 'drapery painter' and engraver; known as 'Old Laroon'. Born The Hague *c.*1648/49; died Richmond, Surrey, 11 March 1701/2. Son of an unknown landscape painter of the same name, with whom he is supposed to have come to England (?Yorkshire) in the 1660s. He was father to Marcellus Laroon the Younger (1679-1772) who was a miscellaneous and better known painter. Lauron was admitted a Painter-Stainer in London in 1674 and his three known portraits show him to have been quite a competent portraitist (all repd. in *Robert Raines, Marcellus Laroon, 1966*), but he worked mainly as an assistant to Kneller (q.v.) and as an engraver. There are mezzotints after a few of his rather low-class genre paintings.

(*Buckeridge.*)

LEE, T. fl.1634

A rather battered portrait, signed 'An. 1634/T. Lee pinxit', and considerably improved (*J.D. Milner, Burlington Mag. (December 1916)*, *374*, later sold Christie's 3 July 1936, 123) seems to have been by T. Leigh (q.v.).

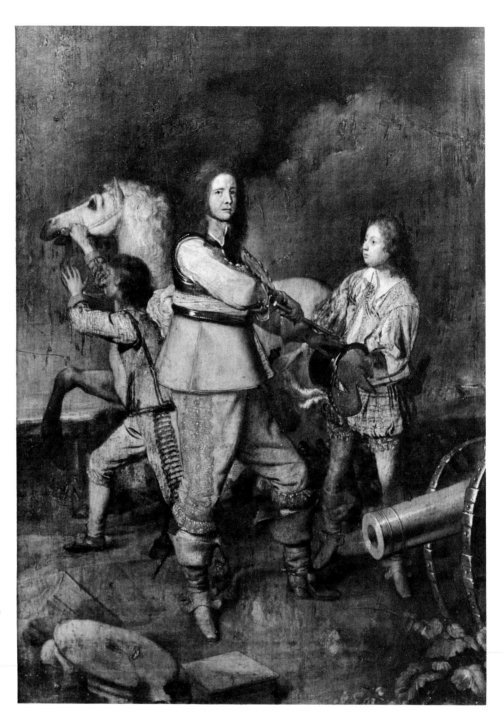

LEEMPUT, Remee (Remigius) van 1607 – 1675

Professional copyist of portraits (especially of Van Dyck and Lely) and occasional portraitist on his own. Generally known as 'Remee'. Baptised Antwerp 19 December 1607; buried London (as 'Remigeus Vanlimpitt') 9 November 1675. Master at Antwerp 1628, he came to England (possibly as an assistant to Van Dyck *c.*1632) certainly by 1635. His copies of Van Dyck were considered deceptively good (*Buckeridge*), and he told Lely he could copy his portraits better than Lely could himself. A number of small head copies after Van Dyck are traditionally ascribed to him. He was in Rome in 1651 and a son, Giovanni Remigio, was later a professional copyist there.

LEFEBVRE, Rolland *c.*1608 – 1677

French painter of portrait and genre, often on a miniature scale. Native of
Saumur; died London 1677, aged 69. He was known as 'Lefebvre de Venise'
to distinguish him from Claude, who did not come to England. He was in
Rome 1636 and 1639; *agréé* at the French Academy 1662. Some of his small
genre pictures were extremely obscene (*Vertue*). He was probably only briefly
in England from 1676 until his death.

(*Th.-B.*)

LEIGH, T. fl.1634 – 1656

Portraitist whose work is related in style to that of Cornelius Johnson i (q.v.).
The only absolutely certain information about him is that he signed and dated
in 1643 half a dozen portraits in North Wales (two in National Museum,
Cardiff). A portrait of 1634 signed T. Lee (q.v.) was probably by him, and
there is said to be a receipt of 1656 for a posthumous full-length portrait of
'Robert Ashley' in the Middle Temple.

(*Steegman, I.*)

PETER LELY, 1618-1680. 'An idyll'. 44½ins. x 78½ins. Destroyed in 1941.

LELY, Sir Peter 1618 – 1680

The dominant Court and society portraitist of the reign of Charles II; also, in his earlier years, the painter of arcadian histories of a suberotic tone. Born van der Faes (but he was already using the name Lely by 1637) at Soest, Westphalen, 14 September 1618; died London 30 November 1680. His father came from Haarlem and Lely was registered in the Haarlem Guild 1637 as a pupil of Frans Pietersz de Grebber. He probably came to England in about 1643 and at first painted slightly erotic pastoral scenes (of which the Dulwich 'Nymphs at a fountain' is the finest), but soon realised that the taste of British patronage was for portraiture. By 1647, when he became a Painter-Stainer, he was employed by the Duke of Northumberland, who had the royal children in his charge, to paint the imprisoned royal family (Syon House and Petworth) and Lely had a chance to study in the Northumberland Collection works by Van Dyck and Dobson, on which he modelled his English portrait style. A fine group of portraits of this period survives at Ham House and, by the end of the Commonwealth, Lely had become the best-known portraitist in England. He painted Cromwell (Birmingham) but also cultivated the patronage of those noble families who were to be prominent in the Restoration. In 1661 he was appointed Principal Painter to the King and was naturalised in 1662, and from then on he maintained a busy and active studio, which turned out an endless stream of portraits (and replicas and copies) of everyone of importance. He relied a great deal on Gaspars (q.v.) and other assistants (e.g. Lankrink (q.v.)

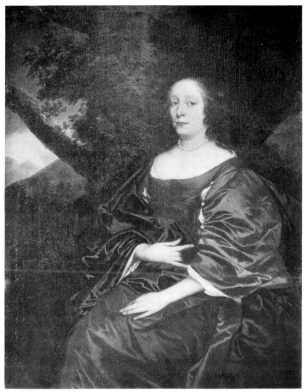

PETER LELY, 1618-1680. 'James II as Duke of York'. s. & d. 1647. Collection of the Duke of Northumberland (Syon House).

PETER LELY, 1618-1680. Portrait of a lady. 49½ ins. x 40ins. 1645-50. Anon. sale N.Y. 20.2.1930 (94).

for landscape backgrounds), but the heads that he painted from the life are of great distinction. He developed a series of stock poses, which were numbered for the convenience of the studio, and which were more lively and romantic than Van Dyck's. When he took the trouble to paint the drapery himself (as in most of the 'Hampton Court Beauties') his execution was splendid and his colour extremely sonorous. He caught to perfection not only the rather raffish tone of Charles II's female associates, but the serious qualities of the Admirals in the Anglo-Dutch Wars (now at Greenwich). By the end of his life he had assembled one of the best non-princely collections in Europe, including more than twenty-five of Van Dyck's major English works (*Burlington Mag., LXXXIII (August 1943), 185ff.*) and an enormous collection of prints and drawings, which were among the first to receive a collector's mark. His executors' account book (*B.M. MS., Add. 16, 174*) is one of the great sources of information about artistic practice in seventeenth century London (*Talley, 359ff.*). Lely's prices in the early 1650s had been £5 for a head size and £10 for a half-length; by 1660 these had risen to £15 and £25, and he raised them again in 1671 to £20 and £30 and £60 for a whole-length. Lely was knighted the year he died and his successor in his dominant role was Kneller (q.v.).

(The only attempt to catalogue the enormous output of the studio is in *R.B. Beckett, Lely, 1951;* bibliography and latest research in *Oliver Millar, cat. Lely exh., N.P.G., 1978.*)

PETER LELY, 1618-1680. 'Admiral Jeremy Smith' (detail). N.M.M.

PETER LELY,
1618-1680. 'Charles
Viscount Ascott, and his
sister Elizabeth' (children of
Charles, Earl of Carnavon).
40ins. x 50ins. Sotheby's
sale 3.4.1946 (128).

PETER LELY, 1618-1680. 'Lady as St. Agnes'. 48½ins. x
39½ins. Christie's sale 23.3.1979 (119).

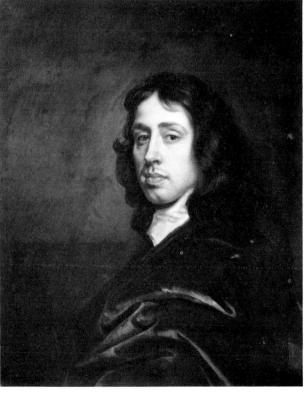

PETER LELY, 1618-1680. Portrait of a man. 28ins. x 24ins.
Christie's sale 1.6.1978 (339).

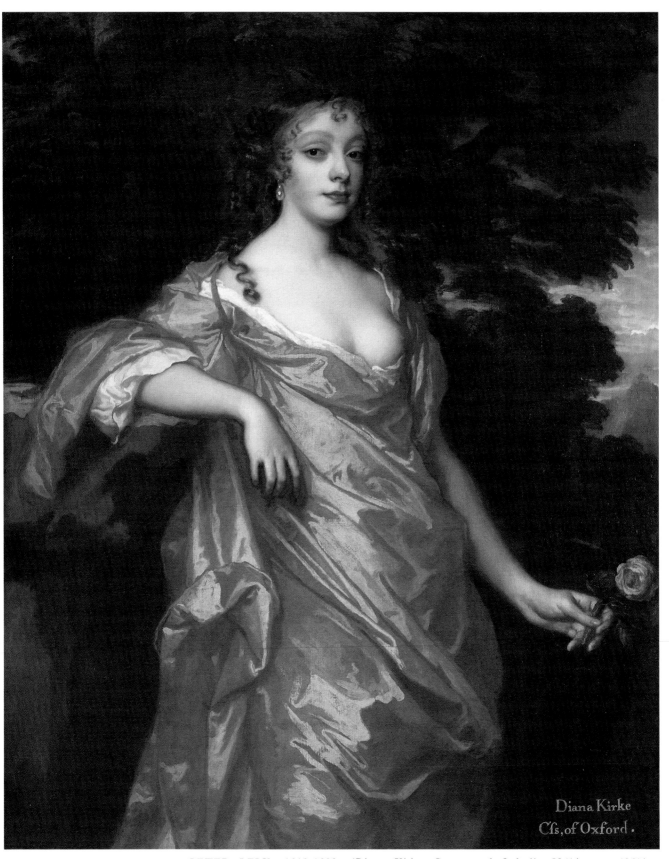

Diana Kirke
Cfs. of Oxford.

PETER LELY, 1618-1680. 'Diana Kirke, Countess of Oxford'. 53¼ ins. x 42¾ ins. c.1665/70. B.A.C. Yale, Paul Mellon Collection.

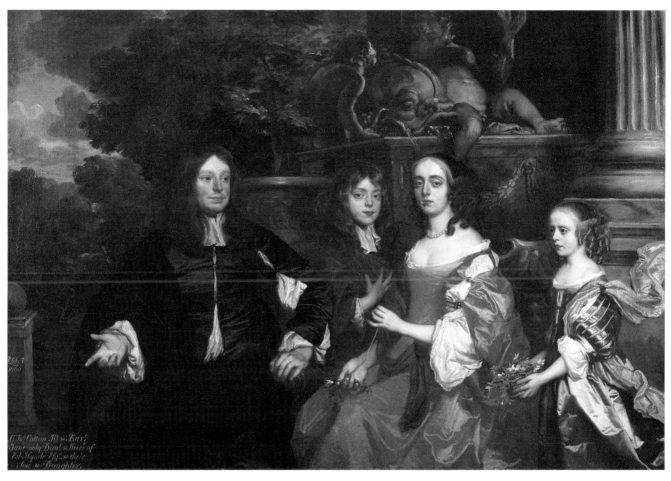

PETER LELY,
1618-1680. 'Sir John Cotton
and his family'. Manchester
City Art Galleries.

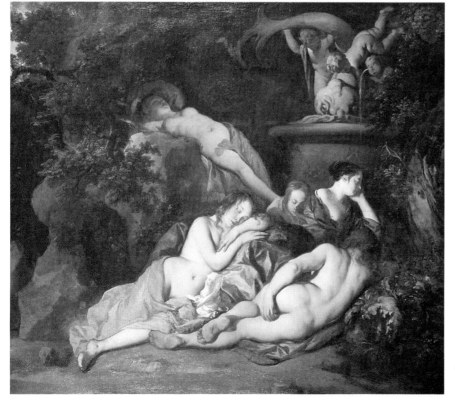

PETER LELY,
1618-1680. 'Nymphs at a
fountain'. By permission of
the Governors of Dulwich
Picture Gallery.

PETER LELY, 1618-1680. Top left: 'Jocelyn, Earl of Northumberland'. 63½ ins. x 54ins. Collection of Lord Egremont, Petworth House. Photograph Courtauld Institute of Art. Top right: 'Sir Christopher Myms' (1625-1666). N.M.M. Bottom left and right: Portraits of a man and a woman playing stringed instruments. 56ins. x 36¾ ins Both from the collection of Dr. D.M. McDonald.

PETER LELY, 1618-1680. 'Charles Killigrew' (1655-1725). 48½ins. x 39½ins. Sotheby's sale
15.3.1978 (57).

LEMMENS (LEMENS), Balthasar van 1637 – 1703/4

Painter of small histories and allegories. Said to have been a native of Antwerp; died London 1703/4 aged 66 (*Vertue*). He settled in London soon after the Restoration but had little success. There are a few engravings after his works.

LE NEVE See NEVE, Cornelius de and Jerome

LENS, Bernard *c.*1630 – 1707/8

Said to have been a portraitist. Died London 5 February 1707/8 aged 77 (*Vertue*). He was the grandfather of the eighteenth century limner and is credited with the authorship of a portrait of 'Archbishop Sancroft' at Emmanuel College, Cambridge, which is dated 1650 on the frame. He is said by Vertue to have written large book in English on 'scriptural matters'.

LENTHAL fl.1694 – 1702

Portrait painter in a style between Murray and Kneller (qq.v.). In the 1740 Claydon inventory he is credited with portraits of the second (d.1694) and third wives of the 1st Viscount Fermanagh. He is last mentioned in 1702.

(*Waterhouse, 1981.*)

LE PIPER (PIPRE), Francis d.1698

Amateur draughtsman, caricaturist and etcher who occasionally deviated into painting. He came from a wealthy merchant family of Flemish origin and settled in Kent; died London 1698. He had a roistering nature and travelled extensively (even as far as Cairo) and most of his artistic creations were associated with the bottle. He is credited with some illustrations to 'Hudibras' in oils in the Tate Gallery.

(*Buckeridge; D.N.B.*)

LIEVENS, Jan 1607 – 1674

Dutch portrait and history painter and etcher. Born Leiden 24 October 1607; died Amsterdam 4 June 1674. He was associated in his early years with the young Rembrandt, and was in England 1632-1635 where he is said to have painted portraits of the royal family, but no trace of his work in England has been discovered. In Antwerp 1635-1644 and then in Amsterdam.

(*H. Schneider, J.L., 1932.*)

LIGHTFOOT, William fl.1647 – *c.*1671

Decorative painter 'in perspective, architecture and lanskip' (*Buckeridge*). Made free by Painter-Stainers 1647; reported to have died 1671 (*E.C-M.*). His elder brother, Edward, 'ye City painter', died of the plague 9 August 1665.

(*Camden Soc., 1849, 64.*)

FRANCIS LE PIPER, d.1698. 'The Combat of Hudibras and Cerdon'. The Tate Gallery.

LILLY, Edmund fl. 1680 – 1716

Portrait painter. Buried Richmond, Surrey, 23 May 1716. Although no certain work is known from before 1700, he must have been in good practice by then to have painted the coronation portrait of Queen Anne, whose favourite painter he may have been.

(*D.N.B.*)

LINTON, J. fl. 1680 – 1693

Portrait painter. He was on a committee of the Painter-Stainers in 1680, and there is a line engraving of his portrait of 'Sir William Ashurst' as Lord Mayor of London (1693).

LITTLEHOUSE See LUTTICHUYS, Simon

LIVINUS VOGELARIUS See VOGELARIUS, Levinus

LIZARD, Nicholas fl. *c.* 1531 – 1571

Serjeant-Painter; also decorative and history painter; of French origin. Possibly in England by 1531 (as 'Nicholas Lasore', *Auerbach, 51*). He was appointed Serjeant-Painter in 1554 and retained that post until his death; buried London 5 April 1571. For his sons, who were painters, and a John Lizard, see *Edmond (178/79)*.

(*Auerbach.*)

LOCKEY (LOCKY), Nicholas fl.1600 – 1624

Miniaturist and portrait painter. Apprenticed to his brother Rowland Lockey
(q.v.) 1600 (*Edmond*); recorded as still alive 1624. His portrait of 'John King,
Bishop of London' was engraved by Simon de Passe.

(*Otto Kurz, Burlington Mag., XCIX (January 1957), 15.*)

LOCKEY (LOCKY), Rowland *c.*1565/67 – 1616

Miniaturist and portrait painter; apprenticed to Hilliard (q.v.) c.1581; buried
London 26 March 1616 (*Edmond*). He is known from two life-size copies of
Holbein's 'More family' at Nostell Priory (1592) and the N.P.G. (1593), and
a large miniature variant of it in the V. & A. (*R. Strong, Artists of the Tudor Court,
1983, 159ff.; O. Kurz, Burlington Mag., XCIX (January 1957), 13ff.*). He also
painted a number of portraits for Hardwick 1608/10.

LODGE, William 1649 – 1689

Amateur artist and distinguished topographical etcher. Born Leeds 4 July
1649; died there August 1689. Vertue reports he painted 'some few pictures
from the life in oil', but none are known.

(*D.N.B.; York Art Gallery cat., II, 1963, 62.*)

LOOTEN (LOTEN), Jan *c.*1618 – *c.*1680

Dutch landscape painter. Born Amsterdam and said to have been 25 when he
married in 1643; died in poverty at York after 1678. He is said to have settled
in England about 1660 and was visited by Pepys in London in 1669. He was
probably living at York in 1678 (*Walpole Soc., X, 64*). He may have worked for
the Royal Collection. His 'River landscape with a wood' (N.G.) owes a great
deal to Ruisdael. Some of his pictures were extremely large.

(*Buckeridge; N.G. cat., The Dutch School, 1960.*)

LOVEDAY fl.1650s

Painter mentioned in Richard Symonds' notebook.

(*Talley, 204/5.*)

LOVEJOY, R.W. fl.*c.*1680

Portrait painter whose name appears on the back of a portrait of *c.*1680 of
'Mary, Duchess of Norfolk'. It is close in style to Riley (q.v.).

ROWLAND LOCKEY, c.*1565/67-1616*. *'Margaret Beaufort'*. *The Master and Fellows of St. John's College, Cambridge. Photograph Paul Mellon Centre.*

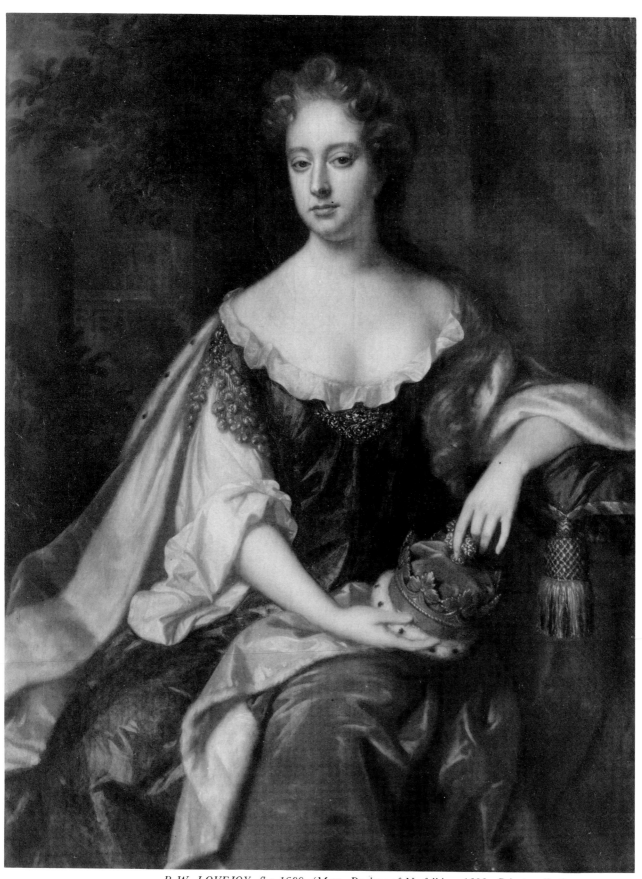

R.W. LOVEJOY, fl.c.1680. 'Mary, Duchess of Norfolk'. c.1680. Private collection.

LUTTICHUYS, Simon 1610 – *c.*1662/63

Dutch painter of portraits and still-life. Baptised London 6 March 1610; died
Amsterdam *c.*1662/63. He appears to have practised as a portraitist in England
and is supposedly the 'Simon Littlehouse' who was paid in January 1637/38
for a full-length of 'Bishop Thomas Morton' at St. John's College, Cambridge
(*Ingamells, 305*). Simon's brother, Isaac (baptised London 25 February 1616;

EDWARD LUTTRELL, c.1650-c.1724. Portrait after Rembrandt. 9½ins. x 8ins. Pastel on copper. Lothian Trustees.

EDWARD LUTTRELL, c.1650-c.1724. Portrait of a lady. 17¾ins. x 12¾ins. s. & d. 1683. Crayon. Sotheby's sale 16.1.1958 (190).

buried Amsterdam 6 March 1673) was a better portrait painter but is not known to have practised in England.

(*W.R. Valentiner, The Art Quarterly, I (1938), 151ff.*)

LUTTRELL (LUTTERELL), Edward *c.*1650 – *c.*1724

Portraitist in crayons and mezzotint engraver. Said to have been born in Dublin, probably *c.*1650, but came early to London (*Strickland*); he was certainly alive in 1723 and there is a pastel said to be dated 1724. He is said to have studied law before turning to portraiture, and both crayons and mezzotints seem to begin in the early 1680s. He sometimes signs 'E.L.' in monogram. In crayons he was a pupil of Ashfield (q.v.) (*Buckeridge, 355*), but he also invented on his own a technique of pastel on a roughened copper base. Some of his pastels are copies after Rembrandt and others, but his portraits show a development from relatively clumsy beginnings to a style parallel with

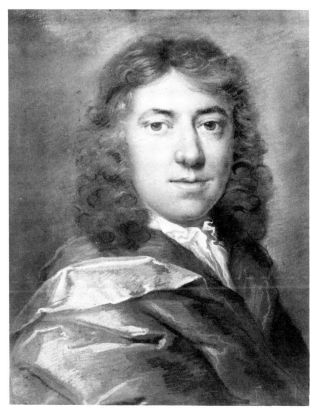

EDWARD LUTTRELL, c.1650-c.1724. Portrait of a young man. 10½ins. x 8¾ins. s. & d. 1689. Crayon on copper. Lothian Trustees.

RICHARD LYNE, fl.c.1572-1598. 'Archbishop Matthew Parker'. By permission of the Archbishop of Canterbury; copyright reserved to the Church Commissioners and the Courtauld Institute of Art.

that of Kneller. He seems also to have practised miniature painting, but no examples are known.

(*E.L., technical treatise, 1683, B.A.C. Yale MS.; Patrick J. Noon, English Portrait Drawings and Miniatures, B.A.C. Yale, New Haven 1979, 11.*)

LYNE, Richard fl.*c.*1572 – 1598

Portraitist. Employed by Archbishop Parker *c.*1572, but it is doubtful if a portrait at Lambeth is by him (*Ingamells, 317*). He is also listed as a painter in 1598.

(*Auerbach.*)

LYNTENFIELD fl.1690/91

In the Master's accounts of the Merchant Taylors' Company is a payment of £55 in January 1690/91 to a Mr. Lyntenfield for 'Sir Patience Ward's picture'. There is a full-length in the Merchant Taylors' Hall (cat. no. 34) wrongly ascribed to Kneller, but nearer in style to Riley (d.1691), which could be this picture, but Lyntenfield need not have been the name of the painter.

LYZARDE See LIZARD, Nicholas

MAAS (MAES), Dirck (Theodorus) **1656 – 1717**

Dutch battle painter and etcher. Born Haarlem 12 September 1656; died there 25 September 1717. He came over to paint the 'Battle of the Boyne' in 1690, possibly for the Earl of Portland (and the picture is at Welbeck), but the etching is inscribed 'Designé après la Nature et peint pour le Roy et gravé par Theodor Maas ...'

(*Hollstein, XI, 151.*)

MALLORY, Robert **fl.*c.*1653 – *c.*1688**

Portrait painter in the City and picture dealer. He appears in Symond's notebook (*c.*1653) as 'a Captain of the City and a doughty painter' (he was a Major by 1672). He was a member of the Merchant Taylors' Company (Master in 1674) and last appears in their records in 1688. He painted for the Company a portrait of 'Walter Pell' in 1672 in a decidedly old-fashioned style.

(*Talley, 201.*)

MANBY, Thomas **fl.1672 – 1695**

Landscape painter and picture dealer. Possibly baptised London 30 May 1633; died London November 1695. He is said to have visited Italy (certainly Rome) several times and specialised in ruins and Italian scenes. He was a friend of Mary and Charles Beale (qq.v.), and painted a landscape background in one of Mary Beale's portraits (*Buckeridge*). The B.M. has some drawings (*Iolo Williams, Apollo, XXIII (1936), 276/77*).

(*Croft-Murray and Hulton.*)

MANUCHI, John **fl.1610 – ?1631**

On 6 May 1610 John de Critz ii (q.v.) was granted, jointly with John Manuchi, the reversion of the office of Serjeant-Painter after the death of John de Critz the Elder (d.1642). A 'John Manikee' was made a denizen in 1631.

(*Auerbach.*)

MARCUS See GHEERAERTS, Marcus

MARESCHALL, B. **fl.1692/93**

Signed a receipt of five guineas, dated February 1692/93, for a bust portrait of 'Lord Grandison' at Arbury.

(*Collins Baker, II, 210.*)

MARLEY (MORLEY), George *or* **Robert** **fl.1686 – 1692**

Painter(s) in the Durham area. George Marley, 'lymner', was married 14 February 1685/86 (*Surtees Soc., 124 (1914), 73*). A painter named Marley was drowned 26 July 1692 (*ib. 132*). A Robert Morley was buried in St. Oswald's, Durham, 27 July 1692.

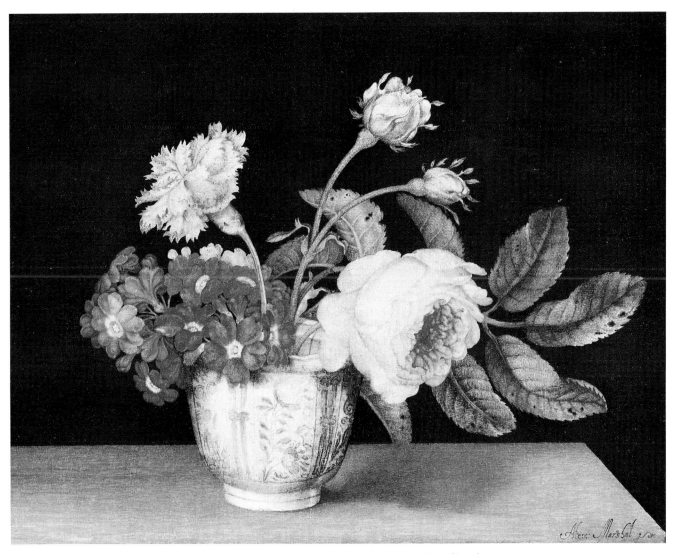

ALEXANDER MARSHAL, fl.1651-1682. 'Flowers in a Delft jar'. 12ins. x 16ins. Signed. 1663. B.A.C. Yale, Paul Mellon Collection.

MARLOE, N. fl.1660

Provincial portrait painter, probably in East Anglia. A bust portrait, somewhat in the manner of Robert Walker (q.v.), of 'Brampton Gurdon' (1607-1669), in the possession of Lord Cranworth, is signed on the back 'Anno Doi, 1660/Ætat: 53:/per/N: Marloe'.

MARQUESS (MARQUIS), Mr. See GHEERAERTS, Marcus

MARSHAL, Alexander fl.1651 – 1682

Flower painter and botanical draughtsman. Died Fulham 7 December 1682. Possibly not English (*A.P. Oppé, English Drawings at Windsor Castle, 1950, 74/75.*) Two oil flower paintings are known — 'A swag of roses', 1651 (Christie's sale 15 July 1983, 43), and 'Flowers in a Delft jar', 1663 (B.A.C. Yale). It is doubtful if a signed 'Siege of Magdeburg' (Christie's sale 22 April 1983, 49) is by the same hand.

(*Croft-Murray and Hulton.*)

ALEXANDER MARSHAL, fl.1651-1682. 'A swag of roses'. Signed 'Alex: Marshal'. 1651. Christie's sale 15.7.1983 (43).

MASCALL, Edward *c.*1627 – after 1675

Portrait painter active in Yorkshire especially during the Commonwealth. Various members of the family were Freeman of the City of York, and Edward, son of a York embroiderer, was admitted *per patrem* in 1660 (*Surtees Soc., CII (1899), passim*). A portrait in the Weld Collection at Lulworth is said to be signed and dated 1675. His portrait style is rather severe and his portrait of 'Oliver Cromwell', signed and dated 1657, is in the Cromwell Museum, Huntingdon.

(*N.A.C.F. Report, 1966.*)

MASON, Randall fl.1580 – 1591

Apprentice to the Serjeant-Painter William Herne (q.v.) in 1580; buried London 5 June 1591.

(*Edmond.*)

EDWARD MASCALL, c.1627-after 1675. 'Mary Edgcumbe'.
1658. Private collection.

EDWARD MASCALL, c.1627-after 1675. Portrait of a man.
30ins. x 25½ ins. s. & d. 1660/?1667. Christie's sale
24.7.1970 (218).

MATHEW d.1674
Felibien writes: 'Matthieu, Anglois de nation, faisait aussi des Portraits, & a travaillé dans les Gobelins aux Ouvrages du Roi. Il mourut en 1674' (*Vies des Peintres, IV, 1725, 328*, quoted by *Vertue, v, 58*, as Matthews). A *tapissier* named Henri Matthieu is said to have left Aubusson for Castres in 1661.

MATHEW, John fl.1578 – 1594
In 1578 John Mathew signed a petition of Painter-Stainers against Heralds (*Auerbach*). In 1592 'John Mathewe of Nottingham, painter' enriched with paint the tombs of the Earls of Rutland at Bottesford (*MSS. of Duke of Rutland, IV (1905), 404/5*). In 1594 'John Mathue, paynter styaner, pickterer' was made a Freeman of the City of York (*Surtees Soc., CII (1899), 38*).

MAYNARD (MAYNERT) fl.1512 – 1523
Portrait painter. Employed in 1511/12 on a posthumous portrait of 'Lady Margaret Beaufort' for Christ's College, Cambridge; last recorded in London 1523 (*Auerbach, 191*). A 'Harry Maynert, paynter' was a witness to Holbein's will, 1543.

(*R. Strong, Tudor & Jacobean Potraits, N.P.G. 1969, 20/21.*)

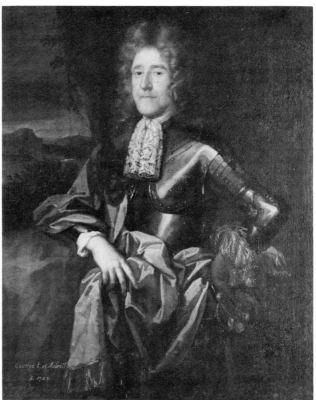

JOHN BAPTIST MEDINA, 1659-1710. 'David, Earl of Leven' (d.1728). 50ins. x 40ins. s. & d. 1691. S.N.P.G.

JOHN BAPTIST MEDINA, 1659-1710. 'George, Earl of Melville' (d.1707). 50ins. x 40ins. S.N.P.G.

MEDINA, Sir John Baptist **1659 – 1710**

Portrait and history painter. From a Spanish family, but born at Brussels, where he was a pupil of Duchatel. Knighted in Scotland 1707; died Edinburgh 5 October 1710. He came to London c.1686 and adapted his style and studio practice to that of Kneller, but his prices were £8 for a half-length and £4 for a head. Under the patronage of the Earl of Melville (later Earl of Leven), he took a large collection of 'postures' to Edinburgh in 1688 and had an immense success. He raised his prices to £10 and £5 and settled there for good about 1693 (*John Fleming, Connoisseur, CXLVIII (August 1961), 23-25*). His success as a portraitist in Scotland was almost as great as that of Kneller in England — and equally conscienceless: he specialised in arrangements of dark rose and blue. His few portraits of his own family or persons of modest pretensions show that he had a lively sense of character. His series of portraits in the Surgeons' Hall, Edinburgh (*D. Mannings, Medical History, 23 (1979), 174-190*) is the Scottish equivalent to Kneller's Kit-cat series. His eldest son, John Medina ii (fl.1686-1764) inherited many of his father's 'postures' and carried on with increasing incompetence.

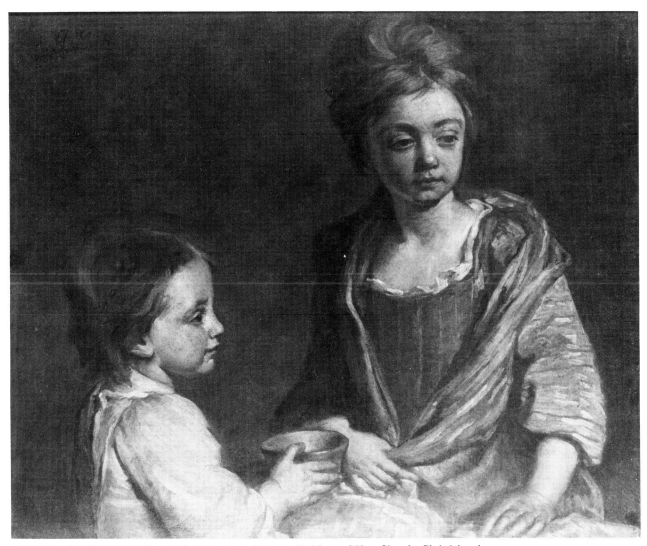

JOHN BAPTIST MEDINA, 1659-1710. Two children. 23½ins. x 28ins. Signed. Christie's sale 10.12.1954 (120) as Mercier.

MEHEUX, John **fl.1680s**

He signed a portrait of a boy of the family of Freeman of Aspenden (Christie's sale 5 March 1982, 27). It was from the 1680s and much in the style of Willem Wissing (q.v.)

MELE (MEELE), Matthäus de **See also DE MELE** **1664 – ?1724**

Dutch portrait painter; said to have been born at The Hague and to have been named Matthäus; died there probably 1724 (?1714, 1734). He was said to have been an assistant to Lely and to have returned to Holland. Two portraits of ladies of the Knightley family, from Fawsley, both signed and dated 1689, were sold by Christie's 7 March 1952 (138) and (162), the signatures being read as 'A. de Mele' and 'A. de Wiele'. They were both by the same hand and nearer to Kneller than to Lely.

(Wurzbach.)

JOHN MEHEUX, fl.1680s. 'Son of William Freeman of Aspenden'. 49ins. x 39ins. Signed. Christie's sale 5.3.1982 (27).

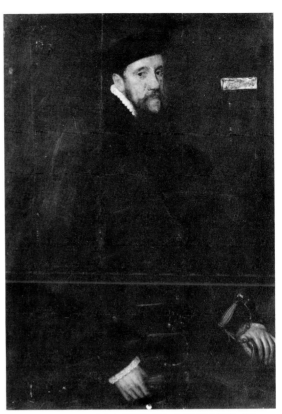

MATTHÄUS DE MELE, 1664-?1724. 'Elizabeth Knightley'. 29ins. x 24ins. s. & d. 'A. de Mele 1689'. Christie's sale 7.3.1952 (138).

STEVEN VAN DER MEULEN, fl.1543-1563. 'Henry Fitzalan, Earl of Arundel'. 47ins. x 33ins. Christie's sale 23.11.1979 (135).

MEULEN (VERMEULEN), Steven van der **fl.1543 – 1563**

Flemish portraitist. Pupil of Willem van Cleve at Antwerp 1543, where he became a Master 1552; in London 1560 where he was naturalised 4 February 1562; dated portraits of 'Lord Lumley' and wife 1563. His only documented portraits are very battered and his style is without strong individuality.

(Strong, 119ff., including doubtful attributions.)

MICHEL, Master See SITTOW, Michel

MODENA, Nicholas da See NICHOLAS DA MODENA

MONNOYER, Jean-Baptiste **?1636 – 1699**

Known as 'Old Baptist'. One of the great masters of the baroque flower piece. Baptised Lille 12 January 1636; died London 16 February 1699. He was received in the French Academy 1663 and exhibited flower pieces at the first Salon in 1673. He painted floral overdoors for Le Brun at Versailles but was brought to England by Lord Montagu c.1690. For Lord Montagu he painted

wall and ceiling decorations for Montagu House (destroyed) and many floral canvases for Boughton (many of which were sold 1 November 1946, 21-26). Under William and Mary he was a good deal employed by the Crown and had good employment with the nobility (*Buckeridge, 356/57*). He only briefly revisited Paris before his death in London.

(*E. C-M.; S.H. Pavière, J.B.M., 1966.*)

MONTINGO, Antonio fl.1678 – *c*.1690

Foreign flower painter. First employed as assistant to Verrio (q.v.) at Windsor Castle. Later on his own and employed Parmentier (q.v.) 1688.

(*E. C-M.*)

MOR (MORO), ?Sir Athonis *c*.1517/20 – 1575/76

A Dutchman and one of the most important portraitists of the sixteenth century, the creator of the Hapsburg Court Portrait. Born, probably at Utrecht between 1517 and 1520; died Antwerp 1575/76. He is often called 'Antonio Moro', and he was certainly an international character. He devised a reticent portrait style as a deliberate counterpoise to that of Titian. He visited London only in 1554, to paint Queen Mary (Prado and Fenway Court, Boston), and it is widely supposed that he may then have been knighted, but there is no documentary evidence for this. He was probably apppointed Spanish Court Painter when Phillip II eventually went to Spain in 1559, but he returned to Utrecht in 1560 and never returned to Spain. He was registered a Master in the Antwerp Guild from 1547 until his death, and most of his few portraits of British sitters were probably painted at Antwerp. In these he consciously owes something to Holbein. He was certainly a great master, and his portrait style influenced both Rubens and Velasquez.

(*M.J. Friedländer, Altniederländische Malerei, XIII.*)

MORE, J. *or* T. fl.1690s

Signed a male portrait 'More ft.' (Christie's sale 19 May 1939, 133). Perhaps the 'Mr. More, a painter' mentioned in a letter of 18 June 1694.

(*A.L. Cust, Chronicles of Erthig on the Dyke, I, 1914, 20.*)

MORE, Mrs. Mary fl.1674 – 1684

Called 'Moore' by Redgrave. She presented a copy of a sixteenth century portrait, of her own painting, to the Bodleian Library, Oxford in 1674 (*Poole, I, 11*). She was taking apprentices in 1684/85 (as 'Mary Morn, widow') in the Painter-Stainers' records.

MORELAND See MORLAND, Henry

MORGAN, John d.1588

A 'John Morgayn, painter', was buried 21 May 1588 at St. Anne's, Blackfriars.

(*Edmond, n. 83.*)

J. or T. MORE, fl.1690s. Portrait of a man of the Hanford family. 30ins. x 25ins. Signed 'More ft.'. Christie's sale 19.5.1939 (133).

GARRET MORPHEY, fl.1680-1715/16. 'Henry Cavendish, 2nd Duke of Newcastle'. 86¼ ins. x 52½ ins. 1686. Private collection.

GARRET MORPHEY, fl.1680-1715/16. 'Anne, Duchess of Kingston'. 20½ ins. x 17½ ins. Private collection. Photograph Courtauld Institute of Art.

MORLAND (MORELAND), Henry fl.1675 – c.1700

Portrait painter. A picture of 'Four children' at Bruges (131) is signed: '1675/Hen: Morland/Pinxit', which is rather in the manner of Riley; portraits signed 'Moreland' c.1700 were formerly at Aynhoe ('Lady Cottrell') and Rousham.

MORLEY See MARLEY

MORPHEY (MURPHY), Garret fl.1680 – 1715/16

One of the earliest Irish portraitists of any consequence; working mainly in Dublin where his will was proved 1 May 1716. He may have been a pupil of Gaspar Smitz (q.v.) (*Crookshank and Knight of Glin*). In England in 1680s (in Yorkshire 1686-1688) and his work shows traces of the influence of Lely, Netscher (in Holland) and perhaps French portraiture. He received £24 for a full-length (private collection) of the 'Duke of Newcastle', 1686. He was a Roman Catholic and probably settled finally in Ireland c.1689, where he had a good practice among the nobility.

(*Strickland.*)

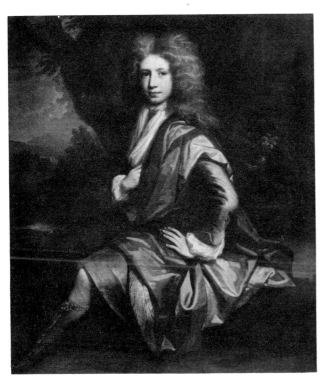

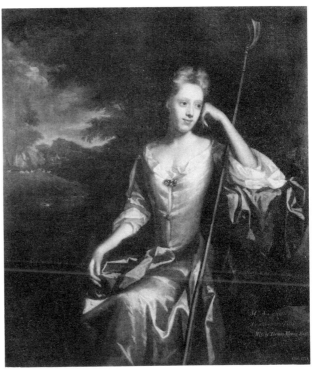

THOMAS MURRAY, 1663-1735. 'Sir Edward Smyth, Bart.'. 49½ins. x 39½ins. Signed. 1699. Sotheby's sale 27.2.1952 (101).

THOMAS MURRAY, 1663-1735. 'Mrs. Vernon, Twickenham Park. Wife of Thomas Vernon Esq.'. 56½ins. x 49½ins. Christie's sale 29.6.1951 (137).

MURRAY, Thomas **1663 – 1735**

Portrait painter. Born 1663 (*Vertue, iii, 57*), perhaps in Scotland; died London 1 June 1735 (his name wrongly reported as John). He was a pupil of John Riley (q.v.) and was practising on his own in the 1680s. His works of before 1700 are more independent of Kneller's style than his later portraits, many of which are engraved. By penurious habits he managed to die very rich, but he had quite a considerable practice.

(*Waterhouse, 1981.*)

MYTENS, Daniel *c.*1590 – *c.*1647

The only Court portraitist of real distinction in England before Van Dyck. A Dutchman; born probably at Delft *c.* 1590; died The Hague *c.*1647 (before 1648). He seems to have been trained in the style of van Ravestyn (The Hague) and Miereveld (Delft) and became a Master in The Hague Guild in 1610. By 1618 he was settled in England and had painted the 'Earl of Arundel' and 'Countess of Arundel' (probably the full-lengths now at Arundel Castle, property of N.P.G.). He was soon employed by the Crown (1620) and, on the death of Van Somer (q.v.), 1622, became Court Portrait Painter. He was

 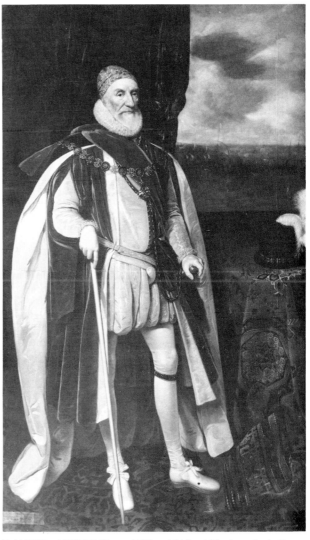

DANIEL MYTENS, c.1590-c.1647. 'Alathea Talbot, Countess of Arundel'. 81½ins. x 50ins. c.1618. Arundel Castle (N.P.G.).

DANIEL MYTENS, c.1590-c.1647. 'Charles, 2nd Baron Howard of Effingham and 1st Earl of Nottingham' (1536-1624). 99ins. x 57ins. N.M.M.

made a denizen 1624 'by direction of the Prince' (who became Charles I in 1625 and appointed Mytens 'one of our picture drawers'). In 1626 he went to the Low Countries for six months to improve his knowledge of European portrait style and, until the arrival of Van Dyck in 1632, he was the chief provider of royal portraits, and was kept busy painting originals and replicas of the chief figures about the Court. In spite of the high distinction of his style with an impressive sitter, he did not satisfy the King's almost pathological desire to look more impressive than he was, and Mytens had to give way to Van Dyck (q.v.). He retired to The Hague in the early 1630s, where he continued as an agent in Lord Arundel's collecting, but only four portraits are known from his years in Holland.

(O. Ter Kuile, Nederlands Kunsthistorisch Jaarboek, XX (1969), 1-106 with full cat. and documentation.)

Opposite:
DANIEL MYTENS, c.1590-c.1647. 'William Knollys, 1st Earl of Banbury'. 81ins. x 51ins. The Suffolk Collection, Rangers House, Blackheath (English Heritage).

199

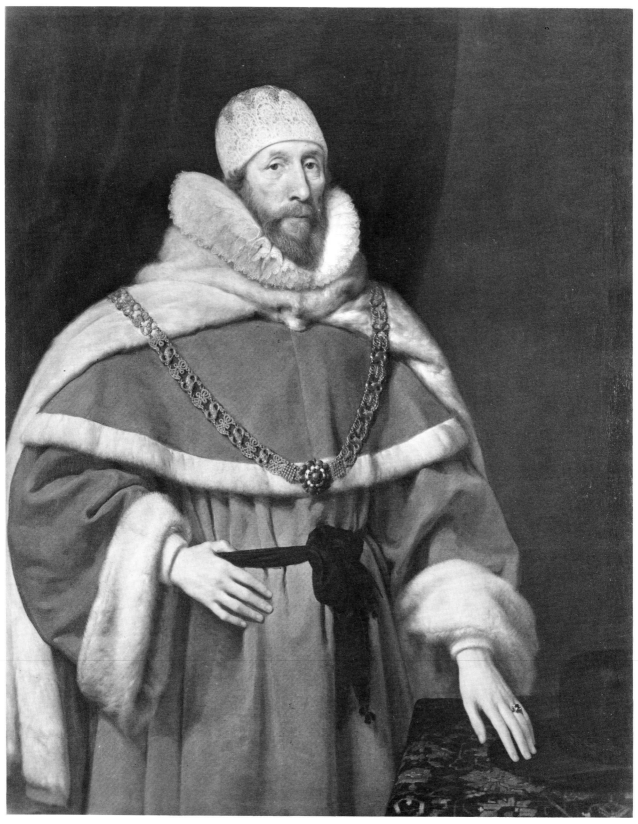

DANIEL MYTENS, c.1590-c.1647. 'Sir Henry Hobart'. 51 ¾ ins. x 41ins. 1624. Blickling Hall (National Trust).

PIETER NASON, c.1612-c.1689. 'Anthony, 1st Earl of Shaftesbury'. 31½ins. x 25¾ins. s. & d. 'P.Nasn.f.1663' Sotheby's sale 13.7.1988 (27).

NASON, Pieter *c.*1612 – *c.*1689

Dutch portraitist of considerable distinction who lived and worked mainly at The Hague. It is far from certain that he came to England, but he may have done so in 1663. His signed and dated (1651) portraits of 'Oliver St. John' and 'Walter Strickland' (both N.P.G.) were certainly painted at The Hague, but the richly coloured '1st Earl of Shaftesbury', 1663, suggests a visit to England, and the payment to a Mr. Nason *c.*1680 by Lely's executors may indicate another visit.

NEAL, Elizabeth fl.?1662

An ?English lady who painted flowers with great skill, perhaps in Flanders.

(*Cornelis de Bie, Het gulden Cabinet, Antwerp 1662, 588.*)

NEVE, Cornelius de (Leneve) (i) fl. 1576 – c. 1608

Native of The Netherlands and said to have been a painter (*Edmond, 149*). He was the father of Cornelius de Neve ii (q.v.) and his widow remarried John de Critz i (q.v.) in 1609. He married an earlier wife in London in 1593.

NEVE, Cornelius de (Leneve) (ii) ?1594 – after 1664

Portrait painter; listed 1594 in a return of aliens with his father; last documented as painting 'Elias Ashmole' in 1664. To judge from two portraits, signed and dated 1627, he may have been trained in Holland under Miereveld, but he was in London in 1627 (*M. Whinney and O. Millar, English Art 1625-1714, 1957, 81*). He sometimes (but not always) signs 'C.D.N.', and two portraits, one perhaps of himself, are in the Ashmolean Museum, Oxford. His later style has some connection with that of Thomas de Critz (q.v.)

NEVE, Jerome fl. 1641

Two large pictures at Petworth (1920 cat. nos. 526/27), one of them dated 1641, show a painter with his wife and child, and a group of eight children which is inscribed as painted by their father 'Gieronimo Nypho'. These have usually been associated with Cornelius de Neve ii (q.v.) but are by a totally different artist, much influenced by Van Dyck, who need never have worked in England.

NEWNAN, Thomas fl. 1698

His name occurs as a limner in 1698 in the Parish Registers of St. Michan.

(*Strickland.*)

NEWTON, John d. 1635

A limner at Cambridge, according to *D.N.B.* under his son 'Samuel Newton'.

(*Long.*)

NICHOLAS DA MODENA fl. 1516 – 1568/69

Painter, carver and sculptor of Italian origin; presumably a native of Modena, and named Niccolo Bellin. Died intestate in London 1568/69. He is first recorded in the sevice of François I at Fontainebleau in 1516. He left France under some sort of cloud in the 1530s (?1532 or 1537) and entered the service of Henry VIII; a denizen 1541. He was employed by the Crown on various decorative tasks, but there is no record of him under Mary I. His annuity was renewed in 1560. He painted pictures, but none are known, and he was probably instrumental in importing French (and Franco-Italian) Renaissance ideas into England.

(*Auerbach; E.C-M.*)

CORNELIUS DE NEVE (ii), ?1594-after 1664. Portrait of a man. 29ins. x 24ins. s. & d. 'Cornelius Neve/fecit 1629'. Christie's sale 10.3.1939 (143).

NORGATE, Edward **1581 – 1650**
Authority on miniature painting. Baptised Cambridge 12 February 1581; son of the Master of Corpus. Buried London 23 December 1650. He specialised in limning and heraldry and became very competent in both fields, and wrote a treatise 'Miniatura' (which was not published until 1919; original MSS. survive at Oxford and in the B.M.). He became Windsor Herald 1633 and Clerk of the Signet 1638. Some family miniatures sold Sotheby's 15 July 1984.

(*D.N.B.; Talley, 156ff.*)

NYPHUS See NEVE, Jerome

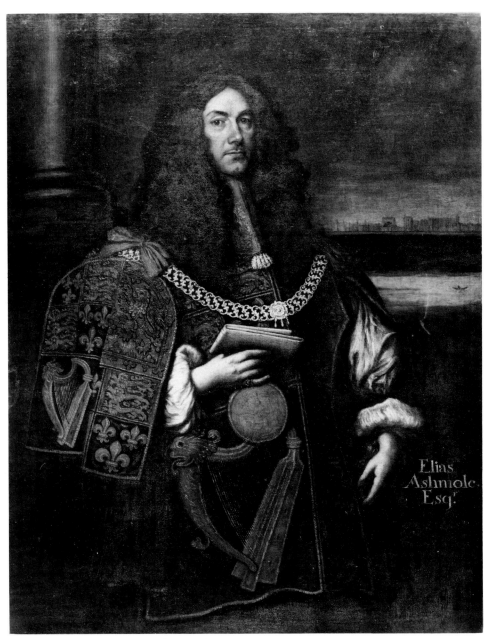

CORNELIUS DE NEVE (ii), ?1594-after 1664. 'Elias Ashmole Esq.'. 53ins. x 41ins. c.*1664. Private collection.*

OLIVER, Isaac *c.*1565 – 1617

Portraitist, especially on a miniature scale, and painter of miniature 'histories'. Born at Rouen, son of a French goldsmith, Pierre Olivier, but brought to London by 1568. Probable date of birth *c.*1565 (or earlier) (*Mary Edmond, Hilliard and Oliver, 1983, 71*). Buried London 2 October 1617. Hilliard and he are the two great masters of the English portrait miniature, but the aesthetic approach of each is quite distinct and, although Oliver certainly learned a great deal from Hilliard, his basic training was European (perhaps at first

ISAAC OLIVER, c.1565-1617. 'Deposition of Christ'. 8⅛ins. x 11⅛ins. Signed. c.1586.
The Fitzwilliam Museum, Cambridge.

Fontainebleau), and his earliest dated work, probably of 1586 (Fitzwilliam Museum, Cambridge), is a version of a 'Deposition of Christ' in a Romanising Flemish tradition. He is known to have been in Venice in 1596, but other visits abroad are not documented. His normal signature is 'I.O.' in monogram, and pictures of sitters of no great pretensions begin in 1587. By 1605 he was appointed limner to Queen Anne of Denmark and he developed a good Court practice. He also made mythological drawings and small religious histories (most of them copies). No signed portraits on the scale of life are known, but he must have done some. Oliver's full-length melancholy courtier sitting under a tree (Windsor Castle), the size of a playing card, is the most complete and flawless statement about the Court life of a sensitive nobleman of around 1600.

(*Artists of the Tudor Court, exh. cat., V. & A., 1983; Long; R. Strong, The English Renaissance Miniature, 1983.*)

See colour plate p. 207.

ISAAC OLIVER,
c.1565-1617. 'Virgin and
child'. 10½ ins. x 7¼ ins.
Signed. Vellum. Beaverbrook
Art Gallery, Fredericton,
New Brunswick.

OLIVER, Peter *c.*1589 – 1647

Portrait miniaturist and copyist in miniature of old masters. Son of Isaac
Oliver (q.v.); born London *c.*1589 (*Mary Edmond, Hilliard and Oliver, 1983, 99*);
buried London 22 December 1647. Pupil and close imitator of his father, but
he also specialised, at the instigation of Charles I, in making miniature copies
of Italian old masters in the Royal Collection. His early work is hard to
distinguish from his father's, except that he signs 'P.O.' in monogram.

(*Long; Murdoch &c., 88ff.*)

ISAAC OLIVER, c.1565-1617. *'Portrait of a young man'*. c.1600. *Reproduced by Gracious Permission of Her Majesty the Queen.*

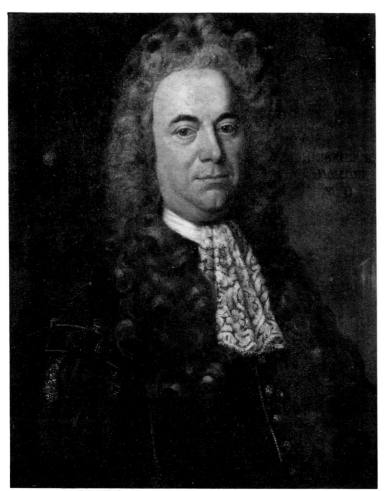

B. ORCHARD, fl.1692. 'Richard Morton M.D.'. 30ins. x 25ins. By permission of the Royal College of Physicians of London.

PIERRE OUDRY, fl.1578. 'Mary, Queen of Scots'. 1578. Collection of the Marquis of Salisbury, Hatfield House.

ORCHARD, B. fl.1692
The Royal College of Physicians owns a portrait of 'Richard Morton M.D.', which was engraved as 'after B. Orchard' as the frontispiece to Morton's *Exercitationes*, 1692.

OSBORN(E), ?John fl.1637 – 1641
Two portraits, quite probably by the same hand, are signed 'I.O.': 'Lady Astley', 1641 (*Duleep Singh, II, 40*), and 'Sir Edward Hussey', 1637 (*Burlington Mag., LXXVI (July 1940), 25* — foolishly as C. Johnson). It has been suggested that they are by the painter John Osborne, but the only English artist of that name was a medallist who worked in Amsterdam and died in the 1630s.

OUDRY (ODRY), Pierre fl.1578
Apparently the French embroiderer brought by Mary, Queen of Scots from Paris to Edinburgh, and who accompanied her in exile. In 1578 he painted and signed a full-length portrait of 'Mary, Queen of Scots', which is probably a copy of a lost portrait. It is a very pedestrian affair.

(*L. Dimier, Le portrait en France au XVI siècle, I, 1924, 114.*)

ISAAK PALING, fl.1664-c.1720. 'Colonel Metcalfe Graham of Pickhill'. s. & d. 'Paling 1704'. Private collection. Photograph Courtauld Institute of Art.

PAERT See PEART, Henry

PALING, Isaak fl.1664 – *c.*1720

Dutch portrait and history painter. Native of Leyden where he entered the Guild 1664; moved to The Hague 1681; settled in London with his wife 1682 (attestation from The Hague to Dutch Church in London 25 July 1682); first recorded back at The Hague 17 November 1703; probably died at The Hague after 1719. Portraits painted in England in a style close to Kneller are known dated 1693 and 1703.

(*A. Bredius, Künstler-Inventare, VI (1919), 2122-2129.*)

ROBERT PEAKE (i), c.1551-1619. 'Henry, Prince of Wales'. 68ins. x 44¾ins. c.1610. N.P.G.

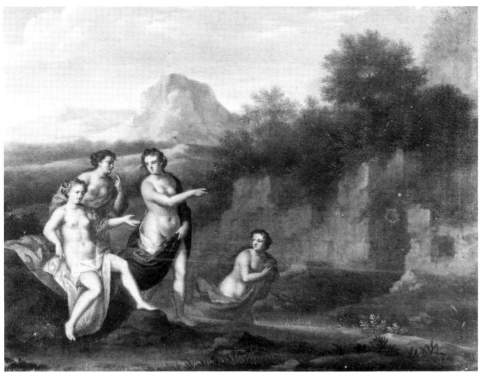

JAMES PALMER, 1584-1658. Miniature after Poelenburgh. 6½ins. x 9ins. Signed. Sotheby's sale 23.3.1949 (58).

PALMER, Sir James 1584 – 1658

Talented amateur limner; Chancellor of the Order of the Garter to Charles I, 1645. His portrait miniatures, in a style derived from Isaac Oliver, are signed 'I.P.' in monogram (*Graham Reynolds, Burlington Mag., XCI (July 1949), 196*). He also made miniature copies after old masters in the Royal Collection, which he had helped to form.

PARKER, J. fl.1637 – 1658

Portrait painter. A portrait of a lady, signed and dated 1637, was sold at Robinson & Foster's 26 November 1953 (124). It was in a slightly feebler version of the style of Gilbert Jackson (q.v.). On the strength of this several Evelyn family portraits have been attributed to Parker quite plausibly. He is mentioned as an amateur painter by W. Sanderson (*Graphice, 1658*).

PARMENTIER, Jacques 1658 – 1730

French history and portrait painter. Nephew and pupil of Sebastien Bourdon and later pupil of Charles de Lafosse (q.v.). Died London 2 December 1730. In England from 1680 and worked for Berchet (q.v.) and for Lafosse at Montagu House. From *c.*1694 to 1698 he worked for William II at The Hague (where his chief surviving work remains), but he later returned to England and settled in Yorkshire from *c.*1701 for twenty years.

(*E.C-M., 256; Waterhouse, 1981.*)

PATON (PATTON), David fl.1668 – after 1708

Portrait painter, especially in plumbago miniatures, but also on the scale of life. Miniatures after Samuel Cooper (q.v.) are dated 1668 and 1669. He

accompanied the Hon. William Tollemache (b. 1662) on the Grand Tour to Italy, where he certainly visited Florence and Venice (1677 miniature at Lamport); later worked mainly in his native Scotland until coming to London in his old age 1707/8 (*Burlington Mag., CII (June 1960), 260*). Fifteen of his plumbago miniatures (some after Cooper) are at Lennoxlove.

(*Long.*)

PEACHAM, Henry *c.*1576 – *c.*1643

Amateur painter and limner; primarily a man of letters. Born North Mimms, Hertfordshire, *c.*1576; admitted a scholar at Trinity College, Cambridge, 1593; probably died London *c.*1643. He was an abundant writer on the arts of drawing and limning, and 'in view of the technical knowledge displayed in his books, it may be presumed that he painted ...' (but no works are known) (*Long*). He travelled extensively.

(*D.N.B.; Talley, 46ff.*)

PEAKE, Robert (i) *c.* **1551 – 1619**

Portrait painter. Apprenticed to a goldsmith 1565; free of Goldsmiths' Company 1576; will (10 October) proved London 16 October 1619 (*M. Edmond, Burlington Mag., CXVIII (February 1976), 74*). Employed in the Revels 1576/77, but soon became a fashionable portrait painter. Serjeant-Painter, jointly with John De Critz i (q.v.), 1607; Picturemaker to Henry, Prince of Wales (d. 1612), for whom he painted the best official portraits; in 1613 painted 'Charles, Duke of York' for Cambridge University (Old Schools). He was the last, but not the most competent, of the exponents of Elizabethan 'medieval' portraiture. He was the father of William Peake and the grandfather of Sir Robert Peake (qq.v.)

(*R. Strong, Burlington Mag., CV (February 1963), 63ff.*)

See colour plate p.210.

PEAKE, Sir Robert (ii)　　　　　　　　　　　　　　　*c.*1605 – 1667

Painter, presumably portraitist. Son of William Peake (q.v.); buried London
2 August 1667. He was knighted at Oxford (as a lieutenant-colonel) 28 March
1645. His work has not been identified.

PEAKE, William　　　　　　　　　　　　　　　*c.*1580 – 1639

Portrait painter; son of Robert Peake i (q.v.); will proved London 5 September
1639. He was probably assistant to his father in his later years and continued
his father's style. A plausible attribution is 'A boy aged 5', 1627 (Rangers
House, Blackheath). Dobson (q.v.) and the engraver Faithorne were his
pupils.

(*M. Edmond, Burlington Mag., CXVIII (February 1976), 79.*)

PEARCE See PIERCE, Edward

PEARS, P.　　　　　　　　　　　　　　　fl.1683

A portrait of a man of the Yonge family ('Aetatis 38, 1683') is quite plainly
signed 'P. Pears fe.'

PEART (PAERT, PERT), Henry fl. 1679 – *c.* 1699

Professional copyist; occasionally painted portraits on his own. Recorded as copying Lely in 1679 (*Burlington Mag., XCVII (August 1955), 256*), but by then already a well-known copyist; died shortly before 1700 (Lord Bristol bought a collection from his widow 14 June 1700). Buckeridge says he had been a pupil of Francis Barlow and Symon Stone (qq.v.). The N.P.G. has three of his copies. He left a son of the same name who was also a copyist and still alive in 1741.

PEETERS See PIETERS, Jan

PEMBROKE, Thomas *c.* 1658 – *c.* 1686

A 'history and a face painter and disciple of Laroon' (*Buckeridge*). Known only from Buckeridge who says he painted several pictures for the Earl of Bath (1628-1701) 'in conjunction with one Woodfield ...' (q.v.) and died at the age of twenty-eight.

PEN(N), Jacob d. *c.* 1686

Known only from Buckeridge as a competent 'Dutch history painter' who 'died in London about twenty years ago' (i.e. 1686). A picture of 'St. Luke writing his gospel' was presented to the Painter-Stainers' Hall in 1723 and was still catalogued in 1913 as 'Jacob Pen. d. 1674'.

PENNI, Bartholommeo *c.* 1491 – *c.* 1553

Known in England as 'Batholomew Penny'. Probably born Florence 1491, the eldest of three painter brothers (one of whom, Luca, became a pupil of Raphael). In England he is always associated with Antony Toto (q.v.) and may have come to England with him about 1519 into Cardinal Wolsey's service. From 1530 until 1552/53 he was in receipt of an annuity in the service of Henry VIII. Denizen 1 September 1541. He is only documented as a decorative painter, but he presumably had greater capabilities.

(*E. C-M.*)

PEPYS, Elizabeth (Mrs. Samuel) 1640 – 1669

Amateur limner; wife of the diarist. In 1665 she had lessons in limning from Alexander Browne (q.v.) and Pepys, in his diary, mentions some of her limnings under 27 September 1665.

(*Long.*)

PERCIVALL, John fl. 1631 – 1651

'Picture-drawer' at Salisbury. The Salisbury Corporation paid him £6 in 1630/31 for portraits of the King, Queen and Earl of Pembroke, of which only the last survives (*C. Haskins, The Salisbury Corporation Pictures and Plate, 1910,*

51). An indenture of 25 July 1651 also exists concerning property at Wilton between 'John Percivall, picture-drawer of Newe Sarum' and another. In 1612 a John and a William Percivall, 'picture-drawers', subscribed towards a charter of incorporation for the City of Salisbury.

PERREAL, Jean *c.* **1455/60 – 1530**

French Court Painter and humanist; portrait painter. Born between 1455 and 1460, probably at Lyons; known as 'Jean de Paris'. Court Painter to Charles VIII, Louis XII and Francis I of France, and visited England in connection with a portrait of Mary Tudor, daughter of Henry VII, who married Louis XII. This portrait is not known and Perreal's work has proved elusive.

(*Best and most succinct account is Grete Ring, Burlington Mag., XCII (September 1950), 255ff.*)

PETITOT, Jean (i) **1607 – 1691**

Swiss miniature painter in enamel. Born Geneva 12 July 1607; died Vevey 3 April 1691. He was an extremely elegant practitioner of the enamel portrait miniature (often after Van Dyck and other painters). He was in England *c.*1637 to the early 1640s and worked for Charles I.

(*Long.*)

PETITOT, Jean (ii) **1653 – after 1700**

Portrait miniaturist in enamel. Born Blois 2 January 1653; thought to have died in London. Eldest son and pupil of Jean Petitot i (q.v.), whose style he carried on, but he was apprenticed to a miniaturist in London in 1677 and worked there until 1682; from 1683 in France; returned to London *c.*1696.

(*Long.*)

PHILLIPS, Thomas **fl.1664**

Welsh heraldic painter. '1664 July 30. Paid Thomas Phillips of llangollen painter for the King's armes he put up in llangollen hall'.

(*Chirk Castle Accounts, 1605-1666, 1908, 117.*)

PIERCE, Edward **fl.1630 – 1658**

Decorative and history painter. Free of Painter-Stainers' Company 1630; died Belvoir Castle 17 August 1658. He had been apprenticed to Rowland Buckett (q.v.) and had a good practice in the City of London for altarpieces, church ceilings, etc., but most of his work is said to have perished in the great fire of 1666 (*Buckeridge*). He is also said to have had a particular talent for perspective arrangements. His only surviving works are wall paintings at Wilton House (probably of shortly before 1654) which are based on Tempesta engravings. He himself published an etched 'Book of Freeze work' (*E.C-M.*). Two of his sons also were Painter-Stainers: John in 1651 and Thomas in 1655/56.

PIETERS (PEETERS), Jan *c.* **1667 – 1727**

Drapery painter, portrait painter, restorer and perhaps forger. Said to have been born at Antwerp; died London September 1727. Came to England 1685 and was drapery painter for Kneller until *c.*1712. He then worked largely as a restorer and improver of old masters. He was one of Vertue's most valued teachers.

(*Vertue, iii. 33.*)

PIPER See LE PIPER, Francis

PLACE, Francis **1647 – 1728**

Primarily an amateur draughtsman and etcher and engraver. Born in County Durham 1647; died York 21 September 1728. He is best known for his landscape drawings and etchings (good collection in B.M.; cat. of engravings in *H.M. Hake, Walpole Soc., X (1922), 39ff.*) He also painted animals and still-life. He abandoned London and the law as the result of the outbreak of the plague in 1665, and settled in York where he became one of the local virtuosi and was particularly friendly with William Lodge (q.v.). He was an amateur artist of fine sensibility (*D.N.B.*). There is a small oil self-portrait at Hospitalfield (*T. Moorman, Burlington Mag., XCIV (June 1952), 160*).

(*Croft-Murrary and Hulton, 456ff.*)

POELENBURGH, Cornelis van *c.* **1595 – 1667**

Dutch painter of Arcadian landscapes. Born Utrecht probably nearer 1595 than the usually given date of 1586; buried Utrecht 12 August 1667. Pupil of Bloemaert; studied in Italy (Rome and Florence) 1617-*c.*1626. Mainly resident at Utrecht for the rest of his life, except for occasional visits to London, to work for Charles I, in 1637, 1639 and perhaps 1641 (*C. White, Dutch Pictures in the Collection of Her Majesty the Queen, 1982, xxxiii*). He specialised in mythologies and also painted figures, usually female nudes, in the landscapes of others.

POLE **fl. 1689/90**

Portrait painter whose name appears in the Duke of Newcastle's accounts 1689/90 (*Goulding and Adams, 469*). One of the pictures is probably a full-length copy after Lely of 'Charles II' (Welbeck 479). He is perhaps the same as Thomas Pooley (q.v.).

POOLEY, Thomas **1646 – 1722/23**

Portrait painter and copyist, mainly working in Ireland. Born Ipswich 1646; buried Dublin 13 February 1722/23. Trained in England; working mainly in Dublin from 1677, often copying Lely.

(*Crookshank and Knight of Glin, 1978, 21; Strickland.*)

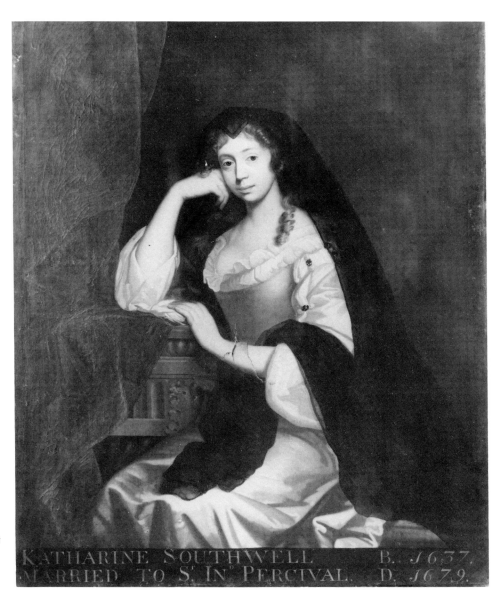

POQUET See BUCKETT, Rowland

PORTMAN, George fl. 1626 – 1637

Decorative landscape painter; already a practising painter when first mentioned in 1626. A 'View of Greenwich' by him was in the Royal Collection, and he painted landscape overmantels for Sir William Paston at Oxnead in 1633 (*E.C-M.*). De Mayerne quotes some technical recipes from him. He had a son, James, who was free of the Painter-Stainers in 1638 and was still alive in 1652.

POT, Hendrick Gerritsz *c.* 1585 – 1657

Dutch painter of portrait, history and genre. Born, probably at Haarlem, *c.* 1585; buried at Amsterdam 1 October 1657. He belongs to the Haarlem tradition of painting and lived there until 1648; later at Amsterdam. He visited England briefly and painted a small full-length of the King in 1632 (Louvre) and a royal group (Buckingham Palace). He signs 'H.P.', sometimes in monogram.

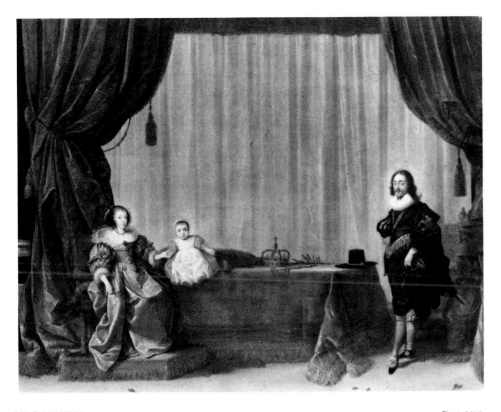

HENDRICK GERRITSZ POT, c.1585-1657. 'Charles I, Henrietta Maria and ?Charles, Prince of Wales'. Reproduced by Gracious Permission of Her Majesty the Queen.

?POUVEY fl.1679

In the 5th Earl of Exeter's accounts for 1679 £40 was paid 'Mr. ?Pouvey' for portraits of the 4th Earl and his wife.

(*Note from Geoffrey Beard.*)

POWELL, Martin fl.1686 – 1711/12

A member of the Painter-Stainers' Company, who lived in Cat Street, Oxford, *c.*1686 until his death in 1711/12. He painted several versions of a rather rustic portrait of 'Mother George', who lived to the age of 120 in 1691 (*Poole, III, index*). He was probably the all-purpose painter at Oxford during these years.

PRIEUR, Paul *c.*1620 – after 1682

Miniaturist in enamel. Trained in Geneva and worked in France, Spain, England and Denmark (1671-1680). His latest known enamel is signed 'à Londres 1682'. His work is of very high quality.

(*Long.*)

PRIWIZER, Johann fl.1627 – 1635

Portrait painter of Hungarian origin. He is only documented by his signature, 'Johanes Priwizer de Hun/garia Faciebat', on a portrait, dated 1627, of 'Lord William Russell and his dwarf' at Woburn, but he certainly painted panel portraits (26ins. x 20ins.) of all the other children of the 4th Earl of Bedford, also dated 1627. His style is like that of Cornelius Johnson i (q.v.), but with a rather more porcelainy finish and a general pink and silver tonality. Other portraits of children can plausibly be attributed to him, but his name is not otherwise known.

(*Collins Baker, I, 61ff.; The Age of Charles I, exh. cat., Tate Gallery 1972, 30.*)

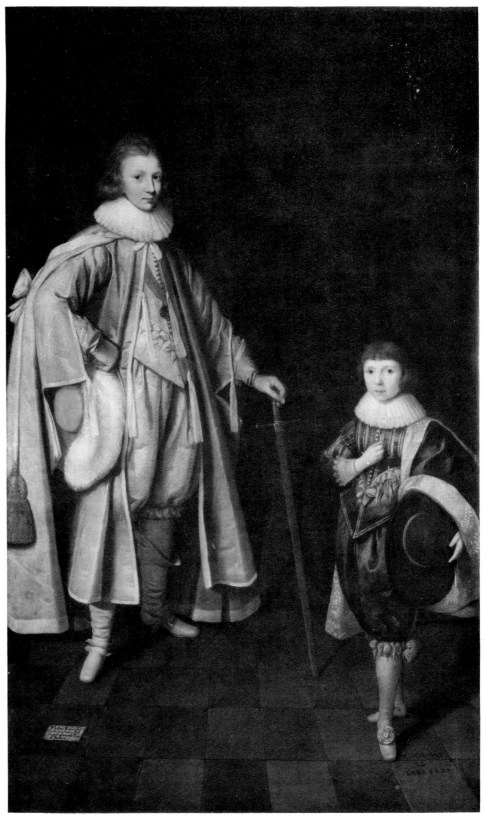

JOHANN PRIWIZER, fl.1627-1635. 'Lord William Russell and his dwarf'. 83ins. x 49ins. s. & d. 'Johanes Priwizer de Hun/garia Faciebat 1627'. By kind permission of the Marquis of Tavistock and the Trustees of the Bedford Estates.

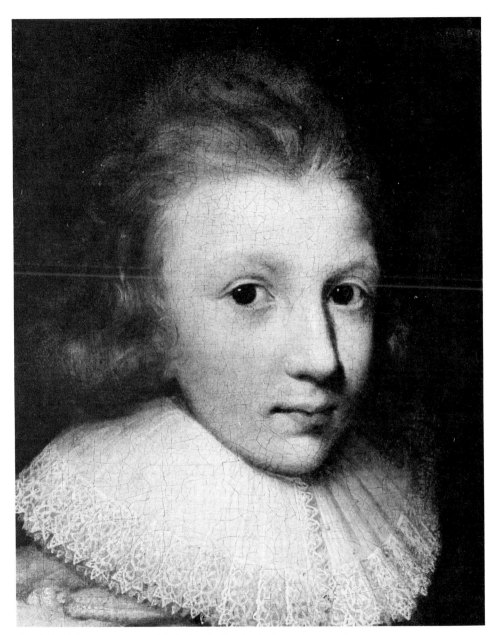

JOHANN PRIWIZER, fl. 1627-1635. Detail of illustration opposite.

QUESNEL, Pierre fl. *c.*1538 – 1580

French painter (?of portraits) and designer of tapestries; father of the French Court Portraitist François Quesnel, who was born in Scotland, and of other painters. He was taken into the service of James V of Scotland by Marie de Lorraine (married 1538) and was in Edinburgh in 1545; back in Paris by 1561.

(*L. Dimier, Le portrait en France au XVI siècle; information from Professor H. Miles.*)

RAFF See CORVUS, Joannes

PIERRE QUESNEL, fl. c.1538-1580. 'Lady Dorothy Shirley'. 1567. Warwick District Council.

RANKEN, William **fl.1685**

The inscription 'Gu: Ranken fecit 1685' appears on the back of a picture said to be of 'Sir John Scott, 1st Bart.', formerly in a Scottish collection.

RAWLINSON **fl.?1650s**

A small-scale full-length of 'Queen Henrietta Maria', 1650s, probably not from life (Mellerstain) is inscribed in the handwriting of Lady Grisel Baillie 'Rawlinson P.'. At least one other picture by the same hand is known. The style is based on early Lely.

READER, William fl.1672 – after 1700
Portrait painter. Born Maidstone, Kent. Vertue (*iv, 83*) reports he 'was
reduced and got into the Charterhouse' *c*.1700. He was a pupil of Soest (q.v.)
and lived for some time in the house of a nobleman (perhaps of the Finch
family). His earliest known portrait is dated 1672. He was a clumsy portraitist
of some character.

REMEE See LEEMPUT, Remee van

REYN, Jean de *c*.1610 – 1678
Portrait and history painter. Born Bailleul *c*.1610; died Dunkerque 20 May
1678. He is said (*Descamps, II, 189ff.*) to have accompanied his master Van
Dyck (q.v.) to England and stayed with him till his death, being an extremely

WILLIAM READER, fl.1672-after 1700. Portrait of a boy. 57ins. x 41ins. Robinson & Fisher sale 17.6.1938 (166).

accomplished copyist, but he was settled at Dunkerque by 1640 ('Martyrdom of the Four Crowned Saints', St. Eloi, Dunkerque) and perhaps earlier. His powerful altarpieces show little Van Dyck influence and his only picture possibly painted in England is a female portrait in the Brussels Gallery signed and dated 1637.

(*Cat. de l'exposition Le siècle de Rubens, Paris 1977, 145-148.*)

JONATHAN RICHARDSON, 1664/65-1745. 'Edward Rolt and his sister Constantia'. 75½ins. x 57ins. With Colnaghi, London, 1983.

RICHARDSON, Jonathan **1664/65 – 1745**

Portrait painter and writer on art and literary topics. Born London 1664/65; died there 28 May 1745. He was a pupil of John Riley (q.v.), at whose death in 1691 he became his heir and married his niece. He was the best native-born portraitist of his generation and his style in the later 1690s is half-way between that of Riley and Kneller. Most of his known work dates from after 1700 (*Waterhouse, 1981*) and has the character of sound prose. He owned one of the greatest collections of old master drawings.

(*D.N.B.*)

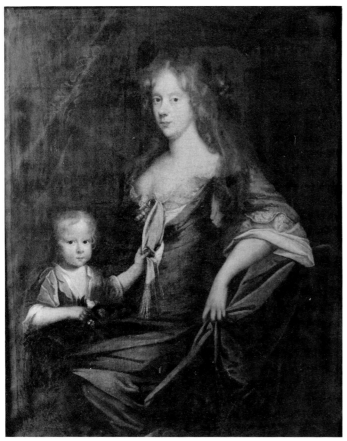

JOHN RILEY, 1646-1691. 'Mary Masters, wife of Sir Richard Spencer of Offley, and her son John'. 50ins. x 40ins. Sotheby's sale 10.7.1985 (32).

JOHN RILEY, 1646-1691. 'A scullion of Christ Church'. 38¼ ins. x 23ins. The Governing Body, Christ Church, Oxford.

RILEY, John
1646 – 1691

Portraitist. Born London 1646, where his father was Lancaster herald; died there 27 March 1691. His name is sometimes spelled Royley or Ryland (once perhaps Rowley). Pupil of Isaac Fuller and Gerard Soest (qq.v.), he is said to have been in good practice among the middle classes before Lely's death (1680), but most of his known works are later and he did not join the Painter-Stainers' Company until 1682. In December 1688 he and Kneller (q.v.) were jointly 'sworn and admitted chief painter' to the King. From *c.*1688 he had an arrangement with John Closterman (q.v.) that Riley did the heads and Closterman the draperies, etc., of half- and full-lengths; he also took on J.B. Gaspars (q.v.) for 'postures'. He has a good sense of the character of unpretentious sitters and serious men. He was the teacher of J. Richardson (q.v.).

See colour plate p.229.

ROBINSON, Robert
fl.1674 – 1706

All-purpose painter and scene painter. Made free of the Painter-Stainers 1674;

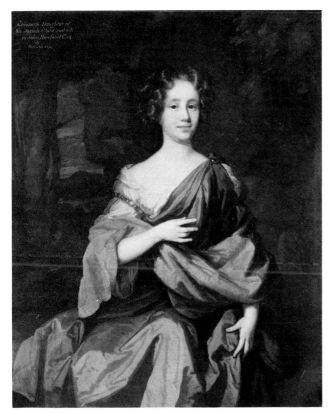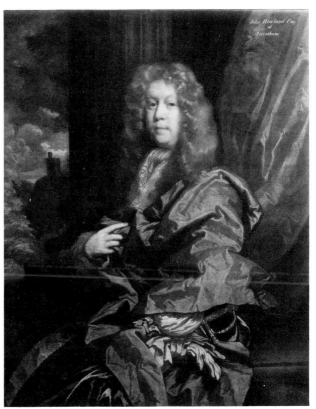

JOHN RILEY, 1646-1691. 'Elizabeth, wife to John Howland Esq.'. By kind permission of the Marquis of Tavistock and the Trustees of the Bedford Estates.

JOHN RILEY, 1646-1691. 'John Howland Esq. of Streatham'. By kind permission of the Marquis of Tavistock and the Trustees of the Bedford Estates.

buried London 6 December 1706. Probably son of another decorative painter, he took on a number of apprentices. He also experimented in mezzotinting and specialised in exotic scenes.

(*E.C-M.*)

ROESTRAETEN, Pieter Gerritsz van *c.*1627 – 1700

Dutch painter of genre and, especially, still-life. Born Haarlem *c.*1627; buried London 10 July 1700. Said to have been a pupil of Frans Hals, whose daughter he married (1654), but perhaps more influenced, in his genre pictures, by Jan Steen. Probably came to England in the 1670s (a set of six genre scenes, with dates ranging from 1672 to 1676, is in a private collection). By 1678 he had begun to specialise in still-life arrangements of 'gold and silver plate, gems, shells, musical instruments, etc.' (*Buckeridge*), at which he became very adept.

ROSSE (ROSE), Susannah Penelope *c.*1652/55 – 1700

Miniaturist. Born London 1652 (*Buckeridge*) or 1655 (*Vertue*); buried there 30 October 1700. Daughter and pupil of the dwarf miniaturist Richard Gibson (q.v.) but also studied and copied Samuel Cooper (q.v.). She signs 'S.R.' or 'S.P.R.', and was a very capable executant. She married a jeweller, Michael Ros(s)e.

(*Edmond, 108/9; Long.*)

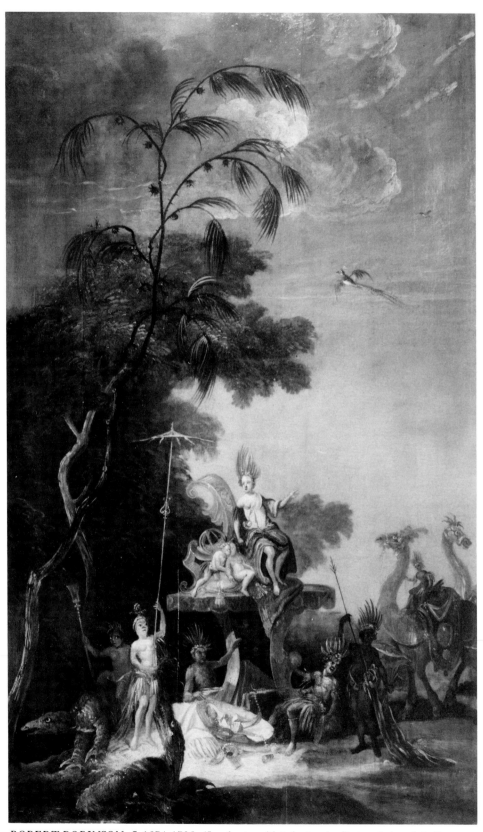

ROBERT ROBINSON, fl. 1674-1706. 'Landscape with palm trees'. By permission of the Governors of the Sir John Cass's Foundation.

228

JOHN RILEY, 1646-1691. 'Elias Ashmole' (1617-1692). 49ins. x 39¾ins. Ashmolean Museum, Oxford.

PIETER GERRITSZ VAN ROESTRAETEN, c.1627-1700.
Genre scene. 30ins. x 24ins. s. & d. 1672. Private collection.

PIETER GERRITSZ VAN ROESTRAETEN, c.1627-1700.
Still-life. 103ins. x 82ins. Christie's sale 27.6.1958 (15).

ROUSSEAU, Jacques 1630 – 1693

French specialist in 'ruin pieces and perspectives' and later in landscapes of a Poussinesque character; also an etcher. Said to have been born Paris 1630; died London 16 December 1693. He came from a Protestant family and perhaps formed his style under Swanevelt, whose sister he married. In Rome 1654/55; received into the French Academy 1662, but emigrated first to Switzerland and then to Holland as the result of the revocation of the Edict of Nantes 1685. He came to London *c.*1689/90 at the invitation of the Duke of Montagu and was put in charge of the decoration of the staircase of Montagu House (cf. Lafosse and Momoyer). He also painted overdoors (some now at Hampton Court) and some classical landscapes for the Duke of Montagu (one remains at Boughton).

(*E.C-M.*)

ROWLEY (ROYLEY) See RILEY, John

ROYDEN VAN See EYDEN, Jeremias van der

RUBENS, Sir Peter Paul 1577 – 1640

The greatest master of the northern Baroque and a dominating figure in

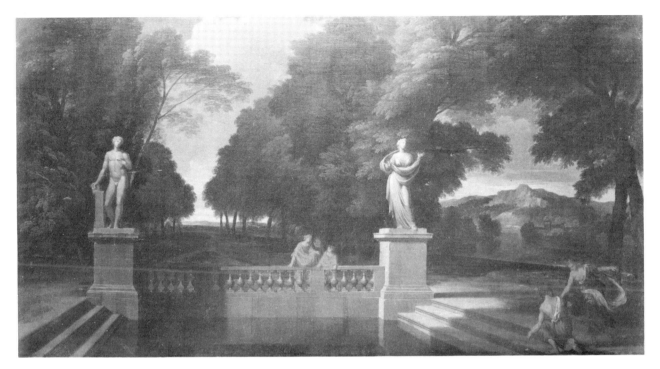

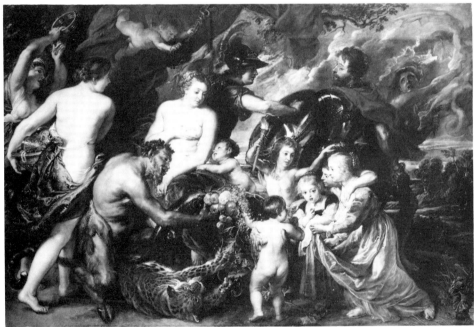

PETER PAUL RUBENS, 1577-1640. 'Minerva protects Pax from Mars — an allegory of Peace and War'. N.G.

seventeenth century art in northern Europe. Born, probably at Siegen, 28 June 1577; died Antwerp 30 May 1640. He visited London on a diplomatic mission from Philip IV of Spain from May 1629 to March 1630; knighted by Charles I as 'Ambassador from the Archduchess' 21 February. In London he stayed in the house of Gerbier (q.v.), whose family he painted (National Gallery Washington, perhaps finished in Antwerp). He painted in England

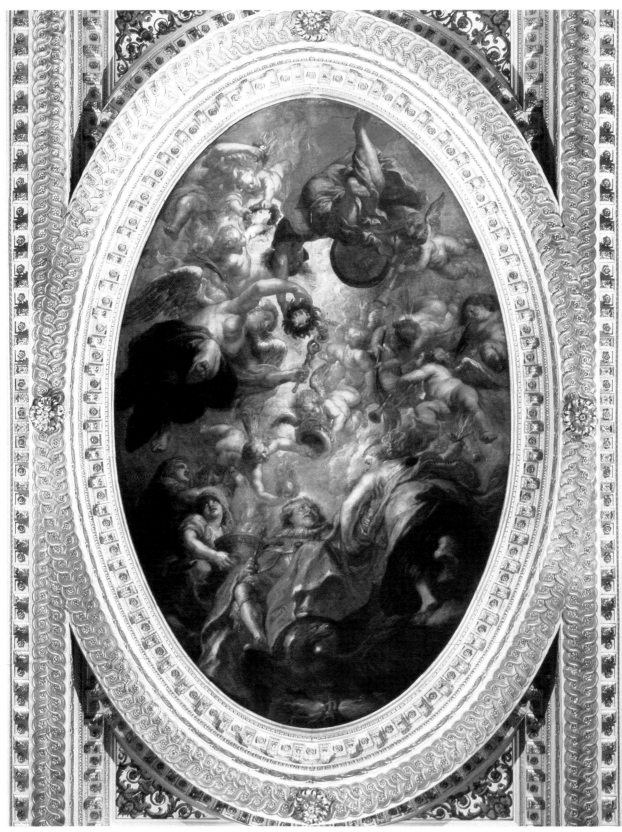

PETER PAUL RUBENS, 1577-1640. 'The Apotheosis of James I'. Ceiling of the Banqueting Hall, Whitehall, London. Crown Copyright: Reproduced with the permission of the Controller of Her Majesty's Stationery Office.

PETER PAUL RUBENS, 1577-1640. 'Summer'. Reproduced by Gracious Permission of Her Majesty the Queen.

the 'Allegory of Peace and War' (N.G.) which he gave to Charles I, and the 'St. George and the dragon' (Buckingham Palace). He also received in England the commission for the ceiling for the Whitehall Banqueting Hall. But the influence of Rubens on British painting was largely mediated through Van Dyck (q.v.) who, though not Rubens' 'pupil', formed his style very largely from that of Rubens.

(*Per Palme, 'Triumph of Peace', Uppsala 1957; Oliver Millar, Rubens: The Whitehall Ceiling, 1958.*)

RUSE fl.1653
A Dutch miniaturist recorded as working in London in 1653.

(*Long.*)

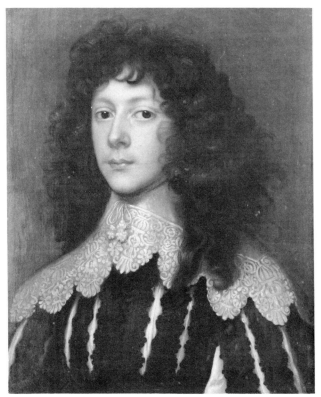 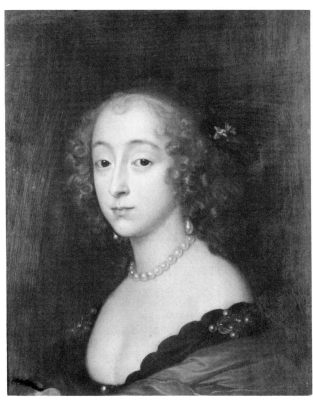

ANTHONY RUSSEL, c.1663-1743. 'Henry Murray'.
15½ins. x 12ins. Sotheby's sale 16.11.1966 (71/2).

ANTHONY RUSSEL, c.1663-1743. 'Anne, Viscountess
Bayning'. 15½ins. x 12ins. Sotheby's sale 16.11.1966 (71/1).

RUSSEL, Anthony *c.*1663 – 1743

Portrait painter of very modest powers. Died London July 1743 aged about 80
(*Vertue*). Son of Theodore Russel (q.v.). He went as a pupil to Riley about
1680.

(*Waterhouse, 1981.*)

RUSSEL, Theodore 1614 – 1688/89

Portrait painter. Baptised London 9 October 1614; died there 1688/89. His
grandfather, named Roussel, had come from Bruges and settled in London in
the 1570s as a jeweller. He was for nine years a pupil of Cornelius Johnson
(i) and then spent a year with Van Dyck (qq.v.). One or two portraits of 1644
(one signed and three companions at Knebworth) reveal these origins, but his
main speciality was small copies (usually the head only) on panel after Van
Dyck. No signed example of these is known, but there is a group at Woburn
traditionally given to him. They are very neatly and competently painted.

(*Edmond; Vertue.*)

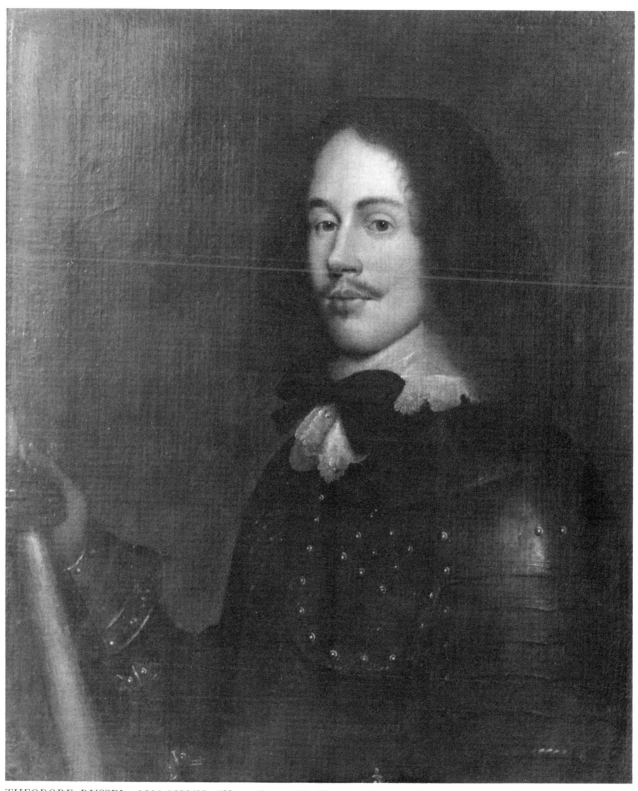

THEODORE RUSSEL, 1614-1688/89. 'Henry Cromwell'. 29ins. x 24ins. s. & d. 1644.
Christie's sale 30.3.1951 (24).

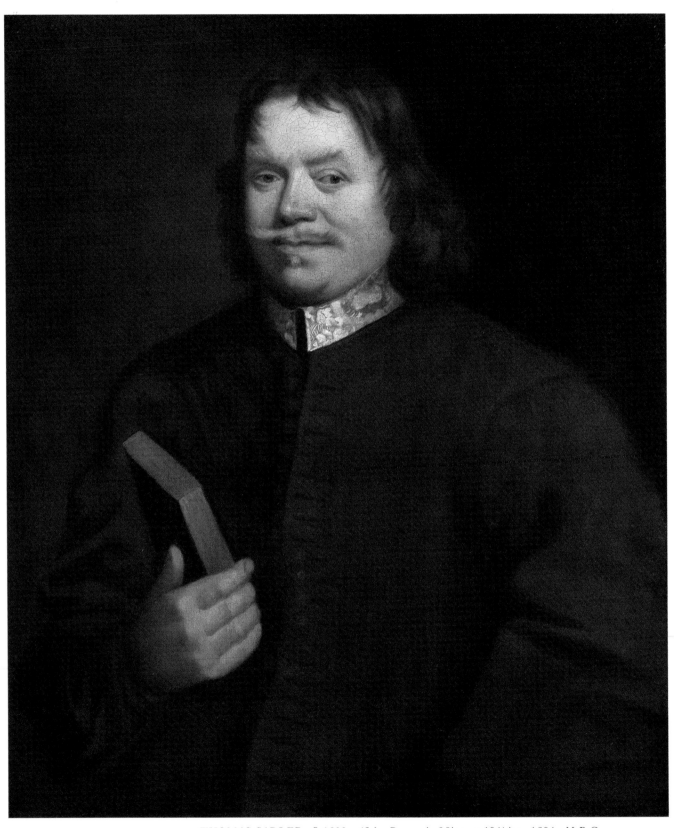

THOMAS SADLER, fl.1680s. 'John Bunyan'. 25ins. x 19½ins. 1684. N.P.G.

WILLEM DE RYCK, fl.1673-c.1699. 'Charles Amherst'. 28½ins. x 23ins. Signed 'G. de Ryck'. Robinson & Fisher sale 29.7.1937 (161), and Sotheby's sale 18.1.1967 (188).

WILLEM DE RYCK, fl.1673-c.1699. 'Dorothy, second wife of Jeffery Amherst'. 50ins. x 40ins. Signed 'G. de Ryck'. Robinson & Fisher sale 29.7.1937 (130).

RYCK, Willem (Guillaume) de fl.1673 – c.1699

Flemish portrait and history painter. Master in the Antwerp Guild 1673/74; died London c.1699 (*Buckeridge, 368* under 'William Deryke'). Pupil of Erasmus Quellinus at Antwerp and still there in 1684; in London by 1688 (a 'Christ on the Cross', sold Sotheby's 1 November 1972 (141), was signed 'G. de Ryck F./Lond. A°. 1688). A portrait at Longleat of a lady is also signed and dated 1688. In Robinson & Fisher sale 29 July 1937, lots 129, 130, 161 and 163 were English sitters all signed 'G. de Ryck' in a style like that of Riley.

(*Vertue.*)

SADLER, Thomas fl.1680s

Portraitist on scale of life and reportedly in miniature. Said to have been the second son of John Sadler (*D.N.B.*), who married in 1645, and to have had some teaching from Lely. His background was nonconformist and he painted 'John Bunyan' in 1684 (N.P.G.). A portrait of 'Mary Bryan' (private collection), of no decided character, is also said to be signed and dated 1684 on the back. He perhaps lived to near 1700.

ISAAC SAILMAKER, 1633-1721. 'The first Britannia'. *30ins. x 46ins. s. & d. 'I.S. 1683'. Christie's sale 27.10.1961 (127).*

SAILMAKER, Isaac **1633 – 1721**

Painter of shipping and marine subjects. Born Scheveningen; died London 28 June 1721 aged 88 (*Vertue, i, 74*). He came young to London and worked first for Geldorp (q.v.). He was a rather pedestrian marine artist.

(*Archibald.*)

SALABOS(SH), Melchoir **fl.1571 – 1588**

Portrait and herald painter. Chiefly known from a remarkable monument (with full-length portraits and much heraldry) to the Cornewall family, 1588, at Burford, Salop. (*E.C-M.*). He is said to have been known as 'Gerardino Milanese'.

(*The House of Cornewall, Hereford, 1908, 210.*)

SAMPSON See STRONG, Sampson

*GODFRIED SCHALCKEN, 1643-1706. 'William III'. 29¼ins. x 24½ins. Signed. Christie's
sale 22.7.1938 (117).*

SAVIL(L), D. fl.1652 – 1661(?1662)

Miniaturist. Certainly known (without any initial) from Pepys's *Diary* for
1660-1661(?1662) (*Long*). It seems likely that he was the same as the 'Savill'
after whom Hollar engraved a portrait, 1652, of 'John Rogers', and the 'D.
Savil' after whom T. Cross engraved a portrait of 'Lambroch Thomas'
(*Redgrave's* Dorothea Saville for these seems to be a myth!).

SCHALCKEN, Godfried 1643 – 1706

Dutch painter of portraits and specialist in candle-light scenes. Born Made,
near Dordrecht, 1643; died The Hague 13 (or 16) November 1706. His main
teacher was G. Dou. He may have been in England briefly before 1692, when
he came, with his family, for some years (perhaps until 1697), when he painted
portraits of William III and was employed by Lord Sunderland at Althorp.

(*Hofstede de Groot, V.*)

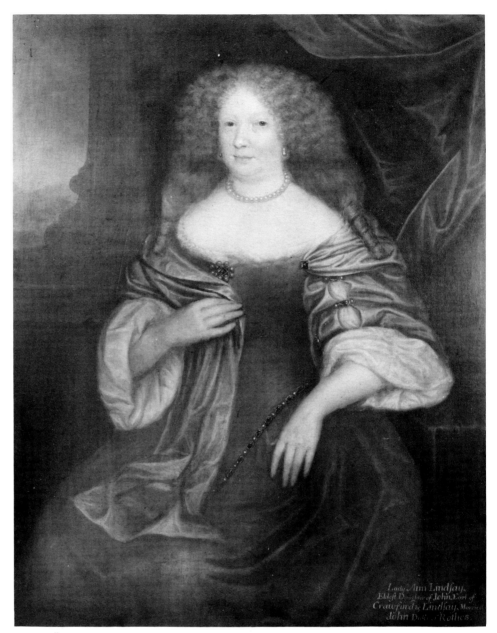

L. SCHÜNEMANN, fl.1666/67. 'Ann Lindsay, Duchess of Rothes'. Private collection. Photograph Paul Mellon Centre.

SCHÜNEMANN, L. fl.1666/67

Portraitist working in Scotland by whom signed works are known from the middle 1660s (*Waterhouse, 1978*). A portrait bearing a date of 1681, formerly at Invereil, and with 'L.S.' in monogram, may also be by him.

SCOUGALL, David fl.1654 – 1672

Scottish portraitist and the earliest of the name of Scougall certainly known; an earlier putative John Scougall is probably a myth (*Cat. of Paintings and Sculpture, National Gallery of Scotland, 1957, 248*). He was perhaps influenced by John Michael Wright (q.v.) in the 1660s.

(*Waterhouse, 1978, 122.*)

DAVID SCOUGALL, fl.1654-1672. 'Anne, Duchess of Hamilton'. Brodick Castle (National Trust for Scotland).

JOHN SCOUGALL, c.1645-1730. 'Lord David Hay' (1656-1727). 36ins. x 30ins. Private collection.

SCOUGALL, John *c.*1645 – 1730

The leading Scottish portraitist of his time; died Prestonpans 'aged 85'. He was known as 'Old Scougall' to distinguish him from a deplorable son, ?George, who was only active in the eighteenth century. He may have been a son of David Scougall (q.v.), and his earliest known works (of 1675) also suggest some knowledge of John Michael Wright (q.v.). His later works are increasingly feeble and he probably gave up painting about 1715.

(*Waterhouse, 1978, 123.*)

SCROTS, Guillim (William) fl.1537 – 1553

Court portrait painter from The Netherlands. Painter to Mary of Hungary, Regent of The Netherlands, 1537, and persuaded to come to England in late 1545, probably to succeed Holbein (q.v.). He was perhaps the ablest available Hapsburg Court portrait painter at the time. He disappears from the royal accounts in 1553.

(*Auerbach; Waterhouse, 1978, 24/26.*)

GUILLIM SCROTS,
*fl.1537-1553. 'Edward VI'.
Reproduced by Gracious
Permission of Her Majesty
the Queen.*

242

GUILLIM SCROTS, fl.1537-1553. 'Henry Howard, Earl of Surrey'. 87½ins. x 86½ins. Arundel Castle (N.P.G.).

SEBRIGHT (SEABRIGHT) See SIBERECHTS, Jan

SEGAR, Francis fl.1598

Mentioned by Francis Meres (*Palladis Tamia, 1598*) as brother of William Segar (q.v.) and also a painter, but he seems to have spent most of his life out of England.

(*Strong, 215.*)

SEGAR, Sir William fl.1585 – 1633

Portrait painter and miniaturist and Herald. Died December 1633. His career as a Herald is well documented (*E. Auerbach, Nicholas Hilliard, 1961, 271ff.*); he was certainly a painter and it is not certain if the known miniature of 'Dean Colet' (Mercers' Company) and portrait of 'Robert Devereux, Earl of Essex' (Dublin) are by him or his brother Francis (q.v.). He may well have given up portraiture on being appointed Garter King of Arms (1607), but either William or Francis was an important portraitist at the end of Queen Elizabeth's reign.

(*Auerbach, op. cit.; D.N.B.; Strong, 218ff.*)

WILLIAM SEGAR, fl.1585-1633. 'Robert Devereux, Earl of Essex'. 44½ins. x 34½ins. 1599. Possibly by Francis Segar (q.v.). The National Gallery of Ireland, Dublin.

WILLIAM SEGAR, fl.1585-1633. Portrait of a lady. Present whereabouts unknown. Photograph Courtauld Institute of Art.

SHEPPARD, William fl.1641 – after 1660

Portraitist. Mentioned in Painter-Stainers' records in 1641; living in London after the Restoration and said to have retired to Yorkshire. He was travelling in 1650/51, and was in Rome, Venice and Constantinople (*Long*); by 1658 he was in good practice in London. He was the first teacher of Francis Barlow (q.v.). Apart from one engraved portrait, his one certain work is a portrait of 'Thomas Killigrew', painted at Venice, 1650, of which many versions are known, one signed and dated is in N.P.G. (*D.N.B.*). He seems to have been influenced by Van Dyck (q.v.).

SHUTE, John fl.1550 – 1563

Painter and architect; author of *The First and Chief Grounds of Architecture*, 1563. Born Cullompton, Devon; died London 25 September 1563 (*Long*). He was a protégé of John Dudley, Duke of Northumberland, who sent him to Italy in 1550 to study architecture. He may also have practised as a miniaturist, but no certain works are known.

(*Auerbach, 84/85; D.N.B.*)

SIBERECHTS, Jan 1627 – c.1703

Flemish painter of landscape in oil and watercolour. Baptised Antwerp (where his father was a sculptor) 29 January 1627; died London c.1703 (*Buckeridge*). He was a master at Antwerp 1648/49, and was still living there in 1672, which

WILLIAM SHEPPARD, fl.1641-after 1660. 'Thomas Killigrew'. 47ins. x 38½ins. s. & d. 1650. N.P.G.

is about the time he settled in England, where he remained until his death. His earliest landscapes (1651) suggest experience of Italy or at least of Italianising Dutch painters, but he developed a Flemish landscape style, with peasant figures, wholly independent of Rubens, which he continued to exploit after settling in England. In England he also perfected a type of country-house portrait and made some remarkable bird's-eye views of country estates. He also painted a few panoramic views of English river valleys, which are almost the beginnings of native landscape. He is recorded as having painted much in watercolours, but few such works are known, though those few are remarkable. He usually signed and dated his works and the latest so far known are from the end of the 1690s.

(*T.H. Fokker, J. S., Bruxelles 1931, with cat.*)

See colour plate p.246.

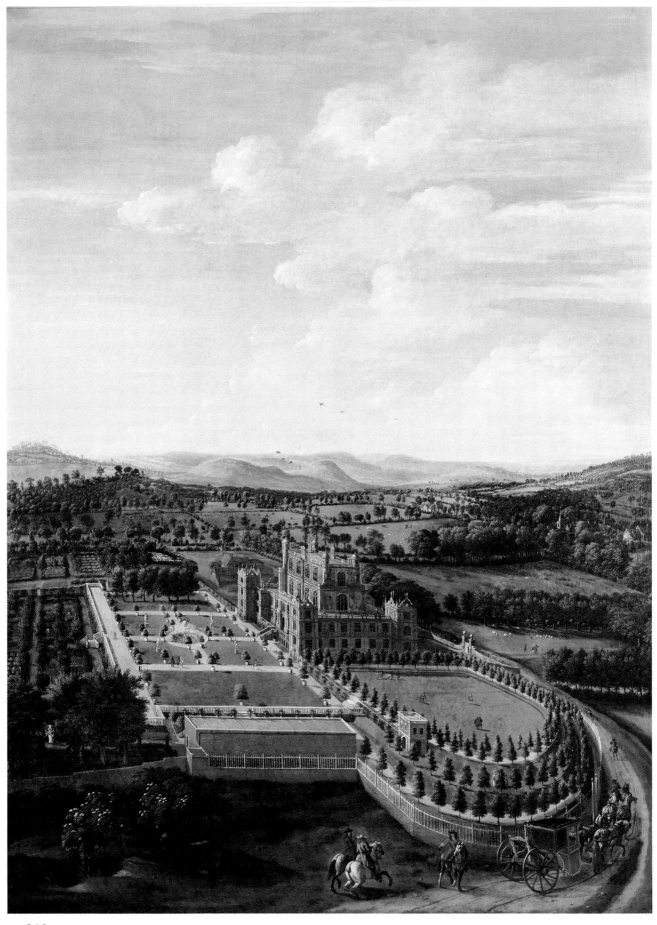

SITTOW, Michel 1469 – 1525

Court Painter to Isabella the Catholic of Spain (1492-1502), and to Margaret of Austria (1515/16); often known as 'Master Michel'. Born Reval 1469; died there 1525. He was trained at Bruges. He is generally credited with having painted in England the portrait of 'Henry VIII' (N.P.G., 416), dated 20 October 1505, which was sent to Margaret of Austria.

(Martin Weinberger, Burlington Mag., XC (September 1948), 247ff.)

Opposite:
JAN SIBERECHTS, 1627-c.1703. 'Wollaton Hall and Park, Nottinghamshire'. 75½ins. x 54½ins. B.A.C. Yale, Paul Mellon Collection.

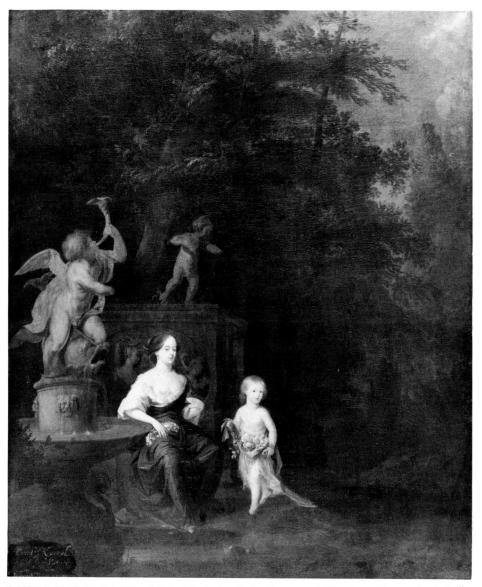

GASPAR SMITZ, fl.1662-c.1689. 'Catherine Cecil, Countess of Kinoul, and her son'. Collection of the Marquis of Salisbury, Hatfield House. Photograph Courtauld Institute of Art.

SKINNER, Martin fl.1698

Portrait painter in Dublin. Admitted to Guild of St. Luke, Dublin, 1698, on presentation of a portrait of 'William III'. He was dead in 1702.

(*Strickland.*)

SMITZ (SMITH), Gaspar fl.1662 – *c.*1689

Painter of portraits, history and still-life, and especially pictures of the Magdalen (hence known as 'Magdalen Smith'). Said to be a Dutchman (but perhaps Flemish); in England by 1662 ('Magdalen' in Painter Stainers' Hall, London, is so dated but the monogram seems to be 'S.F.'). In Dublin by the 1670s, where he died *c.*1689 (or 1707). He was also a restorer and picture dealer. Some religious pictures are at Hatfield.

(*Crookshank and Knight of Glin, 1978.*)

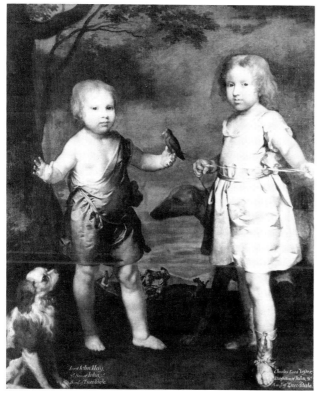 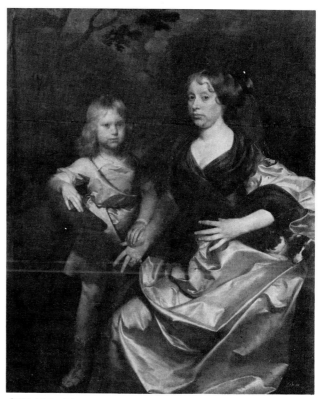

GERARD SOEST, c.1600-1680/81. 'Lord John Hay and Charles, Lord Yester, sons of the 2nd Marquis of Tweedale'. 50ins. x 40ins. B.A.C., Paul Mellon Collection.

GERARD SOEST, c.1600-1680/81. Portrait of a lady with her son. 57ins. x 47ins. Christie's sale 18.3.1949 (127).

SNELLING, Matthew 1621 – 1678

Miniaturist and occasional portraitist on the scale of life. Son of Thomas Snelling (d. 1623), Mayor of King's Lynn; died 1678. He was early friendly with Samuel Cooper (q.v.), and was, perhaps, to some extent an amateur. Dated works (signed 'M.S.') range from 1647 to 1674 and are of good quality (*Murdoch &c., 142ff.*). He has been confused with a drawing master, Matthew Simpson.

SOEST (ZOUST), Gerard *c.*1600 – 1680/81

Portrait painter, perhaps the most sensitive of Lely's rivals. Said to have been born at Soest in Westphalia and to have been about 80 when he died in London 11 February 1680/81. His training seems to have been Dutch and he was probably in England by the middle 1640s. He had good patronage after the Restoration, but not in Court circles, and he stressed human rather than social values in his sitters. His prices were lower than Lely's (in 1667 £3 for a head, as opposed to Lely's £15). His rather pulpy hands and drapery folds suggestive of zinc make his portraits easy to recognise. He was the teacher of John Riley (q.v.). A picture in the Boston Museum (49.1707: 'Inspiration of an artist'), probably of the 1650s, is the only work other than a portrait so far known.

(*Waterhouse, 1978, 101ff.*)

GERARD SOEST, c.1600-1680/81. 'Captain Robert Harland'. 30ins. x 25ins. Private collection.

WILLEM SONMANS, fl.1670s-1708. Portrait of a girl. 27ins. x 24½ins. Private collection. Photograph Courtauld Institute of Art.

SOMER See **VAN SOMER, Paul**

SON(D) See **VANSON, Adriaen**

SONMANS (SUNMAN), Willem fl.1670s – 1708

Portraitist of Dutch origin. Native of Dordrecht; buried London 15 July 1708 (*Th.-B.*). Also sometimes called 'Souman'; signs 'W.S.'. He came into some prominence after Lely's death and was based in London, but spent term-time in Oxford, where a few academic portraits remain (*Poole*). His style has echoes of both Riley and Kneller.

(*D.N.B. s.v. Sunman.*)

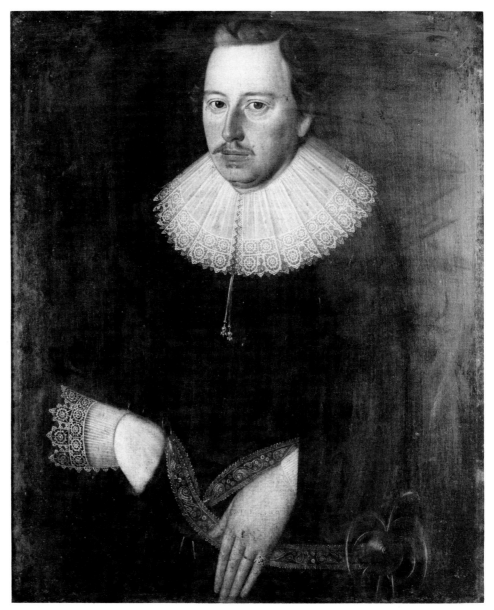

JOHN SOUCH, c.1593-1645. 'Sir Roger Puleston'. 29ins. x 24ins. 1618. Christie's sale 28.11.1958 (122).

SONNIUS, ?Frederic **fl.1680 – 1688**

One of the principal assistants in Lely's studio and active in completing his unfinished portraits. Described as 'old and touchy' in 1688.

(*Talley.*)

SORA, Henry **fl.1590**

Painter of unknown character. He married 1590/91 a daughter of the Serjeant-Painter, Leonard Fryer (q.v.).

(*Edmond.*)

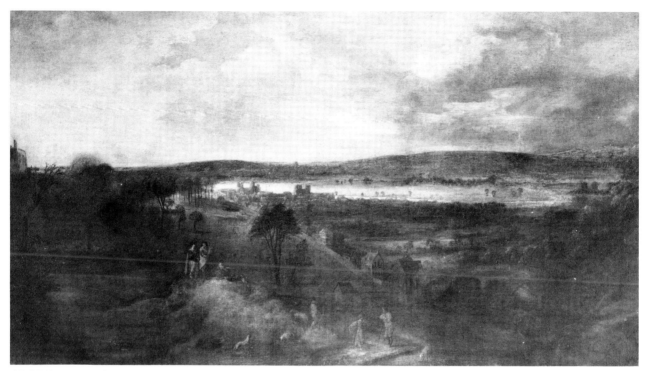

ADRIAN VAN STALBEMT, 1580-1662. 'View of Greenwich'. Reproduced by Gracious Permission of Her Majesty the Queen.

SOUCH, John *c.* **1593 – 1645**

Cheshire portrait painter. Apprenticed to Randle Holme (q.v.), the herald painter at Chester, 1607-1617, when he became a Freeman at Chester. Apparently died 1645. His chief work, showing a humanised variant of a heraldic style, is 'Sir Thomas Aston at the deathbed of his first wife', 1635 (Manchester City Art Gallery). There is a marriage portrait, signed 'J.S. Fec. 1640', in the Grosvenor Museum, Chester. He was paid 30s. for a portrait of the Earl of Cumberland, 1620, and took one Thomas Pulford as an apprentice 1636.

(*Waterhouse, 1978, 63/64; N.A.C.F. Report 1983.*)

SOUVILLE, Alexandre **fl.1685 – 1694**

French painter; assistant to Verrio. None of his work is known to survive.

(*E.C-M.*)

STALBEMT (STALBENT), Adrian van **1580 – 1662**

Flemish painter of topographical landscapes. Born Antwerp 12 June 1580; died there 21 September 1662. Brought up at Middelburg, but returned to Antwerp where he became a Master in 1609. He briefly visited England 1632/33, when he painted a 'View of Greenwich', with figures of the royal family by Belcamp, which is still in the Royal Collection.

ABRAHAM STAPHORST, 1638-1696. 'Lord Robert Russell'. 30ins. x 24ins. Signed. By kind permission of the Marquis of Tavistock and the Trustees of the Bedford Estates.

HENDRIK VAN STEENWYCK (ii), fl.1604-1649. '3rd Earl of Pembroke'. Private collection.

STAPHORST, Abraham 1638 – 1696

Dutch portrait painter. Born Edam, near Dordrecht, 1638; died Dordrecht 1696. He visited England (?twice) and painted half a dozen portraits for the Duke of Bedford in February 1660/61, one of which survives at Woburn.

(*G. Scott Thomson, Life in a noble household, 1641-1700, 1937, 292.*)

STEENWYCK, Hendrik van (ii) fl.1604 – 1649

Painter in a Flemish tradition of architectural scenes (especially church interiors) and backgrounds. Probably born at Frankfurt (whither his father had fled from Antwerp); died in The Netherlands 1649. Pupil of his father (Hendrik Steenwyck i), who also painted church interiors. He was active by 1604 and in England by 1617, where he remained until 1637. He received some patronage from Charles I and painted architectural backgrounds for certain portraits of the King (e.g. that at Turin 1625/27 signed by both Mytens and Steenwyck). He probably latterly lived in the northern Netherlands, where his widow was recorded, at Leyden, in 1649. He was a very neat executant and the figures in his architectural paintings are usually religious.

(*G. Martin, The Flemish School, N.G. cat. 1970, 240/41.*)

STEPHENSON See STEVENSON, Thomas

STEVEN See MEULEN, Steven van der

STEVENSON, Thomas fl.1669 – *c.*1680

Landscape and scene painter. Renter Warden to the Painter-Stainers'

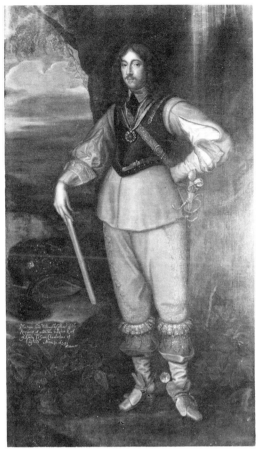

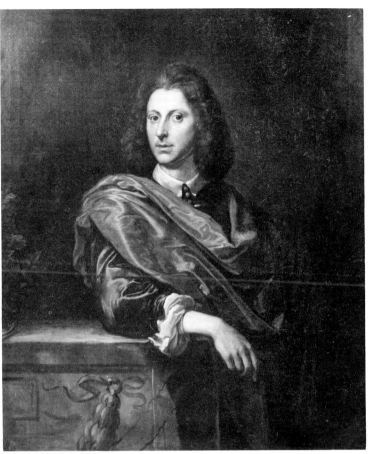

HENRY STONE, 1616-1653. 'Montagu, Lord Willoughby'. 86ins. x 50ins. s. & d. 'Old Stone pinxt. 1639'. Sotheby's sale 19.2.1969 (32).

HENRY STONE, 1616-1653. 'Hon. Christopher Leigh'. 43ins. x 36ins. Christie's sale 20.11.1981 (94).

Company 1678/79, the ceiling of whose hall he was going to paint. As this was done by Fuller in 1681, Stevenson had presumably died. He has been confused with Timothy Stephenson, a portrait painter of Newcastle (fl.1701ff.).

(E.C-M.)

STONE, Henry 1616 – 1653

Portrait painter (and ?copyist). Baptised London 18 July 1616; died there 24 August 1653. Known as 'Old Stone'. Son of the sculptor Nicholas Stone (1583-1647). Pupil of Thomas de Keyser in Amsterdam 1635-1638, and then travelled in France and Italy with his brother John until 1643 (*Walpole Soc., VII, 20ff.*). Buckeridge calls him John and says he was a famous copyist of Van Dyck's portraits, but this may be a confusion with Symon Stone (q.v.). An inscribed (rather than 'signed') portrait from Stoneleigh (Sotheby's sale 20.11.1981, 94) is vaguely Dobsonesque.

STONE, Symon fl.1648 – 1671

Copyist and general artistic factotum; recorded in the Northumberland accounts from 1648 to 1671 (*Burlington Mag., XCVII (August 1955), 256*). His name of Symon appears in a bill of 1661 at Woburn.

(*G. Scott Thomson, Life in a noble household, 1641-1700, 1937, 290.*)

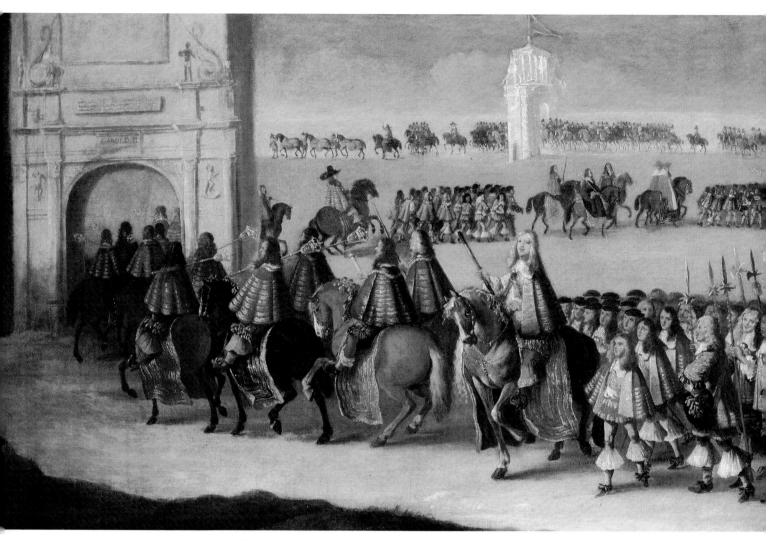

DIRCK STOOP, c.1618-?1686. 'Charles II's entry into London on the day before his Coronation in 1661'. Museum of London.

STOOP, Dirck (Rodrigo) *c.*1618 – ?1686

Dutch painter and etcher; specialist in pictures involving horses. Said (but without documentation) to have been born at Utrecht and died there. His signed paintings give his initial as 'D.', but he seems (when in Portugal) to have enlarged his name to Rodrigo, which he employs on a number of etchings. (Buckeridge wrongly calls him Peter and he has been made into three different artists!). He came to England in 1662 in the suite of Queen Catherine of Braganza, and signs his etchings made of Lisbon at the time 'Ipsius Majestatis Pictor'. His major painting done in London is 'Charles II's entry into London on the day before his Coronation in 1661' (based on Hollar and Loggan engravings), now in the London Museum (Christie's sale 23 June 1978, 120). He may have remained in London until 1665.

(*Catalogus der Schildereijen, Central Museum, Utrecht 1952, 125.*)

STREATER (Streeter), Robert 1621 – 1679

Portrait, history, landscape and all-purpose painter and etcher. Baptised

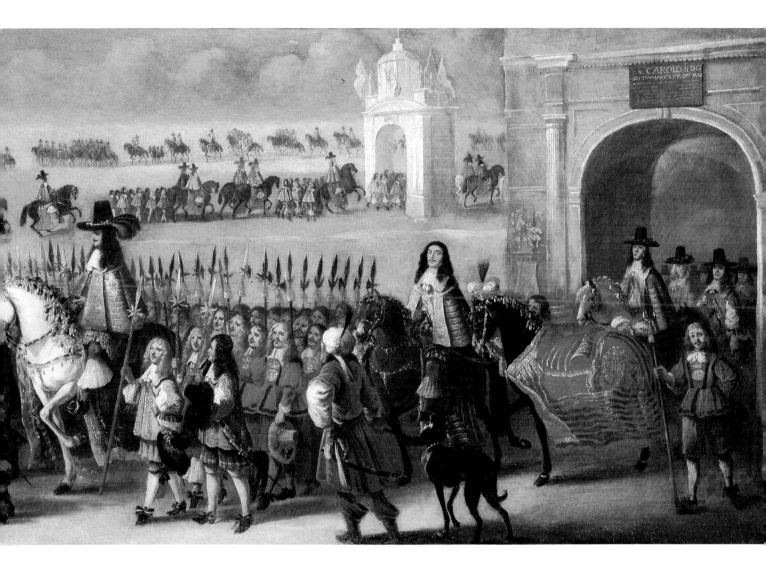

London 16 December 1621; buried there 23 April 1679 (*Edmond*). He acted as Serjeant-Painter from the time of the Restoration (but the actual appointment was 21 March 1663) until his death. He was one of the most considerable native painters of his time. His major surviving work is the huge history painting on canvas on the ceiling of the Sheldonian Theatre, Oxford, 1668/69, and there is also a 'View of Boscobel House' in the Royal Collection. His son, Robert Streater (ii), succeeded him as Serjeant-Painter in 1679 and held the office until 1707, and a number of works by him and his father are recorded in his posthumous sale 13/14 December 1711, but none of them have been identified.

(*Burlington Mag., LXXXIV (January 1944), 3ff., and E.C-M., I, 226ff., both list recorded or attributed works.*)

See colour plate p.267.

STRETES See SCROTS, Guillim

STRONG, Sampson *c.* 1550 – 1611

Dutch painter, who anglicised his name from Starke to Strong, and specialised on founder's portraits for Oxford colleges, 'based on brass, stone or stained

ROBERT STREATER, 1621-1679. 'Brancepath Castle'. Manchester City Art Gallery.

ROBERT STREATER, 1621-1679. 'View of Boscobel House and Whiteladies'. Reproduced by Gracious Permission of Her Majesty the Queen.

glass' models. Settled in Oxford 1590 aged 40; died there 1611. He also painted a portrait for Oxford City in 1597, and for Christ's Hospital, Abingdon in 1607. He was also employed as an all-purpose artist by the Oxford colleges.

(*Poole, II, xi-xiii.*)

SUNMAN See SONMANS, Willem

SYBERECHTS See SIBERECHTS, Jan

SYLVIUS, Johan fl.1658 – 1695
Swedish baroque history painter; died Sweden 1695. He was in England as an assistant to Verrio in the mid-1680s.

(*E.C-M.*)

TAYLOR, John (i) *c.*1580 – 1651

London Painter-Stainer and portrait painter. Probably born *c.*1580; buried
London 24 June 1651. He was Master of the Painter-Stainers' Company
1643/44, and is a possible candidate for having painted the Chandos portrait
of Shakespeare (N.P.G.).

(Mary Edmond, Burlington Mag., CXXIX (March 1982), 146ff.)

TAYLOR, John (ii) *c.*1630-?1714

Oxford portrait painter and copyist. Married in London (St. Botolph's) in
August 1655; presented a self-portrait in 1655 to the Bodleian Library,
Oxford; perhaps buried Oxford 24 August 1714 (*Poole, I, 81n*). He painted
portraits for Oxford Corporation 1659 and 1664; for Magdalen College 1669;
and for Christ's Hospital, Abingdon, 1684. He was Mayor of Oxford 1695.

(Poole, I, xxvii ff., III, 349.)

TEERLINC, Levina *c.*1510/20 – 1576

Miniaturist (portrait and subject pieces). Born Bruges, daughter of the
miniaturist Simon Bening (q.v.); died London 23 June 1576. She had married
George Teerlinc by 1545, when they both moved to London and entered the
service of Henry VIII, but they did not become denizens until 1566. She
continued in royal service (Edward VI, Mary and Elizabeth) until her death
and is described as the Queen's 'pictrix' (*Auerbach*).

(R. Strong, Artists of the Tudor Court: Portrait Miniatures Rediscovered, 1983, 52ff.)

TERBORCH (ter BORCH), Gerard 1617 – 1681

Dutch genre and portrait painter. Born Zwolle late 1617; died Deventer 8
December 1681. He is supposed to have travelled extensively as a young man
and he was in England in July 1635, but spent only a very short time there
and no works of that period are known.

(Hofstede de Groot, V.)

THACH(E), Nathaniel 1617 – after 1652

Only certainly known as a miniature painter of copies from portraits. Baptised
Barrow, Suffolk, 4 July 1617; last recorded in his father's will December 1652.
He was a first cousin of Mary Beale (q.v.) and practised in London before
moving to The Hague (probably before 1644), where his surviving signed
works (all copies of life-scale portraits of noble persons connected with the
Bohemian exiled royal family) must have been painted. He presumably died
before the 1660 Restoration. His miniatures are of good quality.

*(Elizabeth Walsh and Richard Jeffree, The excellent Mrs. Beale, exh. cat., Geffrye
Museum, London and Eastbourne 1975/76.)*

JOHN TAYLOR (ii), c.1630-?1714. Self-portrait. 1655. Photograph Bodleian Library, Oxford.

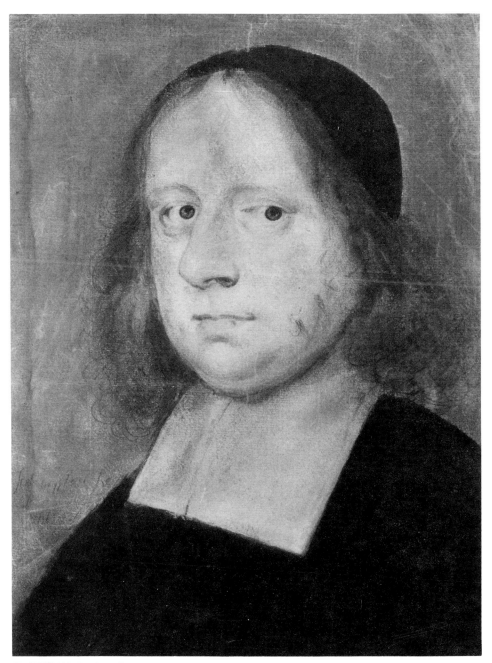

T. THRUMPTON, fl. 1667. 'A divine'. 10½ ins. x 8½ ins. s. & d. Present whereabouts unknown.

THORNHILL, Sir James 1675/76-1734

Although it is possible that Thornhill was working in the late 1690s, the earliest known work is of *c.*1702 (Hampton Court).

(*Waterhouse, 1891.*)

THRUMPTON (THRUMTON), T. fl.1667

Painter of portraits in crayons in London. His style derives from Lely, but his signed and dated portrait at Oxford ('T. Thrumton fecit/Londini 1667') is the earliest known English portrait in a pastel medium.

(*C.F. Bell, Walpole Soc., V, (1917).*)

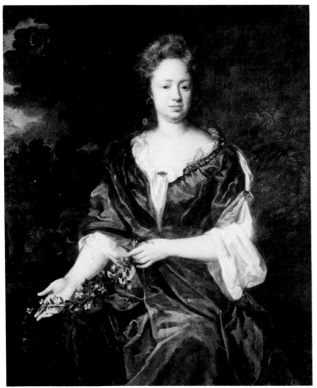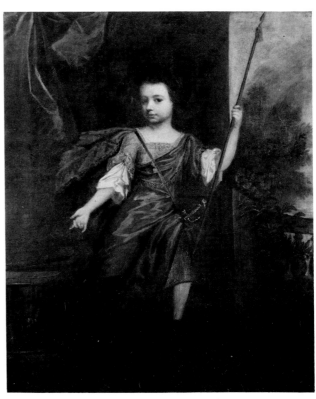

HENRY TILSON, c.1659-1695. 'Miss Howell, wife of Archbishop Wake'. 50ins. x 40ins. Signed 'H. (in monogram) Tilson pinxit/1693'. Winkworth sale (Padworth House) 26.9.1933 (577) as Wissing.

HENRY TILSON, c.1659-1695. 'Master William Blathwayte' (1688-1742). 49ins. x 39½ins. s. & d. 1691. Dyrham Park (National Trust).

TIBURIN (TO BUREN), Henry fl.1679 – after 1726

Probably mainly a drapery painter; of German origin. He left Osnabrück for Paris in 1679 with John Closterman (q.v.) where they worked for de Troy. They came to London in 1681. According to his father, a son, Willem (born London 1691; died March 1726/27) was a painter of great promise, but the work of neither is known.

(*Vertue MSS.*)

TIELIUS, Johannes fl.1694

A painter of this name was a member of the Dutch Reformed Church in London in 1694 (coming with an attestation from Hölvarenbeek in Brabant). Nothing is known of his work. He may be a painter who signs 'Tilius' and appears in *Wurzbach* as 'Fielius'.

(*J.H. Hassels, Archives of London Dutch Church, Register of Attestations, no.2107.*)

TILSON, Henry c.1659 – 1695

Portraitist in oils; also did portraits and copies in crayons. Member of a respectable Lancashire family (his grandfather was Bishop of Elphin; his father baptised Rochdale March 1623/24); buried London 25 November 1695 'aged about 36'. Pupil (and perhaps assistant) to Lely in 1680 and an occasional

buyer at Lely's studio sale. He was perhaps later with Kneller, where he met the young Dahl (q.v.) with whom he made friends and they travelled together, 1684-1688, to Paris, Venice (where he met Bombelli), and Rome, where they spent at least a year and Tilson did a few portraits of British sitters (e.g. 'Hon. Thomas Arundell', 1687, formerly at Wardour Castle) and made crayons copies after old masters (*Buckeridge*); also did crayons portraits of Bernini and Francesco Borri, which were at Kingsweston in 1695 (the latter, signed 'fecit Roma in Castello Sant.l'Angelo' and dated 1687, in J.W. Hansteen Collection, Oslo, 1941). Both Dahl and Tilson were back in London March 1689, where Tilson had a fair practice in portraits in a style between Kneller and Riley, when he committed suicide for sentimental reasons. Some family portraits were last recorded at the National Portrait Exhibition 1866.

(*Vertue.*)

TO BUREN See TIBURIN, Henry

TOTO, Antony 1498/99 – 1554

Florentine painter and decorator (and possibly also architect); known in England as Antony Toto or Toto del Nunziata, but his real name was Antonio di Nunziato d'Antonio. Born Florence 18 January 1498/99; died London 1554. He was a pupil of Ridolfo Ghirlandajo in Florence, where he signed a contract in September 1519 with the sculptor Pietro Torrigiano to accompany him to England. He probably came to England 1519, with Bartolommeo Penni (q.v.), and entered Wolsey's service. From 1530 he was in the employment of Henry VIII and was made a denizen in 1538 and Serjeant-Painter 26 January 1543/44. He presented the King with a picture of 'Calumny', 1 January 1538/39 (cf. *David Cast, In memoriam Otto J. Brendel, Mainz 1976, 215-225*) but is mainly documented on the usual decorative and heraldic works required of Serjeant-Painters before his death in 1554. Some decorative panels at Loseley Park (probably from Nonsuch) are the only known works which are at all plausibly ascribed to him.

(*Auerbach; E.C-M.*)

TRABUTE (TRABUTTY), William fl.1670 – 1678

Portrait painter. A portrait of 'Mr.Foley', signed and dated 1670, is said to be in the Oldswinstead Hospital at Stourbridge. William Trabute and his family were indicted for recusancy in 1673, but 'William Trabutty, neare Fleet Ditch Picture Drawer' is in the list of reputed Catholics who took the oath 21 November 1678 (*Catholic Record Soc., XXXIV (1934), 169 and 205*). A portrait of 'Sir Vere Fane, 1677' reproduced in *The Ancestor (XII (1905) 17)* is half way between Lely and Riley.

TREVISO See GIROLAMO DI TOMMASO DA TREVISO

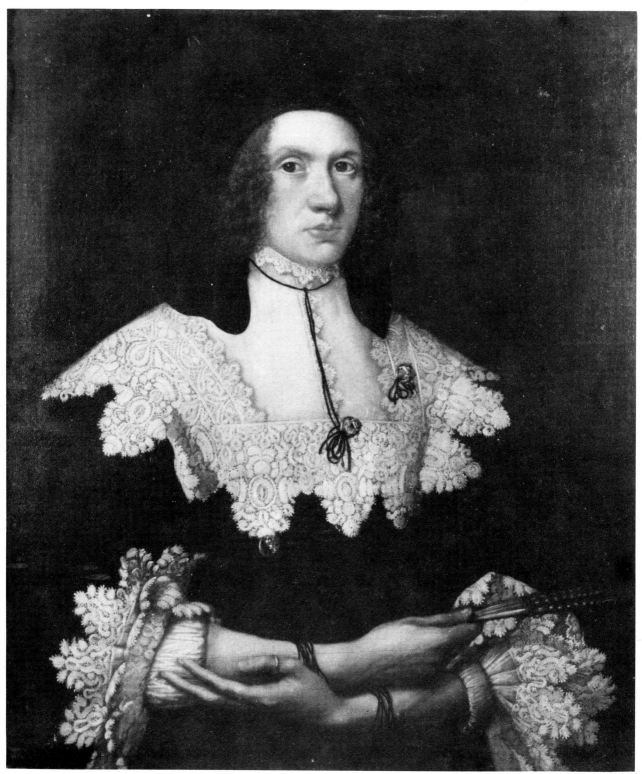

NICHOLAS TROILUS, fl.c.1630. 'Mrs. Niccols'. 29ins. x 24½ins. c.1630. Sotheby's sale 5.2.1969 (42).

TROILUS, Nicholas fl.*c.*1630
Portraitist. A portrait of 'Mrs. Niccols' of *c.*1630, in a style related to that of Gilbert Jackson (q.v.), was sold Sotheby's 5 February 1969, 42 (signature not verified).

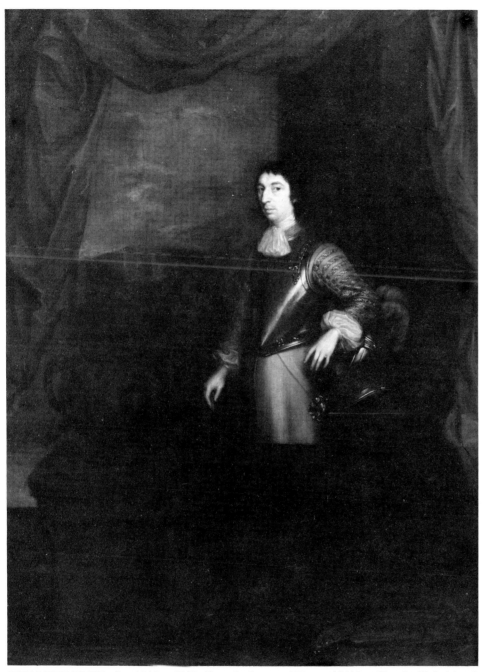

HERBERT TUER, fl.c.1649-c.1680. Portrait of a man. 22ins. x 16½ ins. Signed. Christie's sale 23.7.1970 (43).

TUER, Herbert fl.*c.* **1649** – *c.* **1680**

Portraitist. From an English clerical family (his mother was a niece of the poet George Herbert). He retired to Holland after the execution of Charles I where he took to portrait painting. His signed 'Sir Leoline Jenkins', painted in Holland in 1679, is in the N.P.G. He is said to have settled at Utrecht and died there about 1680.

(*Walpole.*)

VAART See VANDERVAART, John

VALKE, Jacob de fl.1640s
John Aubrey (*Lives, I, 152*) notes at Great Tew a full-length of 'Lucius Cary, Viscount Falkland' 'by Jacob de Valke, who taught me to paint'.

VAN BELCAM See BELCAMP, Jan van

VAN BLIJENBERG See BLYENBERCH, Abraham

VAN CLEEF See CLEEF, Cornelis van

VANDERBORCHT, Hendrick 1614 – at least 1678
Painter (but no works are known) and engraver, son of an artist, Hendrik the elder (Brussels 1583-1660 Frankfurt am Main); baptised Frankenthal 8 March 1614; perhaps still living in Amsterdam 1678 (*W.R. Valentiner, Pieter de Hooch, 1930, xlv*). Pupil of his father, with whom he moved to Frankfurt, 1627, where he was recruited into the service of the Earl of Arundel in 1636; sent to Italy for a year and became Keeper of the Arundel Collections in London 1637-1642, where he made etchings after a number of the paintings. By 1652 he was a 'painter' at Amsterdam, where he married in 1654. He has been confused with a Delft genre painter, Hendrik van der Burch (*Peter Sutton, Burlington Mag., CXXII (May 1980), 315-326*).

(*Buckeridge.*)

VANDEREYDEN See EYDEN, Jeremias van der

VANDERMEULEN, Pieter 1638 – after 1679
Said to have painted battle pictures in the manner of his brother Adam; baptised Brussels 28 April 1638, and said to have come to England about 1670, where he was painted by Largillierre (mezzotint by Beckett, on which he is called 'pictor'). He and his wife, living in London, were accused of recusancy in 1673 and 1679, he being called 'lymner' (*Catholic Record Soc., XXXIV (1934)*). His work is not known.

VANDERVAART, John 1653 – 1727
All-purpose painter; also mezzotint engraver in the 1680s; after 1713 mainly restorer and 'expert'. Born Haarlem; buried London 30 March 1727 aged 74 (*Vertue, iii, 32*). He came to London in 1674 and became assistant and collaborator to Wissing (q.v.) until the latter's death in 1687, painting especially the landscapes, still-life and draperies. In 1687 he started portrait practice on his own and was at first much patronised by the Shirley family (a large 'Family of the 1st Earl Ferrers', signed and dated 1688, is on loan at

Opposite:
ROBERT STREATER, 1621-1679. Ceiling of the Sheldonian Theatre, Oxford. 1668/69. Reproduced courtesy of the Curators of the Sheldonian Theatre. Photograph Thomas-Photos, Oxford.

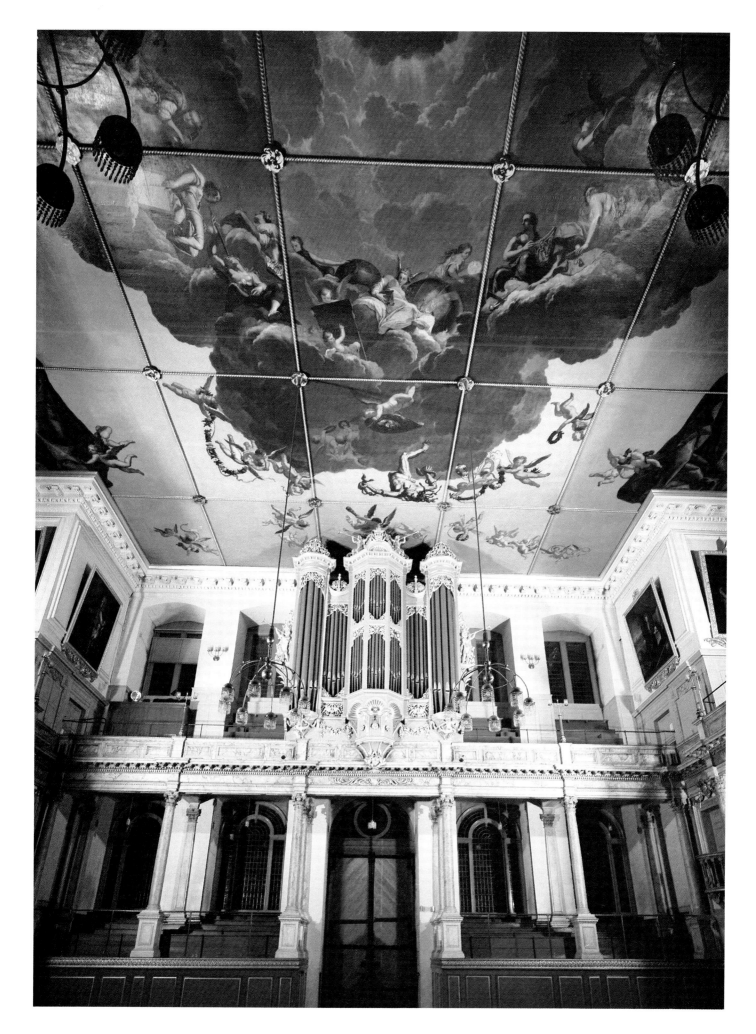

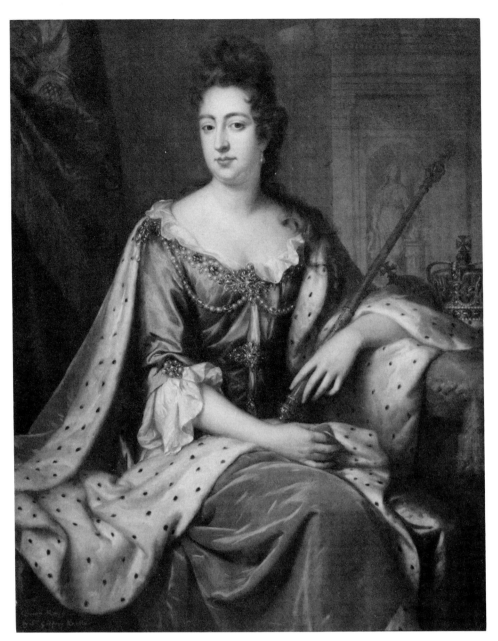

Leicester). His portrait style is modelled on Wissing but is less elegant. Failing eyesight made him give up mezzotint and he sold all his pictures in 1713. There are engravings after a number of his portraits and he is reported to have had a special talent for still-life.

(*Waterhouse, 1981.*)

VANDERVELDE See VELDE, Paulus and Willem van der

VAN DIEST See DIEST, Adriaen

VANDRO fl.1682
'A Dutch painter', mentioned in Ralph Thoresby's *Diary (1830, I, 112)* as at Leeds under 13 January 1682. This must be a mistake, perhaps for 'Vanroyden' (see Eyden, J. van der).

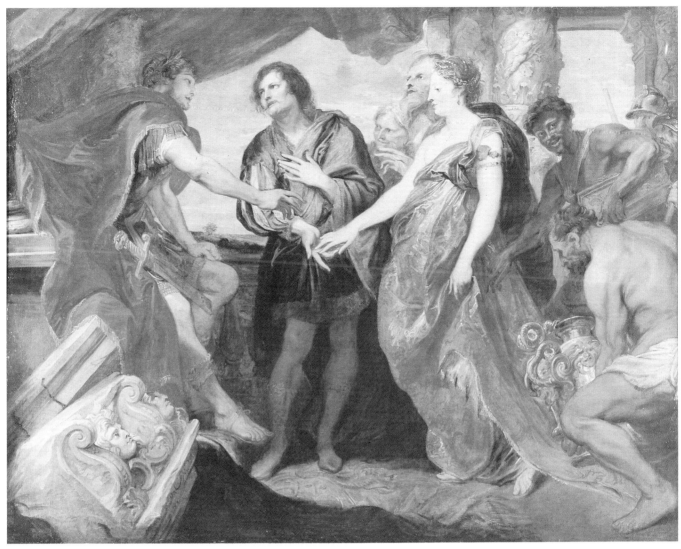

ANTHONY VAN DYCK, 1599-1641. 'The continence of Scipio'. The Governing Body, Christ Church, Oxford.

VAN DYCK, Sir Anthony 1599 – 1641

The greatest master of the European baroque portrait, and also (though he had no chance to employ this talent in England) a great religious painter. Born Antwerp 22 March 1599; died London 9 December 1641. He became a pupil of Van Balen in 1609, and his talent was sufficiently precocious that, when he became a Master at Antwerp in 1618, he already had his own independent studio and acted as the most trusted assistant to Rubens (q.v.), whose style he had assimilated, and from whom he derived a powerful predilection for the painters of the Venetian High Renaissance. For all his life his career at Antwerp was overshadowed by the dominance of Rubens (d.1640), whose robust and extrovert style was the exact opposite to his own. His first visit to England was from November 1620 to February 1621, when he painted 'The continence of Scipio' (Christ Church, Oxford) for the Duke of Buckingham, and a portrait of the 'Earl of Arundel'; and he sufficiently impressed James I

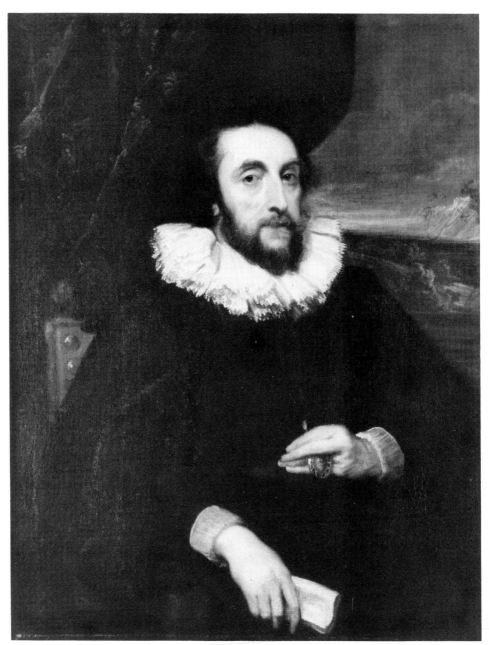

ANTHONY VAN DYCK, 1599-1641. 'Earl of Arundel'. 44ins. x 31½ins. Christie's sale 8.7.1983 (92).

to be classed as 'His Majesty's servant' and given eight months' leave to travel. In fact he returned to Antwerp and left for Italy towards the end of 1621, where he remained until the autumn of 1627. In Italy he travelled extensively but was mainly based on Genoa, where he created, largely from a study of Titian and Veronese, a new and very splendid kind of portrait, suited to merchant-princes with aristocratic pretensions and their families, which was a sort of training for his second English period. From the autumn of 1628 until he left for London in March 1632 (Van Dyck's 'second Antwerp period') were the years of his greatest achievement — while Rubens was away from Antwerp until March 1630. Splendid altarpieces and portraits, both of the nobility and especially of

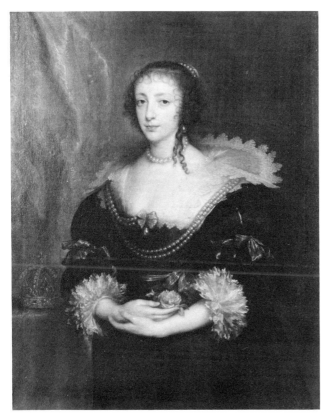 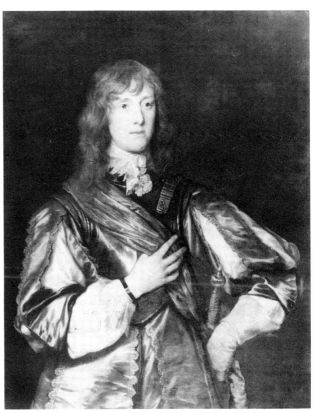

ANTHONY VAN DYCK, 1599-1641. 'Queen Henrietta Maria'. 42ins. x 32ins. Private collection.

ANTHONY VAN DYCK, 1599-1641. Portrait of a man. Sotheby's sale 2.11.1949 (77).

fellow artists, abound, and during these years he began a series of portrait etchings (later coarsened by 'completion' by inferior students) now known as the 'Iconographia' (*M. Mauquoy-Hendrickx, 'L'Iconographie de A.V.D.', Brussels 1956*), which established a new kind of art which has never been surpassed.

In 1632 Van Dyck entered the service of Charles I as 'Principal Painter in Ordinary' and he was knighted on 17 October 1633. He was provided with a house and treated with every honour, but his task was essentially to provide portraits of the King (and royal family) which would enhance the royal prestige at home and abroad, and they have in fact probably affected the judgement of history about that tiresome monarch. His English clientele was essentially the circle of courtiers, many of whom lived in a romantic royalist dream world which collapsed in the Civil War, soon after Van Dyck's death. Of the more serious figures of the Caroline court (such as 'Strafford', Fitzwilliam Trustees, Bourne Park), his portraits are truly memorable, and of the more frivolous they are of astonishing elegance and have contributed to the myth of the romantic valour of the Caroline court. They were remarkably truthful, but usually showed their sitters to their best advantage. They set a standard towards which British aristocratic portraiture is still aspiring.

Van Dyck was not continuously in London from 1632; he was again in Flanders for a year 1634/35, and went to Antwerp again after the death of

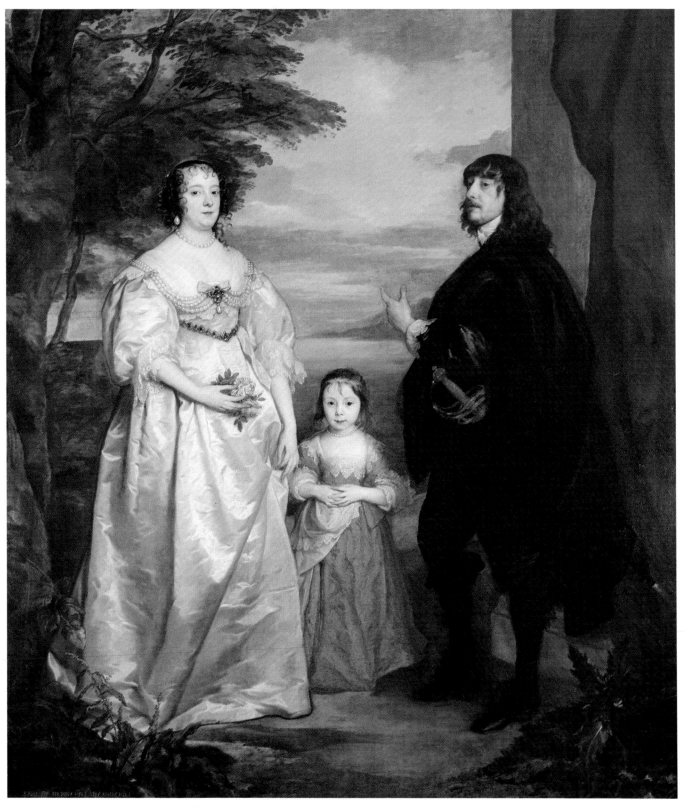

ANTHONY VAN DYCK, 1599-1641. 'James, 7th Earl of Derby, his lady and child'. Copyright The Frick Collection, New York.

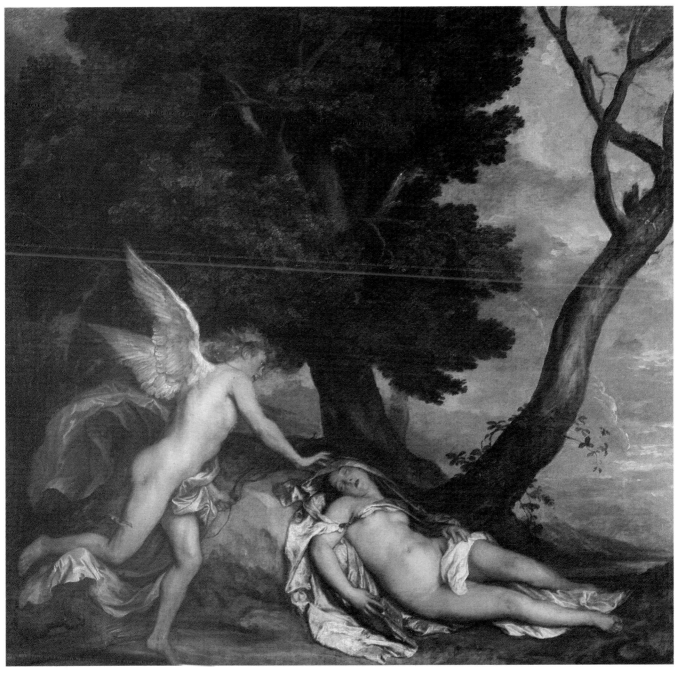

ANTHONY VAN DYCK, 1599-1641. 'Cupid and Psyche'. Reproduced by Gracious Permission of Her Majesty the Queen.

ANTHONY VAN DYCK, 1599-1641. 'Lady Mary Villiers, Duchess of Richmond and Lennox with her son, Lord Arran'. 83½ ins. x 53½ ins. c.1638-40. North Carolina Museum of Art.

ANTHONY VAN DYCK, 1599-1641. 'Martha Cranfield, Countess of Monmouth'. 85½ins. x 50ins. Private collection.

ANTHONY VAN DYCK, 1599-1641. 'Dorothy Percy, Countess of Leicester'. Collection of Lord Egremont, Petworth House.

ANTHONY VAN DYCK, 1599-1641. Portrait of a lady. 53ins. x 42ins. Collection of the Duke of Northumberland (Syon House).

Rubens towards the end of 1640, but his pretensions were excessive: in January 1641 he was in Paris, hoping for an appointment which eventually was given to Poussin. He had been made a denizen in March 1638, and his prices in England latterly were £50/£60 for a full-length, £30 for a half-length and £20 for a bust, and he also did a good business in arranging repetitions on the scale of life by his scholars (mainly Flemings) and in miniature by John Hoskins i and Jean Petitot i (qq.v.). He did a certain number of groups (the grandest the 'Pembroke family' at Wilton), but these were often not very skilfully arranged (though the 'Charles I *à la chasse*' (Louvre) is perhaps his masterpiece). In spite of its importance for the history of British painting, the English period was the least distinguished, and Van Dyck had lost by then his earlier insight into the minds of children. The only history painting done in England, the 'Cupid and Psyche' (still in the Royal Collection), shows that his creative powers were still as impressive as ever.

(E. Larsen, L'Opera Completa di Van Dyck, 2 vols., Milan 1980 (for fullest collection of illustrations, including over-generous attributions); O. Millar, Van Dyck in England, exh. cat., N.P.G. 1982.)

VAN HOOGSTRAETEN See **HOOGSTRAETEN**, Samuel van

VAN LEEMPUT See **LEEMPUT**, Remee

PAUL VAN SOMER, c.1577/78-1621/22. 'The Countess of Devonshire and her daughter Anne'. *51½ins. x 41½ins. s. & d. 'P. van Somer, 1619'. North Carolina Museum of Art.*

VANROYDEN See EYDEN Jeremias van der

VAN SOMER (VAN SOMEREN), Paul (Paulus) *c.***1577/78 – 1621/22**
Portrait painter (reputed also as history painter). Born Antwerp 1577/78; buried London 5 June 1621/22. Possibly trained in Holland, where he was working before he settled in England December 1616. Already a Court portrait painter in 1617 and perhaps official painter to Queen Anne of Denmark. His full-length royal portraits cost £30 (1620) and are between Marcus Gheeraerts ii and Daniel Mytens (qq.v.) in style.

(Millar, 1963, 80; Waterhouse, 1978, 51-53, 340 n.1.)

PAUL VAN SOMER, c.1577/78-1621/22. 'William, 2nd Earl of Devonshire and his son William'. 51½ins. x 41½ins. s. & d. 'P. van Somer, 1619'. North Carolina Museum of Art.

VANSON, Adriaen **fl.1580 – 1601**

Portraitist and all-purpose painter of presumably Flemish origin. Working in Edinburgh as 'His Majesty's painter' 1580-1601; dead by 1610. He was probably the father of Adam de Colone (q.v.).

(Duncan Thomson, The Life and Art of George Jamesone, 1974, 46-48.)

VAN STALBEMT See STALBEMT, Adrian van

VAN STEENWYCK See STEENWYCK, Hendrik van (ii)

VAN ZOON See VANSON, Adriaen
 ZOON, Jan Frans van

VELDE, Paulus van de **fl.1593 – 1617**

Painter, apparently of history, as he was paid for pictures of '12 emperors' 1610-1612. He came to London in 1593, where he 'had lived 24 years' in 1617. His works are not known.

(Auerbach.)

VELDE, Willem van de (i) **1611 – 1693**

Painter and draughtsman of shipping and sea fights. Born Leyden late 1611; died London 13 December 1693. He was primarily a marine draughtsman and specialised in grisailles in Indian ink on a prepared white ground. He was one of the first artists to accompany the navy to sea fights to take an accurate record of what occurred. He was first in the Dutch service but, probably in 1673, with his son and pupil Willem van de Velde ii (q.v.), moved to England and, by 1674, was in the employment of Charles II and the Duke of York (Lord High Admiral). He and his son worked together in England and their paintings and drawings (which are extremely numerous) are impossible to disentangle. The elder Willem's paintings (as opposed to grisailles) are probably not very numerous.

(For bibliography see Willem van de Velde ii.)

VELDE, Willem van de (ii) **1633 – 1707**

The most distinguished marine painter of his age. Son of Willem van de Velde i (q.v.); baptised Leyden 18 December 1633; died London 6 April 1707. Pupil at first of his father, for the drawing of ships; later, for sea painting, of Simon de Vlieger. He began as a painter in the early 1650s, when he was living in Amsterdam, and his best marines date from his Dutch period. By 1672 he had settled in England, and both he and his father were in the service of Charles II in 1674, the father 'for taking and making of Draughts of seafights' and the son 'for putting the said Draughts into colours' (*Vertue, v, 75*). His later pictures are largely 'representations of specific vessels and naval events' (*The

WILLEM VAN DE VELDE (ii), 1633-1707. 'The Battle of Texel, 1673'. N.M.M.

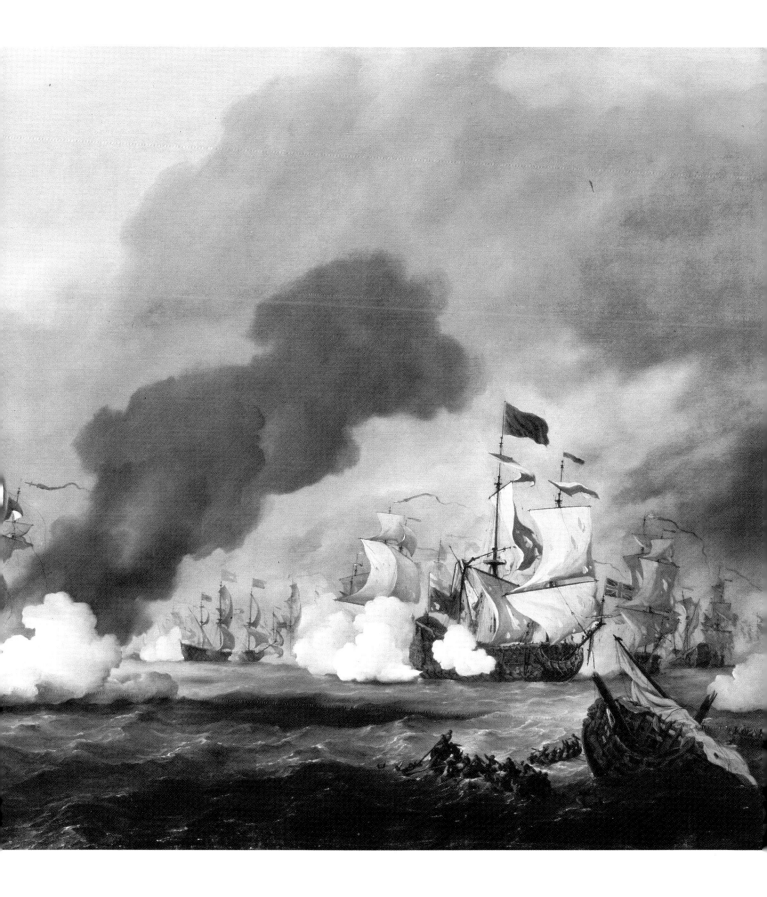

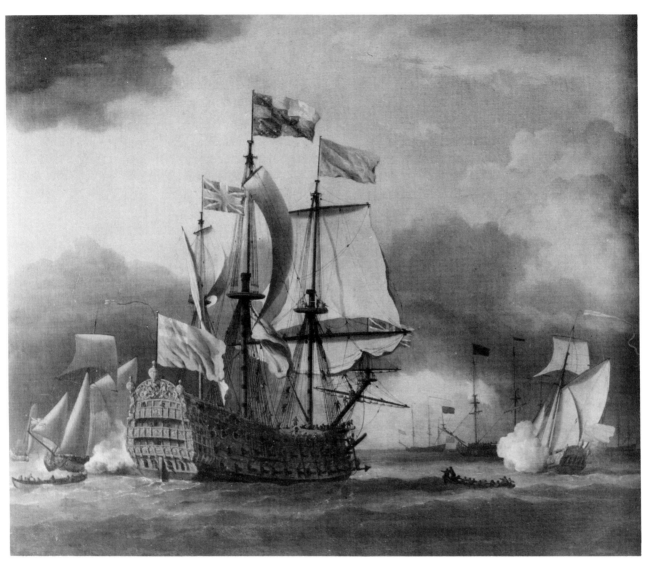

WILLEM VAN DE VELDE (ii), 1633-1707. 'The Royal Charles'. *Private collection.*

Dutch School, N.G. cat., 1960, 411). He signs in a variety of ways, often adding 'J' or 'de J.' (for 'the Younger') to 'W.V.V.'. There are many examples of both father and son at the N.M.M. and in the Royal Collection, and they cannot always be distinguished. Although neither father nor son learned the English language, their predominant influence on English marine painting lasted until the time of Turner.

(Archibald; Hofstede de Groot, VII; M.S. Robinson, cat. of V. de V. drawings at N.M.M., 2 vols., Cambridge 1958, 1974.)

VERELST, Harman (Hermann) *c.*1643 – 1702
Portrait painter of Dutch origin who painted 'history, fruit and flowers'

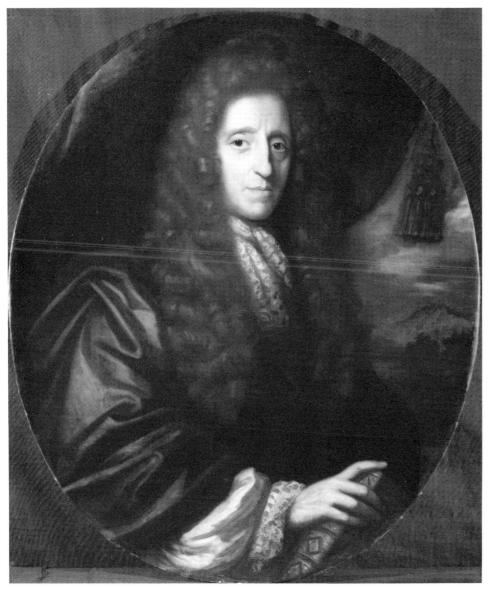

HARMAN VERELST, c.1643-1702. 'John Locke'. N.P.G.

(*Buckeridge*). Said to have been born at The Hague *c.*1643; died London 1702 (posthumous sale 31 December 1702). Pupil of his father, Pieter Verelst, a portrait painter at The Hague, and elder brother of Simon Verelst (q.v.). He was also the ancestor of several eighteenth century Verelsts who worked in England. About 1680 he was in the service of the Emperor at Vienna, but he left for England in 1683 on account of the Turkish attack. His earliest English portraits, signed and dated 1683, are found in Suffolk (*Farrer, 44*). Although based on London he seems to have had a respectable practice in the provinces, but his style remains decidedly Dutch. His family came over to England with him, but nothing is known of the pictures of his son Cornelius (1667-1728), and known portraits by his daughter Maria (1680-1744) are all after 1700.

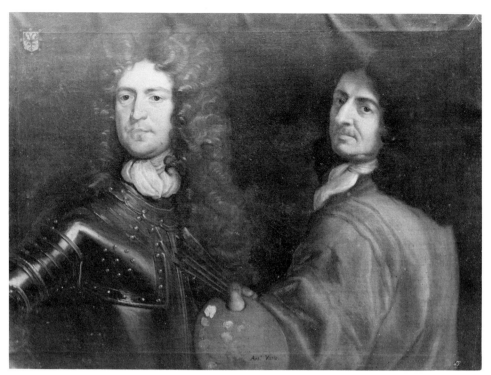

ANTONIO VERRIO, ?1639-1707. 'General Robert Killigrew and Antonio Verrio'. 30ins. x 40ins. Signed 'Ant°. Vario'. J.D. Wood sale 27.5.1937 (1108).

VERELST, Simon Pietersz 1644 – 1710

Painter of flower pieces and occasional portraits. Baptised The Hague 21 February 1644; died London 1710. Brother of Harman Verelst (q.v.) but he came to London 1669 already with a high repute for his flower pieces (*Pepys Diary 11 April 1669*). He became the most famous and expensive flower painter in London, became very vain, and ultimately went mad, painting roses and peonies of gigantic size. He also painted portraits (sometimes, it is reported, with elaborate floral accessories) but signed examples are curious and do not suggest great talent.

(*Frank Lewis, S.P.V., Leigh on Sea 1979, with list of flower pictures only; Vertue.*)

VERGAZOON, Hendrik fl.*c.*1690 – *c.*1703

Dutch landscape painter, especially of ruins. Came to England early in the reign of William III and left before 1700. He is said to have died in France (*Buckeridge*). At Althorp are two rather Brouwerish scenes which in 1746 were said to be by 'Verguson of Lyons'.

VERRIO, Antonio ?1639 – 1707

Decorative and historical painter in a coarse Italianate Baroque style. Born Lecce, South Italy — the date 1639 is 'traditional' but unreliable; died Hampton Court 15 June 1707. After a picaresque career in Naples, Toulouse and Paris (where he was received into the Académie in 1671) he came to England in 1672, where he soon came to the attention of Charles II. He became a denizen 5 May 1675 and was extensively employed, with a considerable team of assistants, on the painted wall and ceiling decorations of Windsor Castle until 1688, where his work was immensely admired and very heavily remunerated, but very little survives today. On 30 June 1684 he was

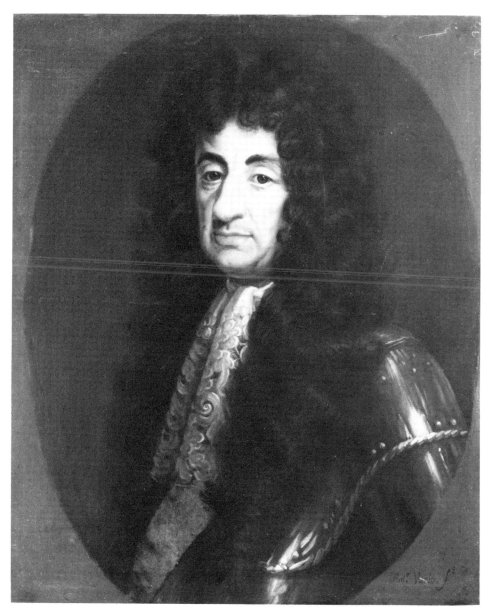

ANTONIO VERRIO, ?1639-1707. 'Charles II'. 29¼ins. x 24ins. Signed 'Ant? Vario. ft.'. Sotheby's sale 2.3.1983 (31).

made 'first and chief painter to His Majesty' in succession to Lely (d. 1680). This appointment ceased in 1688 and Verrio refused to work again for the Crown until 1699. During that decade he seems to have been based on Burghley, where much of his work survives, and he also painted a good deal at Chatsworth and in other great houses. From 1699 he did a good deal of work at Hampton Court but his eyesight failed and he retired on a pension in 1704. He was also quite a capable portraitist and painted a huge 'Charles (James) II giving audience to the Governors, masters and children of Christ's Hospital', 1682-88, now at Christ's Hospital, Horsham. Verrio was the first to introduce full Baroque historical painting to England, but in a very vulgar form, and he was surpassed by his assistant Louis Laguerre (q.v.).

(E.C-M., 50-60, 236ff. with full bibliography.)

See colour plate p.288.

JOHANN VOSTERMAN, c.1643-1690s. 'A view of Windsor Castle'. Reproduced by Gracious Permission of Her Majesty the Queen.

VIGNON, Philippe **1638 – 1701**

French portrait painter. Born Paris 27 June 1638; died there 7 September 1701. Younger son of Claude Vignon (1593-1670), a historical painter of some eminence. Together with his elder brother, Claude François Vignon (Paris 4 October 1633; Paris 27 January 1703; Académicien 1667), a history painter by whom nothing is known done in England, was sworn in as 'limner in ordinary' to King Charles II on 4 October 1669. A portrait by him of the 'Duchess of Portsmouth' is in the Royal Collection, and a portrait of 'Mary, Lady Godfrey' (private collection), signed 'F. Vignon f. 1675', seems to be by the same hand. He was back in Paris by 1686 and became an Académicien in 1687.

(*Millar; Th.-B.*)

VOGELARIUS, Levinus **fl. 1550 – 1568**

Flemish artist; perhaps the Lieven de Vogeler who became a Master (as a 'coffermaker') at Antwerp 1554. He is only known from the signed 'Darnley Memorial', a vendetta picture (Holyrood Palace) which was painted in London in January 1567/68. It is an artisanal object.

(*Millar, 75-77.*)

JOHANN VOSTERMAN, c.1643-1690s. 'A view of Althorp'. Reproduced by permission of the Earl Spencer. Photograph Courtauld Institute of Art.

VOLPE, Vincenzo fl. 1512 – 1536

All-purpose Italian painter in the service of Henry VIII. Native of Naples; died London, where his will of 17 November 1536 was proved 4 December 1536. He was mainly employed on tasks of a decorative and topographical nature. No certain examples are known.

(E. Auerbach, Burlington Mag., XCII (August 1950), 222-227.)

VOSTERMAN (VORSTERMANS), Johann *c.*1643 – 1690s

Painter of topographical and ideal landscapes. Born at Zalt-Bommel, traditionally in 1643; died at uncertain date and in unknown place. Pupil of Herman Saftleven at Utrecht. He came to England probably *c.*1677 and his 'View of Althorp' (still in the house) was seen there by Evelyn in 1678. He painted two views of Windsor, probably *c.*1678/80 (*Millar*) and left England in 1686 for Constantinople, where he had great plans which were thwarted by the death of his patron. Two views of Stirling Castle (one in a private collection, allegedly with figures by Wyck) suggests he may have visited Scotland.

(Buckeridge.)

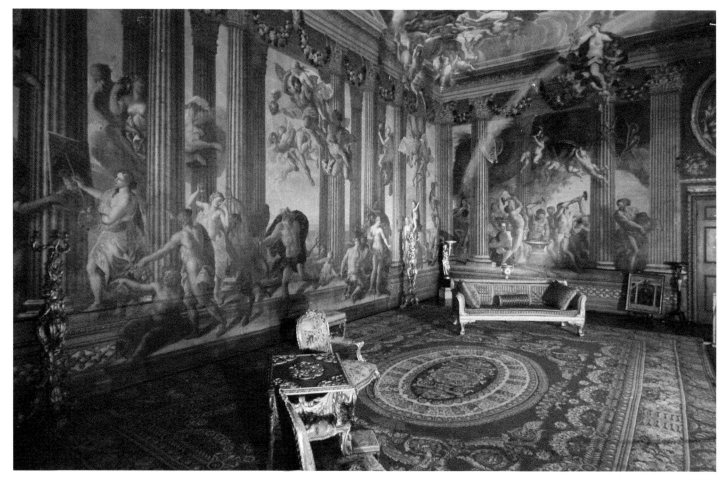

ANTONIO VERRIO, ?1639-1707. The Heaven Room, Burghley House. By permission of Burghley House Preservation Trust Ltd.

VOUET, Simon **1590 – 1649**

French history and portrait painter. Born and died in Paris. He visited England at some time between 1604 and 1611 but it is not known what he did there. He appears to have painted, in Paris, for Charles I, a ceiling canvas for Oatlands Palace with an 'Allegory of the Peace between France and England', engraved by M. Dorigny 1639.

(*E.C-M., 210, fig. 69.*)

VROOM, Hendrick Cornelisz **?1562/63 – 1640**

Dutch marine painter from Haarlem, where he was buried 4 February 1640. It is probable, but not certain, that he visited England before 1604 and in 1627 and painted for Charles I a picture of the 'Return of the Fleet with Charles I as Prince of Wales in 1623' (Hampton Court), but it is possible that this may be by his son, Cornelis Hendricksz Vroom (*c.*1590/91-1661).

(*C. White, Dutch Pictures in the Collection of Her Majesty the Queen, 1982, 146/47.*)

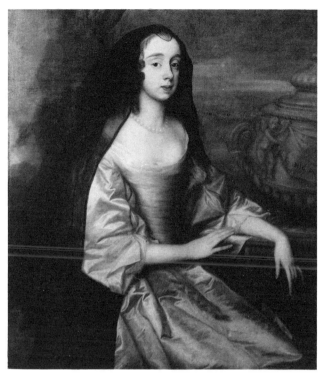 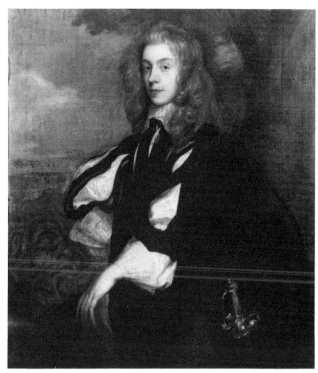

ROBERT WALKER, fl.1641-c.1658. '1st Duchess of Beaufort'. 49ins. x 39½ins. Collection of the Duke of Beaufort, Badminton.

ROBERT WALKER, fl.1641-c.1658. Portrait of a man. 48½ins. x 40ins. s. & d. 'R. Walker/Pinxit 1656'. Private collection.

W.I. fl.1648

Provincial portrait painter working in Leicestershire. Only known from a group of portraits, all dated 1648 and signed 'I. W.F.' or 'I. WF.', of Leicestershire sitters and in local collections. The style is individual but unfashionable.

(A.G. Sewter, Burlington Mag., LXXVI (July 1940), 20-24.)

WAGGONER fl.1666

His dates are given as *c.*1666-1685 (*M. Whinney and O. Millar, English Art 1625-1714, 1957, index*). Known only from an inscrutably dark picture of the Great Fire of London of 1666 in the Painter-Stainers' Hall (*Sir G. Scharf, Cat. of Soc. of Antiquaries' Pictures, 1865, 47-49*).

WALKER, Robert fl.1641 – *c.*1658

The leading portraitist of the Parliamentary party under Cromwell; also painted subject pictures and copied old masters (e.g. Titian). Perhaps born *c.*1605/10; he was settled in London in the 1650s. His postures are taken from Van Dyck, but it is unlikely that he was his pupil, and they are adapted with a deliberate avoidance of Van Dyck's panache. He only occasionally signs and his prices in the 1650s were £10 for a 50ins. x 40ins. He became a Painter-Stainer in 1650. His speciality was in a variety of portraits of Cromwell (a good one in N.P.G.), and he did most of the other Parliamentary leaders, with solemn and melancholy expressions; also a very curious portrait (1648) of 'John Evelyn' with a skull in a consciously penitential role. Buckeridge says 'he died a little before the Restoration'.

(Waterhouse, 1978, 86-88, 341 n.25.)

ROBERT WALKER, fl.1641-c.1658. Portrait of a man. Present whereabouts unknown.

WALL, Thomas **fl.1698**

Known only as the designer (not necessarily also 'painter') of a curious allegorical mezzotint of John, Lord Cutts, by Bernard Lens, which can be dated to 1698, 'Printed for Tho: Wall at ye Golden Spiers in James Street, Covent Garden' (*Chaloner-Smith, II, 814*).

WALTON, Parry **fl.*c.*1660 – 1699/1700**

All-purpose painter; but chiefly restorer, dealer and 'expert'. Pupil of Robert Walker (q.v.), presumably in the 1650s; he is said to have been an accomplished painter of still-life. He succeeded Thomas Chiffinch (d. 1666) as Keeper of the King's Pictures. He was succeeded in this post by his son, Peter, who died March 1744/45 'aged 80 or more'.

(*Buckeridge.*)

PARRY WALTON, fl.c.1660-1699/1700. Still-life. 25ins. x 21¾ins. By permission of the Governors of Dulwich Picture Gallery.

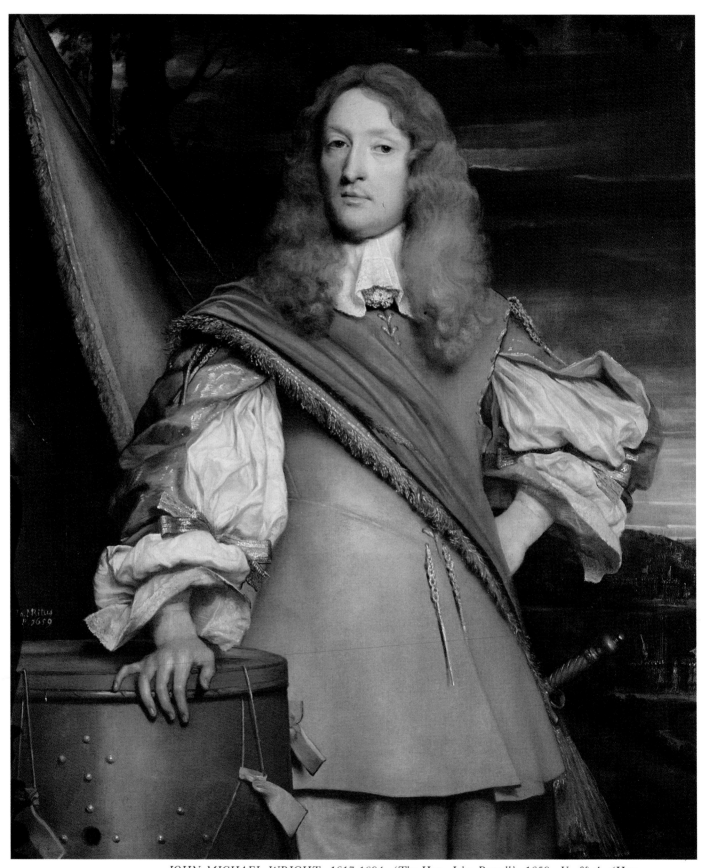

JOHN MICHAEL WRIGHT, 1617-1694. 'The Hon. John Russell'. 1659. V. & A. (Ham House).

WANSLEE fl.*c.*1576

Portrait painter; only recorded in letters among the Loseley papers about a picture of Queen Elizabeth and portraits of Mr. More and his wife (*Auerbach*). He lived at Lambeth and was in the service of the Earl of Lincoln.

(*R. Strong, Portraits of Queen Elizabeth, 1963, 11.*)

WATSON, Assabel fl.1589/90

A 'picture maker or painter' of Markfield, Leicestershire (*Henry Hartopp (ed.), Register of the Freeman of Leicester, Leicester 1927, 89*). For an equally obscure 'Mr. Wattson' of *c.*1655 see *Talley* (*397*).

WEBSTER, William d.1633

A freeman of the Painter-Stainers' Company, whose will was proved in 1633.

(*Edmond, 213n., 549.*)

WEESOP (WESEP) fl.1641 – 1649

Presumably a Flemish portrait painter; known only from *Vertue* (*i, 49*) who says he came to England in 1641 and left in 1649 after the decapitation of Charles I, and that 'many pictures painted by him pass for Vandyke'. An alleged signature on an 'Execution of Charles I' (with inset portraits of the King and the Executioner, on loan from Lord Rosebery to the S.N.P.G.) was removed in 1972 as being a later addition (the portraits could not have been mistaken for Van Dyck). A John Weesop is reported as having died in 1652 in the registers of St. Martin in the Fields.

WEIMES, Mrs. fl.1658

Sanderson (*Graphice, 1658*) lists her among female painters in oil, perhaps of miniatures. She is not otherwise known and her name could have been Wemyss.

WELLS, John d.1645

On 25 September 1645 'John Wells, painter by London Wall' died (*Camden Soc., 1849, The Obituary of Richard Smyth, 22*). He need not have been a painter of pictures.

WET, Jacob de (the younger) *c.*1640 – 1697

Decorative 'history' painter. Born at Haarlem, son (and presumably pupil) of Jacob Willemsz de Wet (*c.*1610-after 1671); died Amsterdam 11 November 1697. He came to Scotland in 1685 and painted a ceiling and 110 (largely legendary) figures of kings in Holyrood House; similar decoration at Glamis Castle, 1688/89.

(*E.C-M., 260b*, with false date of 1675).

WETHERED, Francis fl.1630

Probably mainly a decorative painter; pupil of Rowland Buckett (q.v.), he was made free of the Painter-Stainers' Company in 1630.

(*E.C-M.*)

WHITE, Robert 1645 – 1703

Best known as the leading exponent of portrait engraving in line, but also did neat plumbago miniatures. Said to have been born in London 1645; buried there 26 October 1703. He was a pupil of David Loggan (*Croft-Murray and Hulton; Long*). His son, George White, born *c*.1684, died London 27 May 1732 'aged about 48' (*Vertue, iii, 60*), began as a painter in oil (but no works are known), finished off his father's line engravings and, about 1712, became a leading exponent of mezzotint.

(*Chaloner Smith.*)

WILDT fl.1670s

Presumably a Dutch painter, otherwise unknown, who lived in London, probably in the 1670s, when he was taken by Greenhill to see Soest.

(*Vertue, ii, 72.*)

WILLCOCKE, Randle fl.1670

'Randle Willcocke, picture drawer, son of William Willcocke, later of Chester, gentleman' was admitted a Freeman of the City of Chester 10 November 1670.

(*Lancashire and Cheshire Record Soc., LI, 157.*)

WILSON, Jacob fl.1692

He had a certain reputation as a portrait painter in the City of London in 1692, but no examples are known.

(*Marshall Smith, The Art of Painting..., 1692.*)

WISSING, Willem 1656 – 1687

Fashionable portrait painter. Born Amsterdam; died Burghley House 10 September 1687, aged 31. He was trained at The Hague and in Paris. He arrived in London from The Hague in the latter part of 1676 and soon became an assistant to Lely (q.v.), with whom he remained until Lely's death in 1680 when he helped to finish off his uncompleted portraits. He was taken up by the Court and was sent by James II in 1684/85 to Holland to paint the Prince of Orange (later William III) and Princess Mary. Later he was much patronised by the Earl of Exeter and the Lincolnshire gentry, and Lord Exeter put up an elegant tombstone to him (which survives) in St. Martin's, Stamford. Wissing's known works are entirely based on Lely's, somewhat Frenchified in style: Collins Baker is unjust in saying that all his sitters have

WILLEM WISSING, 1656-1687. '9th Earl of Derby'. 47ins. x 38ins. s. & d. 1684. B.A.C. Yale, Paul Mellon Collection.

'an underbred leer'! His full-lengths tend to be richly diversified with huge weeds and similar accessories, but these are often the work of his assistant Vandervaart (q.v.), who took over his studio after his death. Wissing's best works are at Burghley and Belton.

(*Buckeridge; Waterhouse, 1978, 112/13.*)

WITT, J. de See WET, Jacob de

WILLEM WISSING, 1656-1687. 'Frances Therese Stewart, Duchess of Richmond'. 84ins. x 50ins. Signed by Wissing and Vandervaart. Christie's sale 21.6.1974 (164).

 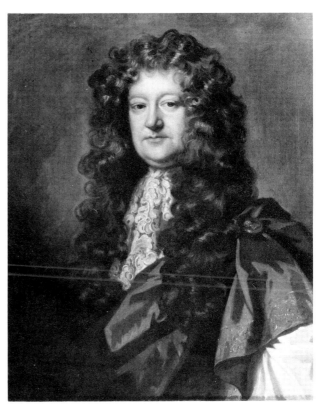

WILLEM WISSING, 1656-1687. 'William III when Prince of Orange'. 50ins. x 40ins. Signed. By permission of Viscount de L'Isle, V.C., K.G., from his collection at Penshurst Place.

WILLEM WISSING, 1656-1687. Portrait of a man. 28½ins. x 24ins. Signed 'W. Wissing fecit'. Christie's sale 26.4.1985 (87).

WOODFIELD, Charles c.1649-1724

Topographical artist and probably also history painter. Died December 1724 aged 75 (*Vertue, i, 135*). Pupil of Fuller, he collaborated with Thomas Pembroke (q.v.) in painting pictures for the Earl of Bath (*Buckeridge, 408*). Vertue says he was wretchedly idle.

WOTTON, John c.1626

A Painter-Stainer, whose will was proved in 1626 and suggests he was a journeyman artist.

(*Edmond, 213, 549n.*)

WOUTERS, Franchoys (Frans) 1612 – 1659

Flemish landscape and figure painter; also picture dealer. Baptised Lier (Lierre) 12 October 1612; died Antwerp 1659, probably at the end of December. Pupil at Antwerp of Peeter van Avont from 1629 and very briefly of Rubens before he became a Master in 1634. He was in England 1637-1641 and at some time was 'painter to the Prince of Wales'. From 1641 settled at Antwerp and worked in the aura of Rubens.

(*Glück, 1933, 222ff.; Gregory Martin, The Flemish School, N.G. cat., 1970, 286.*)

WRAY, Mr. fl.c.1650

Probably a portrait painter. Only known from some advice recorded in Richard Symonds' notebook of 1650/52 about how to copy faces.

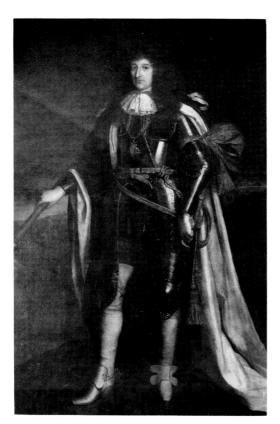

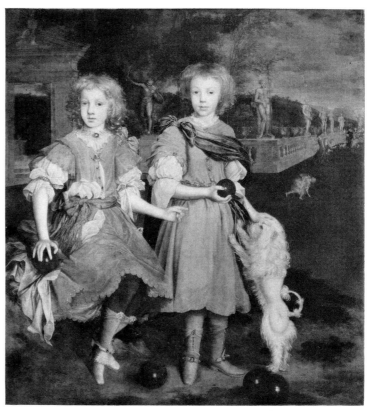

JOHN MICHAEL WRIGHT, 1617-1694. 'Prince Rupert'. 91½ins. x 58¼ins. 1672. Magdalen College, Oxford.

JOHN MICHAEL WRIGHT, 1617-1694. 'Randolph and John Corbet'. 58ins. x 52ins. Formerly in the collection of William Randolph Hearst.

WRIGHT, Andrew fl.1532 – 1543

Serjeant-Painter from 19 June 1532 until his death in 1543 (will proved 29 May). Only decorative work is documented. It is unlikely that he painted portraits, but a portrait dated 1536 and dubiously called the 'Countess of Lennox' (Lee Bequest to the Courtauld Institute) has on it a monogram which has been read as 'A.W.' and has been wrongly supposed to be that of Andrew Wright (cat. of R.A. exh. 1950/51, 50); other portraits have, equally speculatively, been associated with it. Two of his sons, Christopher and Richard, were Painter-Stainers (*Auerbach*).

WRIGHT, John Michael 1617 – 1694

The most sensitive (but not the most fashionable) portraitist of the Restoration Court. Probably baptised London 25 May 1617; buried there 1 August 1694. His family may have been Scottish and he was apprenticed in Edinburgh to George Jamesone (q.v.) 6 April 1636. He went to Rome in the early 1640s and became a Roman Catholic. He studied to become an Antiquary (and a learned one) and improved his painting style so that he became an Academico di St. Luca in 1648. His earliest known signed portrait (signed and dated 'J.M. Wrightus 1647', Sotheby's sale 30 January 1985, 36) suggests some knowledge of William Dobson (q.v.). He also at first signs 'MRitus' and only adopted the additional name of John later. He is reputed to have acted as Antiquary to the Archduke Leopold Wilhelm in Flanders 1653-56; returned to London 1656,

JOHN MICHAEL WRIGHT, 1617-1694. Three ladies. 45ins. x 67ins. Private collection.

leaving a family in Rome. He was a successful portraitist in London by 1659, with many clients who were by no means Catholics, but the honesty of his interpretation of character and an absence of Court vulgarity (especially in his female portraits) seems to have appealed to Catholic sitters. He was, however, sometimes employed by the Crown and painted the ceiling of Charles II's bedroom at Whitehall Palace (now in Nottingham's Castle Museum). In 1671/73 he painted a set of judges' portraits for the Guildhall (of which there are only two battered survivors), and in 1679/80 he was in Dublin. From 1685 to 1687 he acted as Steward to Lord Castlemaine's foolish Embassy sent by James II to the Pope, of which he published an account, with engravings, in both Italian (1687) and English (1688). But he had lost ground as a portrait painter (to Kneller and others) by his absence in Rome, and the expulsion of James II finished his career as a Court Painter (he had latterly signed occasionally as 'pictor regius', but no appointment is documented). He ended his life in ill-health and genteel poverty. He bequeathed his pictures, etc., to a nephew, Michael Wright, who had perhaps been his assistant and may have painted some of the numerous repetitions which are known of some of his uncle's portraits, but whose work is not otherwise known.

(*Sara Stevenson and Duncan Thomson, cat. John Michael Wright exh., S.N.P.G., 1982.*)

See colour plate p.292.

JOHN MICHAEL WRIGHT, 1617-1694. 'Astraea returns to earth' (allegory of the Restoration). 90ins. x 56ins. Castle Museum, City of Nottingham.

JAN WYCK, 1645-1700. Top: 'William III at the Battle of the Boyne, 1690'. 53ins. x 77ins. Christie's sale 24.7.1953 (53) Above: Battlescape. 53ins. x 92ins. s. & d. 1694. Christie's sale 11.6.1948 (198).

WYCK, Jan 1645 – 1700

Dutch landscape and battle painter. Born Haarlem 1645 (his parents married in 1644 and in 1676 he gave his age as 'about 31'); died Mortlake 17 May 1700. Son and probably pupil of Thomas Wyck (q.v.), whom he probably accompanied to England 'soon after the Restoration'. He married in England, for the second time, in 1676, but the greater number of his dated works are from the 1690s, when he specialised in battle scenes with military commanders on horseback (especially William III at the Battle of the Boyne). He also painted hunting scenes.

(Croft-Murray and Hulton, 551ff.)

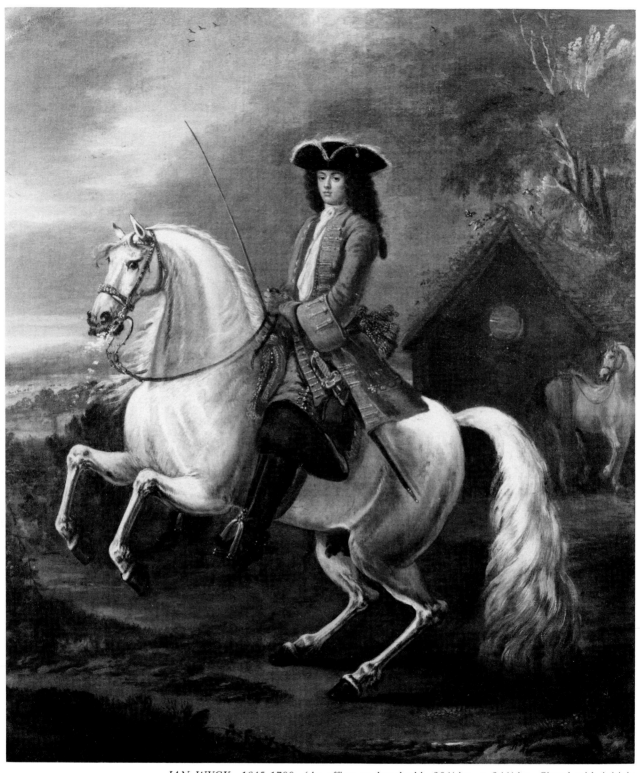

JAN WYCK, 1645-1700. 'An officer on horseback'. 28 ¼ ins. x 24 ½ ins. Signed with initials. Sotheby's sale 5.7.1967 (2).

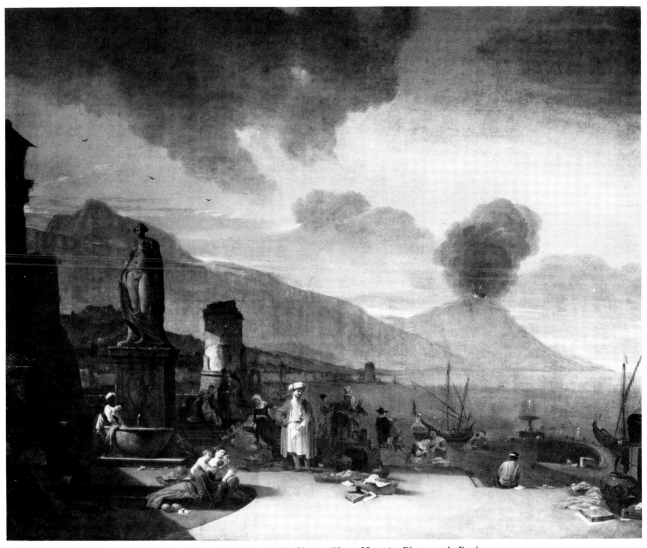

THOMAS WYCK, c.1616-1677. 'View of Naples'. V. & A. (Ham House). Photograph Paul Mellon Centre.

WYCK, Thomas *c.*1616 – 1677

Dutch genre and landscape painter; also engraver. Born at Beverwijk, near Haarlem; buried Haarlem 19 August 1677; known in England as 'Old Wyck' since he probably came over with his son Jan (q.v.). He entered the Haarlem Guild in 1642, and spent some time in Italy where he developed a line in Mediterranean harbour scenes and genre in the style of Van Laer. His pictures are often signed but very rarely dated. He was perhaps not in England long, but two pictures survive done *c.*1673 for Ham House (one 'An alchymist', which was a favourite theme).

(Ogdens; C.S. Schloss.)

WYNNANN, Gaeryt fl.1637

Among Lord Kenyon's MSS. is a letter written by George Rigby of Peel Hall, Little Hulton, Lancashire, mentioning an artist 'Gaeryt Wynnan' coming from Chester to spend a day or two at Peel Hall in 1637.

THOMAS WYCK, c.1616-1677. 'An alchymist'. V. & A. (Ham House).

YEEKES See **EYCKE, John**

ZEEU, Cornelius de **fl.1563 – 1565**
Dutch portrait painter of distinction, presumably from Zeeland. Three signed portraits by him are known: an 'Unknown man' of 1565 (St. John's College, Oxford), another of 1563 (Rijksmuseum, Amsterdam, bought in England), and a portrait of 'Andries van de Goes' (Dutch private collection). He need not necessarily have worked in England. For suggestions of his identity see *Poole (III, 154)*. A painter 'Cornelius' is also mentioned in England in Meres' *Wit's Commonwealth*, 1598.

ZITOZ (ZITIUM) See **SITTOW, Michel**

ZOON (SON), Jan Frans van **1658 – *c*.1700**
Flower painter of Flemish birth and training. Son of the flower painter Joris van Son. Apprentice at Antwerp 1677/78; died London (*Buckeridge*). He came to London early and married a niece of Robert Streater (q.v.), which brought him good commissions for decorative flower painting. His work is not known.

(*E.C-M., 229b.*)

ZOUST See **SOEST, Gerard**

ZUCCARI (ZUCCHERO), Federico **?1539 – 1609**
The leading painter, on canvas and in fresco, of the Roman Mannerist school, also theoretical writer, and an occasional portraitist. Born at St. Angelo in Vado, Urbino, probably 1539 (*G. Gronau, Documenti artistici Urbinati, 1936, 231*, the date usually given is 1542/43); died August 1609 in Italy. He was briefly in England from March 1574/75 for about six months and is known to have painted full-lengths of 'Queen Elizabeth' and the 'Earl of Leicester', for which drawings survive in the B.M., and he may have been responsible for reintroducing the full-length costume piece into English Court portraiture. For no serious reason his name was long falsely given to almost all Elizabethan portraits of any distinction.

(*R. Strong, Portraits of Queen Elizabeth, 1963;* fullest documentation of his career outside England is in *W. Körte, Der Palazzo Zuccari in Rom, Leipzig 1935, 70-79.*)

ZYL (ZIJL), Gerard Pietersz van **_c_.1607 – 1665**
Dutch portrait and genre painter; also known as 'Geraerts'. Born at Haarlem; buried Amsterdam 19 December 1665. He came to England to work with Van Dyck in 1639 and left after Van Dyck's death in 1641. Nothing is known of his work in England, but his later work owes a good deal to Pieter de Hooch.

(*J.H.J. Mellaart, Burlington Mag., (September 1922), XLI, 147/48.*)

Bibliography

With abbreviations used in the text and some notes on sources.

Archibald E.H.H. Archibald, *Dictionary of Sea Painters,* 1980.

Auerbach E. Auerbach, *Tudor Artists,* 1954.

Buckeridge B. Buckeridge in R. de Piles' *The Art of Painting, and the Lives of the Painters... To which is added An Essay towards an English School written for the most part by B. Buckeridge,* 1706.

Chaloner Smith John Chaloner Smith, *British Mezzotinto Portraits,* 5 vols. and a vol. of plates, 1878-83.

Colvin Howard Colvin, *Biographical Dictionary of British Architects, 1600-1840,* 1st edn. 1954; 2nd 1978.

Croft-Murray and Hulton Edward Croft-Murray and Paul Hulton, *Catalogue of British Drawings — British Museum,* 1960; a further volume is forthcoming. For Croft-Murray see also under **E.C-M.**

Crookshank and Knight of Glin Anne Crookshank and the Knight of Glin, *Irish Portraits 1660-1860.* Catalogue of an exhibition held in Dublin, London and Belfast, 1969/70.

Crookshank and Knight of Glin, 1978 *The Painters of Ireland, c.1660-1920.* This has the largest collection of illustrations of paintings by Irish painters and valuable bibliographical notes, but a certain number of the attributions are rather speculative.

Descamps J.B. Descamps, *La Vie des Peintres Flamands, Allemands et Hollandais,* Paris, 4 vols., 1763.

D.N.B. *Dictionary of National Biography,* 22 vols.

Duleep Singh H.H. Prince Frederick Duleep Singh, *Portraits in Norfolk Houses,* Norwich, 2 vols., *c.*1927.

E.C-M. Edward Croft-Murray, *Decorative Painting in England 1537-1837,* vol. i: Early Tudor to Sir James Thornhill, 1962; vol. ii: The Eighteenth and Early Nineteenth Centuries, 1970.
This has lists of known works and very full bibliographies and has been a major source of reference.

Edmond Mary Edmond, Walpole Society XLVII, 1980, 60-242.
The full title of the article is 'Limners and Picturemakers — new light on the lives of miniaturists and large-scale portrait-painters working in London in the sixteenth and seventeenth centuries.

Foskett Daphne Foskett, *Miniatures: Dictionary and Guide,* 1987.

Goulding and Adams Richard W. Goulding and C.K. Adams, *Catalogue of the Pictures belonging to the Duke of Portland, K.G.,* 1936.

Grant Colonel Maurice Harold Grant, *A chronological History of Old English Landscape Painters,* 3 vols., n.d. and 1947; revised 8 vol. edn. 1957-61.

Colonel Grant has looked attentively at a great many bad pictures and he illustrates many landscapes attributed to little known painters (usually signed, but he gives no indication). There is a great deal of waffle but he lists engravings.

Hofstede de Groot *A Catalogue Raisonné of the works of the most eminent Dutch Painters of the Seventeenth Century,* English edition, 8 vols., 1908-27. (Vols. 9 and 10 exist only in the German edition, Esslingen, Stuttgart and Paris 1926 and 1928.)

Ingamells John Ingamells, *The English Episcopal Portrait 1559-1835,* Paul Mellon Centre (privately published) 1981.

Kren Thomas Kren, *Renaissance Paintings in Manuscripts,* 1983.

Long Basil Long, *British Miniaturists,* 1929.
Although not always as up to date as Mrs. Foskett's *Dictionary* (q.v.), this is much richer in incidental information.

Millar (Sir) Oliver Millar, *The Tudor, Stuart and Early Georgian Pictures in the Collection of Her Majesty The Queen,* 2 vols., 1963.

Murdoch &c. John Murdoch, *The English Miniature,* 1981.

Nisser Wilhelm Nisser, *Michael Dahl and the contemporary Swedish School of Painting* (in England), Uppsala (London), 1927.

Ogdens Henry V.S. Ogden and Margaret S. Ogden, *English Taste in Landscape in the Seventeenth Century,* Ann Arbor 1955.

Poole Mrs. Reginald Lane Poole, *Catalogue of Portraits in the possession of the University, Colleges, City and County of Oxford,* vol. i, 1912; vol. 2, 1925; vol. 3, 1925.

Redgrave S. Redgrave, *A Dictionary of Artists of the English School,* 1878.
The latest one volume work including artists of all sorts and periods, but now often out of date. It is only given as a reference when information from other sources is not available, but it can almost always be looked at with profit.

Steegman John Steegman, *A survey of portraits in Welsh Houses,* vol. i *(North Wales),* 1957; vol. 2 *(South Wales),* 1962.

Strickland Walter G. Strickland, *A Dictionary of Irish Artists,* 2 vols., 1913. A most remarkable work, with lists of works where possible. Strickland had access to a number of papers which no longer survive.

Strong Roy Strong, *The English Icon,* 1969.

Talley M.K. Talley, *Portrait Painting in England: Studies in the Technical Literature before 1700,* 1981.

Th.-B. Dr. Ulrich Thieme and Dr. Felix Becker, *Allgemeines Lexikon der bildenden Künstler, von der Antike bis zur Gegenwart,* 37 vols., Leipzig 1907-50.

Vertue The notebooks of George Vertue (in B.M.), published in Walpole Society: *Vertue i* XVIII (1929-30); *Vertue ii* XX (1931-32); *Vertue iii* XXII (1933-34); *Vertue iv* XXIV (1935-36); *Vertue v* XXVI (1937-38); index to *Vertue i-v* XXIX (1940-42); *Vertue vi* XXX (1948-50).
These were the basis of Walpole's *Anecdotes* (q.v.) but contain a mass of facts which Walpole did not use.

Walpole Horace Walpole, *Anecdotes of Painting in England,* original edn., 4 vols., 1765-71.

I have used the most convenient edn., 3 vols., 1876, ed. by Ralph N. Wornum and including the additions of the Rev. James Dallaway. A volume of extracts from Walpole's Collections, by Frederick W. Hilles and Philip B. Daghlian, was published by Yale University Press 1937 as *Walpole's Anecdotes of Painting in England,* vol. V.

Waterhouse 1978 Ellis Waterhouse, *Painting in Britain 1530-1790,* 4th edn., 1978.

Waterhouse 1981 Ellis Waterhouse, *The Dictionary of British 18th Century Painters,* 1981.

Weyerman Jacob Campo Weyerman, *De Levensbeschryvingen der Nederlandsche Konst-Schilders. . .,* 3 vols., The Hague, 1729.

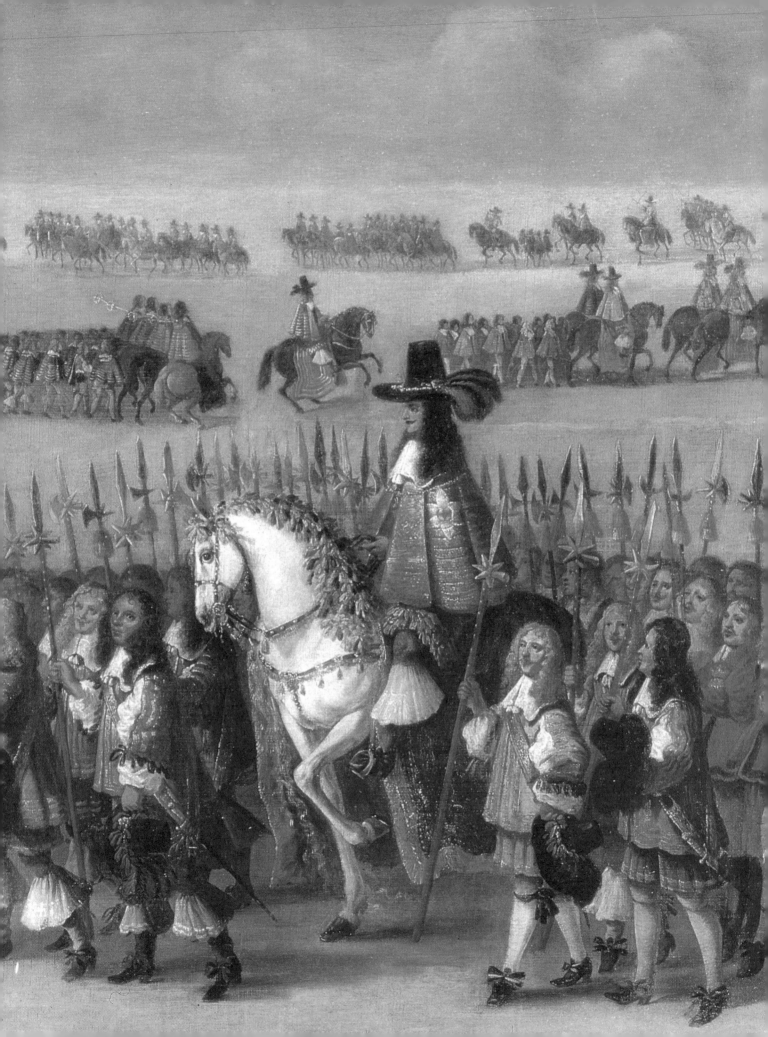